CLAY LANCASTER

The Japanese Influence
in America

第一ヶ条

一 日本と合衆国と、其人民永世不
朽れ和親を取結ひ場所人柄れ
差別無之事

*"There shall be a perfect,
permanent and universal peace,
and a sincere and cordial amity,
between the United States
of America, on the one part,
and the Empire of Japan on
the other, and between their
people, respectively, without the
exception of persons or places."*

ARTICLE ONE
COMMODORE PERRY'S TREATY
WITH THE JAPANESE
1854

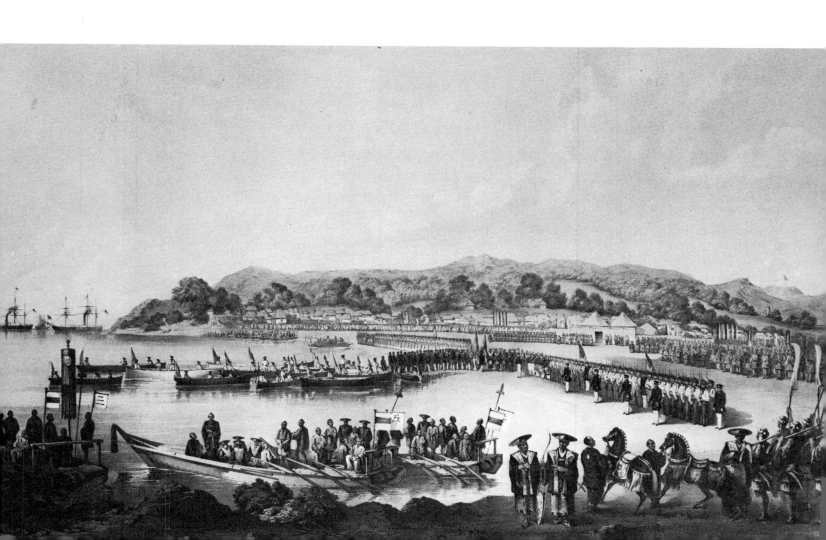

Japanese Influence in America

BY CLAY LANCASTER

With an Introduction by ALAN PRIEST

Former Curator of Far Eastern Art at the Metropolitan Museum of Art

ABBEVILLE PRESS • PUBLISHERS • NEW YORK

This book originally was issued by Walton Rawls: Publisher in 1963 and is reprinted with his permission and by arrangement with the author.

Library of Congress Cataloging in Publication Data

Lancaster, Clay.
 The Japanese Influence in America.

 Includes bibliographical references and index.
 1. Architecture—United States—Japanese influences.
2. Architecture, Japanese—United States. 3. Art, American—Japanese influences. 4. Gardens, Japanese—United States. I. Title.
 NA705.L3 1983 709'.73 82-22650
 ISBN 0-89659-342-8

TO JAPAN SOCIETY

which since 1907
has been actively engaged in promoting
good relationships
between the United States
and Japan

THIS BOOK IS
RESPECTFULLY DEDICATED

Table of Contents

Preface to the Second Edition

FAR FROM HAVING BEEN EXHAUSTED during the twenty years since the first edition of this book was published, Japanese influence and Japanese commodities have become so much a part of American life as to be taken for granted. Who any longer pauses to reflect, when confronted with paper napkins, paper handkerchiefs, or paper packaging, how surprised Commodore Perry was when he first encountered these items in Japan, or that they figured prominently among the gifts and curios that he brought back to the United States in 1854? What American wears or calls the ultimate in lounging robes anything other than a kimono, though he may have forgotten—or never known—its origin? And in summer what youngster has found footgear as free and comfortable as zoris, short of going barefoot? Every block in suburbia includes families who drive Japanese-manufactured automobiles and whose sons ride Japanese motorcycles; and every rural community possesses its share of Japanese pickup trucks and station wagons. Throughout America's houses are plastic imitations of Japanese lacquer, as well as Japanese-style dishes and other ceramics. Low-slung and built-in furniture bespeaks Nippon, and, very likely the families' radios and televisions were made in the Island Empire. That they were produced there is testimony to our influence upon Japan, and their appearance here shows that the phenomenon is reciprocal. Small-scale gardens (visible through sliding floor-length windows) and their flowering cherry and quince trees, wisteria, iris, chrysanthemums, and other perennials are transplantations from Japan. Our tendency to overlook the origin of these things indicates their complete assimilation. The Japanese influence has made a permanent imprint upon the American life style.

The chief characteristic of this influence, over the last two decades, has been wholesale adoption rather than the achieving of something new. There are more houses, more interiors, more landscaping, and more fine and decorative arts reflecting the Japanese manner than ever before. Innovation has given way to multiplication, and so the examples shown in the first edition of this book retain—or are

intensified in—their distinction. Some of these items, extant in 1963, have disappeared, whereas others have sprung up to take their places. For instance, the Japanese garden on the Clemson estate at Middletown, New York, at the junction of three states (pp. 203-5), came to an end when its contents were auctioned on 28 July 1966 and subsequently removed. However, the two-storied Japanese house was transported to Chestnut Hill, Massachusetts, and it was restored and occupied as a dwelling. Also, other Japanese gardens were built at the nearby Hammond Museum, North Salem, New York, and at the Duke Gardens, Somerville, New Jersey. The latter is accompanied by a Chinese garden. And at the Queens Botanic Gardens, Long Island, current construction includes Japanese, Chinese, and Korean landscapes.

An author may receive sundry additional data related to his subject after publication, and this gives him the good feeling that somebody "out there" has seen and perhaps read his book. Some data fit into the study perfectly, enlarging the material encompassed. Other contributions can present an initial "puzzlement." One such item, discovered and submitted by a roving friend, is a fifty-page booklet issued by the Millicent Library of Fairhaven, Massachusetts, in 1918 and reprinted in 1926. Entitled "The Presentation of a Samurai Sword," it concerns a fourteenth-century weapon that was given to the town by Dr. Toichiro Nakahama of Tokyo, commemorating his father's sojourn in Fairhaven during the 1840s. The episode occurred as the result of a New Bedford whaler, Captain William H. Whitfield, having picked up five Japanese fishermen stranded on a barren Pacific island in June of 1841. The youngest, named Manjiro Nakahama, a youth of fourteen or fifteen years of age, became the cabin boy and accompanied the captain to America. He attended school in Whitfield's home town, Fairhaven. In 1849 Manjiro followed the Gold Rush to California, did well for several months, and subsequently sailed on a ship bound for China. Within an easy pull of his native island, he had himself set afloat in a whale boat. After encountering considerable red tape with the local officials, his return was cleared and he proceeded home. Manjiro had been with his mother but three days when he was called to the emperor's court, where he became (as he later wrote to Captain Whitfield) "an emperian officer." Thus, several years before Commodore Perry arrived, the Japanese officials had been advised of the great continent to the east. Perry was astonished that one of the princely envoys asked, among other questions pertinent to America, how the Panama Canal was progressing (at that time the link being built across the isthmus was a railroad), indicating an inside source of

information. However, from first to last, during both official visits of the Americans, negotiations were conducted in the Portuguese language, through interpreters, according to the account in *The Narrative of the Expedition of an American Squadron to . . . Japan*, published in 1856. If Manjiro Nakahama actually faced the Americans he was not allowed to address them in their native language. In 1870 he was sent on an official Japanese assignment to Europe to study military science during the Franco-Prussian War. He returned by way of the United States, was formally received in Washington, and took the opportunity to visit Captain Whitfield at Fairhaven.

A number of important books have come out since the first edition of *The Japanese Influence in America* went to press. One that deals with the topic set forth in Chapter Two is Hugh Honour's *Chinoiserie: The Vision of Cathay* (E.P. Dutton & Co., 1962). Copiously illustrated and written with great insight and charm, Mr. Honour's study begins with an eleventh-century carved ivory casket in the Cathedral Treasury at Troyes, which shows a phoenix that he considers the earliest European example of *chinoiserie*. The book presents considerable examples dating from the seventeenth century, reaches its stride in the eighteenth, and includes survival and revival specimens of the nineteenth century. The only American work discussed is that of Whistler. Another delightful book of similar scope is Patrick Conner's *Oriental Architecture in the West* (Thames & Hudson, London, 1979), which is also beautifully illustrated. Limited to buildings and their appropriate garden settings, this volume includes Asian and exotic styles, other than Chinese, such as "Hindoo," "Morisco Gothic" or Mughal, Egyptian, and a bit of Japanese; the last, or twelfth, chapter is devoted to "Oriental Experiments in North America," mostly having to do with Middle Eastern influences.

For more ample discussion of the Far Eastern imprint upon the New World, one is referred to three articles in the publication accompanying the Nineteenth Annual Washington Antiques Show in 1974. The first is H. A. Crosby Forbes' "The American Vision of Cathay" (pp. 49, 51-4). The second is the present author's "The Chinese Influence in American Architecture and Landscaping" (pp. 33-6, 92-4, 97, 99). The issue also contains Arete Bernice Swartz's "Japanese Influence in 19th Century American Decorative Arts" (pp. 70-4, 115, 117-8).

The Japanese influence upon European art and culture since the middle of the nineteenth century has been explored considerably. Notable was the exhibition held during the Twentieth Olympian Games at Munich in 1972. The scope was "the encounter of 19th and 20th century European art and music with Asia, Africa,

Oceania, Afro- and Indo-America," as presented in 2394 display items. Most of the "encounter" was traceable to an Asian origin, and much was Japanese. A 650-page catalog in German and a 360-page equivalent in English, each with hundreds of illustrations, were issued. The author furnished an essay on "Japan's Contribution to Modern Western Architecture" in Europe and America.

An exhibition called "Japonisme: Japanese Influence on French Art 1854-1910" was assembled and displayed for six- or seven-week periods at the Cleveland Museum of Art, the Rutgers Art Gallery, and the Walters Art Gallery, during the summer of 1975 through January of 1976. Heads of the three museums and two members of the faculty of Rutgers University wrote the text for the catalog. Upwards of 300 items, including paintings, prints, ceramics, enamels, metalwork, bookmaking, textiles, and wood, were presented and illustrated in the 220-page publication.

The Metropolitan Museum of Art sponsored a study by Colta Ives resulting in a book called *The Great Wave: The Influence of Japanese Woodcuts on French Prints*, a 116-page volume handled by the New York Graphic Society in 1975.

An impressive tome edited by Dr. Chisaburoh F. Yamada, Director of the National Museum of Western Art, Tokyo, entitled *Dialogue in Art: Japan and the West*, was published by Kodansha and appeared in 1976. Contents include both the impression made by Japan on Europe and America and the reverse flow from the West to Japan. Subjects range from painting and graphics to sculpture, architecture, and decorative arts. Gordon Washburn, former director of Asia House Gallery, contributed a chapter on "Japanese influences on Contemporary Art: A Dissenting View," and the current writer, dealt with "The Japanese Imprint on American Architecture." Two authors were Europeans, and the other six Japanese. An edition of the book in French came out in 1976-77 and was called *Japon et Occident*.

In this day when world's fairs have accrued high interest and everything pertaining to them has become collectible, the first true one in America, the Philadelphia Centennial, has come in for its prime share. Two articles about it appeared in the Autumn 1976 issue of the Victorian Society's quarterly, *Nineteenth Century*, one on the Kansas–Colorado Building, and the other—which concerns us here—by Dallas Finn, called "Japan at the Centennial" (pp. 33-40). The author makes a strong case regarding the sale of Japanese exhibits, not only those in the Japanese buildings but the more valuable articles exhibited in the Main Hall. Although marketed all during the fair, they could not be taken by their buyers until the exposition closed. An old gold lacquered cabinet brought as much as $5,000, and a new equivalent went for

$1,000. A pair of tall Arita vases sold for $2,500, and smaller porcelains and bronzes were priced between $200 and $300. Also, there were many pairs of vases that were sold for $20, and tea services that cost as little as $15. The expensive treasures were the ones that were to figure prominently in the mansions on Fifth Avenue and elsewhere in Eastern cities rather than the simpler purchases in the bazaar. They adequately reflected the elaborate tastes of wealthy Americans of that mauve age.

Margaret Williams Norton, the holder of a master's degree in Far Eastern art history from the University of Chicago, furnished an article on "Japanese Themes and the Early Work of Frank Lloyd Wright" for the second quarterly issue of *The Frank Lloyd Wright Newsletter* in 1981. In addition to probable sources of inspiration from illustrations in Morse's *Japanese Homes and Their Surroundings* and the Hōō-den at the Columbian Exposition, Miss Norton's essay reproduces several photographs taken by Wright during his trip to Japan in 1905, including one of the Katsura Villa.

The works of no other American architects have received as much well-deserved praise as those of Charles Sumner Greene and Henry Mather Greene. In 1974, Janann Strand, first president of the Docent Council for the David B. Gamble House Museum and Library, brought out a most attractive book, *A Greene & Greene Guide*, with pen-and-ink sketches by Gregory Cloud. Included are discussions of various phases of the brothers' theories and works, quotations by various authors about them, an inventory of their buildings, four walking tours in Pasadena, and information about the Gamble House and its facilities, which, since 1966, have come under the aegis of the School of Architecture and Fine Arts of the University of Southern California. About the same time that this guide appeared, the Amon Carter Museum of Western Art at Fort Worth, Texas, issued William R. and Karen Current's magnificent picture book, *Greene & Greene: Architects in the Residential Style*. Mrs. Current gives a many-faceted consideration to the architecture, and Mr. Current's photographs are superb, with a warm richness of tone seldom achieved in offset reproduction. Several drawings by the author of the *Japanese Influence* appear in the book unexpectedly and uncredited.

A third opus of the seventies is Randell L. Makinson's *Greene & Greene: Architecture as a Fine Art*, published by Peregrine Smith of Salt Lake City in 1977. Mr. Makinson earlier had written a number of articles on the brothers, including Chapter Three in Esther McCoy's *Five California Architects* (Reinhold, 1960). Now Curator of the Gamble House, he did a comprehensive study of the architects' background and a painstaking analysis of their houses, including the several stages of those they built for one

client and enlarged and altered for another. The fine new photographs are by Marvin Rand. An article entitled "The Legacy of Greene & Greene, the Craftsmen-Architects of Pasadena," published in the April–May 1978 issue of *American Preservation* (pp. 42-59), amounts to a pictorial review of the Makinson-Rand presentation. Peregrine Smith followed up the first volume with an equally notable second by the same team in 1979: *Greene & Greene: Furniture and Related Design*. The depth of Mr. Makinson's involvement in the Greene brothers has led to his restoring and residing in one of their finest medium-sized houses in Pasadena.

Worthy addenda to the art of building in Japanesque style in the United States include three complexes dating from about the time that *Japanese Influence in America* first appeared. Newly built was a vacation resort at Osage Beach in the Ozarks, Missouri. Called Tan-Tar-A, its principal buildings, or Tradewinds unit, feature *irimoya* roofs (hipped with end apex gable) and encircling open galleries supported by slender posts. Accommodations include offices, a convention hall for 850 people, bowling alley, gift shop, cocktail lounge, and numerous guest suites, some with kitchenette. A ski jump is nearby. The other two groups are Zen retreats, one on the East and the other on the West Coast. The First Zen Institute of America since the early sixties has had a place in the Catskills, the renovation of a pre-existing structure designed by Deborah Reiser and executed by a Japanese carpenter. Its Buddha figure and shrine were sent by Dai Tokuji in Japan. The Zen Center in San Francisco acquired and fashioned a similar retreat at Tassajara, Monterey County, California, in 1966. It formerly had served as a small hot-springs oasis. Natural stone and timbers were blended with Japanese imports to produce an appropriate monastic atmosphere. The complex suffered severe damage by a forest fire and a later internal conflagration during 1977.[1]

Dwellings in the Japanese manner have been built apace with institutions. A vacation house was constructed for Dudley Miller at East Hampton, New York, in the early 1960s and given later additions. The roof curves up at the ridge instead of having the usual dip at the eaves. Robert Venturi and William Short were the architects.[2] A later summerhouse on Long Island is that of Mr. and Mrs. William Johnstone at Saltaire. It makes use of *shoji*, an authentic ceremonial tea room with *tatami*, and architectural details from Japan. Tom Moore was the architect.[3] A notable Southern example is Maho-no-Yama (Magic Mountain) built by architect James W. Deter for himself near Charlottesville in 1967. Sparked by his former involvement in Oriental philosophy at the University of Virginia, the architect set as his objectives a

residence embodying serenity, a oneness between the occupant and nature, and a harmony between the building and its picturesque woodland setting. Clues were taken from the Katsura Imperial Villa and garden. Recently, architect Deter has created a new office building in Albemarle County reflecting Japanese inspiration: steel and concrete are combined with stone and wood in a compact and low-spreading mass dominated by horizontal lines, adjusted to the crest of an irregular rise, and surrounded by unspoiled clumps of trees.[4]

Published almost simultaneously with the first edition of *The Japanese Influence in America* was Lawrence W. Chisolm's scholarly book, *Fenollosa: The Far East and American Culture* (Yale University Press, 1963). Of special interest is the critical analysis of Far Eastern art written by the subject, Ernest Francisco Fenollosa, which Professor Chisolm has discovered and documented in now-forgotten periodicals such as *The Knight Errant, The Golden Age,* and *The Lotos,* which gives us insight into his lecturing and teaching. To Fenollosa, painting should be related to poetry rather than to a scientific text; it should touch the soul and not merely record for the mind. Traditional Western painting follows the limited latter method, whereas Far Eastern art achieves a fine balance between visual and design elements. Other misconceptions then in vogue in Europe and America, Fenollosa felt, were that art ought to have a useful purpose and that merit lay in technical skill. He noted that these ideals were proper to crafts and not to fine arts. Virtuosity was like putting Paderewski's fingering above Chopin's music. Still another error was the mistaking of pleasure derived from art for intrinsic worth; they are separate entities. Fenollosa's ideal came to the fore in discussing the three absolutes—Truth, Goodness, and Beauty. His interpretation of the first is Platonic. Truth is not a literal reflection of the world but the transcendental reality that lies beneath appearances. Goodness is an ethical ideal, which is in no way puritanical or ascetic, but a happy state to be attained in a sort of millennium. The third, Beauty, is to be realized now and reaps the benefits of the other two. It is the aesthetic ideal, and the joy that it imparts is the farthest one can go in experience during the present life.

Fenollosa noted that three times in history man reached a high order of Beauty: "The first was five centuries before Christ at Athens; the second, twelve centuries after Christ at Hang-Chow; the third, fifteen centuries after Christ at Florence and Venice."[5] The Western world has run dry with imitating the first and third. "With us the old standards are dead, and gather like mummies into museums," said Fenollosa. He advised seeking fresh inspiration in the second instance of efflorescence—China

of the Sung dynasty. In the Far East of the late nineteenth century, art, although inferior to what it had been, was far from decadent. The trouble with Western art is that it is too analytical, disjointed, separated in subject from form; whereas, in Sung painting "there is perfect marriage on equal terms between the beauty in the subject and the beauty in the pictorial form. I call this Synthesis, because every part and relation has been absorbed in the new organic product without a remainder."[6] It was this quality that lived on in Japan and kept art alive. Fenollosa sermonized for a complete change in the West, starting with art education, substituting vital means for the rigid methods then being taught. Although his vehicle of persuasion remained superficially Ruskinian, Fenollosa's basic concepts cut clear, new channels.

Professor Chisholm throws additional light upon Arthur Wesley Dow and his connection with Fenollosa. Dow had studied in Boston and Paris and returned to America when he discovered, on his own, how much modern artists were learning of composition and decorative effects from Hokusai's prints. This took him to the Boston Museum of Fine Arts to examine the collection. There he met Fenollosa, who led him beyond Japanese prints to the finer subtleties of Japanese painting. Dow eventually became Fenollosa's assistant. During the first year that Dow taught composition at Pratt Institute, Fenollosa served as visiting lecturer, which must have provided a treasured experience for the students.

It was in his role as Director of Fine Arts at Teachers' College, Columbia University, that Arthur Wesley Dow converted a generation of artists and art teachers to Fenollosa's principles. One of the best-known painters was Max Weber, who had come to Dow first as a student at Pratt Institute. The synthetic method liberated Weber's imagination from the naturalistic norm and prepared him for an understanding of the paintings of Cézanne and Matisse that he was to see subsequently in Paris. The impact of these post-Impressionists is implicit in Weber's painting, but in the 1940s the artist declared that he was still "following Dow's principles."[7] Another painter who made a name for herself was Georgia O'Keeffe, who first heard of Dow from one of his former students. Realizing that he held the key to what she was after in art, she matriculated at Teachers' College in 1914. After two years' work under the master she joined the corps of missionaries spreading the new gospel across the country. Her domain was Texas, and she became head of the Art Department of West Texas State Normal College. After a few years she gravitated back to New York. The simplicity of O'Keeffe's painting suggests a fusion of Eastern models and the bigness of the region in which she executed her first important work; her style

remained exclusively her own.

Perhaps there has been too much emphasis upon the new trend's having been introduced by Americans directly from Japan. Besides earlier Americans who had learned of it in Europe and remained abroad, such as Whistler and Cassatt, and who made use of Japanese elements, there were full-fledged Impressionists who returned to the New World. Foremost among them was William Merritt Chase (1849-1916), born and brought up near Williamsburg, Indiana, where art lessons consisted of making pencil copies from a drawing book after school hours. The boy showed an aptitude for portraiture in sketches made of relatives. At twenty Chase went to New York and entered the studio of J. O. Eaton and took classes at the Academy of Design. A few years later he was at the Munich Royal Academy, and while there he shared a studio with Frank Duveneck. In 1878 Chase was invited to teach at the newly founded Art League in New York and returned to the United States. He joined the Tile Club and engaged in such activities as moonlight parties on barges bedecked with Japanese lanterns and Oriental hangings. It is reported that on one Oriental-inspired occasion he delineated willow-tree shadows on a white sheet. Visiting London in 1885, Chase called on Whistler, with whom he formed a strong friendship. Undoubtedly this association was one source of the Japanese influence in Chase's work, since in the following year he painted Mrs. Chase dressed in kimono and holding their first baby. Other paintings with Japanese motifs were *The Red Box* (1901), and *The Flame*, executed the year before his death. The French *plein air* school of the 1880s emancipated Chase from the somber tones of his Munich training; and contact with the art and commodities of Nippon were manifested in "his decorative use of the kimono-clad figure, the Japanese arrangement, [and] the introduction of Japanese objects into his compositions; [and] the indirect influence is found in his sense of elimination and color composition, and most of all, in his absorption of that indescribable thing that is the essence of a people's art."[8]

The statement in this book that "Zen was introduced to America in 1906" (p. 243) may be misleading. Cited is Soyen Shaku's *Sermons of a Buddhist Abbott*, published that year. As a matter of fact, Soyen Shaku had been in America thirteen years earlier, having participated in the World's Parliament of Religions, a conference auxiliary to the Columbian Exposition and held at the Chicago Art Institute. He gave two papers: on the eighth day his subject was "The Law of Cause and Effect as Taught by Buddha," and on the sixteenth day it was "Arbitration Instead of War." They were translated by D. T. Suzuki (as were other papers submitted by Japanese) and read by

the chairman of the Parliament, Dr. John Henry Barrows.[9] There were other talks at Chicago by Zen affiliates, but none of them was especially Zen. From this time on Americans were acquainted with the principles of Buddhism, but they awaited the appearance of the *Sermons* before learning the particular Zen viewpoint. The full story of the assimilation of Buddhism in the United States has been laid out in a recent study by Rick Fields. It is called *How the Swans Came to the Lake* (see Note 1 below).

Last spring (1-9 May 1982) the first Sakura Matsuri in New York City was held. It accompanied the old annual practice of viewing the cherry trees in blossom at the Brooklyn Botanic Garden, adjoining the Brooklyn Museum. The recent festival was a nine-day program of Japanese dance, music, karate and judo, sumi-e (painting) and ikebana (flower arrangement) demonstrations, haiku (poetry) readings, displays of origami (paper folding), toys, calligraphy, and folk art, accompanied by the sale of plants and the presence of *yatai-mise* (food vendors) offering sushi, tempura, teriyaki, and yakitori. A sweepstakes prize consisted of a week's trip for two to Tokyo. Sahomi Tachibana—currently in her fiftieth year of Japanese Odori—and her dance company performed on the two Sunday afternoons. Such a celebration of natural phenomena mostly ignored is greatly needed to give a firmer set of values to modern American life.

As we penetrate deeper into the last quarter of the twentieth century, approaching its close, we become increasingly conscious of how accelerated influences have borne down upon us from every direction, until we stand in the midst of a world of such thoroughly mixed antecedents that it has become confused and colorless. This observation is applicable across the entire continent, and actually around the whole world. Much of the recent innovativeness is gross: for instance, the vast shopping center, a seemingly interminable flat parking lot enframed by shoddy squat stores, is alike in every community from Maine to Southern California. This boring sameness seen throughout our environment, augmented by indifferent and tasteless television shows penetrating the sanctity of our homes, undermines the culture that countless generations have labored to perfect, thereby allowing it to sink to nothingness. Regeneration—even survival—depends upon an acute analysis of the condition and a workable solution to the problem. When our forebears came face to face with only a fraction of the decadence that confronts us, they turned for fresh inspiration to various vital civilizations of the past. So might we. The note of simplicity struck by Zen (which is entirely different from the rule of cheapest and easiest currently

employed by us) and the underlying ideal of nature and of the natural, which permeates so much of classic Japanese art and life, aptly could be applied to our situation today. By this must be understood not an advocacy of imitation, but the advice of searching out the principles and processes that made an age truly great, with the aim of applying them in improving ours. It is with this in mind that new readers may review what has been achieved in one field by the reissuing of this book. It is hoped that instruction may be accompanied by pleasure for a twofold reward.

<div align="right">

CLAY LANCASTER

WARWICK,

JANUARY 1983
</div>

NOTES

1 Rick Fields, *How the Swans Came to the Lake*, Boulder, 1981, pp. 359, 258–69, 367.

2 Clay Lancaster, Robert Stern, Robert Hefner, *East Hampton Heritage, an Illustrated Architectural Record*, New York, 1982, p. 202.

3 *Long Island*, 17 August 1980, pp. 24–6.

4 *Historic Garden Week in Virginia*, 1974, p. 15; letter from James W. Deter, 17 January 1983, with enclosure.

5 Ernest Fenollosa, "The Significance of Oriental Art," *The Knight Errant*, Vol. I, 1892, p. 65.

6 *Ibid.*, p. 66.

7 Lloyd Goodrich, *Max Weber*, New York, 1949, p. 8.

8 Katharine Metcalf Roof, *The Life and Art of William Merritt Chase*, New York, 1917, pp. 278–80.

9 John Henry Barrows (ed.), *The World's Parliament of Religions*, Chicago, 1893, pp. 829–31, 1285.

INTRODUCTION

TO MANY, AS TO ME, MR. LANCASTER'S ACCOUNT OF Japanese influences on the West will give great pleasure and profit. Complaints of the effects of Western culture on the Far East have been myriad and most of them justified. The more welcome then to have a book devoted to the reverse of the picture—the effect of Japanese art and culture on the Western scene.

Few of us have had any idea of the extent of the Japanese influence, especially in gardens and architecture, and here is a clear and comprehensive account presented with clarity and charm.

The world has always changed; young people have always wanted new and "modern" things and have rebelled against old customs and too often against their wiser parents. This is true, but in this twentieth century the pace has been accelerated and the results sometimes make one a little dizzy. I hear of a new train soon to be used— a train which will whiz one from Tokyo to Kyoto in three hours, a trip which today in a fast train takes seven. I myself do not want to be rushed through the beautiful countryside at any such speed.

The late Dr. Denman Ross of Cambridge, Massachusetts, a power in the affairs of the Museum of Fine Arts in Boston and of the Fogg Museum, traveled extensively and was one of the early travelers to the Far East, often to Japan in the last quarter of the nineteenth century. In 1923 he listened to a student's account of a first trip to Europe, where the American way of life was already very much in evidence with American jazz records drowning out the strains of the beautiful Blue Danube, with Bavarian girls except at hotel performances "fur den Fremden" minus their golden braids and clad in American cottons. After hearing him out, Dr. Ross exclaimed sadly, "To think I have seen the entire world destroyed in my lifetime!"

He did not mean the destruction of wars. He meant the ravages of what is often called progress. There is no way of halting the march of progress, but many of us wish that countries would retain their own characteristics.

There are consoling thoughts. The Japanese have gobbled up and digested other civilizations before this and turned back enough to retain much of their old culture.

Except for wondrous spots like the Imperial Palace and some (now) great public gardens Tokyo is a modern Westernized city, likewise Kobe, Osaka, and others. True, but if the traveler will go just as little off the main lines as to the mountain temple town of Kōya San, with some sixteen temple complexes of which several date back into the ninth century, he will straightway move out of the twentieth century into the nineteenth.

Mr. Lancaster's book gives us quite another side to the changing scene and how much this country has gained from its contacts with Japan—the effects of the Philadelphia, Chicago, and St. Louis expositions, and the surprising numbers of houses and gardens in the last part of the nineteenth century either direct copies or more often modifications of Japanese originals. He makes excellent survey of the California bungalow and perhaps does not go so far as to say as some of us do that these are the seeds (or spores) of the ranch house type of dwelling that has sprung up like a plague of mushrooms throughout the land, albeit practical no doubt.

Mr. Lancaster's prose is most agreeable to read and the subject matter so interesting that one is led to read almost as if it were a historical novel.

ALAN PRIEST
August 19, 1963

ACKNOWLEDGMENTS

THE AUTHOR wishes to express appreciation to the College Art Association for the publication of four of his articles having to do with aspects of the subject encompassed in the present opus and appearing in The Art Bulletin. *These include:* "Oriental Forms in American Architecture, 1800-1870" (*September, 1947*), "Oriental Contributions to Art Nouveau" (*December, 1952*), "Japanese Buildings in the United States before 1900: Their Influence Upon American Domestic Architecture" (*September, 1953*) *and* "The American Bungalow" (*September, 1958*). *He is indebted to the American Institute of Architects for his two reports issued in the* Journal: "My Interviews with Greene and Greene" (*July, 1957*) *and* "Some Sources of Greene and Greene" (*August, 1960*). *The author also is indebted to the publishers of* The Journal of Aesthetics and Art Criticism *for printing his* "Metaphysical Beliefs and Architectural Principles. A Study in Contrasts Between Those of the West and Far East" (*March, 1956*); *to* Fashion Digest *for publishing his* "Liberty Prints—Their Indebtedness and Western Contributions" (*Spring-Summer, 1957*); *to* Dance Magazine *for issuing his* "The First Japanese Dance Performed in America" (*January, 1956*); *and to* Plants and Gardens *for his essay on* "Takeo Shiota's Japanese Gardens" (*Winter, 1958*). *Many of the author's photographs and drawings illustrating these articles have been included among the plates in the current book.*

The author is most grateful to the John Simon Guggenheim Memorial Foundation for the award of a Fellowship in 1953 making possible a year of study and travel gathering material on the Japanese influence in America.

He is beholden to the staffs of the libraries in which research was conducted, and also often for help through correspondence about matters that came up when personal investigation was not practical or possible. Special mention should be made in this regard of Prof. James Grote Van Derpool, Mr. Adolph Placzek, and Mrs. Betty Megerdichian of Avery Library, Columbia University; Dr. Ryusaku Tsunoda, Mr. Howard Linton and Miss Miwa Kai of the East Asiatic Library, Columbia University; Mr. Wilson Duprey, Print Room, New York Public Library; Miss Betty Ezequelle, Print Room, New-York Historical Society; Miss Mildred M. Harper, Head of the Art Department, The Free Library of Philadelphia; Miss Helen P. Bolman, Librarian, Long Island Historical Society, Miss Virginia Daiker, Library of Congress; Mrs. Mary M. Moser, Reference Librarian,

San Francisco Public Library; Mrs. Elizabeth Tindall, Reference Librarian, and Mrs. Ruth K. Field, Curator of the Pictorial History Gallery, Missouri Historical Society; Mrs. Miriam Lucker Lesley, former Art Librarian, Minneapolis Public Library; and Mrs. Gladys Percey, Head of Research Library, Paramount Pictures Corporation. Other useful information has been acquired through the cooperation of Mrs. Frances S. Ballard, Fairmount Park Commission, Philadelphia; Miss Rhoda M. Musfeldt, Public Information Service, Chicago Park District; Mrs. George F. Havell, Assistant to the Supervisor, Manlius School; Mr. Lewis Mumford; Mr. Marcus Whiffin; Mr. Edo McCullough; Mr. John P. B. Sinkler; Mr. William Miller; Mr. Henry H. Saylor and Mr. Joseph Watterson, Editors of the A.I.A. Journal; Dr. George S. Avery, Director, Brooklyn Botanic Garden; Prof. Donald R. Torbet, Department of Art, University of Minnesota; Prof. David Gebhard, Department of Art, University of New Mexico; Mr. Robert Judson Clark and Mr. Allen Temko, students of California architecture; Mr. William C. Latchford of Gunn and Latchford, Inc.; Mrs. Ruth Sasaki and Mrs. Mary Farkas, First Zen Institute; Mr. R. N. Williams, 2nd, Director, Historical Society of Pennsylvania; Mr. Robert Schwartz, President, The Motel on the Mountain; Mr. L. N. Furch, General Manager, Sheraton-Astor Hotel; and Chief of Police Joseph Ostaseski, Oyster Bay, Long Island. For the excellent facilities and courteous service extended to him, the author wishes to acknowledge his indebtedness in general to Avery Library, the New York Public Library, the libraries of Cooper Union and the Metropolitan Museum of Art, the Saint Louis Public Library, the San Diego Public Library, the San Francisco Public Library, the Lexington Public Library and the Library of the University of Kentucky.

Certain museums and other depositories have been equally generous and helpful in making available their stores of treasures and information. Particular recognition is due Mr. Alan Priest, Curator of Far Eastern Art, the Metropolitan Museum of Art; Mr. Arthur Drexler, Director of the Department of Architecture and Design, the Museum of Modern Art; Mr. Kojiro Tomita, Curator of the Department of Asiatic Art, Boston Museum of Fine Arts; the late Mr. Fiske Kimball, Director of the Philadelphia Museum of Art; Miss Eleanor Olson, Curator of the Oriental Collection, Newark Museum; Mr. Marvin O. Schwartz, Curator of the Department of Decorative Arts, Brooklyn Museum; Mr. Franklin M. Biebel, Director, The Frick Collection; Miss Margaret McKellar, Executive Secretary, Whitney Museum of American Art; Mr. Richard H. Howland, Head Curator, Department of Civil History, Smithsonian Institution; Mrs. Lnor O. West, Administrative Assistant, Freer Gallery of Art; Col. George L. Smith, Honorary Curator of Anthropology, East Indian Marine Hall, Salem; and Mrs. Louise Lockridge Watkins, Director, George Walter Vincent Smith Museum, Springfield, Massachusetts.

For interviews and correspondence the author wishes to acknowledge the kindness of the following architects and designers and members of their families: the late Mr. Charles Sumner Greene and Mrs. Alice Greene, the late Mr. Henry Mather Greene, Mr. and

Mrs. W. S. Greene, Mr. Henry D. Greene, the late Mr. Frank Lloyd Wright, the late Mrs. Emily Post, Mr. Lucien A. Marsh, Mr. Hale I. Marsh, Mr. Burnham Marsh, Mr. and Mrs. Richard J. Neutra, Mr. William Gray Purcell, the late Miss Ethel Traphagen, Mr. and Mrs. Harwell Hamilton Harris, Mr. Daniel H. Burnham, Mr. Philip Johnson, Mr. L. L. Rado, Mrs. Lucille Raport, Mr. Thomas P. Coke and Mr. J. A. Schweinfurth. Equal acknowledgment is due the artists Mr. Sigismund Adler, Mrs. Bert B. Livingston and Mr. Peter Voulkos.

The owners and former owners of houses or other buildings included in this study have been most cordial in extending a welcome for inspecting, photographing and measuring, and in patiently answering questions. Noteworthy among them are: Mrs. Noemie D. Fortier, the late Mrs. Jessie T. Maxson, Mrs. F. W. Cochran, Mrs. Helen Hines Caskey, Mrs. Claire Tison Kennard, Miss Blanche Sloan, Mr. and Mrs. Luther Evans, Mrs. Henry C. Corbin, Mr. William E. Cross, Mrs. Melvin Osborn, Mr. Walter M. Jeffords, Mr. Hollis M. Baker, Jr., Mr. and Mrs. Bergman Richards, Mr. Gerald Swope, Mrs. George Martin, Jr., Mr. Cecil Gamble, Mr. and Mrs. Peter A. Horn, Mrs. Arnold Fedde, Mrs. William K. Dunn, Mr. Harley Culbert and Mr. Gail M. McDowell.

The author feels the deepest gratitude towards a group of persons who have taken a personal interest in his project on the Far Eastern trend in the United States and who have been of inestimable value in furthering this project. Heading the list is Mr. Douglas Overton, Executive Director of Japan Society. Others not referred to in other connections include: Mrs. Agnes Addison Gilchrist, Mrs. Ellen Kramer, Miss Louise Hall, Miss Mary Kam, Mr. Ralph Parker Bishop, Mr. Alan Burnham, Mr. William Sterling Dillon, Mr. Frank Hrubant, Mr. Chester Page, Mr. Donald L. Pray, and Mr. Douglas Rowley. Thanks are due Mr. Charles S. Terry and Mr. Peter Brogren for their excellence in planning and directing production of this book. Far from least on the list is Mr. Walton Rawls, who has been lavish in offering advice and editorial assistance, and to whose efforts are largely due whatever merits this book may contain.

CLAY LANCASTER
BROOKLYN HEIGHTS, NEW YORK

CHAPTER ONE
Early Japanese Contacts
with the
Foreign World

JAPAN has fluctuated greatly in its policies toward the outside world. These have ranged from a braggard's defiance to a learner's eager submission, and from extending esteemed personages a cordial invitation to the threat of immediate annihilation of all aliens setting foot on Japanese soil. The comparative isolation of the islands permitted Japan to indulge in its self-willed policies—at least up to modern times.

Earliest contacts were with the nearby mainland of Asia. Traditions claim that the exchange of communications between the rulers of Japan and China goes back to the beginning of the Christian era, but the oldest preserved text dates from the last quarter of the fifth century. This is a memorial to the Wei Emperor from the Emperor of Japan, who qualified himself as Supreme Director of Military Affairs in Japan, Paikché, Silla and other kingdoms in Korea. Although dubiously boastful, it indicates that the Japanese ruler exerted some measure of dominion over the Asian peninsula north of China.

Japan's political foothold on the continent at this time was short-lived, but relations with Korea and China resulted in great intellectual, artistic and spiritual gains for the Japanese. The adoption of the Chinese characters inaugurated the traditional mode of reading and writing in Japan.

In the middle of the sixth century a number of scholars well versed in the Chinese classics, medicine, divination, calendar-making and music came from Paikché. They were accompanied by Buddhist monks. An image of the Buddha had preceded them, and the monks conveyed a message from the King of Paikché recommending the adoption of Buddhism. Although it was described as being hard to explain and difficult to comprehend, the king proclaimed it the most excellent of all doctrines. For a while there were mixed feelings over accepting the foreign religion. The Japanese who opposed it played up the fears of offending the local gods. But by the end of the century the ruler known posthumously as Shōtoku Taishi—the Crown Prince "Sage Virtue"—had begun to propagate the moral and intellectual benefits of Buddhism, to encourage its teachings, to build temples and to establish its practices. Thus Japan adopted the first important outside influence, one that was to become strongly rooted in its heritage and a vital factor in shaping its culture and destiny.

The introduction of Buddhism brought the immigration of continental master-builders, image-makers, painters and various artisans, who came to construct and furnish buildings needed for temples and monastaries. Of course the menial labor was performed by native help. The influence of the foreigners instituted in Japan a new style in architecture, sculpture, painting and the decorative arts. It is noteworthy that the world's oldest existing timber buildings in the Chinese manner are to be found not in harassed China but in Japan. The intermediary was Korea. The Yakushiji at Nara preserves a pagoda dating from the third quarter of the seventh century. The Golden Hall (*Kondō*), the pagoda, and the gate house (*chūmon*) at Hōryūji were built as the replacement of earlier structures at the beginning of the eighth

[1]

century. In 749 a 53-foot bronze image of Roshana was installed in the Daibutsuden of the Todaiji. The hall measured 284 by 166 feet and was 152 feet high. It unfortunately burned during the twelfth century; and the building that replaced it, although only two-thirds the size of the original, is still the largest wooden building under one roof in the world. The people from the mainland brought the traditional method of Chinese painting, which makes use of monochrome ink washes. The technique is called *sumie* in Japan, where artists, including many of the highest rank, became throughly dedicated to it and expressed themselves in it perfectly.

Japan's intercourse with the continent subsided during the ninth century. Official missions ceased to be exchanged between the courts of Japan and China, and only two Japanese ships were allowed to port yearly in Korea. There was private abuse of the privilege, but nonetheless commerce was reduced to a trickle.

The next drastic encounter with foreigners was neither beneficial nor pleasant for the Japanese. In 1263 the Mongol Kubilai Khan became emperor of all China, and his realm was extended from the Pacific Ocean across the whole of Asia and as far into Europe as the Black Sea. His thirst for conquest finally turned toward Japan, and in 1268 he sent an envoy proposing friendly negotiations yet threatening belligerent reprisals if his requests were not complied with. Other menacing dispatches followed, but the Japanese refrained from replying. In 1274 Kubilai launched a fleet of several hundred ships manned by Korean sailors and carrying 15,000 Mongol troops. They captured the islands of Tsushima and Iki without difficulty, then sailed for Kyushu. Here they were met by the armies of local chieftains. Although at a disadvantage because of the Mongols' long experience in warfare and superior weapons—including some kind of combustible firearm and machines flinging heavy missiles—the Japanese fought bravely. At dusk the islanders retired behind their earthworks to await reinforcements known to be on the way. The invaders retired to their ships. During the night a violent storm broke, and the fleet suffered heavy losses. The survivors headed for safety out to sea and returned to Korea, where it was estimated that the expedition had cost the Mongols 13,500 men.

A few months later Kubilai transmitted a message bidding the Japanese ruler pay him homage at Peking. The Japanese were infuriated and beheaded six deputies from the mainland, displaying their heads in public. Within the next few years the Japanese made periodic raids against Korea, hoping to forestall another invasion originating from this quarter. They also pressed defensive measures, principally the construction of a stone rampart on the shores of the bay of Hakozaki. Meanwhile, Kubilai was diverted by a campaign against the Sung Dynasty in southern China, and it was not until 1281 that he again sent a force to Japan. It was composed of two hosts, one of 50,000 Mongols and Koreans and the other of 100,000 Chinese from south China. The ensuing struggle lasted more than seven weeks. Finally a fierce storm arose and for two days wreaked havoc with the enemy's vessels, driving them into the narrows where they were jammed and battered to pieces. The crews became an easy prey to the Japanese. At least half the invaders lost their lives before the rest pulled out. The Japanese stood in readiness for a return attack for about fifteen years, and relaxed their efforts only after receiving news of the death of Kubilai.

Japan was engrossed in its own affairs during the next two and a half centuries. The country had no foreign policy because there was no need for one. A little before the middle of the sixteenth century three Portuguese, who had taken passage on a Chinese junk bound for Liampo, were thrown off their course by a typhoon and landed on the small island of Tanegashima. They were given a warm welcome, and the natives manifested considerable interest in the arquebuses that they carried. The Japanese immediately set about to copy these firearms, and for generations the name for a gun in Japan was "Tanegashima." Other Portuguese in China

and Indochina heard of their countrymen's reception and set out to take advantage of trading opportunities in this rich new field. The Portuguese visited harbors in Kyushu and reached the capital, Kyoto, which they estimated to have contained 96,000 houses, evidence of a population exceeding half a million. It was larger than any European city of that day.

Portuguese merchants were followed by Jesuit missionaries from Macao and Goa. The Society of Jesus was formed in 1540, and it conducted its first seminaries in Portuguese territory. The Pope had granted the Portuguese a monopoly on both commercial and spiritual undertakings in the East; and hence all the traders at this time were Portuguese, and all the missionaries were Jesuits. For this reason Japan's first knowledge of Christianity was derived from the most militant and inflexible of its orders, which had a marked effect upon the Japanese outlook—and later policies—toward the West.

Francis Xavier and two other Spanish Jesuits first arrived at Kagoshima in 1549. They began to preach with the permission of the Lord of Satsuma and soon baptised 150 converts. It is doubtful that the understanding of Christianity among these people was very great, because an early document states that the Jesuits were propagating the Law of the Buddha. Japanese is a difficult tongue for newcomers to grasp, and the interpretation of Christian redemption in groping language must have sounded close to the salvation doctrine of Amidism. Besides, the Japanese were wont to conciliate the priests because of the deference paid to them by the Portuguese traders, in hopes of furthering their own business interests. As often as not, tired of waiting for Portuguese trading vessels that never came, the Japanese barons expelled the missionaries and ordered the people to revert to their former faiths. The intolerance of the Jesuits was another reason for their expulsion. In 1550 Xavier himself was ordered out of Satsuma because of offending the Buddhist monks; and at Yamaguchi he incensed the populace by insisting that all the dead who had not become Christians during their lifetime were burning in perpetual hell-fire.

The Jesuits' best reception was at court, where, in 1568, they were granted an audience by Nobunaga, then at the peak of his power. Their relationship became intimate, intensified by Nobunaga's troubles with rebellious Buddhist sects. Yet he was far more interested in the Jesuits' secular learning than their dogma. His policy was inherited by his successor, Hideyoshi, who, however, began to acquire misgivings over the fanaticism of Christian converts and the general craze of adopting foreign dress and manners. When the Jesuits became a nuisance through intrigues and squabbles over sectarian differences with newly arrived Spanish Franciscans and showed signs of assisting as a front to Western colonial enterprise, Hideyoshi took steps against them. Six Spanish Franciscans, three Jesuits and seventeen Japanese were executed in 1597. It was a miniature counterpart of the contemporary Inquisition in Europe.

The persecutions were continued only nominally by the next ruler, Ieyasu, who favored foreign trade. During his regime Protestant Dutch and English dealers began to supplant Catholic Portuguese and Spaniards, and this lessened or eliminated political intimidation. In 1610 Will Adams, a shipwrecked English pilot of a Dutch vessel, became adviser to the Shōgun on matters pertaining to trade and navigation. But beginning in 1612 Ieyasu issued several edicts authorizing the destruction of Christian churches, banishment or death to converts and the expulsion of Christian priests and monks. Ieyasu's son, Hidetada, who came into power four years later, pursued drastic measures to rid Japan of the troublesome foreigners, a process that persevered for approximately twenty years.

Meanwhile, toward the end of the sixteenth century, Japan launched against Korea a campaign that proved unsuccessful. It was followed several years later by another, which termi-

nated in 1598. In 1638 the government forbade Japanese to travel abroad. Japan lapsed into a long period of seclusion, interrupted only by the admission of a few Dutch trading vessels annually to Deshima in Nagasaki harbor. English proposals to renew commerce were rejected in 1673. American and Russian ships visited Japan in 1791-92 and likewise were repulsed. Decrees were reissued against outside intercourse, with death prescribed for any foreigner landing in Japan. Such was the Japanese isolation policy that prompted Herman Melville in *Moby Dick* to qualify the Island Empire as "impenetrable Japans."

Japan learned reading, writing, Chinese literature, art, architecture and the peaceful way of the Buddha from early contacts with continental Asia, which reached a high point during the mid eighth century. The trust established at that time was undone by the Mongol invasion five hundred years later. In the middle of the sixteenth century Europeans arrived and began a twofold program of proselytizing and enterprising. As foreigners they made the mistake of overplaying their role and brought upon themselves a program of expurgation. Most of the things introduced by Europeans were soon forgotten in Japan, but there were a few items that persisted in use, the principal ones being potatoes, tobacco and guns.

CHAPTER TWO

Far Eastern Influence
on Europe
before the Nineteenth Century

RARE WAS the European—or American for that matter—who, prior to modern times, could discern the difference between Chinese and Japanese, be it the people themselves, their language, fine arts, ceramics, costumes, or any other aspect of their cultures. Although outstanding differences do exist—the spoken languages, for instance, are totally unrelated—there was some justification for the confusion in the racial similarities of the two nations and the many facets of Japanese culture which had been adopted either from or through China, as we have already seen. Because of Japan's strict closed-door policy up to the middle of the nineteenth century, the bulk of Far Eastern exports to the West was Chinese, and the few Japanese articles that seeped through were usually distributed along with, if not actually represented as being, Chinese. The ascendance of Japanese shipments came comparatively late; and the Chinese mode in Europe, therefore, was prelude to the Japanese. Or, considering the long continuity of the former, perhaps it would be more accurate to say that the Chinese was a first movement, and the Japanese a second. In any event the two bear to each other an ethnic and sequential relationship. Our concern in this chapter is with the inception, development and scope of the first.

Chinese silks were known and used in ancient Rome prior to the beginning of the Christian era. They were transported along the famous Silk Route across the deserts of Central Asia, through the Pamirs to Turkestan, and over the Hindu Kush Mountains, dividing on the west side into the north branch, which went by the Caspian to Trebizond on the Black Sea, and the southern, which led out onto the Persian plateau. The exchange between China and Rome was not always affable. In 36 B.C. Chinese soldiers confronted Roman legionnaires in Sogdiana, and arrows from the powerful Chinese crossbows pierced Roman shields. Later Mediterranean—especially Alexandrian—mariners traveled to the East by sea, though principally to Indian ports, whence they returned laden with spices, textiles, and circus animals for Roman entertainment.

With the collapse of Rome and the ushering in of barbarian feudalism, intercourse between Europe and the Far East came virtually to a standstill. If items from China appeared at European market fairs they did so only after changing hands many times, and they were sold without a clear understanding of their identity. While eastern Asia was basking in the enlightenment radiating from India, western Europe was simmering in its own juices or diverting itself by imports from no farther away than Mediterranean countries of comparative decadence. Provincial Europeans of the middle ages had neither appreciation nor use for the delicate and artistic wares of the Far East; and, on the other hand, cultivated contemporary Chinese and their neighbors had no desire for the rustic products of Europe. Thus matters stood for centuries, or until a cultural revolution in the West and a political turnover in the East provided once more an atmosphere conducive to mutual exchange.

It is understandable that the first widening of the indrawn view of what constituted accept-

able civilization for medieval Europe should focus upon local efflorescence of a bygone age. Here lay exposed, as in Rome itself—or buried awaiting excavation, as in Pompeii and Herculaneum—treasures of rare beauty and grandeur. Ancient Roman monuments began to be regarded as something of more value than sources of ready-cut ashlar for new building enterprises. Ruins became the touchstone to a culture of richness and sensuality, the art of which was easily understood because it was literal, perhaps somewhat to the point of being naïve. Yet it was free from the fearful and other-worldly aspects of medieval art, with the restrained moralities, agonizing histrionics and mystical symbolisms of a pious religion. Ancient art interpreted life without shame or guilt, and the rediscovery of it caused men to question how valid the promised future rewards for unnatural present inhibitions might be. In the classic world man was the measure of all things. What better selling power could one have to offer?

The Renaissance was accompanied by an awareness of many things formerly overlooked, in addition to the ruins and remains of antiquity. An interest in the physical world brought about new discoveries which constituted the birth of modern science. Another aspect of the Renaissance ferment was travel and exploration—investigation of the foreign world. It was this facet of the Renaissance that prompted Maffeo and Nicolo Polo, and Nicolo's son Marco, to trek all the way from Venice across Asia to visit Cathay in the time of the great Kubilai Khan. The account of their peregrinations from about 1272 to 1293, as told by Marco to Rustician, filled all who read or heard of it with wonder and amazement. Thus was begun a new concern over the fabled lands of the East that was to stir men's imaginations for several centuries. Christopher Columbus made his daring—if ill-advised—voyage westward in search of the riches of the East. The simple, dark-skinned inhabitants whom he found were certainly not Chinese; but persisting in his belief of having reached Asia, Columbus concluded, therefore, that they must be Indians. Although the mistaken identity soon afterwards was recognized as absurd, the cognomen was never changed.

The obscurity of relationships between East and West is such that no clear records exist showing how certain practices or inventions originating in one part of the world, and employed there for centuries, found their way eventually to the other. A case in point, of outstanding significance for distributing knowledge, is printing. Printing was known in China as early as the fifth century, and by the ninth it was put to many uses: reproducing books of religious treatises (Diamond Sūtra in the British Museum, dated 868), poetry (that of Po Chü-i, 800-810), calendars (877 and 882) and works on divination, and even patterned textiles (a blue print in the British Museum). Before the middle of the eleventh century Pi Sheng made movable type of earthenware. It was fixed to a thermoplastic base consisting of an iron plate covered with a mixture of resin, wax, and paper ash, which was softened through heating and the type pieces pressed in. Movable type was used in Korea in 1242, and here type casting was advanced over the ensuing centuries. The Chinese preferred block printing to movable type because of their love of calligraphy, and perhaps because the single blocks printed faster. The Tripitaka issued in China between 971 and 983 required 130,000 wooden blocks. In Japan prayers were printed on a wholesale scale and deposited in wooden reliquaries before 770, and books were printed during the tenth century. From the early sixteen hundreds onward the Japanese printed and illustrated books in purely native style, and later in that century Hishikawa Moronobu began reproducing genre-painting subjects by woodblock printing. From this developed the great art of the Japanese print of the eighteenth and nineteenth centuries, which had a tremendous influence upon pictorial arts in Europe beginning in the latter half of the nineteenth century (Chapter Four). By that time printing was prevalent throughout the

West, where it is claimed to have been used first in the second quarter of the fifteenth century by Johann Gutenberg of Mainz or Laurens Coster of Haarlem. However, the sophistication of their use of movable type indicates antecedents. One notes that this is a thousand years after the employment of printing in the Far East. William Caxton learned printing in Cologne and introduced it into England in 1476. Published in the vernacular, instead of Latin as on the Continent, Caxton's work did much to standardize the English language. Printing has promoted phenomenal changes in every culture it has entered. It has been lavish as a teacher and yet holds as a closely guarded secret the exact particulars concerning its adoption in the Occident.

Another invention conceived by the Chinese is eyeglasses. Magnifying glasses set in frames were worn in China as early as the tenth century. Across Eurasia, the first mention of the optical use of lenses was recorded by Roger Bacon in 1268. A few years later Marco Polo reported having seen eyeglasses at the court of Kubilai Khan, and the first popular use of glasses in Europe was manifested in Marco's homeland, where they are said to have been introduced by Alessandro di Spina of Florence. A Fresco painted in 1352 on a wall of the Church at Treviso depicts Cardinal Ugone wearing spectacles. As with printing, the time lag between the invention of sight aids in China and their appearance in the West can be reckoned in centuries.

That the Polos were in Cathay during a highly cultivated era makes all the more tragic the fact that Marco was not addicted to art, his account being conspicuously lacking in reference to it. No art objects are known to have been brought back to Europe by the Polos, which, however, does not rule out their importation through other channels at this time. A number of modern critics have felt that they could discern in late thirteenth and fourteenth century Italian painting tangible evidence of Far Eastern influence. One writer, considering the elements that appear for the first time in Western painting in the works of contemporary masters such as Giotto, Duccio, Simone Martini, Pietro Lorenzetti, Antonio Pisanello, Barna, Luca Signorelli, and Sassetta, has pointed out those likely of Chinese derivation.[1] These may be summarized as: (1) the language of hands[2]; (2) elongated, narrow eyes; (3) the human figure shown in back view; (4) foreshortening; (5) a wider range of figure attitudes, from the extremes of dynamism to meditative tranquillity; (6) the figure consistently clothed; (7) interest in animal subjects; (8) a treatment of supernatural beings (angels); (9) the introduction of landscape backgrounds; (10) the use of inscriptions within the picture area; (11) representation by linear means (contours); (12) a new conception of composition, which is no longer limited by a rectangular frame but takes on the freedom proper to a scroll; (13) the giving way of symmetry to casual arrangements; (14) a gentleness of manners; and (15) the appearance of figures in Chinese costumes.

Late thirteenth century European travelers to Cathay were preceded by missionaries and succeeded by more missionaries and traders. The merchants were not to prosper long, because the Mongols were overthrown in 1368 by Chu Yüan-chang, the founder of the Ming Dynasty. The Mings constituted a line of conservative and nationalistic rulers who viewed foreigners with disfavor. Their reign lasted almost three hundred years. Trade received an additional blow in the fifteenth century with the rise of the belligerent Ottoman Turks in western Asia and eastern Europe, discouraging all but the most tenacious merchants. Only the Venetians did not give up. After 1479 they were obliged to pay the Turks for the privilege of trading beyond the Black Sea, but the monopoly enabled the Venetians to force Europe to buy on their terms or do without. Another alternative was to find a different route to the Far East.

The Portuguese, encouraged by their Prince, Henry the Navigator, sought a way by sea around Africa. In 1488 Bartholomew Diaz reached the Cape of Good Hope. Nine years later Vasco da Gama rounded it and continued up the east coast of Africa and across the Indian Ocean, finally reaching Calcutta. During the early sixteenth century the Portuguese established trading posts along both coasts of India, in Ceylon, Malaya and Indonesia, from which posts expeditions went on to China. The piratical practices of the Portuguese made them unpopular, and it was not until 1557 that they were granted a permanent base at Macao, about eighty miles south of Canton in south China. By this time, as we have seen *(Chapter One)*, the Portuguese had gained a foothold in Japan. From 1580 until 1640 Portugal became an annex of Spain. It was then that the ranks of Portuguese Jesuit missionaries in the East were reinforced with Spanish Franciscans, and friction between them came to be a source of considerable annoyance in Japan. Three other European nations joined the Latins in commercial ventures in the Orient. The English East India Company was founded in 1600, the Dutch in 1602 and the French in 1664. Like their southern neighbors, the later European merchants began implanting trading bases in India, the southeast Asian archipelago—especially the Moluccas or Spice Islands—and up the east coast of the mainland to Macao, and Yedo (modern Tokyo) in Japan.

With the establishment of the sea trade, products reached Europe in proportional quantities from India, China, and until the Exclusion Acts of the seventeenth century, from Japan as well. Even afterwards the Dutch shipments were supplemented by smuggled goods and by Japanese products that had found their way into Siam, Sumatra, Java, India and China and were transshipped from these intermediaries. As all kinds of glazed pottery came to be called "china," so all types of lacquer came to be referred to as "japanning." John Stalker, in his *Treatise of Japanning*, published in 1688, says: "Let not the Europeans any longer flatter themselves with the empty notion of having surpassed all the world.... The glory of one country, Japan alone, has exceeded in beauty and magnificence all the pride of the Vatican and Pantheon heretofore." He was referring, without doubt, not only to the architecture and Renaissance painting in the Vatican, but to the extensive collection of antique sculptures there as well. According to Stalker the visual pleasure given by the art forms of the ancients was outdone by those of the Japanese.

We have spoken of the influx of Oriental wares and indicated appreciation for them in Europe, and now we turn to the influence of the Far East upon works produced in Europe during the late seventeenth and eighteenth centuries. These fall into two principal categories, one being garden structures, and the other decorative items, including, sometimes, whole rooms in the "Chinese Taste" or *chinoiserie* style.

The first monument of major significance in Europe showing Chinese influence was the Trianon de Porcelaine, built in the park at Versailles for Louis XIV in 1670-72. The Trianon de Porcelaine was a single-storied architectural composition of five pavilions enclosing three sides of a paved court that opened onto a circular forecourt *(§1)*. The three main blocks were connected by curved screen walls, and at the back expanded a vast formal parterre which was terminated by a gilded bower of narrow galleries framing an open quadrangle. The Trianon itself was embellished with quoins and pilasters, entablatures, pediments, balustrades, and sculptured busts on consoles, and the mansard roofs were enlivened by dormer windows and urns, all of which features belong to the Baroque style. The Chinese constituent was the "porcelain" covering the walls, suggested by the famous Porcelain Pagoda in Nanking. The Chinese pagoda was not actually surfaced with porcelain but with colored glazed tiles. The Trianon revetment was even less durable, a sort of faïence that did not weather well, causing

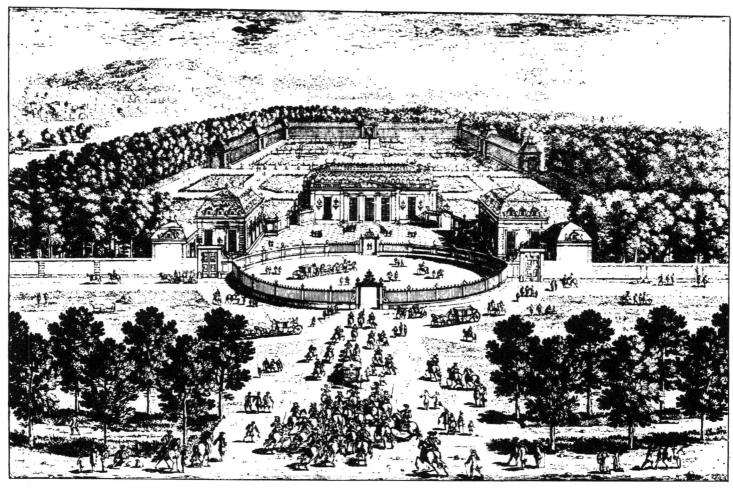

§1. *Trianon de Porcelaine, Versailles.* (*Perelle*, Veües des plus beaux bastimens de France.)

Louis XIV to order the building demolished fifteen years after its completion. Thus the one external element linking the building to the Flowery Kingdom proved to be its undoing.

The Trianon de Porcelaine was torn down before the beginning of the eighteenth century, but the Chinese vogue continued. At Versailles the court welcomed in the 1700's as the "Chinese Century." The celebration took the form of a spectacular night *fête*, in which the courtiers paraded in costumes of shimmering silk to the accompaniment of bursting fireworks appropriately imported from Cathay.

Louis XIV's original Trianon had been greatly admired, and many persons of position sought to possess at least a modest imitation of it. Accordingly there was begun a fashion that spread far and wide, seeming to justify the theme of the Versailles *fête*. Most manifestations were small garden pavilions with flaring roofs and other recognizable features related to Chinese buildings. Models could be had from engraved plates in various books, and these became more accurate as the eighteenth century progressed. It is important to note that the style of garden in which these bits of bizarre architecture were implanted was quite different from the Renaissance-Baroque formal garden, such as that adjoining the Trianon de Porcelaine. The ideal shifted from grandeur to picturesqueness. The new type originated in England as a natural park inspired by the Chinese. On the continent this species of romantic garden was designated *jardin anglo-chinois*, and many beautiful old gardens fell victim to the new craze. Their parterres and clipped hedges were destroyed, their stone basins converted into irregular lakes fed by meandering streams crossed by arched bridges; artificial hills were raised where all before was flat, their summits crowned by fanciful summerhouses or gazebos, with

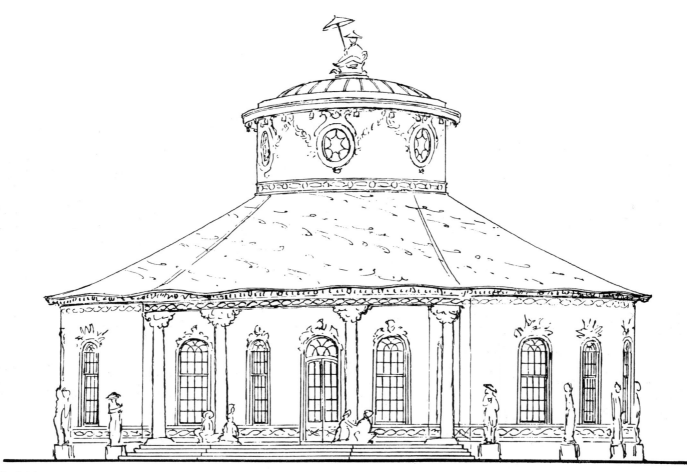

§2. *Sketch of the Chinese Tea House, Sans Souci, Potsdam.*

incidental aviaries or tea houses scattered about, and of course as many exotic plants as could be procured. Such conceits were publicized through G.L. LeRouge's *Détails des Nouveaux Jardins à la Mode*, 19 portfolios of engravings printed at Paris and circulated from 1776 to 1787.

Eighteenth-century progeny of the Trianon de Porcelaine include: the Chinese House of the Désert de Monville (begun in 1771) at Chambourcy, not far from Paris, the seven-storied Pagoda (1775-78) at Chateloup, near Amboise, in France; the Japanese Palace (1715-41), the Wasserpalais (or Indian Garden House—1720) and Bergpalais (1723) near Dresden, the circular Chinese House (1754-57) *(§2)* and the four-storied Dragon House (1769-70) in the park of Sans Souci at Potsdam, the "Indian House" in the pheasantry (finished 1750) at Brühl, near Cologne, in Germany; "Peking" and "Canton," two late-eighteenth-century houses at Baarn, near Hilversum, Holland; China House (1753) at Drottningholm, Sweden; the Chinese Village (begun 1764), consisting of eighteen houses, a small temple and a hexagonal pagoda, at Tsarskoe Selo, near Leningrad, Russia; the Chinese Dairy at Woburn Abbey (1789) in Bedfordshire, the House of Confucius (before 1763), the Chinese Pavilion in the Pheasant Ground (1760) and the octagonal ten-storied Pagoda (1761-62) at Kew Gardens, near London, in England.[3] The architect of the last two was Sir William Chambers, who had visited southern China as chief supercargo on a Swedish fleet, and who in 1757 had published a volume of *Designs of Chinese Buildings*. In 1760 Chambers became architect to George III, which gave him the opportunity of planning the grounds and building the structures of Eastern inspiration at Kew Gardens. Drawings of the project appeared in book form in 1763. Of all the buildings named above not one was prompted by serious intentions or served a practical purpose.

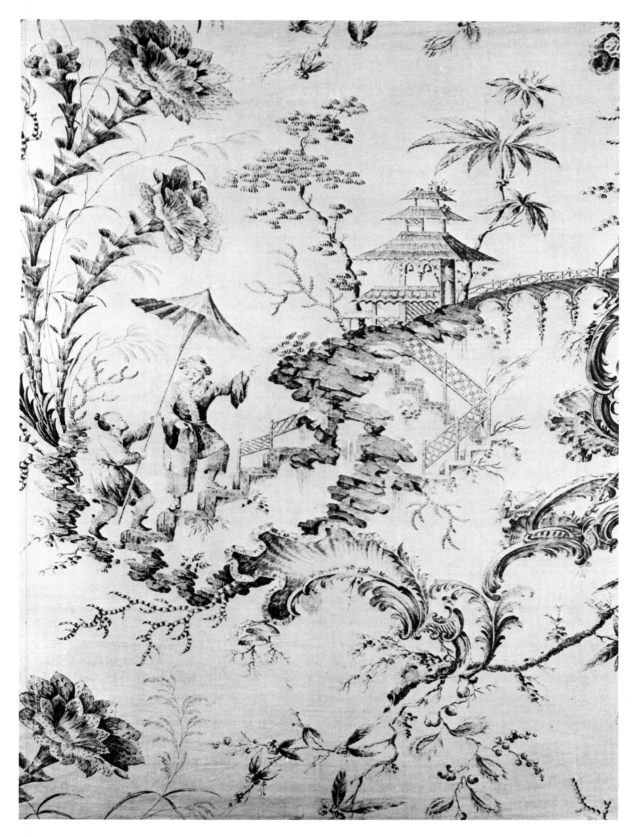

§3. *Chinoiserie design printed in blue on cotton, from Bromley Hall, England. (Cooper-Hewitt Museum, New York.)*

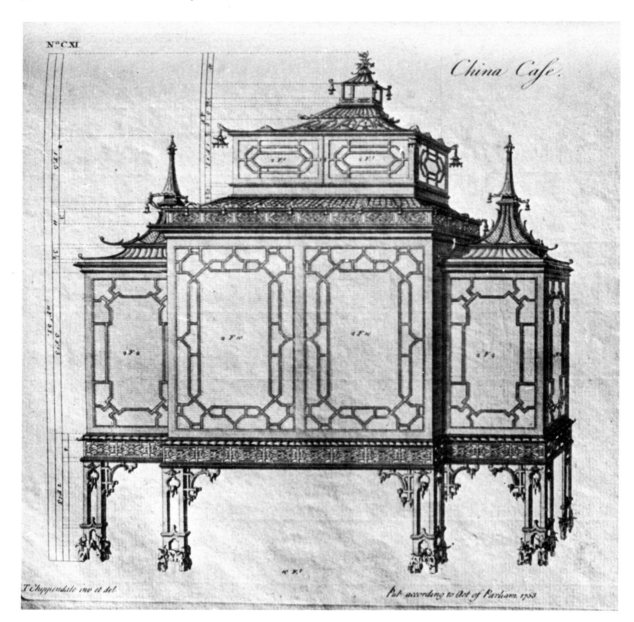

§4. *Design for a china case in the Chinese style. (Chippendale,* The Gentleman and Cabinet-Maker's Director, *London, 1754.)*

The second variety of Far Eastern influence in eighteenth-century Europe was in the field of decorative arts. At this time the ponderous, manipulated and reduplicated architectural forms of Louis XIV Baroque had been supplanted by a sweeping, airy mode that made use of delicate elements resembling plumes, seashells and odd-shaped rocks, from the last of which it acquired its name—the Rococo style. The Baroque was best suited to the exterior of buildings, whereas the Rococo was primarily adaptable to interior treatment. Its predominant colors were shell white and gold, with touches of blue and pink. These were the hues of porcelains. As a matter of fact the word "porcelain" derives from its affinity to the pinkness of "little pigs." Eastern porcelains fitted in perfectly with the Rococo scheme of decoration, and, it might be added, Chinese silks furnished the most harmonious window draperies. It is said that the Trianon de Porcelaine housed the porcelain collection of Louis XIV and that its interiors were high in color value. One supposes, therefore, that imported ceramics may have had something to do with the Rococo style from the outset. It seems only natural that scrolled rockery reliefs on Rococo walls should become peopled with little fairy-like beings from the land of porcelain, disporting themselves on aerial stairways among palm trees and delicate

flared-roofed pavilions—as fancied by European designers creating them, of course. The foremost French designer was Jean Pillement (1728-1808), who turned out hundreds of "Chinese" motifs of the type just described. He lived for a while in the British Isles, and Pillement-type designs often appeared on wallpaper or chintzes for hangings stamped in England (*§3*). This tangential branch of Rococo is labeled *chinoiserie*. It reached a logical climax in rooms lined with polychrome porcelain revetments (a sort of Trianon de Porcelaine turned outside in), examples of which were to be found at the Reggia in Portici—all but the ceiling later moved to the Palace of Capodimonte—in Italy, and in the Palace of Carlos III at Aranjuez, Spain. The first dates from a few years before and the second a few years after the middle of the eighteenth century. It is interesting that the latter, although thoroughly *chinoiserie*, is spoken of as being in the "Japanese style."[4]

The Chinese influence penetrated the realm of furniture for Rococo rooms. One source of motivation was the imitation of lacquered pieces from the Far East. Authentic imports were exceedingly expensive. The French and English developed the art of "japanning," using resin lac (shellac) in place of varnish from the true lacquer tree (*Rhus vernicifera*). Designs of figures and landscape objects were usually raised in gessoed relief. Backgrounds were black, red, green and tortoise shell. Work of this kind was very popular during the middle of the eighteenth century; then it began to wane after 1765. "Japanning" was a surface treat-

§5. English versions of Arita ware: Chelsea covered vase, ca. 1755, and Plymouth teapot, ca. 1770. (Metropolitan Museum of Art, New York.)

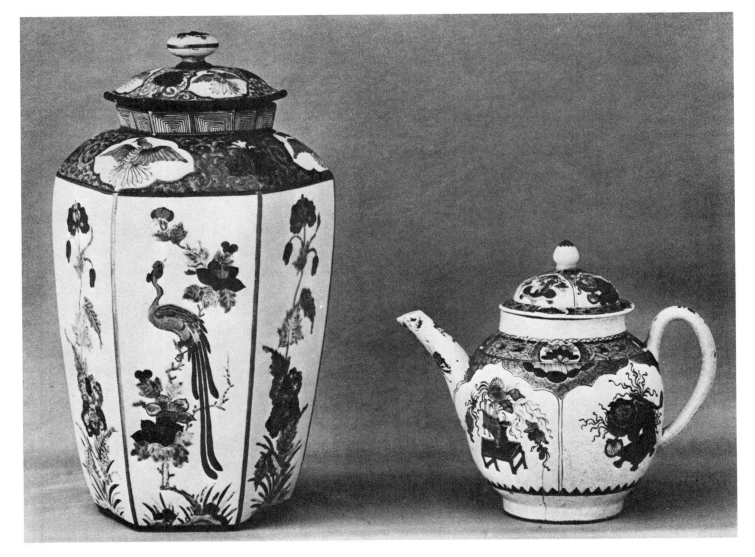

ment superficially related to its Oriental prototype, and often it was applied to furniture having no resemblance in form to Asian pieces.

But many European cabinetmakers were appreciative of the lines of Far Eastern furniture. The cabriole leg of Queen Anne and Louis XV chairs came from the Chinese. The illustrious protagonist of the Chinese Taste in furniture was Thomas Chippendale (1718-79), who borrowed freely from Chambers' designs, producing beds, cabinets and mirrors with dipping canopies, like Chinese roofs, open trellis panels and carved fretwork friezes. His chairs had plain straight legs with brackets at the junction of the seat, or cabriole legs with ball-and-claw (dragon's claw) feet, and latticework in the back, sometimes confused with Gothic tracery. Chippendale's designs were published in *The Gentleman and Cabinet-Maker's Director* of 1754, which made them generally available to furniture manufacturers everywhere (*§4*). However, Thomas Chippendale was an eclectic, and only a modest percentage of his output vividly reflected the Chinese.

The most lasting and complete veneration of Far Eastern artistry in Europe has been in ceramics. The Chinese discovered at an early date that the use of certain ingredients subjected to excessive heat in firing brought about a hardness and glassy appearance known as vitrification. A modification of materials produced an additional quality of translucency, and thus true porcelain came into being. Porcelain was achieved about the third century of our era. Subsequent refinement of shape, color and decoration advanced it into one of the world's most beautiful and sophisticated art forms. By the T'ang Dynasty (618-906) Chinese porcelain had already circulated as far as Persia and Egypt. Europe "discovered" the Chinese wares much later. They were known and appreciated during the seventeenth century when an earnest effort was made toward reproducing them. Europeans experimented in combining glass with white clay for translucency and resonance, but the soft-paste mixture proved to be far inferior to genuine porcelain. Shortly before Père d'Entrecolles wrote from China the first of two letters describing the production of porcelain (1712 and 1722), the German alchemist J.F. Böttger of Dresden independently arrived at the identical hard-paste formula used by the Chinese. In England the use of bone ash in a soft-paste medium provided a reasonable facsimile of porcelain. On the whole English bone china is of more interest than later hard-paste ceramics. The character of T'ang imports had a perceptible effect upon the potters of Staffordshire, especially Thomas Whieldon (active 1740-80), who used a deliberate streakiness in colored lead glazes and developed a "solid agate ware" and marbled ware inspired by the foreign archetypes. Whieldon's partner for five years was Josiah Wedgwood, Britain's greatest name in pottery. In the work of Wedgwood, Chinese influences also are to be found, though not in such distinct categories as in that of Whieldon.

There was a special kind of Chinese ceramic that went to Japan, where it was imitated, and the imitations took on definitive form which, in turn, proceeded westward to make a marked impression upon early nineteenth-century English pottery. The original in China was called *Wu-ts'ai yao* (five-color ware). It was a porcelain of good quality that was decorated with overglaze polychromy. The Japanese version, called Imari, became more elaborate in pattern and color, and introduced relief and profuse gilding. Imari was the progenitor of the showy red and gold Flight & Barr Worcester porcelain, some Spode, and much of Derby. They were manufactured especially for Regency interiors and can even be said to have helped determine the style.

A more praiseworthy species of Japanese porcelain is Arita, associated with the seventeenth-century artist Sakaida Kakiemon. Arita features a white body lightly decorated with prunus and cherry blossoms, peonies and chrysanthemums, phoenixes, quail and other birds,

executed in overglaze enamels of coral-red, blues and greens, yellow and a little gold. In Europe it was copied extensively at Meissen, St. Cloud, and Chantilly, and in England at Chelsea, Plymouth, Bow and Worcester (§5).

Before drawing to a close this discussion of the influence of the Far East upon Europe up to the early nineteenth century, mention should be made of one product that was known and used more commonly than silk or ceramics. The product referred to was tea. Tea drinking began in China about the same time as porcelain making, and tea and porcelain have remained in close association ever since. Early teacups (T'ang period) had ring handles, but later Eastern cups were handleless. Pots were made for hot water, because in the Middle Kingdom tea was brewed in the cup, and cups were provided with covers to retain the heat during steeping. The English became the foremost tea enthusiasts in the Occident, and they imported or made the largest amount of tea accessories. Tea services produced locally suffered several changes, because of differences between English and Chinese tea habits. In England tea was brewed in the pot, and the spout usually was set lower to retain the tea leaves. The teacup cover became meaningless and changed into the English saucer. Cream jug and sugar-bowl were strictly Western innovations. Early in its career only mild green tea was imported, whereas later the strong fermented black tea came to be in greater demand. Green tea was Chinese, but black tea was imported mostly from India. Drinking tea was a polite social custom that spread from England to the New World, where excessive taxation on it touched off an incident in Boston that kindled the American Revolution.

The Far East, by virtue of its geographic remoteness, was to Europe a sort of Never-never Land, from which first came diaphanous silks, and later dazzling ceramics, lacquer, and fireworks, delicious tea, and exotic paintings, furnishings and gardens. These items were all used in Europe and the art forms romanticized and imitated in varying degrees. The Far East figures in the discovery of the New World through the search for a sea route to the Orient. From the end of the middle ages up to the time of the decline of monarchies in Europe the Far East contributed to Western culture certain—disputable—innovations in early Renaissance painting, suggested the basis for settings of frivolous diversions, and supplied the finest decorative objects Europe had possessed.

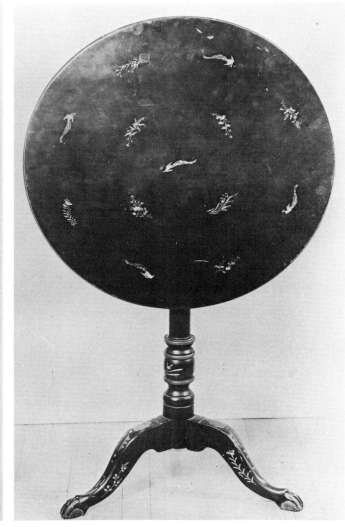

§6. & §7. Knife box in bronze lacquer with gold spray decorations. Tilt-top table in black lacquer with mother-of-pearl inlays. These were brought from Japan by Captain Devereaux in 1799. (Peabody Museum, Salem.)

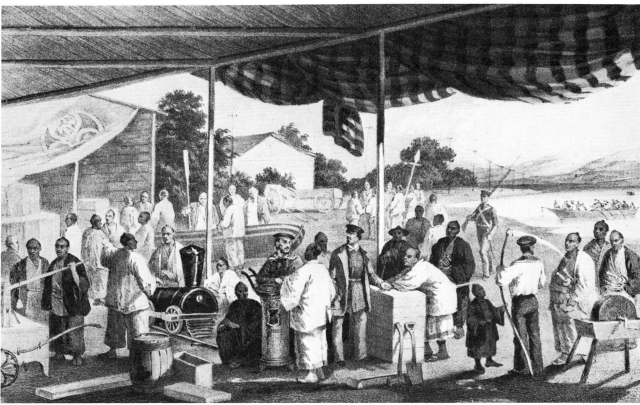

§8. Delivering the American presents at Yokohama, 1854. (Perry, Narrative of the Expedition of the American Squadron . . . , Vol. 1, facing p. 357.)

CHAPTER THREE

The Beginnings
of Japanese
Relations with America

THE FIRST American attempt to engage in trade with the Japanese (mentioned at the end of Chapter One) was rejected in the early 1790's; but before the turn of the century an American ship sailed boldly into Nagasaki harbor, conducted its business and departed, returning for a similar performance twelve months later; this ship was replaced by a different vessel but with identical intent the following year. The Americans were substituting for the annual Dutch engagements, which the Dutch themselves were not able to keep because of general hostilities in Europe after the French Revolution and the frequency with which British men-of-war were capturing the Dutch East India Company transports. The Dutch feared that their failure to appear at Deshima on schedule might terminate their trade agreement with the Japanese, and they hired ships of a neutral country to represent them. In 1797 and again in 1798 they engaged the *Eliza* of New York, commanded by Captain William Robert Stewart, but little is known of Captain Stewart's encounters with the Japanese because he never returned to the United States.

The Perkins' ship *Franklin* of Boston, under Captain James Devereaux of Salem, was the second ship chartered to make the voyage. In 1799 Captain Devereaux set out with the Dutch East India Company's cargo of ivory, tin, cotton, sugar, cloves and pepper. He also took some things to trade on his own, including silver watches, treacle, lanterns and blue glass. The *Franklin* arrived at Nagasaki on July 19, flying the Dutch flag and firing a salute. If the Japanese suspected the true identity of the ship they judiciously kept it to themselves. Although certain restrictions were imposed, such as taking all firearms and books ashore until the boat was ready to leave, the crew was allowed to go sightseeing in guided parties during the four months' stopover. When Captain Devereaux departed he took with him a number of pieces of lacquered furniture that had been made in Japan. The Peabody Museum in Salem now owns four: a black serving tray, a circular tilt-top table, a bronze-lacquer half-round table with a hinged wall leaf and a knife box. They are decorated with phoenixes, flowers and branches in gold and inlaid with mother-of-pearl (§6-7). The Essex Institute across the street from the Peabody Museum has a tilt-top table in bronze lacquer. With the exception of the tray, the forms of these items are Western—barring some peculiarities, such as the feet of the table illustrated—indicating they were made from models in the Americans' possession, yet not too accurately observed by the native craftsmen. The decorations, of course, are pure Japanese. The furniture is lightweight, apparently constructed of Japanese *kiri* wood.[1]

At the beginning of the nineteenth century Japan again tightened the enforcement of its edicts debarring foreigners. When the American vessel *Morrison* entered Yedo Bay in 1837 it was immediately driven away. Nine years later two warships, the *USS Columbus* and *Vincennes*, under Commodore James Biddle, arrived at Uraga to invite the Japanese to sanction trade. During the visit an unfortunate incident occurred. Commodore Biddle was boarding a Japanese junk where no official was in readiness to receive him and a Japanese soldier

either pushed or struck him. Profuse apologies later were offered and Biddle, who was anxious to promote friendly relations, said that he would be satisfied if the soldier received no more punishment than the Japanese law required under the circumstances. His generosity was construed as weakness. The proposals were turned down. Biddle was asked to leave and not return, and a long tow of Japanese row boats assembled to speed the unwelcome vessels out to sea.

The loss of face in 1846 made Japan no less attractive to the United States. The potential value of her products here and the latent market for ours there (especially cotton) were appreciated by American diplomats. One other important factor was involved. In the middle of the nineteenth century many American ships were coal-burning side-wheelers, and if competition with European nations in Asia were to be maintained on an equal footing, a refueling station had to be provided in a convenient country that could be trusted. The location and lack of foreign entanglements made Japan ideal in this respect. Washington prepared for action, and in January of 1852 President Fillmore offered Commodore Matthew Calbraith Perry the most substantial diplomatic mission entrusted to any American naval officer up to that time. The objective was a treaty with Japan providing protection for American seamen and property in Japan and Japanese waters, and the opening of one or more ports for supplies and trade. Commodore Perry sailed from Norfolk in November on board the *Mississippi* bound for China, where he was to assemble the proper fleet to carry the President's message to the Emperor of Japan. Benefiting by his predecessor's errors Perry saw to it that his retinue was sufficient to make an imposing impression upon the Japanese. On July 8, 1853, aboard the

§9. *Bowl in red and gold lacquer and dipper in red lacquer with shell inlays, presented to Perry in Japan. (Smithsonian Institution, Washington.)*

flagship *Susquehanna,* the envoy arrived at Yedo Bay, where he was advised to go to Naga-saki. The Governor came to meet him the next day, but the Commodore insisted upon com-municating directly with the Emperor or his personal representatives. Arrangements were made for the delivery of the official document at Kurihama, where, on July 14, amidst pomp and ceremony, the visiting emissaries went ashore in small cutters. They were confronted by a double column of American forces lined up on the beach, and passing between, they ap-proached Prince Idzu and Prince Iwami, who awaited with a sizable suite to receive the message on behalf of the Emperor. The Americans proposed returning early the following year for the response and withdrew to the Bailey Islands to allow the Japanese time for consid-eration. The historic event in Yedo Bay was memorialized in four large colored lithographs by W. Heine, published in New York by Sarony & Company in 1856.[2] The attractive landscape setting, with only a few huts in evidence, could have been almost anywhere in the world, and gave little or no indication of the age-old culture of Japan.

Commodore Perry returned to Japan in February of 1854. Yokohama was agreed upon for the place of negotiations with the five Japanese commissioners appointed for the purpose. There on March 31 was signed the Treaty of Peace, Amity and Commerce granting Ameri-cans trading rights at the two ports of Hakodate and Shimoda. Because of certain restrictions and the absence of extra-territorial rights the treaty was not considered a sweeping success from the American point of view, but Perry was satisfied that a more generous amendment would be forthcoming.

During the second visit gifts were exchanged between the two parties *(§8)*. The govern-ment of the United States presented a model railroad locomotive, tender and carriage, for which a circular track was laid. The train is reported to have "swept round and round with great rapidity, to the astonishment of the beholders." Another wonder was an electric tele-graph apparatus with copper wires strung on a series of poles to demonstrate sending mes-sages from one place to another. Hardly less spectacular was a daguerreotype camera that produced pictures without pencil or brush. Other gifts included several kinds of hard liquors and wines, perfumes, a telescope, clocks, guns, measuring instruments, and books, among them John James Audubon's four volumes of *Birds of America* and three volumes of *Quadru-peds.* In reciprocation a collection of lacquers, porcelains and costumes was conferred upon the Americans, forty to fifty pieces of which are preserved in the Smithsonian Institution of the United States National Museum *(§9).*

Commodore Perry was received rather indifferently back in Washington. Although Bayard Taylor, who had accompanied Perry as a sort of secretary, had sent accounts of the fleet's travels to the *New York Tribune* and published these sketches in 1855 as a book entitled *A Visit to India, China and Japan,* Perry sought a better press for his venture. He stopped to see Nathaniel Hawthorne, then American consul in Liverpool, to ask him to undertake a full report on the expedition, but Hawthorne declined on the grounds that he was committed to his present post. Commodore Perry then assumed the undertaking himself. His *Narrative of the Expedition of an American Squadron to the China Seas and Japan Performed in the Years 1852, 1853, and 1854,* consisting of three weighty tomes, was issued from Washington in 1856. Among the lithographs illustrating the first volume was the scene of the delivery of the American presents reproduced in §8.

During the summer of 1860 a Japanese mission was sent to the United States to ratify the treaty. The Nipponese took the opportunity to visit several American cities, where they were entertained and paraded before a population curious to see the little men from the other side of the world. The *New York Times* for June 26 called their reception "decidedly the most

magnificent display our city has ever seen." In the midst of the crowds thronging Broadway for a glimpse of the Japanese commissioners stood Walt Whitman, whose poetic impression of the spectacle was published in the *Times* for June 27. The poem was originally entitled "The Errand-Bearers," and ten days after the event it was published independently as "A Broadway Pageant." The first two quatrains run:

> *OVER the Western sea hither from Niphon come,*
> *Courteous, the swart-cheek'd two-sworded envoys,*
> *Leaning back in their open barouches, bare-headed, impassive,*
> *Ride to-day through Manhattan.*

> *Libertad! I do not know whether others behold what I behold,*
> *In the procession along with the nobles of Niphon, the errand-bearers,*
> *Bringing up the rear, hovering above, around, or in the ranks marching.*
> *But I will sing you a song of what I behold Libertad.*

Whitman refers to the decorations, the salutes, and the crowds that "gaze riveted tens of thousands at a time." He sees not one nation alone that proceeds up the narrow space between the marble and irons towers of Manhattan, but all the Orient:

> *For not the envoys nor the tann'd Japanese from his island only,*
> *Lithe and silent the Hindoo appears, the Asiatic continent itself appears,*
> *the past, the dead,*
> *The murky night-morning of wonder and fable inscrutable,*
> *The envelop'd mysteries, the old and unknown hive-bees,*
> *The north, the sweltering south, eastern Assyria, the Hebrews, the ancient of ancients,*
> *Vast desolated cities, the gliding present, all of these and more are in*
> *the pageant-procession.*

"Geography, the world, is in it," he cries. The guests have arrived, not from the East— as Europe might have signified—but from "Western golden shores." This was indeed an American orientation. The poet beheld the "swarming market-places, the temples with idols ranged along the sides. . . ." He saw "Mandarin, farmer, merchant, mechanic, and fisherman, the singing-girl and the dancing-girl, the ecstatic persons, the secluded emperors, Confucius himself, the great poets and heroes, the warriors, the castes, all." These figures came trooping from all quarters of Asia. In his imaginary gathering in of such a throng Whitman forgets not the purpose of the emissaries passing before him. He is an American who visualizes:

> *My sail-ships and steam-ships threading the archipelagoes,*
> *My stars and stripes fluttering in the wind,*
> *Commerce opening, the sleep of ages having done its work, races reborn, refresh'd,*
> *Lives, works resumed—the object I know not—but the old, the Asiatic*
> *renew'd as it must be.*
> *Commencing from this day surrounded by the world.*

The third and last stanza is addressed to Whitman's comrade Americans. It begins: "And you Libertad of the world! You shall sit in the middle well pois'd thousands and thousands of

years..." because, "the orb is enclosed, the ring is circled." He refers to the western march of civilization, which has been the trend for centuries; but now this has changed, as he concludes: "they shall now be turn'd the other way also to travel toward you thence, they shall now also march obediently eastward for your sake Libertad."

After the parade the Japanese commission was entertained at a banquet given in the Metropolitan Hotel by August Belmont, the banker son-in-law of Admiral Perry, and at an opera specially performed in the new Academy of Music on Fourteenth Street.

The interest in Japan and the Japanese that was manifested by the American public in the 1860's was temporary and superficial. The theater capitalized on the visit by hurrying into production such titles as "Our Japanese Embassy" and "Tycoon: Or, Young America in Japan." P.T. Barnum rose to the occasion by advertising a display of Japanese coins, lanterns, autographs and other curios among the more familiar exhibits in his American Museum. With the exception of the presents transported by Commodore Perry, and perhaps other gifts bestowed by the visiting dignitaries, it is doubtful that much of value in the line of Japanese art goods reached the United States prior to the fourth quarter of the nineteenth century. The Japanese influence in America was still in a preparatory stage.

CHAPTER FOUR

The Japanese Imprint
upon Europe in the
Late Nineteenth and Early Twentieth Centuries

THE INFLUENCE of the Far East upon European culture from the end of the medieval period to the middle of the twentieth century may be divided into two phases. The first lasted from the thirteenth until well into the nineteenth century, or from the early Renaissance to and into the Romantic era. As was noted in Chapter Two the source of inspiration for this phase was primarily China. This foreign influence had a somewhat different effect upon European art and life from the rediscovery of the ancient world. The preoccupation with excavated antiquity imposed a rigidity upon Renaissance and later forms, an adherence to the limitations of style and a consciousness of period, whereas the stimulation of objects from the Far East tended to diversify forms, to prompt individual expression and to dissolve the context of time and place. These are characteristics of Romanticism, and in this regard the exotic literal copying of Chinese porcelains in Europe was an interlude having nothing to do with the development of art that is being considered.

The second phase of Far Eastern influence began in the latter half of the nineteenth century. With China closing in on itself and Commodore Perry having recently persuaded Japan to enter into foreign intercourse, the chief source of inspiration was brought about by the new wave of Japanese imports. The opening of the Suez Canal in 1869 helped to accelerate the acquisition of Japanese wares in Europe. At that time Romanticism was showing signs of decadence, the Neo-Classic was preparing to perform the swan song of the well-worn Renaissance theme, Eclecticism had climaxed and exhausted the creative impulse fettered to former styles, and the camera had outmoded pictorial realism. Furthermore, machines of the Industrial Revolution were grinding out pathetic reproductions of articles the character of which demanded individual attention. There was a great need for designs appropriate to new methods of production. The temperature was right for something fresh, dynamic and intrinsically different, for Europe was becoming bored with its traditions and standing on the threshold of modern times.

The Chinese Taste provided frivolous diversion through its applied arts, and escape from the everyday world among the bizarre pavilions and strange plants of its picturesque gardens. Temporary release from stark reality, however, is far from a substantial solution to the problem of human fulfillment. In the realm of art, no less than anywhere else, one has to come to grips with fundamental issues on a rational and not a fanciful basis. This began to be understood in the nineteenth century and became the thesis of the new viewpoint. Expressing individuality and devising new forms took on a meaning that far outstripped adherence to these ideals under the most liberal conditions of Romanticism. Also it was understood that the outward appearance of historic styles was irrelevant to current design needs. The experience of other cultures can be of value only if one finds and utilizes the underlying principles that make a work of art great in its own setting. The influx of Japanese art from the middle of the nineteenth century onward furnished Europe with considerable material for speculation. To

the West the Japanese seemed to be a nation of lucid designers, facile craftsmen, brilliant painters and well-rounded artists.

The imprint of the Japanese was felt strongly in two areas of European art of the late 1800's and early 1900's. One was the decorative arts, especially in the movement known as Art Nouveau. The other existed in painting and graphic media among the works of the forerunners of Impressionism, in those of the Impressionists themselves, and in some of the works of Post-Impressionists.

Art Nouveau came into being as a reaction against the staid confines of contemporary eclectic design. The progenitors of Art Nouveau felt that after the numerous revivals of the eighteenth and nineteenth centuries the styles had run their course, and to revive them again would be utter folly. They wanted to achieve significance through means that would give freedom and originality full rein. It was not that Art Nouveau condemned the art of the past, but, as one of its foremost spokesmen put it, for a people "to counterfeit the genius of their ancestors... [was] to sterilize the genius of their own generation."[1] The author said that what could be beneficially gained from pre-existing art was to find "the spark of that former life which had developed [it]." Alternative names for Art Nouveau indicate its revolutionary aspect: Belgium called it "La Libre Esthétique," Germany labeled it "Jugendstil," Austria gave it the title "Secession," and in France it was sometimes known as "Le Renouveau dans l'Art." The principle of freedom was so deeply ingrained in the movement that Art Nouveau never became, strictly speaking, a style. It varied from one country to another and even from one locality to another.

The living kinetic and nonconforming traits of Art Nouveau relate it to eighteenth-century Rococo. Far Eastern elements—Chinese in the one and Japanese in the other—were determining factors. To a degree Rococo and Art Nouveau employed similar palettes; and, in both, paintings were made to fit into spaces provided for them by décor. In its sweeping curves and bits of odd ornaments the Rococo achieved more unity than Art Nouveau, but Art Nouveau outdid the Rococo in the energy that went into its use of the undulating line, described as the "whiplash line." Through it Art Nouveau immortalized violent movement, and attained its most characteristic feature. The whiplash line has a power and a tension unlike any linear treatment in historic Western art.[2] But if one looks to the Orient one can find an acceptable precedent in the lightning strokes of Far Eastern calligraphy. Since the beginning of the

§10. *Calligraphic rendering of the character sui (to follow) by Wang Hsi-chih of the Chin dynasty, fourth century. (Yee, Chinese Calligraphy, London, 1938, Fig. 81.)*

§11. *Design for a balcony by Maxime Roisin, Paris. (Moderne Bauformen, Vol. I, 1902, p. 23.)*

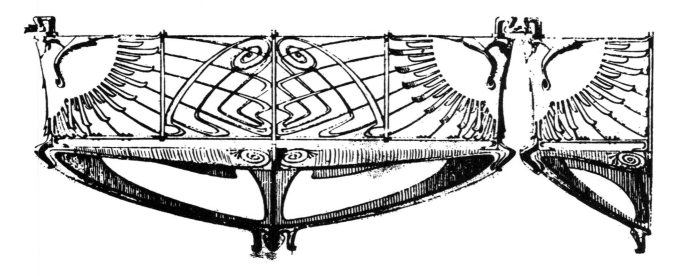

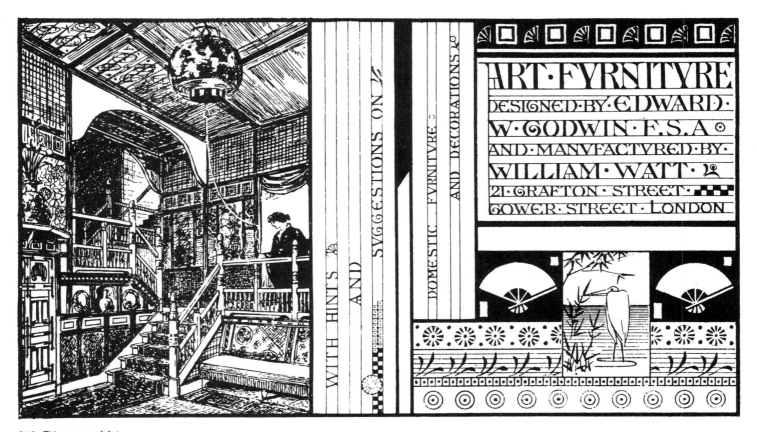

§12. *Title page of* Art Furniture Designed by Edward W. Godwin. . . , *second edition London, 1878*

§13. *Detail of Plate 8 from* Art Furniture Designed by Edward W. Godwin. . . .

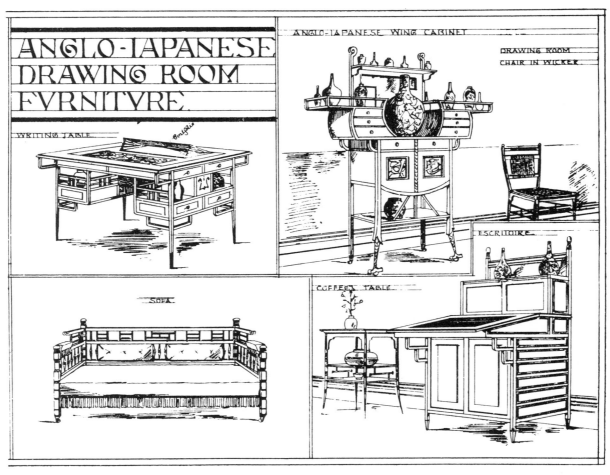

Christian era, in China—and, since the sixth century, in Japan—calligraphers have ranked with painters in honor and esteem. Their works are executed with the painter's equipment, and the technique is the same. With the brush held perpendicular to the painting or writing surface, strokes are made with strong, quick thrusts, a prescribed flourish accenting the limits of a single stroke or a change in direction. Writing styles range from clearly legible square characters to the abstracted cursive "grass" script (§10). The Art Nouveau whiplash line consciously imitated grass calligraphy, sometimes in planned, symmetrical arrangements, which defeated the effectiveness of its free flow (§11).

Japanese art figured in the early careers of a number of the foremost advocates of Art Nouveau, and thus it had a direct bearing upon the direction the mode was to take.

The first person to be discussed was a precursor to the Art Nouveau movement. He was the English architect and designer Edward William Godwin (1833-86). In 1862, the year of the Japanese Court at the International Exhibition, Godwin remodeled for his own occupance a large Georgian house at 21 Portland Square in Bristol. The walls were painted in plain colors—which was considered very daring at the time—as an appropriate backdrop for displaying framed Japanese prints. Godwin's biographer said of him: "When he was able to please himself, his designs had a Japanese character.... He had, from 1860 onward, devoted as much time to the study of Japanese art and its principals [sic] as [previous to that date]... he had employed upon medieval research."[3] Each of his subsequent homes was decorated in the Japanese manner too, and successive wives and a daughter wore kimonos to harmonize with the settings. A sketch of an interior on the title-page of Godwin's book *Art Furniture*, published by William Watt in 1877, can be assumed to have been taken from one of his own apartments (§12). The source of the motifs and delicacy of treatment is unmistakable, and the scene is complete with mistress in kimono. Godwin's London drawing room, as finished in 1874, had matting covering the floor and dadoes above which the walls were white. Godwin designed similar rooms for clients. He also designed wallpapers for Jeffrey and Company, and furniture for William Watt. Several pages of the Watt catalogue were devoted to "Anglo-Japanese" pieces, some of which (such as the escritoire in the lower right hand corner of Plate 8) have a very modern look (§13). Japanese lightness of construction, architectural brackets, and "cloud" pattern lattices (in the sides of the coffee table alongside the desk) are other features in evidence. The wing cabinet above utilizes curves that foreshadow Art Nouveau proper of a decade or more later. The *feel* of Godwin designs was taken over and popularized in the more prosaic style known as Eastlake of the 1870's and 1880's.

Another Englishman who made ample contributions to modern design, and whose name became synonymous with Art Nouveau, was Arthur Lasenby Liberty (1843-1917). The new mode in Italy was specifically called *Stile Liberty* after him. In 1863, as a youth of nineteen, Liberty was appointed manager of Farmer and Roger's Oriental Warehouse in Regent Street, London. It was the first depot in England for the exclusive sale of goods from the East. Customers with whom Liberty came in contact included architects and designers such as Godwin, the William Morris handicraft group, and renowned artists like Whistler and Rossetti. The Oriental Warehouse came to an end in 1874, and the following year, Arthur Liberty opened his own emporium, the East Indian House, at 218 Regent Street, where he continued to stock Peking pilgrim bottles, Imari beakers and Buddhist altar decorations. At the same time he became interested in Eastern techniques of making fine cloth, which he recognized as being greatly superior to European manufactures. He not only began showing fine hand-woven fabrics from India, China and Japan alongside the porcelain and other bric-a-brac, but persuaded mills in the English Midlands to reproduce these cloths through factory

§14. *Japanese dyeing stencil in a design based on the fennel. (Deneken,* Japanische Motive, *Berlin, 1897.)*

methods. Liberty then set up his own silk-printing plants in the south of London, where the exquisite patterns and subtle colors of the Orient were faithfully copied. Most of the archetypes were Indian. They were overspread with blossoming trees and animal forms combined into a balanced scheme of rhythmic undulations based on the principle of infinite correspondence (*§17*). Liberty introduced dyes that formerly had been known only in India. In 1888-89 he visited Japan to study the native arts and crafts and details of their manufacture. Liberty textiles gained far-reaching international fame, as indicated by the adoption of the name for Art Nouveau in Italy. Arthur Lasenby Liberty was knighted in 1913 in recognition of his services to the British textile industry.

On the continent the foremost protagonist of Art Nouveau, S. Bing,[4] like Liberty, started out as a dealer in Oriental art, specializing in Japanese. In 1895 he moved from Hamburg to Paris and opened a shop of decorative arts at 22 Rue de Provence. It had interiors designed by the Brussels artist Henri van de Velde. The establishment was dedicated "as a meeting ground for all ardent young spirits anxious to manifest the modernness of their tendencies, and... to all lovers of art who desire to see the working of the hitherto unrevealed forces of our day." Bing soon found that modern tendencies and unrevealed forces could be quite chaotic and so instituted two guiding rules for artisans to follow : first "*Each article to be adapted to its proper purpose,*" and second, "*Harmonies to be sought for in line and color.*"[5] The first has a venerable heritage in art criticism and functions in the sphere of intellect, whereas the second is less

familiar and is a matter involving taste. Later, Bing became more explicit, admonishing his cabinetmakers to "emphasize purely organic structure... to show clearly the part played by every detail in the architecture of the object," and to avoid "falsifying every material and... carrying ornament to extremes."[6] The author of these principles, besides having dealt in Oriental art, had traveled to the Far East and assembled an extensive collection of Japanese art objects. These he was able to point to for bearing out and giving meaning to his rules.[7] In 1888-91 S. Bing issued a series of publications entitled *Japon Artistique*, edited in an English edition in London as *Artistic Japan*, illustrated with selections from his collection.

An outstanding yet characteristic example of Art Nouveau was the Atelier Elvira in Munich, designed by August Endell (1871-1925) and built in 1897-98. The facade of this photography studio was a rectangular plane pierced by a few openings in the lower part and crowned by a deep gorge cornice. On the flat area between were several free forms in relief, the smaller ones grouped around the entrance. The dominant motif was a fantastic shape—a dragon's wing, a cloud, mist and waves, a flower, or a plant from the depths of the sea *(§18)*. The figuration seems to have been suggested by a Japanese incrustation of a bird on a nelumbian leaf, which belonged to the Bing collection and was reproduced in a book published thirteen or fourteen years before the construction of the Atelier Elvira *(§19)*. The incrusted work is only a fraction of the size of the great relief on the Munich studio, but nineteenth-century designers were accustomed to the most obvious borrowing without regard for scale. Inside the studio rose a weird staircase with a railing of forged iron executed by J. Müller *(§15)*. The railing appears to have been derived from a Japanese stencil of fennel (one of the seven Japanese New Year's herbs), that had been included in Friedrich Deneken's *Japanische Motive* published in Berlin the previous year *(§14)*.

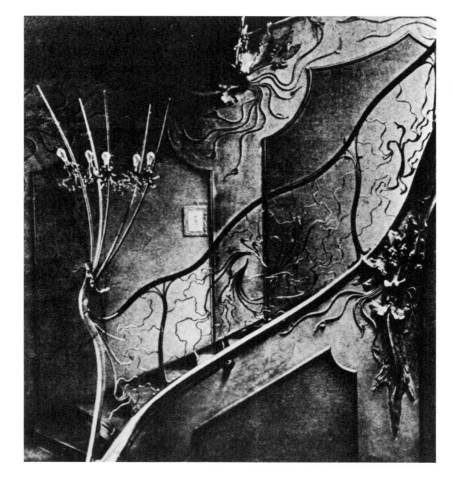

§15. *Staircase, Atelier Elvira, Munich. (Das Werk, Vol. XXIV, 1937, p. 130.)*

§16. *Vase decorated with a snow on bamboo motif, by M. Lachenal. (After a photograph in* International Studio, Vol. VI, 1899, p. 285.)

Numerous other specimens of Art Nouveau could be cited and their origins traced to the Far East,[8] but to dwell upon the issue would be at the expense of distorting the fact that Art Nouveau sought inspiration from many sources—not least of which was Nature—and, of course, it stressed searching for new frontiers of beauty. In contrast to the Rococo, in which the Far Eastern influence constituted a discrete phase *(chinoiserie)*, the Far Eastern imprint upon Art Nouveau was diffused throughout. As was said earlier, Art Nouveau never crystallized into a well-defined style like the Rococo.

Late nineteenth-century Europe followed in the footsteps of the late eighteenth century in imitating Far Eastern ceramics. Some potteries, such as Sèvres and Wedgwood, remained in continuous operation from the Rococo to the Art Nouveau period. Yet it must not be imagined that, despite the high level of workmanship achieved before 1800, additional progress was not made afterwards. The output ranged from literal reproductions to modifications prompted by eccentricities latent in the style of the times. An article in the *Studio* in 1904 stated: "The efforts that have been made in recent years both in Europe and America, to improve the potter's art have been undoubtedly commendable, and the worker in clay is probably at the present time nearer the true understanding of the art of his craft than has been the case for many years past. Honor is due to France for the first important lead given to the movement, and France was inspired in her work by a careful study of the ancient wares of Japan and China. Delaherche, Bigot and Dammouse are among the names which stand prominent as leaders in the modern movement...." Dammouse, the last of the artist-craftsmen mentioned, was typical of the group in adhering to the Eastern precedent in pottery to a far greater degree than in other media. A typical vase form by him has a pheasant in flight painted on a relief background reminiscent of the Chinese 1000-flower pattern and combined with Art Nouveau swirls.[9] The *Studio* article also noted that European ceramicists achieved

§17. *Printed furnishing fabric, an early Liberty design based on an Eastern model. (Liberty & Co., Ltd., London.)*

§18. *Facade of Atelier Elvira, Munich, designed by August Endell, 1897-98. (Das Werk, Vol. XXIV, 1937, p. 131.)*

§19. *Bird on a nelumbium plant, Japanese incrusted work. (Ardsley, The Ornamental Arts of Japan, London, 1884, Sec. V, Pl. V.)*

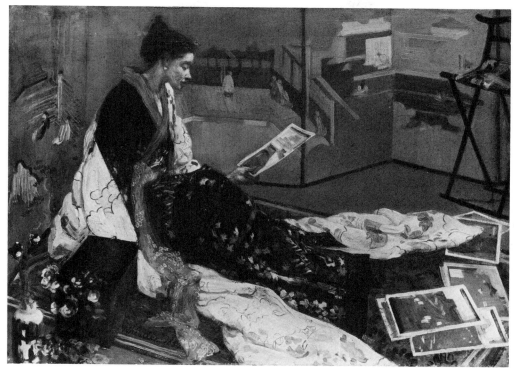

§20. *James Abbott McNeill Whistler, Caprice in Purple and Gold, No. 2: The Golden Screen. (Freer Gallery of Art, Smithsonian Institution, Washington.)*

§21. *Whistler,* The Pacific. *(Frick Collection, New York.)*

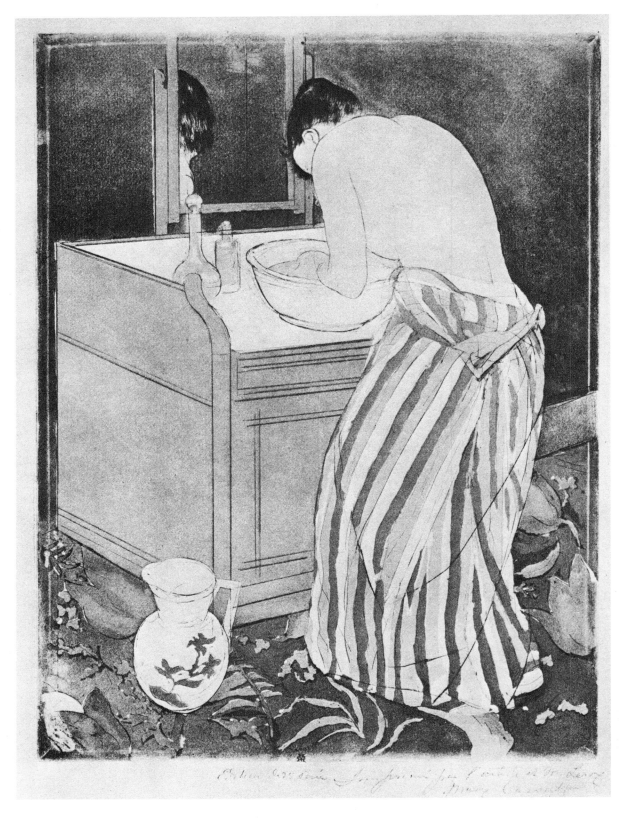

§22. *Mary Cassatt, La Toilette, drypoint and color aquatint. (Metropolitan Museum of Art, New York.)*

" 'orange-skin,' 'egg-shell,' and 'fruit skin' glazes, as well as . . . 'metallic' and 'transmutation' glazes" which "showed how very closely their Chinese prototypes had been imitated." The reference was directed particularly toward the Pilkington Tile and Pottery Company. Among the works based upon motifs from the Far East but displaying some originality was a vase by M. Lachenal decorated with snow-laden bamboo (§16). The reliefs of the bamboo stalks leave the shoulder and join the lip of the vase, becoming handles. The white-glaze frosting realistically simulates melting snow. Actually, adherence to Nature is as prominent as the Japanese theme in the conception of the piece.

Japanese contributions to European pictorial art from the middle of the nineteenth century onward are more in evidence, and many people deem them more important, than in the decorative arts field. Japanese art was first "discovered" by modern Europe upon Félix Bracquemond's finding an edition of the *Manga* in 1856. The *Manga* is a many-volume sketchbook by the Japanese painter and print-maker of landscapes Hokusai (1760-1849). It contains thousands of drawings of figures, animals, plants and other subjects reproduced through the woodcut technique. The *Manga* laid the groundwork in Europe for the reception of colored prints of the *ukiyoe* ("floating-world pictures") school, many of which first reached the West as wrappings around porcelains. Soon, appreciation for these pictures became firmly established and they were imported as art objects of reputable standing. The available market brought out enthusiastic collectors among creative artists, and some of them were affected by Japanese prints and some not. Dante Gabriel Rossetti collected during 1862-63, but no carry-over from the Japanese is apparent in his work. On the other hand, Whistler, also a collector, introduced a number of motifs from them into his paintings. In Japanese prints the West found, already in existence, a highly evolved form of democratic art, and it would have been wasteful had the West neglected to benefit from it.

James Abbott McNeill Whistler (1834-1903) was a rebellious American artist who spent most of his life abroad, principally in London and Paris, where he distinguished himself for his oils, etchings, lithographs and writings. The last served as a medium for expression of a biting wit against the orthodox art critics of his day. Whistler had gone to France to study in 1855, and eight years later he created a stir in the art world through exhibiting his painting *The White Girl* at the celebrated Salon des Réfusés. This full-length portrait, now in the National Gallery, Washington, was executed in a daring high-key palette. Another picture of similar title, *The Little White Girl* (in the London National Gallery), was painted in 1864. It, also, was in a blond key and introduced elements borrowed from Japanese prints such as a linear quality, asymmetrical composition, flat color patterns, and blossoms peeking in along the edge of the frame. The girl leaning against a chimneypiece wears—like her predecessor —a white fluffy dress and holds an Eastern fan. Contemporary with *The Little White Girl* the artist produced a number of subjects dressed in Japanese kimonos. The titles resemble those of musical compositions, through naming the tonal theme and sequence number. *Caprice in Purple and Gold, No. 2: The Golden Screen* is a horizontal composition of a young woman seated on an Oriental rug contemplating Japanese woodblock prints (§20). In the left foreground are a lacquered box and a vase of flowers. A folding Japanese chair is on the right, and a *yamatoe* screen forms a backdrop for the figure. The model's hair is done up in a semi-Japanese fashion. The signature of the artist and date are inscribed on the rug beside the lacquered box. The painting, in oils on wood, belongs to the Freer Gallery of Art in Washington. The Freer also displays, in its original setting, Whistler's *Rose and Silver: The Princess from the Land of Porcelain*, an upright painting that became the center of interest in a large London dining room, the walls of which were lined with a labyrinth of china-laden shelves. In 1876-77,

through redecorating it, Whistler transformed this interior into "The Peacock Room" that was reassembled in the Freer Gallery in 1920.

Whistler, who had attended the United States Military Academy at West Point for three years, in 1866 joined a group of American ex-Confederates in London bent upon supporting the Chileans and Peruvians in their struggle against the tyranny of the Spanish. Thus, much as Lord Byron had set out to help the Greeks against the Turks a generation earlier, Whistler embarked on a noble cause headed in the opposite direction. Arriving in South America he engaged in no more fighting than had Lord Byron; but while abroad, Whistler painted five canvases, two of which were lost in a shipwreck. Among the survivors is one called *The Pacific (§21)*. It was painted in the harbor of Valparaiso, Chile. The colors are gray-greens and gray-blues. The end of a wharf projects into a vast expanse of ocean at the extreme left, and several packets are seen through the haze beyond. The horizon cuts across the picture area two-thirds of the way up. Sprigs of a bamboo-like plant are silhouetted in the right foreground. Nearby, on a terre-verte rectangle resembling a seal impression, is Whistler's dragon-fly cipher. Unlike *The Golden Screen* there is nothing from Japan in the subject matter, but due to the relative emptiness of the composition, the misty atmosphere, the strong brushwork of the plant motif and the signature "seal," one is aware that the view is from the American shore looking westward, and that on the other side of the Pacific lie the islands of Japan. The painting belongs to the Frick Collection in New York City.

Japanese influence shows elsewhere in Whistler's work. Among his other paintings it is perhaps strongest in *The Balcony, Harmony in Flesh Colour and Green*, in the Freer Collection, executed in 1876. *The Balcony* is a moody picture of four women in kimonos resting in front of a railing, with a misty landscape in the distance and a mound of flowers in front. For its period the painting was thought of as quite abstract. Even in 1904 it was still adjudged "a picture more purely Japanese than any other, in which representation has almost ceased to exist."[10] Another borrowing that was originally Japanese was the use of color scumbled over gold on picture frames, a technique learned from Edward Godwin, who designed the White House for him at Chelsea in 1878.[11]

Whistler, an American by birth, may have been the first important artist in Europe to incorporate certain elements from Japanese art, but many Europeans followed in his footsteps with equal enthusiasm. Claude Monet produced a number of paintings of models in Japanese kimonos, such as *The Japanese Fan* in the collection of Lord Duveen. Monet was one of the foremost Impressionists, and Impressionism as a whole adopted from the art of the Far East a sketchy handling of the brush and a flatness of surfaces which was interpreted, mistakenly, as the shadelessness of strong sunlight. The "impressionism" of Sung Dynasty (960-1279) and later Chinese and Japanese painting was a monochromatic and intellectual mode quite different from the polychromatic visual Impressionism of the late nineteenth-century French, and yet superficially they bear a resemblance to one another. The pointillistic style of Georges Seurat recalls the brush-point textures of Mi Fei; the butterfly shapes of Edgar Degas' ballerinas seem to have come from casual Eastern fan paintings; the repertory of Vincent Van Gogh's expressionistic brushstrokes is related to the vocabulary of the painters Li Sung and Chou Chih-mien; and the scratches and smears of Georges Rouault can be referred to those of Shih K'o; whereas the bold diagonals and meandering outlines of Henri de Toulouse-Lautrec are evolved directly from *yamatoe*[12] and *ukiyoe* art.[13]

Toulouse-Lautrec was the most decorative painter of the group named and this aspect of his art came out more vividly in his graphic essays, especially in the posters of demimonde entertainers. In a sense the motivation behind, and the reproduction and circulation of these

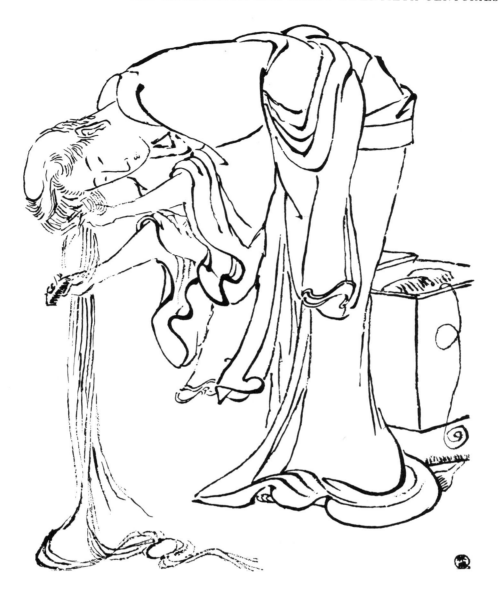

§23. *Hokusai drawing*, Girl at Her Toilet. *(Strang*, the Colour-Prints of Japan, *New York, 1906, facing p. 42.)*

posters are akin to the actor prints of the unique Japanese printmaker Tōshūsai Sharaku (active 1794-95). The European posters bridged the gap between easel painting and Art Nouveau, partaking of representation on the one side and stylization on the other. There were poster makers who were also industrial designers, among them Jules Chéret and Eugène Grasset. A contemporary critic spoke of their posters as characterized by "brilliant imagination, masterly drawing, and admirable color effects, borrowing suggestions from Japanese art, and from any and every source of inspiration."[14] Applied designs by Chéret and Grasset were in stained glass, lava enamel, and various metals, including iron and silver. Other poster artists were Henri-Gabriel Ibels and Theophile Alexandre Steinlein in France, and Dudley Hardy, John Hassall, Cecil Aldin and Edgar Wilson in England.

A third group of pictorial artists benefiting by the Japanese was the printmakers. Some of them used the color woodcut method, including J. D. Batten and F. Morley Fletcher in England; and, on the continent, Auguste Lepère and Henri Rivière of Paris, Franz Hein of Hamburg, and Emil Orlik of Prague. Others were affected by Japanese woodblock prints and yet worked on metal plates. To this group belonged Mary Cassatt (1845-1926), who was, like Whistler, an expatriated American. After studying and working in Italy, Spain and the

Netherlands, Mary Cassatt arrived in Paris in 1874. Two years before she had sent a painting to the Paris Salon from Rome and it had been accepted. But in the art capital of Europe she discovered the work of Degas and the Impressionists, which changed the course of her own painting. The canvas she submitted to the Salon of 1876—a portrait of a young woman in light colors—was refused, and thereafter she exhibited only with the Impressionists. Her friends were Degas, Renoir, Cézanne, Monet, Guillaumin, Pissarro, and the women artists Morisot, Gonzalès, and Mme. Bracquemond. Although Mary Cassatt's art became thoroughly French she herself never became (like Whistler) Bohemian. Unmarried, she lived with her parents, who had moved to Paris. Mary Cassatt worked assiduously; her favorite subject was women with their children, and her techniques ranged from painting in oils or pastels to various types of prints, usually a combination of dry point and color aquatint. Her print, *La Toilette*, in this medium, was made in 1891, the year after she accompanied Degas to the Japanese Exposition at the Beaux Arts *(§22)*. The subject is that of Japanese *ukiyoe*, the attitude of the figure reminding us of that by any of a number of masters from the middle eighteenth century down to Hokusai *(§23)*. Mary Cassatt chose to show a back view of her model bending over a washstand. The figure wears a peach-colored, green and white striped robe tied around her middle. The washstand is ochre and the rug and background are in tones of pale blue. When shown the print, Degas commented that he would hesitate to admit it possible for a woman to be able to draw so well.

The Japanese period of Far Eastern influence in Europe got under way in the late 1850's, after Bracquemond had discovered Hokusai's *Manga*, when Whistler began using Japanese subjects and—more important—Far Eastern compositions and techniques in his paintings, and was followed by the various Impressionist and Post-Impressionist artists, who drew slightly different inspiration from the Extrême Orient. Contributions to the fine arts were matched among the decorative arts, especially in the type designated Art Nouveau. The pictorial and ornamental fields were spanned by posters, best known among which were those of Toulouse-Lautrec. The pioneer English decorator, Edward Godwin, revolutionized the Western interior, and exerted some influence over Whistler. His countryman Arthur Lasenby Liberty, and the European S. Bing, turned from selling Eastern art to becoming important innovators of modern design, their later activities colored by their earlier callings. Ceramics, following a pattern set in the eighteenth century, continued to imitate Eastern wares exactly; but, on the whole, there was more of an attempt to be creative after 1850, or 1860, than there had been before. The Far East supplied not just decorative suggestions—as in the earlier phase—but a general turnover in broad art conceptions. The colored woodblock print, which was an exclusively Japanese expression, made the most dramatic imprint upon modern European art. The Japanese print was a highly evolved form of democratic art that was taken to the heart of a society just reaching the stage where it could fully appreciate its merits. The sequence of first Chinese and then Japanese influence in Europe was pertinent to Western development.

Japanese Exhibition
at the
Philadelphia Centennial

IN THE New World, no less than in the Old World, the acceptance of the Japanese influence was prepared for by a previous flowering of the Chinese mode, thereby familiarizing the American eye with art forms and manufactures of the Far East. The first "Chinese" impressions in America were reflections of the Chinese Taste of eighteenth-century Europe and England (*Chapter Two*). Immediately after the publication of Sir William Chamber's *Designs of Chinese Buildings* in 1757 the style appeared in colonial America. The James Reid house in Charleston was described as "new built. . . after the Chinese taste" in an advertisement of 1757.[1] Gunston Hall in Fairfax County, Virginia, completed by William Buckland in 1758, had a room with Chinese trim consisting of door and window enframements of carved strapwork friezes and a cresting of scallops on the cornices. The decoration of the Miles Brewton house in Charleston, finished in 1769, combines Rococo, "Gothic" and Chinese motifs after the manner of Thomas Chippendale. Two Virginia houses believed to have been designed by Thomas Jefferson, Brandon in Prince George County, and Battersea in Dinwiddie County, built between 1765-70, have staircases with unusually fine Chinese lattice railings.[2]

Although bits of the Chinese style were widely distributed, the early home base for the Far Eastern vogue in the United States was Philadelphia. Contemporary with the Southern examples named above was a three-story brick house built at 244 South Third Street in the City of Brotherly Love. In 1769, while still new, it was purchased by Samuel Powel, a well-to-do young graduate of the College of Philadelphia lately returned from the Grand Tour of England and the Continent. The grounds behind the house were made into a beautiful garden, adorned with statuary, and planted with rare shrubbery and trees, among which were orange, lemon and citron. The house was furnished with pieces from the shops of the skilled cabinetmakers of Philadelphia. The fireplace wall of the high-ceilinged parlor was paneled, whereas the other three walls were hung with an imported Chinese wallpaper. Its tan background was sprinkled with red-roofed pavilions, blossoming trees and ornamental birds (*§26*). The room is now installed in the American wing of the Metropolitan Museum of Art in New York City.

Robert Morris, the financier of the Revolution and Samuel Powel's cousin, ordered for his Philadelphia home a Chinese wallpaper illustrating the various phases of pottery making in Cathay. However, the paper was not used where it was intended but was hung on the walls of a New England residence instead.[3]

A late-eighteenth-century house at Croydon, a suburb of Philadelphia, was named "China's Retreat." It was built to display Chinese articles that belonged to its owner, Andreas Everardus van Braam Houckgeest, who at the age of nineteen, in 1758, began trading in the Far East as supercargo of the Dutch East India Company, and in 1784 became an American citizen. In 1796 van Braam Houckgeest decided to settle down in Bucks County and purchased the estate at Croydon. He caused the existing house to be demolished and commissioned the construction of China's Retreat. A grandson reported that the head carpenter and mason were

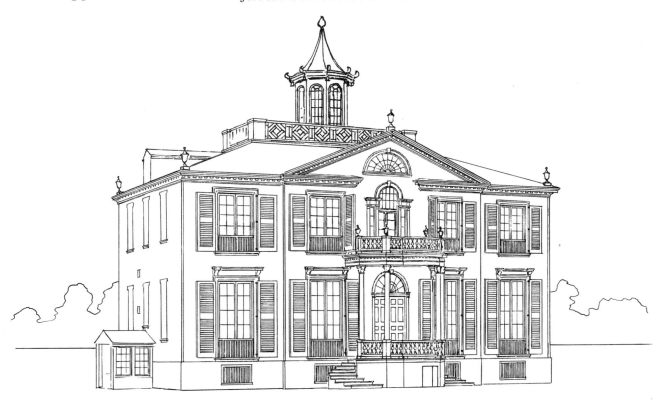

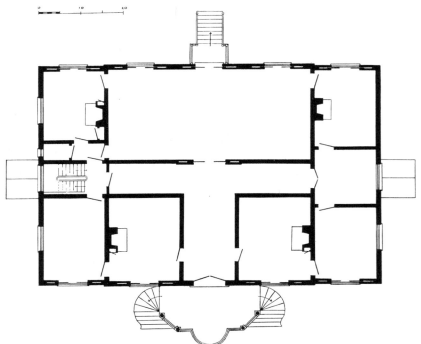

§24. *Perspective sketch of China's Retreat, Croydon, Pennsylvania, after 1792. (Restored cupola and other details are based on a painting by William Birch in the Library Company of Philadelphia collection.)*

§25. *Plan of the first floor of China's Retreat.*

Philadelphians, and that the building was made of wood above the basement story because a frame house could be erected more speedily than one of masonry.[4] The residence has ample dimensions, a central hall and four rooms spanning its 80-foot front. The ballroom, centered at the back, measures 43 feet in length (*§25*). The ceiling height is eighteen feet for the main story and the staircase makes two revolutions to the second floor. The windows are unique; they are six feet broad and twelve tall, and are composed of double panels that slide back into pockets in the wall. The entrance is sheltered by a Baroque-manner porch, and the central pavilion is crowned by a broken pediment set before a hipped roof (*§24*). The cupola (re-

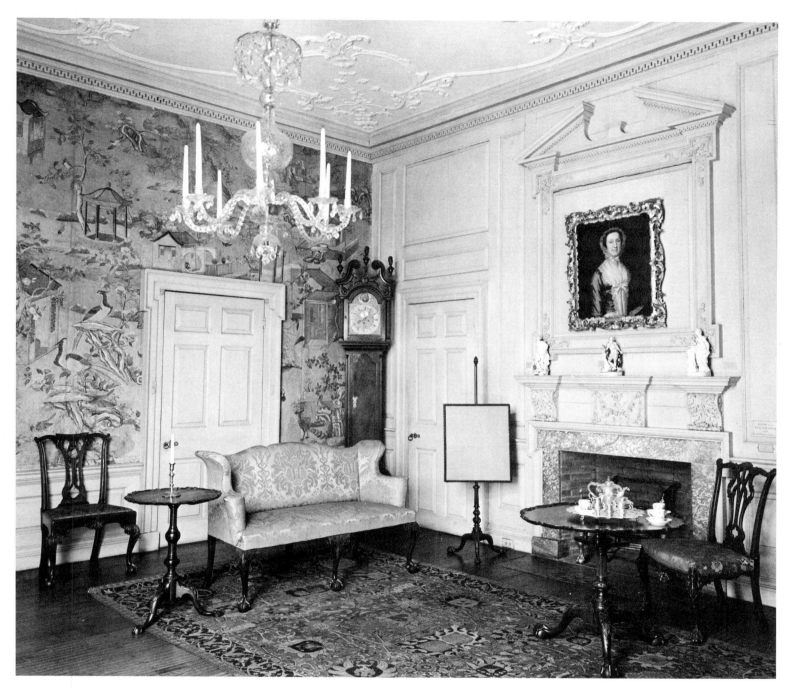

§26. *An interior from the Powel house, Philadelphia, 1769. (Installed in the Metropolitan Museum of Art, New York.)*

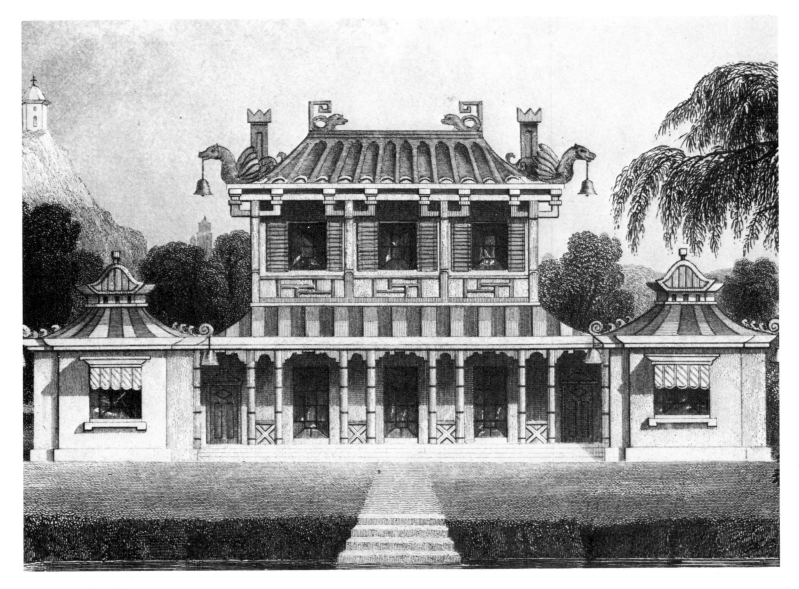

§27. *Elevation of "A Chinese Residence." (Brown,* Domestic Architecture, *London, 1841, Pl. XLIII.)*

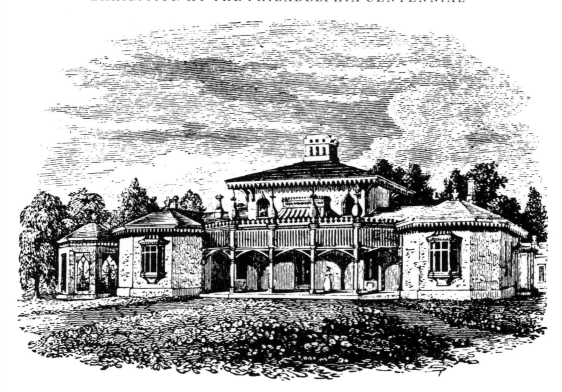

§28. *Residence of Nathan Dunn, Mount Holly, New Jersey. (Downing,* A Treatise on . . . Landscape Gardening, *New York & London, 1841, p. 346.)*

stored in the drawing) was described as resembling a Chinese pagoda. Cornices and other carvings for the building were executed in China but never reached America to take their rightful place on China's Retreat. The cupola having been removed, the empty shell of the existing house has only the sliding windows to suggest the Orient. It was once quite otherwise: Moreau de Saint Méry, who visited the house during the regime of the builder, wrote that "the furniture, ornaments, everything at Mr. van Braam's reminds us of China. It is even impossible to avoid fancying ourselves in China while surrounded at once by living Chinese, and representatives of their manner, their usages, their monuments and their arts."[5] The "living Chinese" were the servants.

On Mason's Island—currently known as Theodore Roosevelt Island—in the Potomac River south of Georgetown, D.C., General John Mason built a house for entertaining in during the 1790's. Robert Mills (architect of the Washington Monument) visited the house in July of 1803 and described it as "built after the Chinese method, very high and airy."[6] The structure was partially burned about 1896, and the single-storied remains contained no suggestion of Far Eastern influence.[7] The island was presented to the government as a park site and what was left of the Mason house was demolished during the early 1930's.

The Philadelphia architect John Notman designed a country house for Nathan Dunn at Mount Holly, New Jersey. It was pictured in A.J. Downing's book, *A Treatise on the Theory and Practice of Landscape Gardening* issued in 1841, in which it was described as a "semi-oriental cottage" *(§28)*. The house was composed of a square central mass of two stories flanked by low projecting wings connected by a front porch. Except for bulbous pinnacles capping the porch colonnettes and pointed windows upstairs there seems little about the building to classify it as "semi-oriental," and even the features named are as much Gothic Revival as they are Eastern. The house may be compared to an English "Chinese" residence shown in Richard Brown's 1841 edition of *Domestic Architecture (§27)*. The chief resemblance lies in the massing, the English version having self-conscious Chinese features—flaring roofs with symbolic animals and bells at the eaves, bracketed posts, lattice railings, and bamboo gallery

supports. The pagoda on the hill behind, the shelter on the bridge to the right of the house, and the summerhouse atop the rock in the foreground are further exotic references. The striped porch roof of the Dunn house hardly shows behind the trefoil cresting. The Far Eastern elements are minimized on the American villa and exaggerated on the English design. Considering the dates of the publications in which the examples appear, one wonders if the British design were derived from the American. If so, this would be in opposition to the normal course of cultural flow.

Nathan Dunn, like Everardus van Braam Houckgeest, had visited Cathay and assembled a collection of Chinese art. His pieces were exhibited in the Chinese Saloon, which occupied the first floor of Peale's Philadelphia Museum, opened in 1838 on the northeast corner of Ninth and George (Sansom) Streets.[8] Four years later the building and its contents were sold by the sheriff on account of debts incurred. The museum was reinstalled in Masonic Hall, but the Chinese collection was shipped to Europe.[9]

The block bounded by Market and Chestnut, Ninth and Tenth Streets, just north of the Philadelphia Museum, was the site of the house and garden of John Markoe. The residence was designed by Benjamin Henry Latrobe and built in 1806. In the garden stood a Chinese-type summerhouse, actually a square pavilion with a flaring roof on an entablature supported by slender classic colonnettes. A bench inside was enclosed by intricate latticework. After the Markoe residence was razed, the summerhouse was moved to the garden of Walter M. Jeffords (*§29*).

The outstanding manifestation of Chinese influence in early Philadelphia was in the Pagoda and Labyrinth Garden, which opened in 1827 on Fairmount Avenue at the present corner of Twenty-Third Street (*§30*). The buildings were the work of the architect John Haviland.[10] On the main road was a large structure with a long porch across the front and extending out to right and left. An upper terrace with a railing spanned the second story, consisting of a pair of square blocks with dipping roofs surmounted by urn forms (presumably chimneys) and connected by a pergola. Behind this building rose a seven-storied pagoda. The model for the pagoda was a "Tower near Canton," the elevation of which was delineated in William Chambers' *Designs of Chinese Buildings* (*§31*). Chambers, it will be recalled (*Chapter Two*), planned the grounds and buildings at Kew Gardens during the reign of George III, his masterpiece being the great ten-storied pagoda. Like the Canton tower pictured in his book the Kew pagoda had arched openings, but it was considerably larger and did not taper as much. Haviland's pagoda in Philadelphia followed the exact elevation of the Chinese tower.

Ornamental structures in the Chinese style sprang up in other parts of the country. In the private garden of Valcour Aime, on the west bank of the Mississippi River fifty miles upstream from New Orleans, a pagoda was stationed on a mound overlooking a labyrinth and lake. The mound was formed over a grotto, and the pagoda was embellished with colored glass and hundreds of tinkling bells.[11] It was built during the second quarter of the nineteenth century. M. Aime being French, one suspects he may have owned and taken the idea for his gazebo from designs published in Le Rouge's *Nouveaux Jardins à la Mode*.

Another oddity inspired by the Chinese is the moon gate on the Wetmore estate near Newport, Rhode Island. William Shepard Wetmore became interested in circular gateways he saw in China, and at his home, Chateau-sur-Mer, built in 1851, he had a granite version set in the fieldstone wall bordering the Shepard Avenue side of his property (*§33*). The gateway included a feature from a moon bridge, which was a stairway up each side of the arch. A small metal seat was fixed at the apex, incorporated in the wrought-iron railing that curved concentric to the coping and gate below.

By the middle of the nineteenth century the Chinese influence had spent its force and later

§29. *The Chinese summerhouse that stood in the garden of the John Markoe residence in Philadelphia.*
(Photograph courtesy of Walter M. Jeffords.)

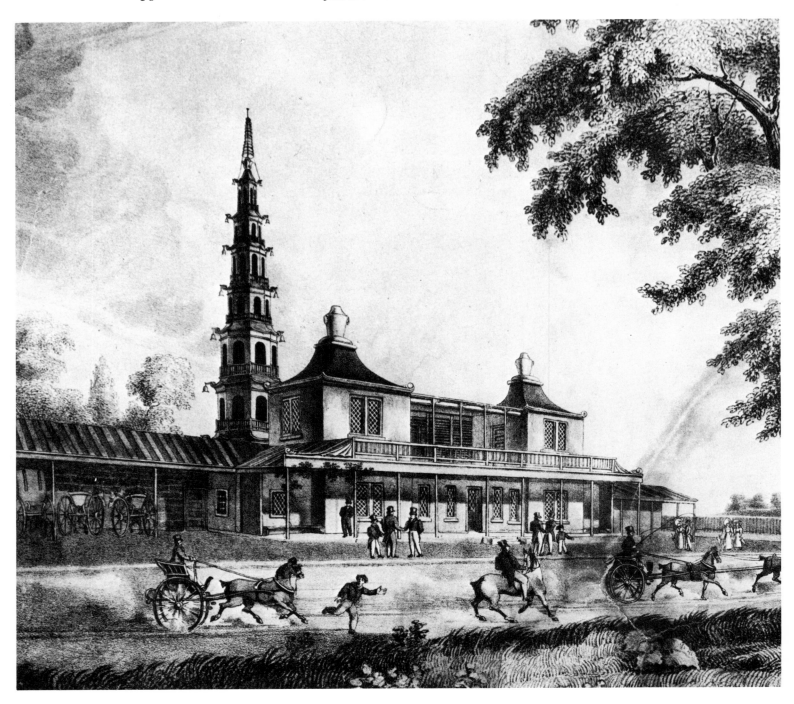

§30. *The Pagoda and Labyrinth garden, Philadelphia. From a lithograph by B. Ridgeway Evans.*
(Historical Society of Pennsylvania.)

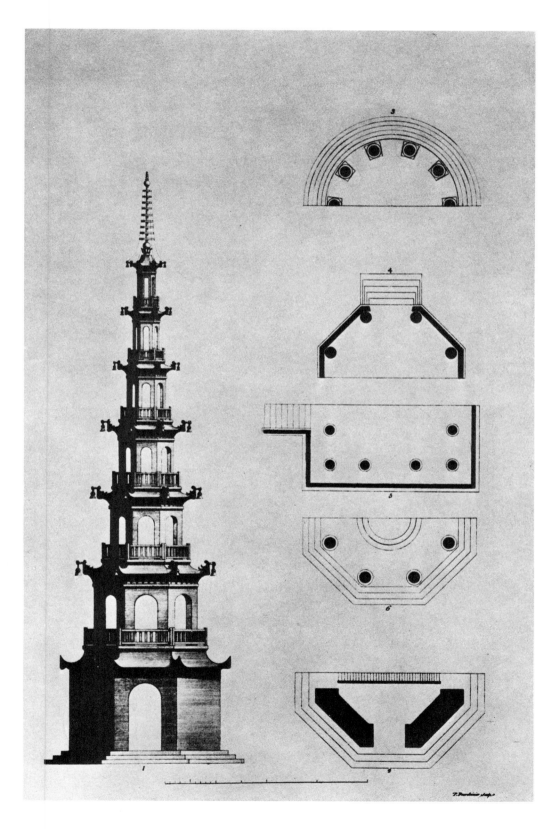

§31. *Elevation and plan (lower right) of a tower near Canton, China. (Chambers, Designs of Chinese Buildings, London, 1757, Pl. V.)*

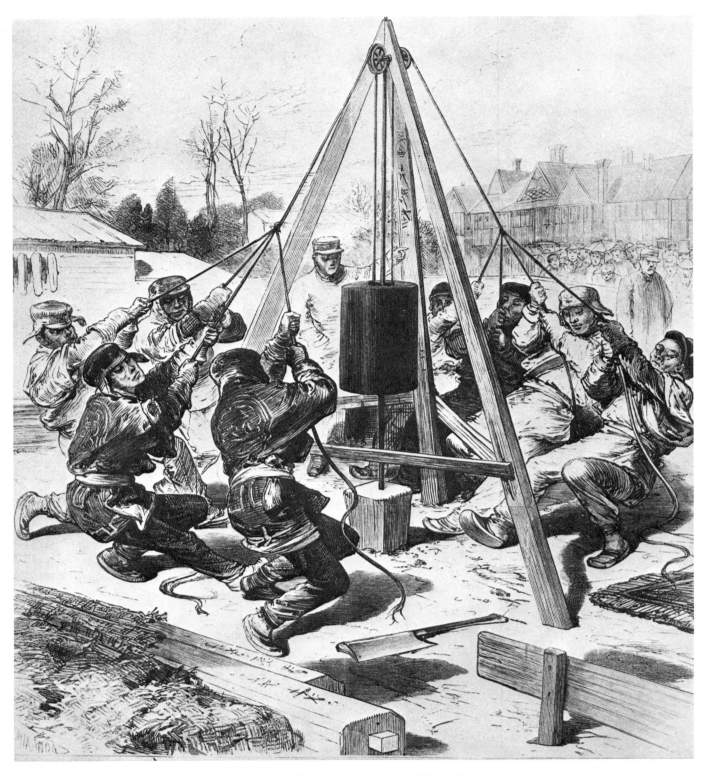

§32. *Japanese workmen setting a foundation post for a building in Fairmount Park, Philadelphia.*
(Norton, Illustrated Historical Register of the Centennial Exhibition, *New York, 1879, p. 64.)*

§33. *The Moon Gate on the William Shepard Wetmore estate, Newport, Rhode Island.*

examples were few and far between. Chinese motifs in late Victorian—or rather Eclectic—interiors were more or less swallowed up by competitive decorations. There were occasional Chinese adaptations in buildings, such as Mrs. Belmont's tea house at Newport, designed by Hunt and Hunt about 1915, or Grauman's Chinese Theatre at 6925 Hollywood Boulevard, by Meyer and Holler, in 1927; and there were serial applications, such as the 1917 bungalows of Formosa Court, Hollywood, or buildings in Chinatown, San Francisco, erected after the Earthquake of 1906. Finally, the Chinese led in the Far Eastern craze that swept the country beginning in the late 1940's, when reproductions of Peking furniture were mass-produced at Grand Rapids. These late examples have diverted our attention far ahead of the proper development of our story, so let us go back to the last quarter of the nineteenth century—to the first display of Japanese wares in America.

Several decades after Philadelphia had ceased to be the political and cultural capital of the United States, tribute was paid to the city through designating it the seat of the Centennial International Exhibition. This world's fair, scheduled for 1876, was to commemorate the hundredth anniversary of the signing of the Declaration of Independence, which had taken place in a building still standing in Philadelphia. During the summer of 1873 invitations to participate in the centennial were sent out by the United States Government to foreign nations, including Japan. There had been a Japanese Court at the London International Exhibition of 1862 and a display at the Paris Exposition of 1867, but the Vienna Exposition of 1873 had been the first international fair to which Japan had sent a well-rounded official exhibit. In 1874 Japan accepted the American bid. The management of the display was entrusted to the commissioners who had handled the Japanese show in Vienna, only instead of being directly responsible to the Emperor, as before, they were organized under the Ministry of the Interior, which was in charge of promoting the country's industry, commerce and agriculture.

Objects selected to be shown in America, and the materials for erecting the buildings to show them in, not to mention the Japanese builders and others in charge of displays, all came by boat across the Pacific to California, thence by train across the continent. The fifty carloads of materials were unloaded in Philadelphia, and the building crew set to work putting up two buildings at the centennial grounds in Fairmount Park. A crowd of curious bystanders gathered daily to witness the strange building operations and tools used by the Nipponese work-

men, and supercilious spectators compared the rising buildings to corncribs because the framework rested on posts rather than on masonry foundations. The posts were driven into the earth by means of a 300-pound hammer mounted on a tripod (§32). Once the buildings began to take shape the critics became silent, and upon completion scorn had changed to praise. A guide book pronounced one of the two, the Japanese Dwelling, "the best-built structure on the Centennial grounds... as nicely put together as a piece of cabinet-work."[12]

The Japanese Dwelling stood on the eastern slope of George's Hill near the west gate. It was a timber-framed, two-storied, U-shaped building measuring 84 by 44 feet (§34). The first story was screened by closely-spaced vertical slats, and the second story could be enclosed or left open by means of movable solid wood panels or rain-doors (amado). Most of the wood was cedar, left unpainted. The roof was covered with glistening black tiles bordered by a lighter color, and carvings of birds and plants enlivened the entrance porch. The Centennial Portfolio described the interior as being laid "with costly carpets of odd design. The walls ... [were] hung with curtains of vegetable fibre, which keep out the sun but admit the air." It is not stated whether tatami, or Japanese straw mats, were used on the floor—in addition to the "costly carpets"—but in all probability those in charge realized that mats could not long withstand Americans' hard-shod feet. However, a portion of the building was reserved for residential quarters of the commissioners, and existing literature is not clear as to what extent any part of the building was open to the general public. In any event the honest construction, straightforward designing, unit planning and restraint in decoration were all apparent from the outside to anybody with a discerning eye.

The second Japanese building at the centennial was a low structure serving as a bazaar and tea house. The trapezoid plot in front was fenced in and gardened in the Japanese manner. Like the Japanese Dwelling the Bazaar had a U-plan and a similar tile roof, and although only a single story, its length and breadth dimensions were about the same (§35). It was located near the main entrance, north of the Public Comfort Building. The ceiling, floor and walls of the bazaar were painted in imitation of tile work and some of the display counters were elaborately carved. There was no solid wall across the north side of the building, it being protected from the weather only by "overhanging eaves and paper curtains," probably shōji. Attendants were dressed in native costumes, and articles for sale consisted chiefly of "antique bronzes, curious specimens of porcelain, and pottery, wood and ivory carvings, and lacquer work."[13] Japan also had displays in the Main Exhibition Building and Agricultural Hall.

The government of Japan, as well as those of Great Britain and Germany and the two states of Ohio and Pennsylvania, left the buildings they had erected as a lasting souvenir of their participation in the fair. Several of the general exhibition buildings also remained standing for a while. When Horticultural Hall was torn down following the 1955 hurricane the survivors consisted of Memorial Hall (the original art gallery, recently a recreation center), the Carrousel building (serving as headquarters for the Fairmont Park guards), and the Ohio building (a park employee's residence).

Philadelphia, the city hospitable to Far Eastern influence during the early (Chinese) period, was thus the site of the first noteworthy display of Japanese art and architecture in America, at the Centennial International Exhibition of 1876. Visitors to the fair viewed the buildings and their contents with mixed feelings, but there were those among them who were smitten by the charm of things Japanese. Some of them went away greatly impressed by the directness of Japanese construction, others became avid collectors of Japanese wares, and still others became enthusiasts over Japanese gardens. The importance of the exhibits, in introducing Americans to these phases of Japanese art, cannot be overestimated.

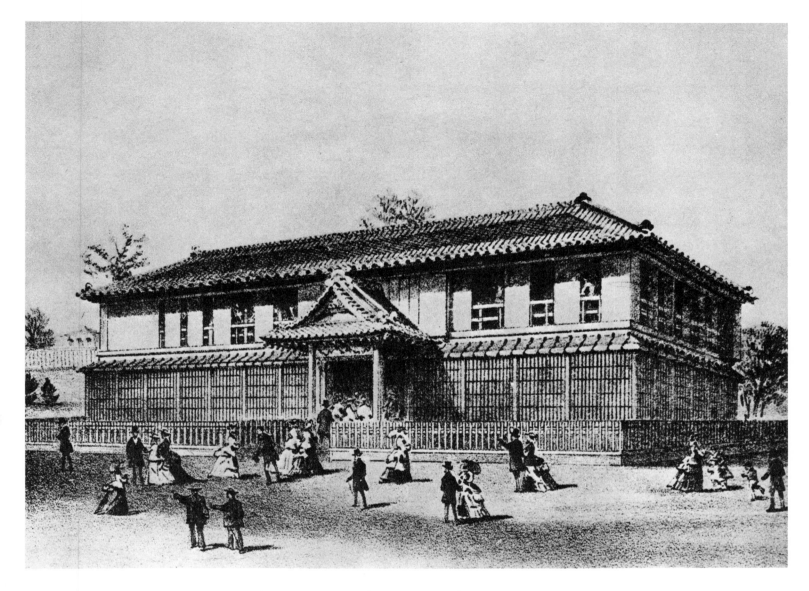

§34. *The Japanese dwelling at the Philadelphia Centennial. (Westcott,* Centennial Portfolio, *Philadelphia, 1876; Pl. 22.)*

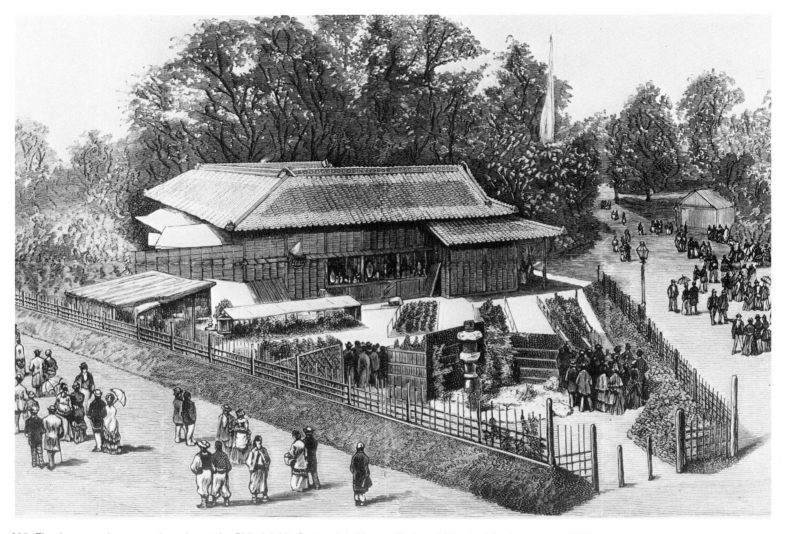

§35. *The Japanese bazaar and garden at the Philadelphia Centennial. (Norton,* Illustrated Historical Register. . . , p. 271.)

CHAPTER SIX

First Adaptations
of Japanese Features in
American Design

THE CULTURAL climate of the United States and the circumstances under which Japanese art was introduced here were quite different from those of Europe. As has been seen (*Chapter Four*) the first taste of things Japanese in Europe was in incidental discoveries—Hokusai's *Manga*, *ukiyoe* prints and decorative articles—and the influences from these imports were felt mostly in Impressionist and related paintings, posters and Art Nouveau designs. In the United States the art of Japan made a big splash at the first important international fair in two authentic buildings filled with bronzes, ceramics, carvings and lacquer wares. It is not surprising, therefore, that in practical-minded America the imprint of Japan should become more prominent in the three-dimensional domestic setting, and should figure only slightly in the specialized two-dimensional field of painting and printmaking. The display at Philadelphia had an immediate effect upon elaborate interiors installed in substantial town houses both in the centennial city and in New York, and a comparable influence showed up on plain vacation houses built along the Atlantic seashore and in the eastern mountains.

The last quarter of the nineteenth century was a period of eclecticism in America, as much as, or even more so than, in Europe. As implied by the word "eclecticism," motifs borrowed from styles of various eras and places were combined in the same scheme. The introduction of Japanese décor at the 1876 exhibition bestowed another set of design elements upon the profuse vocabulary already employed. The influence was quickly patent. The *American Architect and Building News* for March of 1877 published a "Design for a Drawing Room," by B.J. Talbert, that had Japanese overtones (*§36*), though the general style was contemporary English Eastlake, said earlier to be somewhat indebted to designs by Edward Godwin. The Talbert room contains typical Eastlake framing, and if one compares it to the Godwin hall (*see §12*) one notes a similar articulation of main structural divisions, profuse paneling and thin curved flanges near the ceiling. In addition there is a coved frieze of alternating fret and flower sections that are conspicuously Japanese. Both rooms contain recesses for pottery at seated eyelevel and higher shelves for showing vases and platters. The furniture, especially in the Talbert scheme, is mostly inspired by the medieval. Charles Eastlake (1836-1906), creator of the style in England, was himself largely a belated Gothic Revivalist, and this preference shows in his book *Hints on Household Taste in Furniture*, originally published in London in 1868. The book was made available in the United States through seven editions issued from 1872 to 1883.

It was only natural that the Japanese vogue should have put in an appearance in Philadelphia soon after the centennial. The sitting room in the Dr. E. H. Williams house at 101 North Thirty-third Street is a characteristic example of decoration of about 1880, and it is largely determined by things Nipponese (*§37*). As in the Powel house, built in the same city over a century earlier (*see §26*), the fireplace forms the center of interest in the Williams' sitting room, except that in the place of a scrolled Georgian pediment this one has an *irimoya*

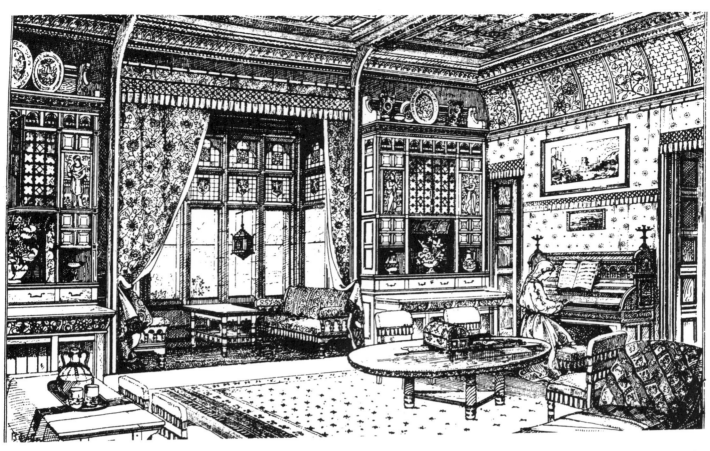

§36. "Design for a
Drawing Room" by
B. J. Talbert. (The
American Architect
and Building News,
March 24, 1877.)

(gable and hip) Japanese temple roof over the mantel. Ebony bookcases and cabinets to right and left are flanked by miniature square towers capped by *hogyo* (pyramid) roofs with ridge and tile treatment matching the *irimoya*. Open or glass-enclosed shelves provide space for art objects and books. Flowering trees fill wall areas above the cabinets or paneled dado and continue into the coved ceiling with its flying storks, though interrupted by a frieze of bronze plaques and a projecting cornice. Lanterns and articles of furniture from the Far East are mixed with Western pieces, and a Chinese rug is on the floor. As with *chinoiserie* interiors, despite the use of Oriental motifs the general scheme of the Williams room remains decidedly Occidental.

In contrast to the huge sitting room in the Philadelphia house was the small bedroom in the Dr. William A. Hammond residence on Fifth Avenue at Fifty-fourth Street in New York City (*§38*). The Japanese decorations in this room were undoubtedly an afterthought. Upon the shelf of a typical castiron mantel of the period is set an open cupboard for porcelains and other bric-a-brac. The walls are overspread with Japanese silk embroidery pictures and fans. A frieze of *ukiyoe* prints encircles the room under the cornice, and the ceiling is divided diagonally, half stenciled with an overall fret pattern and the other half with a large floral shape, a device proper to a Japanese tea room.[1] The theme has been carried out to the extent of having tiny parasols affixed to the gas lighting fixture. Curtains on rods in front of the doorways and an abbreviated canopy over the bed add to the general design confusion of the little room.

There were other contemporary Japanesque rooms in New York, and most of them were rather sizable. The drawing room of the Frederick Thompson house at 283 Madison Avenue had a mantel with a shelf bracketed in the Japanese manner, a carved board above, a bamboo-paneled dado, and deep coved cornice with flowers in relief. The library in the Louis Comfort

Tiffany apartment on East Twenty-sixth Street contained imported cabinet work, a delicately carved *ramma* (transom grille) over the wide doorway to the adjoining room, and a shelf-unit for books and ceramics built around the fireplace.[2] The Japanese Room in the Henry Gordon Marquand house, at 11 East Sixty-eighth Street, designed by Manly N. Cutter, was perhaps the most elaborate in the city. The use of glistening lacquered door panels, richly carved enframements, and a labyrinth of shelves for art objects and curios surpassed even Whistler's Peacock Room for magnificence.[3] The sale of the collection housed in this room and elsewhere in the house after the owner's death was the sensation of the art world in the autumn of 1903. One of the most satisfactory interiors was the Japanese Room on the second floor of the William H. Vanderbilt mansion at Fifth Avenue and Fifty-first Street. This room conceived by Herter Brothers had a sloping ceiling, and all surfaces from the level of the door lintels upward were paneled with split bamboo. Black lacquered beams with gilded fittings spanned the width of the interior, and door jambs were matching. Low cabinets were of chairrail height, and the wall between cabinets and bamboo sheathing was both decorated and covered with shelves. The profusion here was compensated for by the simplicity of the upper part of the room.[4]

Americans of lesser financial status than the smart Fifth Avenue set, unable to afford decorators or collections of imported Japanese art objects, could procure inexpensive reflections of the latest exotic trend in their rooms through the medium of domestic printed wallpapers. These sometimes combined the natural wonders of America with quaint ceramics from Japan *(§39)*. The colors of the example illustrated are typical of the Brown Decades, ranging from a light mustard through terre-verte to a deep aubergine. New York State scenes include Niagara Falls, the bridge over the Niagara River (1851-55), Brooklyn Bridge (1869-83), presumably Montauk Point Lighthouse (1797) at the extreme eastern end of Long Island, and Coney Island. The last shows the 300-foot lattice-truss Iron Tower, originally erected for the Philadelphia centennial outside the fairgrounds on George's Hill (near the west gate and the Japanese Dwelling), and afterwards moved to Coney Island by Andrew R. Culver, the entrepreneur who created the Prospect Park and Coney Island Railroad. Three of the four vases depicted are of Japanese manufacture or of Japanese influence.

The foregoing examples have employed Japanese elements literally, one might even say incidentally. Little imagination went into their planning and little came out by way of artistic results. Regardless of their Oriental contents they remained Western in effect. But this was not always the case. Some American designers of the late nineteenth century—no less than European Art Nouveau designers—began to realize that the time had come for a departure from the tight, mannered, decadent ornateness currently in fashion. Whereas Japanese art lent itself to conservatists preoccupied with manifold details, it had more to offer the forward-looking group seeking evolutionary change. The Japanese house, like the Japanese print, was a pre-existing form of highly developed democratic art; and as such it came on the scene at the exact moment when the need for such was most acute in America.

A radical diversion from muddled convention would not have been initiated on Fifth or Madison Avenues, or on any of the other congested alignments of proper aristocracy. The inception of a new trend required a more casual setting. It materialized in the resort house on the seashore and in the mountains. One of these, which was far from modest in scale, was the H. Victor Newcomb residence overlooking the Atlantic Ocean at Elberon, New Jersey. It was a shingled frame house by McKim, Mead and White, its "Queen Anne" details resembling those of the same architects' Casino at Newport, Rhode Island. The form of the Newcomb house was compact but irregular, the various wings surmounted by low-pitched roofs pierced

by tall, slender chimneys. The Japanese influence is strongest inside, in the broad reception hall, measuring upwards of twenty by thirty feet, where the free flow of space penetrates deep recesses at front and back, and joins with the great living room at the fireplace end, with the vestibule and conservatory adjoining the two recesses, and stairhall at the other end (§40). The fireplace, although large, has been placed to one side and is not treated as the focal point of the room. Tangibly Japanese are the *ramma* in the upper part of the openings into the recesses or adjoining rooms, the beams arranged in groups at right angles in various areas of the ceiling, and a key pattern on the floor carried out in brick and marble instead of Japanese mats. The conglomeration of chairs, tables and other furnishings detracts from the fresh and airy quality the interior otherwise would have, but the assortment tends to emphasize the multipurpose use of the room as a living-hall. One notes the absence of pictures on the wall. Instead, they are placed on easels, a Japanese custom, only the Japanese would not have elevated them so high. The house belonged to Lyman George Bloomingdale at the turn of the century. It was cut down to a single-storied house during the mid 1940's, and the hall stripped of some of its architectural details. In 1880-81 Stamford White, of the firm responsible for the Newcomb residence, added a dining room to a house called Kingscote at Newport, Rhode Island, a Gothic Revival villa built in 1841 after a design by Richard Upjohn. Forty years later, under White's directions, the service wing was moved back from the old house and the dining room constructed in the intervening space. The new room achieved a Japanese feeling through the use of a plain chimneybreast set flush between translucent Tiffany-glass windows divided into tiny squares. Cork covered the ceiling and the walls above a projecting molding or shelf at door-lintel level, a presage of a feature later employed extensively by Frank Lloyd Wright. An openwork screen divided the far end of the room from a passageway.[5]

The essence of the Japanese dwelling could be applied better to much smaller buildings than those of McKim, Mead and White. A few miles south of Elberon, at Asbury Park, a cottage designed by Bassett Jones of New York, was built in 1878 for Ulysses Simpson Grant, Jr., son of the Civil War general (§42). The cottage was not as large as the service wing of the Newcomb house, though it did contain parlor, dining room, kitchen and servant's room on the first floor, and four bedrooms upstairs, all of limited size. The cottage cost only $1,500, including fences, pump and outhouse. Japanese characteristics are prominent in the *irimoya* roof—not visibly interrupted by chimneys from the front—and in the superimposed porches. The supports are plain square posts, in no way related to classic columns, and there are latticed railings with cutout apron boards of authentic shape. The sash windows, chimney at the back, and "Queen Anne" relief on the gable of the stairhall are uncompromisingly Occidental. The cottage evidently did not survive or remain long in the family because none of the Grant descendants contacted during the late 1950's remembered it.

The sphere of influence of the Japanese centennial display was not limited to the region between Philadelphia and New York. It spread far up the Atlantic coast. The design for a small summer house at Kennebunkport, Maine, was delineated by Henry Paston Clark of Boston in February of 1880 (§41). The building was no larger than the Grant cottage, though more complex in form, with its Baroque cupola, articulated hipped roofs, and dissimilar projecting windows and porches. The covered balcony is Japanese, not only as regards its thin posts and railings, but in the full-length window on the stair landing and trellis screen along the gallery to the watercloset over the storage bin. The principal room on the ground floor is a parlor-dining room, which is Japanese in its combined functions. In one corner is an inglenook, or fireplace recess, which suggests the spatial treatment of the hall at Elberon. A number of openings between rooms and two closets are equipped with curtains rather than

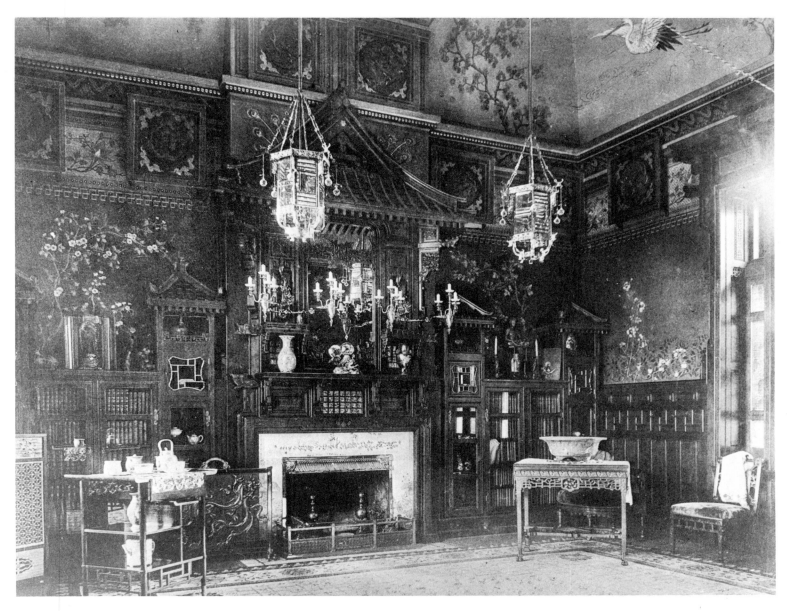

§37. *Dr. E. H. Williams' Japanese room, Philadelphia.* (Artistic Houses, *New York, 1883-84, Vol. I, Part II, facing p. 170.*)

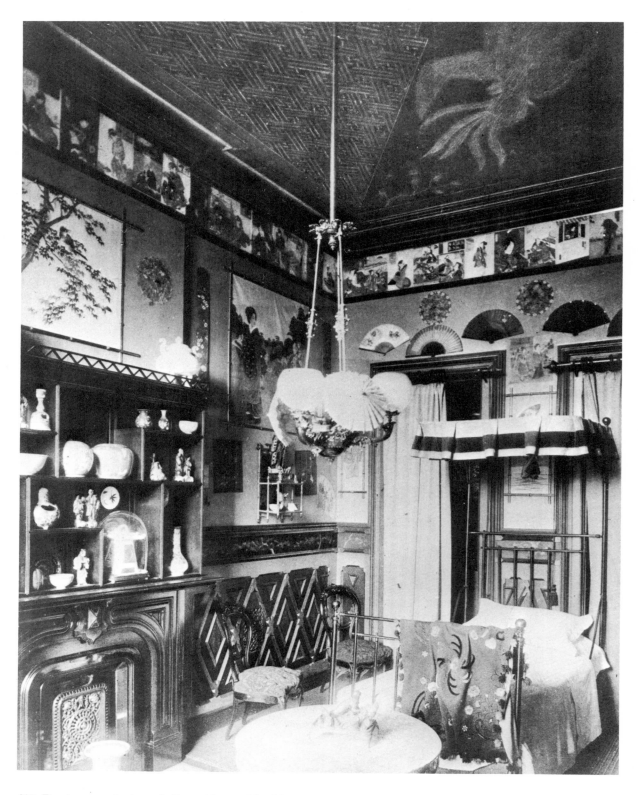

§38. *The Japanese bedroom in the residence of Dr. William A. Hammond, New York.*
(Artistic Houses, *Vol. I, Part II, facing p. 90.*)

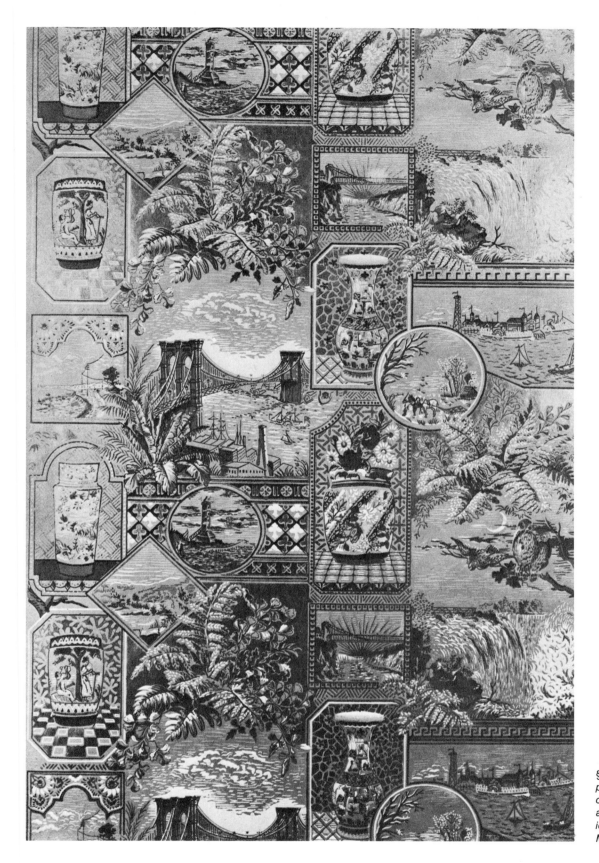

§39. *Wallpaper printed with designs of New York State and Japanese ceramics. (Cooper-Hewitt Museum, New York.)*

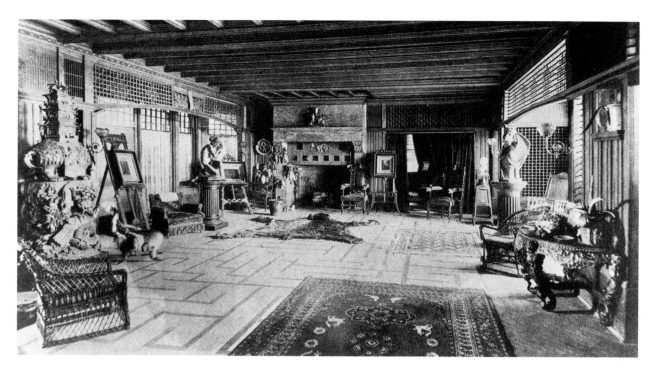

§40. *H. Victor Newcomb hall at Elberon, New Jersey. McKim, Mead & White, architects.* (Artistic Houses, *Vol. II, Part I, preceding p. 1.*)

§41. *Design for a small summerhouse at Kennebunkport, Maine. Henry Paston Clark, architect.* (The American Architect and Building News, *July 3, 1880.*)

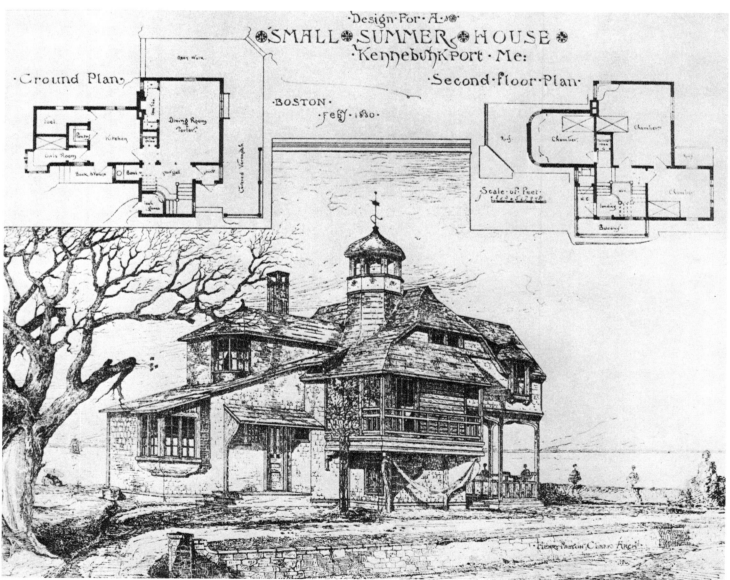

hinged doors. A kitchen, pantry, fuel shed and cubicle for a servant girl occupy the first floor of the wing. Three bedrooms are on the second floor. On the left side of the architect's perspective sketch a couple may be seen seated beneath a Japanese parasol, gazing at a sailing vessel that resembles a Far Eastern junk.

During the decade following the Philadelphia exhibition evidence of a concentration of the Japanese manner materialized at Tuxedo Park, located about thirty miles northwest of New York City in the Catskill Mountains. The project at Tuxedo relates to a forerunner of the 1850's at West Orange, New Jersey, called Llewellyn Park. Here, under the sway of the picturesque beauty of the English park *(jardin anglo-chinois)*, was preserved an extensive acreage of natural woodlands as the setting for a number of romantic retreats, which could be reached by a system of narrow meandering roads. The park was encompassed by a wall and the entrance guarded by a stone gate-keeper's lodge. But whereas the influence of the informal landscaping of Llewellyn Park was Chinese, the source of inspiration for both the grounds and buildings of Tuxedo Park was largely Japanese.

The original aim of Pierre Lorillard, the tobacco magnate who owned the estate at Tuxedo, had been to retain it as a hunting reservation where he and a few friends might put up little cottages, which Lorillard himself designated "boxes." Then society took hold of the development, and the corrupted Indian place-name "Tuxedo" came to be a synonym for a gentleman's black-and-white formal dress. The rustic club house was a sizable social center containing an octagonal ballroom and a hundred guest rooms. For years the New York social season was opened by the Debutantes' Ball in this building. It, the gate house, and forty private residences were designed by the architect Bruce Price and built during the first six months of his regime at Tuxedo Park. One of the dwellings, situated on a hill beyond the club house, was called the Japanese Cottage, shown here in a late nineteenth-century magazine illustra-

§42. *Cottage for U.S. Grant, Jr., Asbury Park, New Jersey.* (The American Architect and Building News, *September 18, 1880.*)

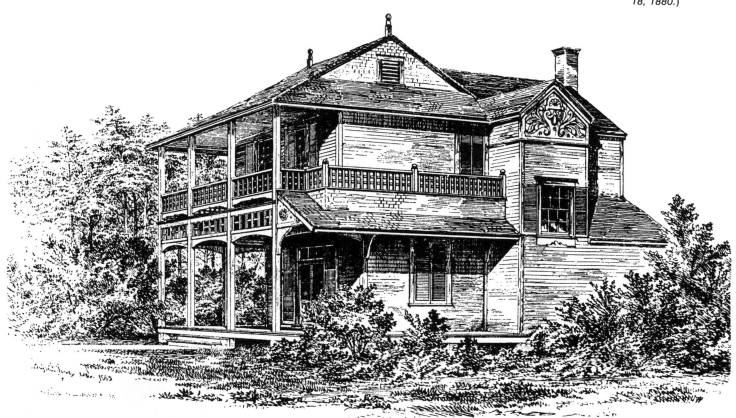

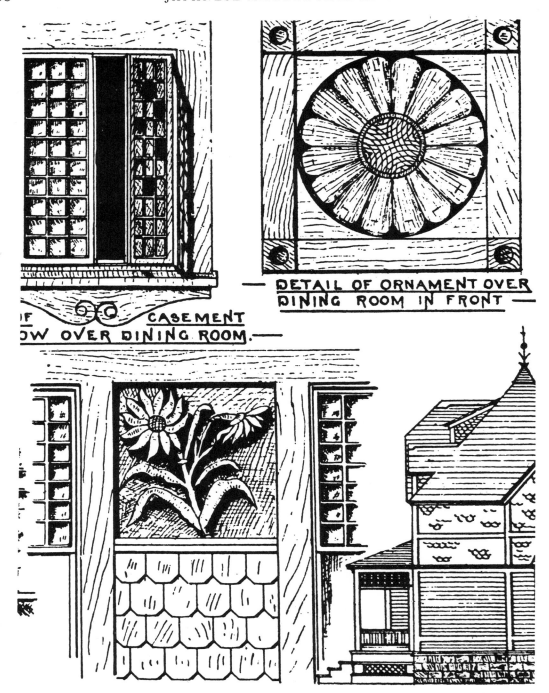

§43. *Architectural ornaments. (Palliser's New Cottage Homes, New York, 1887, detail of Pl. 26.)*

tion *(§45)*. It was the home of Addison Canmack.[6] The lower walls of the three-part composition were of stone. The half-timber second story displayed large Japanese crests in wood against plastered fields, and there were shingled gable ends. Pent roofs forming deep eaves across the base of each gable created a modified *irimoya*. On the whole the Eastern elements are rather superficial. During the construction of the early buildings Bruce Price resided in the Park and here brought up his daughter, who, in this isolated setting favored by society, became America's foremost authority on etiquette, under her married name, Mrs. Emily Post. The Japanese vogue persisted at Tuxedo long after Bruce Price had finished his work there. The Scofield house, built by the New York firm of Walker and Gillette early in the twentieth century, contained an authentic Japanese room,[7] and adjoining the house was a Japanese garden with a ceremonial tea house in it *(Chapter Seventeen)*.

Many houses built during the last quarter of the nineteenth century made incidental use of Japanese motifs. Probably most of the builders were unaware of the origin of these designs. They were copied out of contemporary architectural guide books, such as *Palliser's New Cottage Homes and Details*, published in New York by George and Charles Palliser in 1887. A portion of a plate depicting ornaments to be applied to wooden houses includes two reliefs based ostensibly upon common American flowers *(§43)*. The first is the tall sunflower *(upper right)* that peeks over backyard fences, and the second is the homely daisy *(below center)* that grows wild in the meadows. The sunflower is conventionalized into a geometric shape, the petals somewhat out of proportion to the reduced seed head, thus making the design a facsimile of the imperial Japanese *kiku*, or chrysanthemum. The daisy goes to the other extreme. In its informality it is unlike any other floral ornament appearing previously on Western architecture; its feeling is Japanese. The simplicity of the type of house it was meant to decorate permits its acceptance here.

There were other books of the period presenting house designs with details indebted to the Japanese. One of these was Carl Pfeiffer's *American Mansions* (Boston, *ca.* 1889), the title of which greatly overestimates the plebeian dwellings represented. Typical is Design M, for an average-sized American family home *(§44)*. The upturned roof eaves, and the treatment of

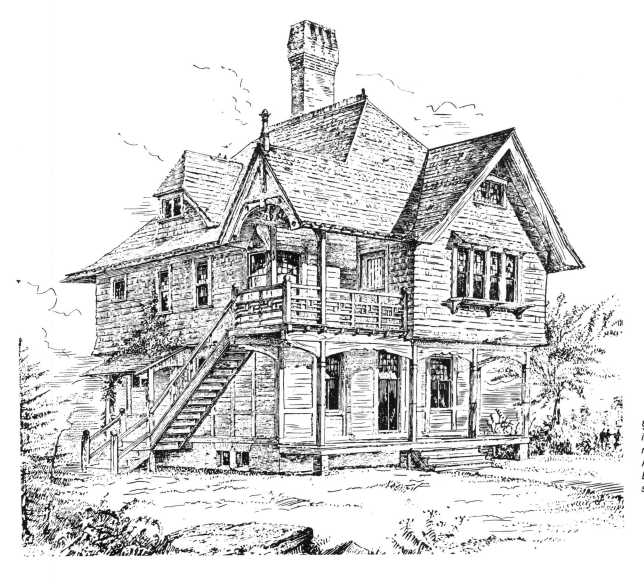

§44. *Perspective drawing for an American residence. (Pfeiffer, American Mansions, Boston, ca. 1889, Design M, Pl. 1.)*

the stairway to the second floor are Japanese. The lattice inserts in the railing are a bit fancier than those to the upstairs porch of the Grant cottage at Asbury Park. Several interior designs in *American Mansions* are also in the Nipponese manner. A dining room fireplace wall in Design E, Plate 1, for instance, has an allover flower pattern above the dado and a frieze of bamboo and flying cranes between the picture molding and cornice. Plates lined up on the mantel shelf could be Japanese, as well as a bulging pot containing a sprig of leaves on the hearth.

As is the case with most new styles, then, the Japanese in America was introduced into the mêlée of contemporary eclectic taste, and appeared in much overdone and overcrowded large drawing rooms, sitting rooms, dining rooms, libraries, and even in small chambers. The imprint of things Japanese also came to light on wallpaper for the homes of more modest folk. But the lesson of simplicity that Japan had to teach was too vital not to assert itself directly. It took root and blossomed in the rarefied atmosphere of seacoast and highland. Here, away from the critical eye of urban dogma, nonchalance ruled supreme; and where formal styles were most discarded the way was open widest for the informal Japanese to come in. It helped determine the multipurpose rooms of larger houses and was apparent throughout smaller vacation cottages. Within a decade after the Philadelphia centennial the Japanese vogue had achieved a firm toehold in the eastern United States.

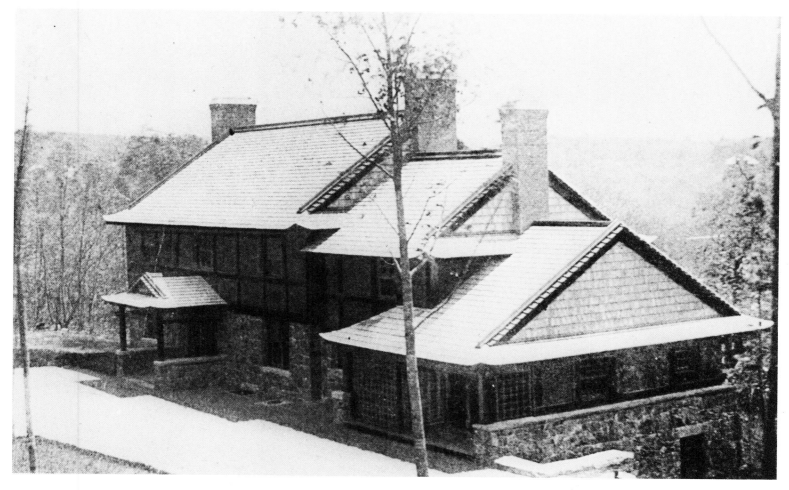

§45. *The Japanese cottage in Tuxedo Park, New York. Bruce Price, architect.*
("Great American Architect Series," No. 5, The Architectural Record, *June, 1899, p. [47].)*

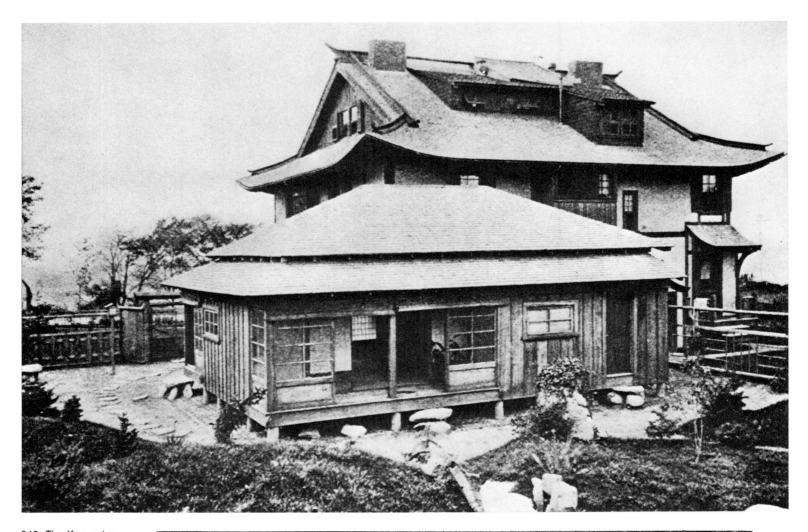

§46. *The Knapp tea house seen from the garden.* (The Architectural Record, *July-September, 1898, p. [84].*)

§47. *Interior of the Knapp tea house.* (Ibid, *p. [90].*)

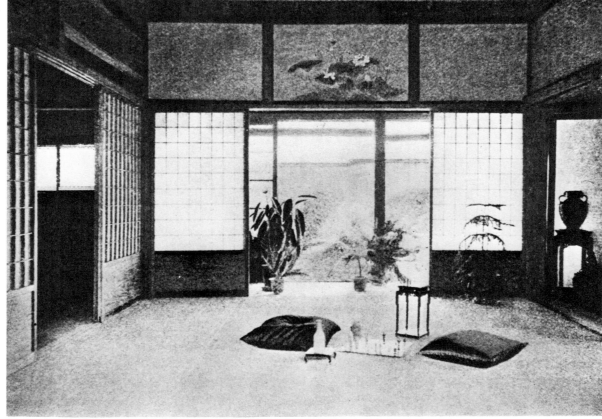

CHAPTER SEVEN

Early Sources & Examples
of Authentic Japanese Architecture
in America

MERELY looking at any new phenomenon in the arts may engender enthusiasm yet not necessarily establish understanding of the phenomenon. As we have just seen, the Philadelphia exhibits had an immediate influence in creating a vogue for the Japanese manner in the fields of casual houses and not-so-casual interiors. But being concerned with the exact meaning and authentic form of Japanese architecture is an attitude quite distinct from the purposes behind the foregoing examples. The more searching viewpoint began to manifest itself on a modest scale through writings put out on the centennial displays in both guidebooks and periodicals. The *American Architect and Building News*, for instance, carried articles on the Japanese work at the fair in the February 12 and April 2, 1876, issues. Afterwards the vista broadened considerably and interest began to pass beyond the two examples actualized in America and focus on buildings in Japan itself.

The authors of this literature were men who had gone to Japan for various reasons, made a study of Japanese buildings, and wished to share their findings with people back home. A forerunner of the American group was the Englishman Josiah Conder, who journeyed to the Far East in 1877 to assume a professorship in the Engineering Department of the Imperial University in Tokyo, and to become a practicing architect to the Japanese government. He submitted two papers on Japanese building to the Royal Institute of British Architects—of which he was a member—in 1878 and 1886, and afterwards they were published in the *Transactions*. Early in 1887 he returned to England and read a third paper before the Institute. The talk was illustrated by the speaker's drawings and a model of a Japanese house. The substance of his discourse and several illustrations were printed in the April 2, 1887, edition of the *American Architect* (pp. 160-62). Later, Josiah Conder went a great deal further in familiarizing the West with Japanese artistry, but his greater contributions were not concerned with architecture. They dealt instead with flower arrangement and gardening and consisted of two books that appeared in 1891 and 1893 *(Chapter Seventeen)*.

The *American Architect and Building News* printed an article on the Temple at Nikko in the May, 1896, issue (pp. 83-85). It was written by C.T. Mathews, who had published a more ample essay on the same subject in the October-December, 1894, *Architectural Record*. This one was followed during the next two years by a series on the buildings of eastern Asia. Number Three in the series, in the first quarterly of 1896, pertained to China, Korea and Japan in general (pp. [288]-297) and Number Four, in the succeeding quarterly, concentrated on Japanese architecture alone, discussing its history and types: dwellings, palaces, castles, *yashiki* (manors), and temples (pp. [383]-392).

Several periodicals were devoted predominantly to the subject of Japan. Among these may be cited the *Transactions* of the Asiatic Society of Japan, the old *Japan Mail*, the old Tokyo *Times*, and the magazine *Chrysanthemum*. The *Transactions* contained a number of informative articles on architecture, some of which already had been circulated by the *Mail*.

These articles served the purpose of creating interest in Japanese architecture, but they amounted to little by way of presenting a well-rounded picture of even one phase of the subject. Certainly they paled to insignificance in comparison with the monumental work that came out within a decade after the Philadelphia fair, and which for over three-quarters of a century has remained the most comprehensive publication in the West on the field explored. It was written and illustrated by an American scientist of Salem, Massachusetts. The author-illustrator was Edward Sylvester Morse (1838-1925), who went to Japan in 1877 to study brachiopods. While engaged in research at Enoshima, Morse was invited to teach zoology at the Imperial University in Tokyo, and, accepting this post, he became a colleague to Josiah Conder. Morse's preoccupation with natural history in Japan seemed a waste to one of his good friends back in Boston, Dr. William Sturgis Bigelow. Dr. Bigelow admonished him for "frittering away" his "valuable time on the lower forms of animal life," when he might be devoting it "to the highest, about the manners and customs of which no one is so well qualified to speak. . . ." Dr. Bigelow with keen foresight predicted that: "For the next generation the Japanese we knew will be as extinct as Belemnites." Morse heeded well the warning, and during his four years in Japan—distributed over three visits—he faithfully kept a journal that was illustrated with little pen sketches made wherever he visited. Many years later the journal was published in two volumes, entitled, *Japan Day by Day* (Boston, 1917), thus preserving for posterity glimpses into Japanese life at the time it was just beginning to show Westernization. The quotations given above were extracted from the preface to the first volume (pp. ix-x).

Edward Morse became an active collector of Japanese ceramics and pottery artifacts, and the latter led him to the discovery of a prehistoric burial mound at Omori, now part of Tokyo, where a monument subsequently was erected in his honor. His ceramic collection was brought to the United States and divided between the Peabody Museum in Salem and the Boston Museum of Fine Arts *(§52)*. Morse became the first director of the Peabody Museum in 1880, and two years later moved on to the Boston Museum as Curator of Japanese Ceramics. On his third trip to Japan in 1882 Morse was accompanied by Dr. Bigelow. Their chief purpose was to collect for the Boston repository. Dr. Bigelow remained seven years. A third American of similar interests who went to Japan was Ernest Francisco Fenollosa, who specialized in Japanese paintings and prints as both a collector and commentator. He compiled *The Masters of Ukiyoe* (1896), a booklet gotten out for the Japanese print exhibition held in the New York Fine Arts Building. He also wrote *Hiroshige, the Artist of Mist, Snow, and Rain* (1901), but his most important work was *Epochs of Chinese and Japanese Art*, a two-volume set which appeared posthumously, edited by Mrs. Fenollosa. Incidentally, Fenollosa and Bigelow became Buddhists, and Dr. Bigelow lectured on Buddhist doctrine at Harvard in 1908, the year his book *Buddhism and Immortality* was published. Morse, Fenollosa, and Bigelow were not only instrumental in opening American eyes to the beauties of Japanese art; they also helped establish a renewed appreciation among the Japanese. The official listing of the National Treasures of Japan can be traced directly to their influence. Edward Morse was decorated with the Order of the Rising Sun (1898) and the Second Degree Order of the Sacred Treasure (1922).

The work for which Morse is best remembered is his detailed study of Japanese dwellings, which, when investigated during the late 1870's had not given in to foreign modifications. The study materialized in 1885 as a book called *Japanese Homes and Their Surroundings*, sponsored by the Peabody Academy of Science in Salem. The following year it was issued commercially by Ticknor and Company of Boston, printed at the University Press, Cam-

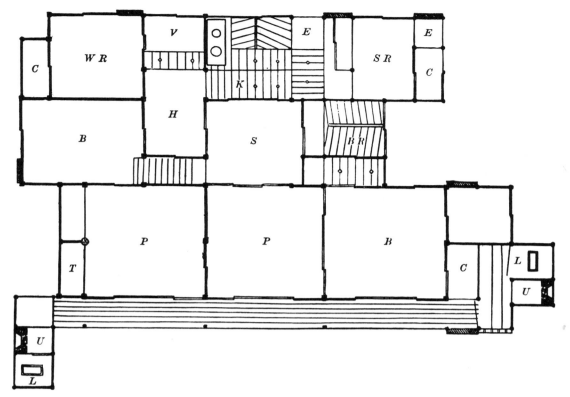

§48. *Plan of a house in Tokyo. (Morse, Japanese* Homes and Their Surroundings, *Boston, 1886, Fig. 98.)*
P,P, *Parlor or Guest Room*
B,B, *Bed-room*
K, *Kitchen*
S R, *Servants' Room*
B R, *Bath-room*
E,E, *Side-entrance*
V, *Vestibule*
H, *Hall*
W R, *Waiting-room*
C, *Closet*
T, *Tokonoma*
U and L, *Privy*

bridge. The book went into at least four editions, including eight or more printings, up to 1895, and a paperback edition came out in 1961. In some 400 pages, including 307 pen-and-ink illustrations, Morse analyzed every aspect of the Japanese house: its aggregate appearance, its construction, builders' tools, representative types of city and country dwellings, shingled, tiled and thatched roofs, house plans, interior characteristics, window treatment, tea rooms, *kura* (storehouses), kitchens, lavatories and privies, porches, gateways, fences, summerhouses and other constructions in the garden, specially cultivated decorative plants, flowers, and wells and water supply. Most of the writers on Japan before Edward Morse (and most after him) admired Japanese temples and other monumental edifices but showed little sympathy for dwellings. Morse approached the Japanese house with an appreciative eye and found much to recommend it. He was the first to make a sustained effort to try to understand it from the Japanese viewpoint, as something suitable to their own needs and aesthetic ideals. Here was a fortunate coincidence that a penetrating observer and capable reporter should have happened in at the right place at the right time and (with a little prodding from Dr. Bigelow) should have felt inclined to put down his impressions in black and white, thus preserving for posterity a well-rounded review of an ethnic-cultural subject that soon was to undergo disruptive changes.

Morse describes a Japanese house as disappointing to an American at first glance. It is lacking in so many features expected in a home in the United States. It has "no doors or windows... no attic or cellar; no chimneys, and within, no fire-place, and of course no customary mantle [*sic*]; no permanently enclosed rooms; and as for furniture, no beds or tables, chairs or similar articles..." (page 7). One of the chief distinctions between Japanese and American houses, he says, is that the Japanese dwelling is without permanent walls on two or more sides, and it has few stationary partitions inside (*§48*). Sliding screens permit opening up the house or closing off sections into individual rooms, which is made possible by a structural framework instead of weight-bearing walls. The outside screens, or *shōji*, are frames stretched over with translucent paper to admit light. Where exterior walls occur they are usually left natural, whether wood, plaster or tile. Roofs are low-pitched, covered with

shingles, tiles or thatch. Open galleries or verandahs are common and are protected by deep overhanging eaves of the main roof or a light supplementary roof. At night they are enclosed by solid wood panels *(amado)*. Entrances are inconspicuous, and only the better houses have a definite porch and vestibule. Interiors are accessible from any number of points. The floor is raised a foot and a half above the ground, and is laid with thick straw mats *(tatami)* of uniform size, closely fitted together, determining square or rectangular rooms. The guest room alone is permitted a departure from this simplicity. It has a deep recess divided into two bays by a slight partition. The recess nearer the verandah is called the *tokonoma*. On its wall is hung a scroll painting, or a sample of calligraphy similarly mounted, and on its raised floor a flower vase or art object is placed on a low stand *(§49)*. These constitute the only conceits displayed in the house. The adjoining bay has shelves and small cabinets. Other rooms may provide built-in drawers or closets, the latter furnished with sliding screens instead of swinging doors. Privies are at the corners of the house, slightly removed. The kitchen is to one side, usually in an ell under a pent roof on the street front of a city residence. The principal out-building is the *kura*, a small tile-roofed, thick-walled, fire-proof private warehouse of one or two stories. It has a single door and may have one or more small windows protected by heavy shutters. Rural dwellings, of course, also have barns and sheds nearby. High fences of boards or bamboo, or solid walls of mud or tile with stone foundations surround the house or enclose it from the street. Intervening spaces are tastefully gardened, offering a pleasant outlook from the house itself *(§50)*.

Reviews of *Japanese Homes* ranged in feeling from wholehearted appreciation for what it accomplished to adverse criticism of its viewpoint. The *American Architect and Building News* called it "a noble and unique book" and acclaimed the author as standing "to modern Japan as Viollet-le-Duc to medieval France." It went on to observe that the detailed information in the volume shows "very clearly what may result when an industrious and ingenious people unconsciously develop, through many generations, indigenous art absolutely free from affec-

§49. *Guest room in Hachi-ishi. (Morse,* Japanese Homes. . . , *Fig. 96.)*

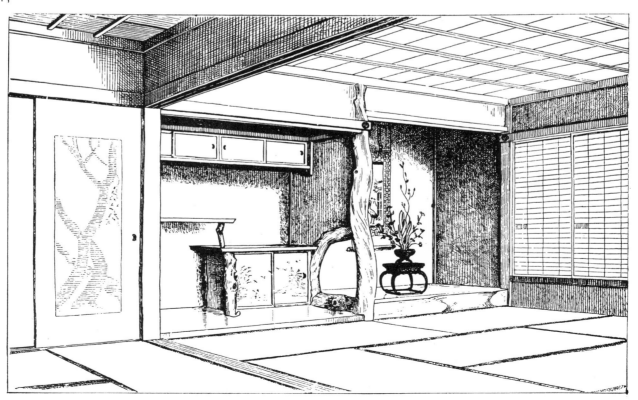

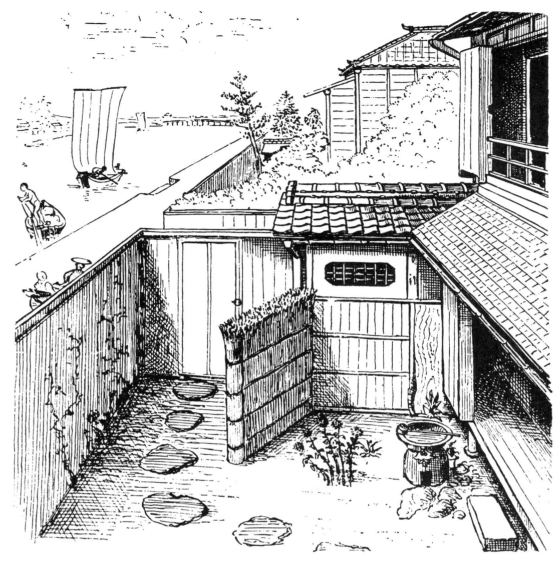

§50. *View from the second story of a dwelling in Imado, Tokyo. (Morse,* Japanese Homes. . . , *Fig. 50.)*

tation or masquerade." Finally: "Professor Morse's book is, in short, well worthy of study by every architect and decorator, because of its fresh ideas in design of detail and construction, and because of its graphic presentation of an artistic spirit manifested in the work and manners of a whole nation."[1] On the opposite side of the fence the reviewer for *Building* remained unconverted to the charms of Japanese dwellings. He wrote: "Japanese homes are very flimsy affairs when compared even with our lightest constructions of wood. . . they [the Japanese] are beginning to build houses like ours, and it probably will not be many years before the Japanese may wonder how it was they managed to live in such great discomfort before the advent of new ideas. Professor Morse seems to regret the spread of foreign notions of building. His intention in writing his book was to preserve a record of something that was dying out." The author of *Japanese Homes* is accused of making allowances for "objectionable features" by comparing "them with something worse that prevails among us. This is really the greatest defect the book has." Yet the same reviewer concludes that "there are innumerable points that can be taken to heart by the architect, and for the general reader there is so much concerning the home life of the Japanese. . . etc., that it will be wise not to attempt even an outline of the matter presented."[2] Space, indeed, was needed to do the book justice. The *American Architect*, which favored it, relegated a couple of pages in each of five issues to reviewing or summarizing *Japanese Homes*. At any rate, whether they liked or disliked Japanese houses the critics agreed that American architects and laymen could benefit from perusing the perceptive study Morse had made of them.

Edward Morse produced one more book on Eastern homes that relates to his definitive work on the Japanese, though this other one is in no way definitive, which in itself is significant. Following his residence in Japan Morse visited China, Annam, Singapore, and Java, and the second opus was written from material gleaned during his stay in the first of these countries. Actually Morse's experience in China was limited, not only because his sojourn was brief but because it was restricted to two places, Shanghai and Canton. Much of his information first was incorporated in six articles in the *American Architect* bearing the title "Journal Sketches in China." The book itself was called *Glimpses of China and Chinese Homes*, published by Little, Brown and Company of Boston, in 1902. The volume has 216 pages with 66 illustrations, which is slightly more than half the number of pages and between one-fourth and one-fifth the number of illustrations in *Japanese Homes*. By comparison the drawings are crude, being, in fact, reproductions of sketches made on the spot and not carefully finished as in the earlier book. The size of *Chinese Homes* and treatment of its illustrations reveal Morse's attitude toward his subject. After his prolonged and agreeable visit with the Japanese the Chinese struck Morse as uncultivated, backward, dirty, surly, superstitious and lacking in courtesy and artistic accomplishments. Seemingly Morse felt the Chinese house had little to recommend it, architecturally. He makes no systematic analysis of it as he had of the Japanese. As a matter of fact he describes only two residences, a farmhouse near Shanghai and a wealthy merchant's mansion in Canton. Morse is preoccupied with the contents of the houses and concerned over the unsanitary conditions in both examples, especially in the kitchens where cooking was performed. Yet Morse found most Chinese food quite palatable, more like American than Japanese. The two books on China and Japan offer a clue to the cultural status of each of the countries and indicate why, in the latter half of the nineteenth century, the exotic attraction in the West shifted from Cathay to Nippon.

A young Japanese by the name of Bunkio Matsuki followed Edward Morse to America and settled in Salem. He married a Miss Almy and worked for a while in the Almy Department Store there. During the 1890's Bunkio Matsuki built a house that was somewhat Japanese in style. It stands on the corner of Hazel and Laurel Streets (*§53*). The two-storied frame structure has an *irimoya* roof with latticework in the gable ends, carving in the entrance porch, a pair of large bronze lanterns stationed by the front steps, and a little side entry with a polygonal Japanese alcove window in it. The plan of the house, however, is typically New England, with a central chimney. The parlor in front has a recess at one end and adjoins the entrance-stairhall at the other. The staircase is animated by carved and gilded protomes. A service hall and kitchen are in back, and the dining room is in the far corner of the house. Bunkio Matsuki gravitated into the Oriental art business before 1900, dealing in Chinese and Japanese porcelains and pottery, paintings and prints, palace and temple carvings, bronzes and other metalwork, including arms and armor. Many of these items were sold in a series of auctions held in Philadelphia, New York and Boston from 1892 to about 1920. Afterwards Bunkio Matsuki returned to Japan, where he is reported to have become a Buddhist monk. The house in Salem, despite its prosaic American plan, possesses many elements that are authentically Japanese. Originally there may have been more, but they have been obliterated by later alterations. Changes to frame houses can be accomplished very easily by any carpenter capable of handling a hammer and saw.

Another contemporary Massachusetts house with genuine Japanese traits was at Fall River. It was the home of Arthur May Knapp, a Unitarian minister who had lived in Japan while making a study of native civilization. Knapp wanted a house that would be an appropriate setting for his valuable store of Japanese bronzes, porcelains, lacquers, *kakemono*,

embroideries and other pieces, and he commissioned Ralph Adams Cram of Boston to create a suitable scheme. The architect at first attempted to cast the house in the American colonial style, which, as a revival, was then in fashion, but he soon came to realize it did not go with the furnishings and gave it up in favor of a modified Japanese. The two-storied rectangular form had half-timber walls pierced by banks of windows, and a very formal entrance with carving on the door jambs, sheltered by a bold, dipping hood having a cutout bargeboard (*§54*). The house had a magnificent *irimoya* roof with deep, flaring eaves and a curvilinear Tokugawa gable piercing the front slope. The chimneys, dormers and a stairwell skylight were all at the back, hidden from the street side behind the main ridgepole. On the whole the details were rather temple-like for a residence.

The interior of the Knapp house showed a synthesis of East and West. The plan was as American as that of Bunkio Matsuki's dwelling. However, the Fall River residence was larger and featured a central transverse hall separating two pairs of rooms of similar size, a library and a parlor at the front, and a kitchen and dining room at the back, with chimneys between each pair (*§51*). The principal rooms combined Occidental fireplaces and Oriental recesses filled with art wares. The recesses occurred along several walls of the same room, which in itself would have seemed an excess to the Japanese. The staircase rose in a square well, its Western stair flights, niche and hinged doors juxtaposed against Eastern railings, open panel carvings and unstained woods (*§55*). It ascended to a gallery lighted overhead through a translucent ceiling screen upheld by a series of slender square posts connected by railings and pierced *ramma*. Although a bit cluttered, the stair hall presented a more agreeable fusion of components from two hemispheres than the adjoining rooms.

A low separate pavilion attached to the dining-room corner of the Knapp house was thoroughly Japanese (*§46*). It was set on posts instead of masonry foundations and the narrow front and rear galleries were covered by an encompassing supplement to the main moderately-pitched hipped roof. The structure was designated the tea house (*see plan, §51*), and the largest room had *tatami* on the floor and no Western furniture. Through the open *shōji* one looked out into the garden (*§47*). At one side were the *tokonoma* and the *chigai-dana*, and on the other side sliding screens gave access to a subsidiary room, with a little preparation room for the tea, and closets beyond. The sliding screens between the rooms here were exactly like the *shōji* opening onto the gallery, whereas considered strictly they should have been solid *fusuma*. The posts and frames were of cypress, the sliding screens of white pine and rice paper, the grilles above of cryptomeria, and the ceiling was of strips of cedar. In the alcoves were combined cedar, cypress and apple woods, all imported from Japan. The architect, after admitting he had least to do with this section of the building, paid highest tribute to it and to the Japanese domestic setting in general in these words: "It would be impossible to imagine anything more quiet and delicate than the effect of this room, either in winter when the shoji are drawn and it is full of soft diffused light, or in summer when they are run back and two sides are open to the fresh air.... There are many things... that one may learn from the Japanese, but if nothing was acquired but a sense of the sanctity of wood and the beauty of fine workmanship, the study would be worth while."[3]

Arthur Knapp found that he preferred the simplicity of the annex to the main house and gradually adopted it for his year-round living room. The next step was giving up the place altogether and moving back to Tokyo. The Fall River residence was razed before the close of the century, but the former owner did not forget either the house or its architect. Through Knapp's intercession Ralph Adams Cram was called to Japan in 1898 to design a new parliament group to replace buildings lately destroyed by fire. Within four months he produced a

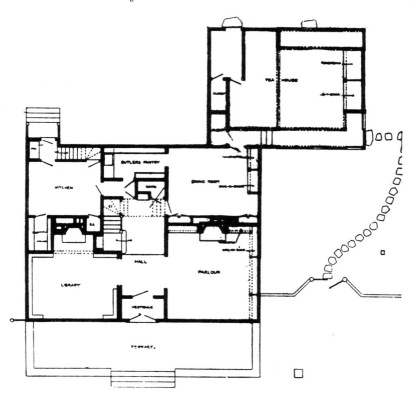

§51. *Plan of the first floor of the Arthur May Knapp house at Fall River, Massachusetts.* (The Architectural Record, *July-September, 1898, p. 83.*)

grandiose plan in the native style that was approved by Premier Itō. Cram sailed for America to await the forthcoming building appropriation. The first item he saw in a newspaper upon landing in Vancouver was an account of the fall of the Itō administration. Although at the moment the trip seemed a fiasco, it later proved otherwise, because of the publication of Cram's book, *Impressions of Japanese Architecture* (Boston), in 1905, reprinted in 1930. The *Impressions* gives a brief sketch of the development of Japanese architecture during historic times, describes and analyzes some of the famous temples and shrines, and discusses the kindred topics of gardens, domestic interiors, sculpture and pictorial and minor arts. It is illustrated by some fifty photographs of Japan's treasures and scenes, the later edition adding pictures of a few foreign-style buildings and a magnificent rendering of Cram's "Dream of a Parliament House."

The book was given an especially appreciative review in the May, 1906, edition of *The Craftsman* (p. 192), in which the reviewer—probably one of the editors—launches a few penetrating and timely remarks. The essay is entitled "Japanese Architecture and Its Relation to the Coming American Style." It begins:

"The trend of modern thought and art, with its strong revulsion toward simplicity and a return to first principles, makes Mr. Ralph Adams Cram's 'Impressions of Japanese Architecture and the Allied Arts' one of the most notable books on architecture that has appeared for years. It is not that the book is an exhaustive and scholarly treatise on architecture; it is rather an appreciation of the peculiar genius of the Japanese people, and the causes... that led to the development of the world-famous art spirit of Japan. With all the appreciation of Japanese art that has arisen of late years, there has been almost nothing said of the architecture of this exquisitely cultivated people. When any comments have been made, the general tendency is either to make light of Japanese architecture as rather a trivial thing having no distinct style, or to rhapsodize over the gorgeous ornamentation of the temples built in the luxurious Tokugawa period, when in fact, as Mr. Cram clearly shows, the architecture of Japan is one of the world's great styles, ranging over a period of twelve centuries, during which was developed a style of construction in wood as perfect as the Gothic is in stone.

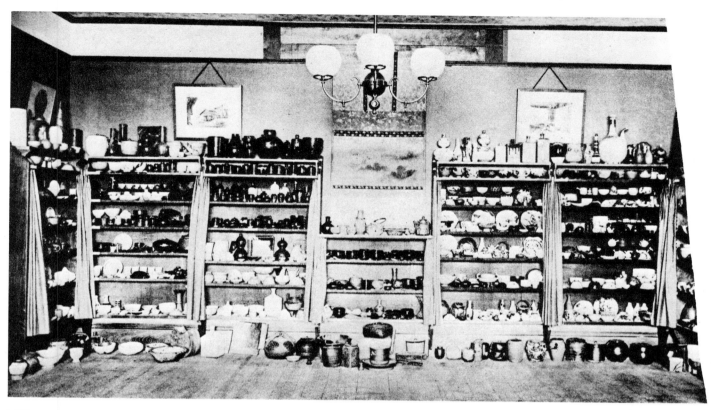

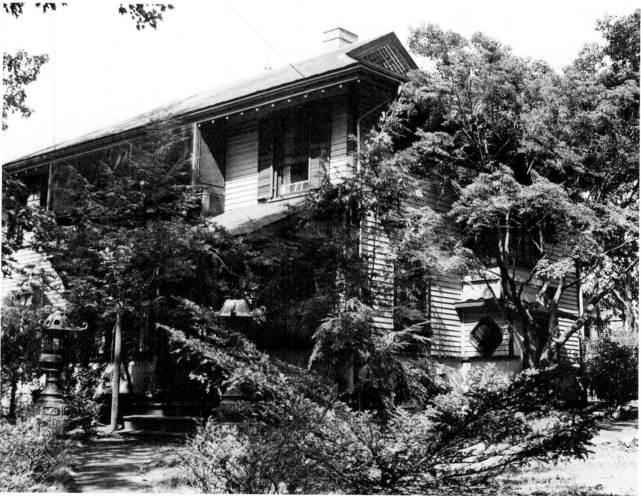

§52. *Portion of the Morse collection of Japanese pottery as displayed in the Morse home in Salem.* (The American Architect and Building News, *Imp. Ed., May 28, 1887.*)

§53. *Bunkio Matsuki house in Salem.*

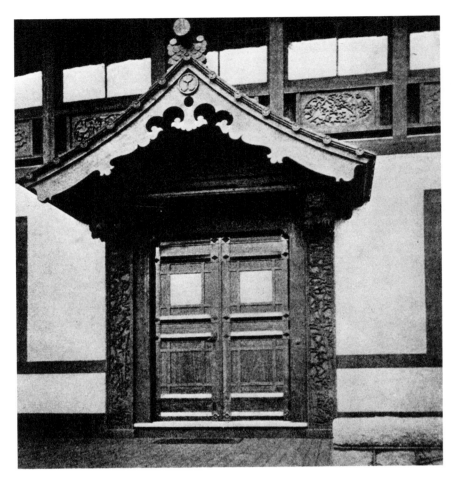

§54. *Front door of the Knapp residence at Fall River.* (The Architectural Record, *July-September, 1898, p. [85].*)

§55. *Stair hall in the Knapp house.* (Country Life in America, *January, 1905, p. 270.*)

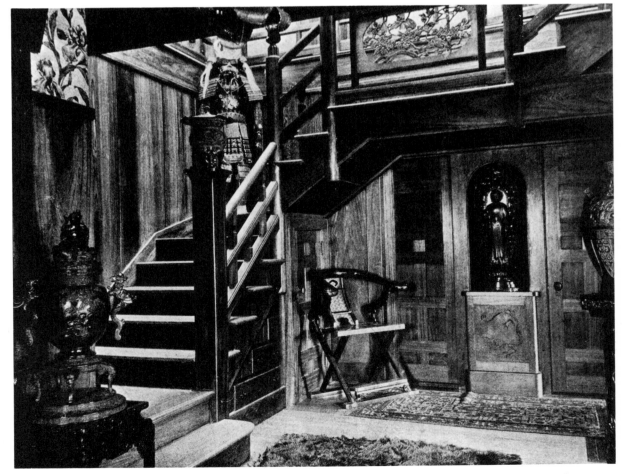

"Even more important...is the fact that the fundamental principles of that architecture are, aside from the universality of the principles underlying all great art, identical with the elements that promise permanence in the new thought that is steadily gaining strength in this country as well as in England, Germany, and France, a return to honesty and simplicity in construction, rejection of all false ornamentation and the meeting of all actual requirements in the simplest and most direct way. The architectural gospel preached by *The Craftsman* ever since its first number is here echoed in no uncertain tones, and from the other side of the world."

The reviewer for the *Brickbuilder*, several years later, did not agree with this viewpoint but said: "It may well be true that the most powerful influence felt by the art of Europe in the nineteenth century came from Japanese painting. Japanese architecture has not played and cannot play such an important rôle. It has abundant charm, however, and its delightful presentation in Mr. Cram's little book is a source of constant pleasure and inspiration."[4]

Impressions of Japanese Architecture had come out in September, 1905, and in January of the following year *The Architectural Record* printed a 26-page lead article on "Japanese Houses," written by Katharine C. Budd and copiously illustrated not only with photographs of the islands' architecture, but with working drawings as well. Miss Budd's convictions about Japanese architecture match those of Morse, Cram and the reviewer for *The Craftsman*, as she declares: "That artistic instinct which in Japan goes hand in hand with mechanical execution renders these houses excellent in line and proportion, as well as perfectly adapted to the needs of the inmates."

As can be seen from the foregoing, regard for authentic Japanese architecture first manifested itself in America among a small selection of intellectuals. The foremost among them was Professor Edward Sylvester Morse, who became associated with the Imperial University in Tokyo, where a British colleague, Professor Josiah Conder, already had done spade work on the subject. After four years in Japan Morse returned to America to compile and illustrate the book, *Japanese Homes and Their Surroundings*, published in 1885. The book proved to be the definitive study on Japanese residential architecture for at least three-quarters of a century. Morse also produced a companion book on Chinese homes, but it was haphazardly conceived and could in no way measure up to the earlier volume. As the first book showed how much Japan had to offer the West in the area of domestic building, the second indicated how little China could impart. Morse became director of the Peabody Museum in Salem for two years and then took the post as Curator of Japanese Ceramics at the Boston Museum of Fine Arts. A Japanese friend, Bunkio Matsuki, settled in Salem, and in the 1890's built a house that was mostly Japanese in character. A larger contemporary house at Fall River, Massachusetts, was constructed for the Rev. Arthur May Knapp, who had lately completed a period of study in Japan. One wing of the house, that was wholly Japanese in style, came to be the owner's favorite retreat. The authenticity of this structure held strong associations and finally brought about Knapp's return to Nippon. Knapp succeeded in getting his architect, Ralph Adams Cram, over for four months to design a government compound. Although the professional scheme fell through, the architect's visit brought about another book in praise of Japanese architecture and other age-old classical arts of Japan. The Cram book, a group of periodical articles, and especially Edward Morse's *Japanese Homes* provided Americans with an ample supply of information on the craft of the Japanese builder. The few early examples of Japanese architecture constructed along the East Coast disappeared long ago, or, as in the case of the Matsuki house, remained obscure, whereas the printed accounts have been continuously available to successive generations of architects and others for use as inspiration or research material in solving their own creative problems.

The Phoenix Villa
at the
World's Columbian Exposition

THE Centennial International Exhibition touched off a series of fairs that more or less were modeled on the show at Philadelphia. Within the decade displays were held at Boston, Saint Louis, Denver, Atlanta, Louisville and New Orleans, and Japan was represented at some of them. For example, plans for the Southern Exposition at Louisville opening in 1883 called for a "Japanese Village."[1] Of special interest was the Japanese exhibit on education at the New Orleans World's Industrial and Cotton Centennial Exposition of 1885,[2] since at that time Japan had the highest literacy rate in the world. As the 400th anniversary of the discovery of America drew near, there was considerable rivalry among several cities to play host to the forthcoming exposition commemorating the event. By the summer of 1889 New York, Washington, Saint Louis and Chicago had committees at work promoting their interests. In the following April Congress passed an act selecting Chicago for the fair site, and all energies then converged on the city at the south end of Lake Michigan. The fair was to be known as the World's Columbian Exposition.

The choice of Chicago was significant as an indication of the decentralization of the early cultural leadership of the East Coast. America was growing westward, and growing with amazing rapidity. Chicago, which took its name from an Indian phrase meaning "wild-onion river," started off as Fort Dearborn built in 1803, but the real development of the community got under way during the 1830's. The location of Chicago as a crossroads was favorable to commerce, and after the advent of railroads the city mushroomed phenomenally. Soon it was reaching upward as well as outward, and by 1890 Chicago had become the home base for the tall building (later called the skyscraper), which became America's most distinctive contribution to world architectural types. Less than a century after its founding Chicago had a population of 1,100,000 and its enterprising spirit gave promise of continued expansion. Chicago embodied what was considered the essence of the New World, and being situated in the middle of the continent, a more appropriate place or a better location could not have been determined upon for the celebration of the founding of the white man's civilization in America.

Congress provided for two committees to manage affairs pertaining to the fair. One committee was responsible for the designing and construction of the buildings and their maintenance; the other was entrusted with the custody and care of exhibits and all communications with foreign and domestic exhibitors. The fairground site was the 600-acre Jackson Park, fronting on Lake Michigan. Here a grand and imposing layout was planned with great edifices grouped around the main Lagoon and several lesser basins. The architectural theme of the fair was fathered by Daniel H. Burnham of Chicago and upheld by Charles A. Atwood, who had been appointed Designer-in-Chief, and was approved by the various architectural firms assigned specific constructions.

The buildings were to be cast in the pure classic, or Neo-classic style, employing the familiar design vocabulary of columns, entablatures, arches, vaults and domes, the group unified

by a gigantic architectural order sixty feet in height. The walls (mostly of plaster) were painted to resemble marble, and when illuminated by electricity at night, the startling effect gave rise to the popular designation of the fair as "The White City." The selection of the most conservative style for the external dress of the exhibition buildings seems rather at odds with the progressive outlook of the adjoining city; or perhaps it was that Chicago felt a bit self-conscious about still being an overgrown frontier town. Anyway, as regards design, the palatial facades had very little to do with the exhibition halls they enclosed. Interiors were strictly utilitarian, having exposed skeletal framework, providing space for displaying samples of arts, crafts, agriculture, horticulture, forestry, machinery, mines, transportation, electricity, anthropology, animal husbandry and fisheries. Daniel Burnham himself defended the architecture of the World's Columbian Exposition on the basis that, being classic, it was therefore "correct." He is recorded as having said: "The intellectual reflex of the Exposition will be shown in a demand for better architecture, and designers will be obliged to abandon their incoherent originalities and study the ancient masters of building."[3] Louis Sullivan, designer of the Transportation Building with its famed Golden Doorway, the only exhibition hall at the fair showing a departure from the rigors of classicism, took leave to differ with Burnham's opinion. Sullivan considered the phrasing, "incoherent originalities," the babbling of a decadent mind unable, or unwilling, to grasp progress; and he looked upon the choice of style for this important assembly of buildings as perpetrating a serious setback to the evolution of American architecture. His famous comment on the subject was: "The damage wrought by the World's Fair will last for half a century from its date, if not longer."[4]

Relief from the pretentiousness of the general exhibition halls was provided by the smaller regional constructions—the state and foreign buildings. Most of them were grouped alongside and back of the Art Gallery, but a notable exception was the Japanese exhibit located on Wooded Island in the Lagoon (§56). In size and architectural meaning it offered a sharp contrast to the United States Government Building, which it faced across the expanse of water to the east, or the vast Manufacturers and Liberal Arts Building, a corner of which is to be seen south of the U.S. Government headquarters. The Nippon group was a serious and straightforward piece of architecture that avoided the pomposity of the great halls on the one hand and the quaintness of most of the imported examples on the other. Its revealed structural members provided pleasing aesthetic harmonies requiring no additional architectural clothing.

Like the Japanese Dwelling and Bazaar at the Philadelphia centennial, the Japanese building at the Chicago fair was transported in pieces from the Far East. The designer was Masamichi Kuru, the Government Architect and a graduate of the Imperial University, who had been occupied mostly planning school buildings in his native land. As at Philadelphia the structure was erected by Japanese workmen. The model for the Chicago exhibit was the mid-eleventh-century Hōō-dō, or Phoenix Hall, of the Byōdō-in at Uji, near Kyoto (§58). The Hōō-dō was built on a diminutive island and was in the form of the legendary phoenix bird with outstretched wings and a long tail that bridged the narrow channel to the mainland. The placid water of the lake in front reflected clouds, thus creating the illusion that the building was the actual bird in flight. The phoenix was believed to transport souls to the Western Paradise of Amida Buddha, whose image, carved by the sculptor Jōchō, was given the place of honor in the main shrine. The Hōō-dō was built by the Regent Yorimichi when he entered religion. Its imaginative association with the mythical bird was entirely original, and for this reason it has been proclaimed the first important monument showing indigenous Japanese genius. Its predecessors had been built after, or at least were primarily influenced by, buildings in China or Korea. Through its archetype the Japanese building on Wooded Island partook

of a fine distinction that set it apart from the two structures built fifteen or sixteen years earlier in Fairmont Park.

The Chicago version of the Phoenix Hall was called the Hōō-den, or Phoenix Villa, signifying that it was modified from a building for sacred use to one of secular or domestic purposes. The axial gallery of the original Hōō-dō was omitted, the main hall was divided into rooms, and the terminal pavilions were enclosed (*§57*). The three units had elevated floors with encompassing platforms sheltered on the outside by the deep eaves of *irimoya* roofs. Railings protected the platforms and stairways centered on each principal side. Timber framework and wall areas filled in with plaster were left unpainted, and the roofs were covered with sheet copper. It was a harmonious composition; the bold roofs with their subtly curving horizontal lines seemed to float over the airy framework put together with exquisite joinery. Each of the three pavilions was treated in the style of a different period of Japanese history.

The north wing was in the manner of the Fujiwara era (980-1185), its features taken from those of the archetypal hall at Uji and the Imperial Palace at Kyoto. It contained a single room. The outermost (north) wall was stationary and covered with paintings, and the ceiling was partitioned into segments filled with relief carvings representing flowers and birds. Appropriate to the period, posts were round instead of square. Ornamental doors were in the innermost front corner bay and opposite the stairs descending to the connecting pergola. The other openings were equipped with *shitomido*, or shutters hinged at the top, that opened outward and could be hooked to the rafters when so desired. *Misu*, a roll blind made of split bamboo suspended from above, also was much used during the Fujiwara Period for obtaining light and air while maintaining privacy.

The south pavilion was in the style of the Ashikaga Period (1333-1568), an age which enjoyed a cultural resurgence prompted by Zen Buddhism and influences come from the brilliant Sung Dynasty in China. At that time Europe was in the throes of the Renaissance, among the chief events of which was the landing of Columbus in America. The second pavilion of the Hōō-den was the exact size of the first, but it had square posts, and sliding *shōji* rather than hinged *shitomido* (*§59*). The interior was a reproduction of the Ginkaku, or Silver Pavilion, built near Kyoto by the Shōgun Yoshimasa in the middle of the fifteenth century. The pavilion at Chicago contained three rooms, a library or reception room occupying the front half of the structure, a square tea room, and a narrow annex behind. The two main rooms were separated by sliding *fusuma*. They featured alcove recesses on one wall, and had *tatami* on the floor (*§60*). The *kakemono*, or scroll paintings, in the library *tokonoma* were by the master Sesshū. Both rooms were of the utmost simplicity, the library being for study and meditation, and the tea room the setting for the restrained *cha-no-yu* (tea ceremony). Other than the few art objects placed on the platforms or shelves of the alcoves the only "furnishings" were the utensils for the *cha-no-yu* displayed in the tea room (*§61*).

The large central hall reflected the taste of the Tokugawa Period (1615-1867). It was portioned into two main connecting rooms, flanked by passages, and had a long vestibule across the front. Small square rooms were attached to the outer sides of the two passages. The décor of the Tokugawa Period was more elaborate than that of the preceding Ashikaga era. The axial suite duplicated an interior in Edo Castle at Tokyo that had been designed for Ieyasu early in the seventeenth century. The *jōdan-no-ma*, or innermost room, was a sitting room for the prince; its floor was raised above that on which the attendants waited. The walls and ceiling were enlivened with paintings of phoenixes, flowers, fruits and clouds, and carved *ramma*. Alcoves spanned the west end of the suite and a single recess was adjacent to them on the left side. The square room in the south arm of the main hall was the *shosai*, or library.

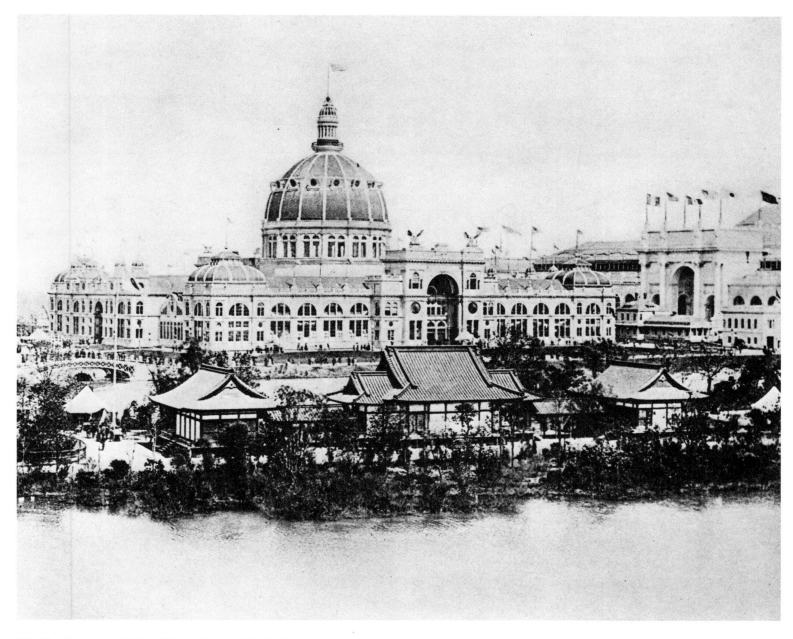

§56. *The Japanese exhibit on Wooded Island, World's Columbian Exposition, Chicago.*
(Witteman, The World's Fair, Chicago, 1893, *New York, 1898.)*

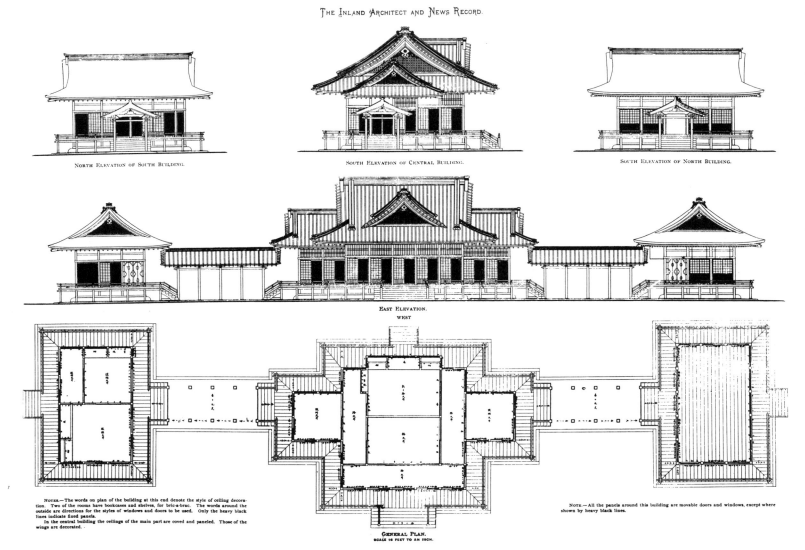

§57. *Elevation and plan of the Hōō-den or Phoenix Villa, Chicago, M. Kuru, architect.* (The Inland Architect and News Record, *December, 1892.*)

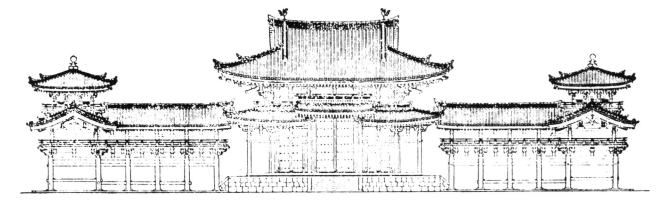

§58. *Elevation of the Hōō-dō or Phoenix Hall of the Byōdō-in at Uji.* (Sansom, Japan, A Short Cultural History, *New York, 1943, p. [252].*)

§59. *South pavilion of the Hōō-den, Chicago.* (Inland Architect. . . , *October, 1893.*)

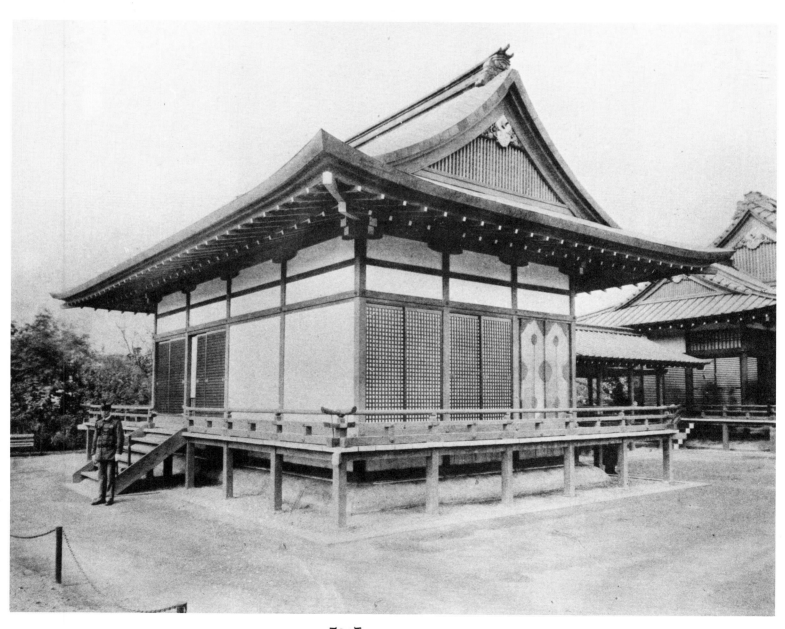

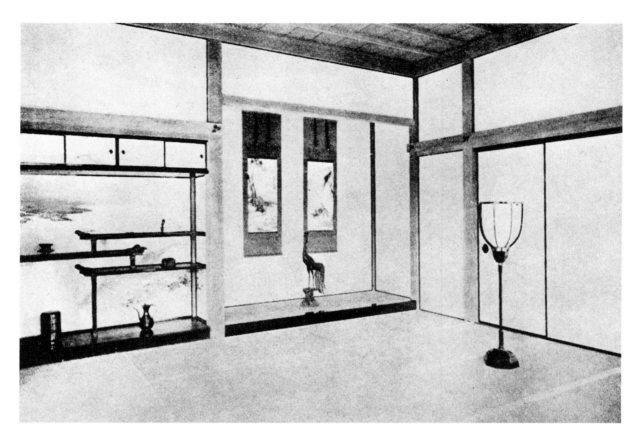

§60. *The library or reception room in the South Pavilion of the Hōō-den. (Okakura, The Hōō-den. . . , Chicago, 1893, p. 21.)*

§61. *Tea room in the South Pavilion of the Hōō-den. (Ibid, p. 21.)*

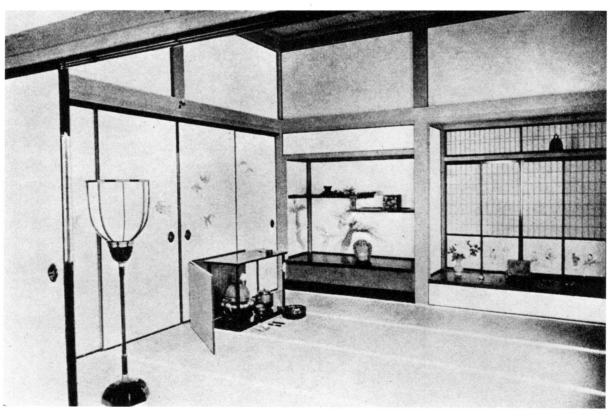

Here, on the walls and *fusuma*, students of the Tokyo Fine Arts School had represented a stream with floating fans painted in minute detail. The *kon-no-ma* (serving room) opposite was similarly decorated. As in the south wing these rooms received diffused light through the *shoji*.[5]

The Hōō-den was estimated to have cost $100,000. At the close of the fair it was presented to the city of Chicago and maintained as a museum and tea garden. The building was completely rehabilitated and landscaped in 1935. Unfortunately, one of the pavilions burned in June, 1946. The other two were damaged by fire four months later and had to be demolished. In addition to the exhibit on Wooded Island, Japan was well represented by sections in the great halls, including Fine Arts, Horticulture, Agriculture and Mines. There was also a Japanese pavilion on Columbia Avenue at the Manufacturers Building, and a Japanese village on Midway Plaisance, though the latter was not given official recognition by the Japanese government.

Other buildings retained after the fair were the Fine Arts Gallery, which became the Field Museum of Natural History and later the Museum of Science and Industry; the German Building, converted into a refectory; the Lo Robida Convent, near the yacht harbor, used as a sanitarium for children; and the Cahokia Court House, an early eighteenth-century building of vertical-log construction, re-erected on Wooded Island for the celebration and returned to its original site in 1939.

The Hōō-den at the World's Columbian Exposition was a more significant and elegant specimen of architecture than the Japanese buildings at the Philadelphia Centennial Exhibition. It was a symmetrical composition of three pavilions, each one displaying the distinct style of a period of Japanese art and architecture—the archaic Fujiwara, the restrained Ashikaga, and the opulent Tokugawa—in all representing almost a thousand years of Japanese development in design. The excellent proportions, superb craftsmanship, sensitive roof curves and structural honesty of the Hōō-den set it apart from the surrounding hulks that concealed prosaic exhibition halls behind sham marble fronts. Although most of the visitors to the fair were awed by the size and ostentation of the bleached piles, among them were those who could appreciate the fine points of the Japanese group. As Sullivan noted, the main theme of the fair acted as a retardation to American architecture by sidetracking it onto a threadbare classic tangent. Mausoleums provided dubious models for Americans about to build. The Japanese Phoenix Villa demonstrated that a building could be unmasked and beautiful, human in scale and appealing, that good workmanship showed to better advantage on the actualized building than on the drawing board, and that architecture—real architecture—need make no apologies for its use of simple, everyday materials. It spoke a word of truth that offered a guiding light for those who looked to the future. The Hōō-den remained standing after the fair for half a century, and during this interim exerted an influence upon several generations of American architects and designers.

CHAPTER NINE
Japanese Influence
upon the
Chicago School

THERE was something prophetic about the little Phoenix Villa's remaining intact while the monstrous exhibition halls around it were being razed following the close of the fair. For the moment the vast forms seemed to be sinking back into ruins out of which, figuratively, they had risen. Their inherent connection with the dead past was becoming a reality. The Hōō-den, on the other hand, did not belong to a bygone age, but to the eternally living present. Its merits bore close, discerning inspection, and what was learned from them could be applied to current building problems. Architects from all over America inspected the structure during their tour of the fair, yet it was the Chicago group that benefited from the Phoenix Villa most, being able to return for a close study of the structure on repeated occasions, even long after the exposition was no more.

A forward-looking titan like Louis H. Sullivan (1856-1924) would be expected to adopt certain elements from the Hōō-den in his work, and indeed he did. Sullivan's houses postdating 1893 stressed horizontal lines; windows were arranged in banks, roofs were low and widespread, and thin timbers were embedded in plaster surfaces, though not always having a structural significance as with the Japanese. At least one architect from the classic camp sometimes indulged in a Japanese diversion (we have already noted the McKim, Mead and White house at Elberon, New Jersey), which seems a bit extraordinary when the person in question was none other than the procreator of the fair theme, Daniel H. Burnham. Burnham met his client, General Henry C. Corbin, while working on a project in Manila, which, at that time, was reached by steamer via Japan. They became close friends, and upon the general's retirement he commissioned Burnham to design a home for him in Chevy Chase, Washington, D.C. The house that was built in 1907 was called Highwood.[1] It was composed of a two-storied main block crowned with deep horizontal eaves that gave an *irimoya* effect to the gabled roof. Single-storied wings were attached to the sides, and a modified half timbering articulated the stucco walls.[2] Burnham's design bore a slight resemblance to Bruce Price's Japanese cottage in Tuxedo Park, but was remarkable primarily for its stylistic departure from the architectural persuasion of the designer. Highwood burned in 1923 and its site became part of a subdivision.

The foremost architect of the Chicago School was Frank Lloyd Wright (1869-1959). Wright acquired the training of an engineer—not the usual education of an architect in those [days]—at the University of Wisconsin. He came to Chicago in 1887 and apprenticed first to [J. L.] Silsbee, who, an enthusiast over Oriental art, had a *kakemono* hanging to the right of his [living] room fireplace, and a large gilded image of a Lamaist Bodhisattva and a pair of porcelain [vases] on the mantel in the hall of his home. A delicate treatment of the beams in this hall [suggests] the Japanese.[3] Before the beginning of 1888 Wright transferred to the office of [Dankmar] Adler and Louis Sullivan, becoming the disciple of the "Lieber Meister," as he [called] Sullivan. This association likewise was not adverse to an appreciation for things Japa[nese. From] Louis Sullivan, Frank Lloyd Wright and others of his generation acquired the

[84]

principle which Wright called "organic architecture," and defined as "an architecture that develops from within outward in harmony with the conditions of its being as distinguished from one that is applied from without."[4] The Hōō-den no less than any other Japanese building, exemplified the principle of organic architecture. Wright's background, as regards his schooling and apprenticeship, opened his eyes to the gross artificialities of the prime architecture of the fair and equipped him for a sympathetic appraisal of the little Phoenix Villa, and for Japanese art in general. He saw and admired the display of Hokusai and Hiroshige prints at the exposition, and later testified: "It was my own stuff." Wright began collecting *ukiyoe* around 1900, because, he said, "Japanese prints taught me much.... Japanese art and architecture...have organic character. Their art...[is] more nearly modern...than [that of] any European civilization alive or dead."[5]

In 1893, the year of the World's Columbian Exposition, Frank Lloyd Wright left Adler and Sullivan to practice independently. He had been entrusted with much of the detailing of buildings and some designing during his six years with the firm, and gained additional experience through free-lance work. His first independent projects reflected in turn the manner of Silsbee and then of Sullivan; but some of the work that Wright handled while still in Sullivan's employ (such as Sullivan's own summer house at Ocean Springs, Mississippi) bore an impress that was Wright's own. His style had begun to mature before he launched his solo career. In 1895 he designed a residence for Chauncey L. Williams at 520 Edgewood Place, River Forest, Illinois. The house showed Japanese picturesqueness in its steep roof and an emphasis upon horizontal lines in the lower part, with irregular boulders set against the base

§62. *Perspective sketch of the B. Harley Bradley and Warren Hickox houses at Kankakee, Illinois, Frank Lloyd Wright, architect.*

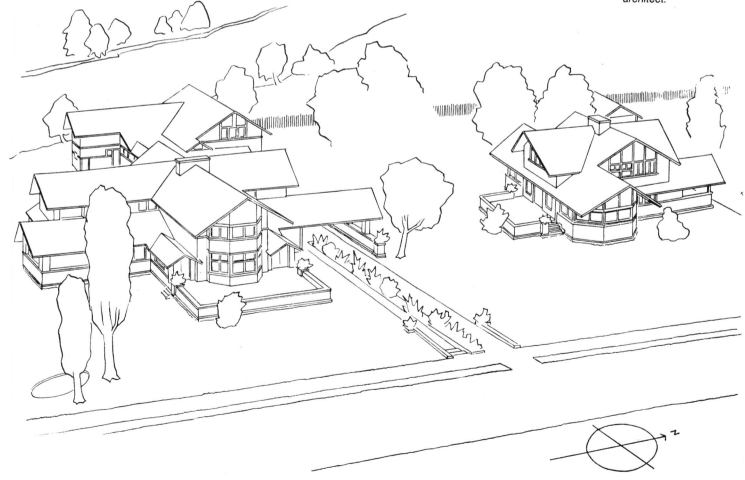

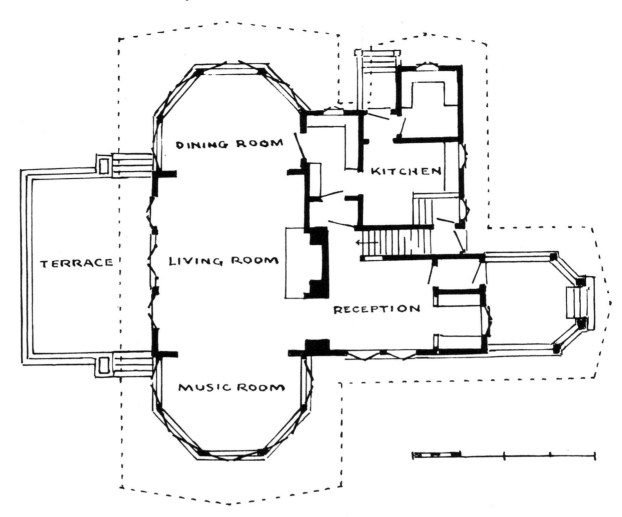

§63. *Plan of the first floor of the Hickox house, Kankakee.*

of the walls purely for decorative effect.[6] The proportions of short walls to high roof gave the house the look of a farmhouse in a Hokusai woodcut print.

Within the next few years Wright's Japanese influence shifted from a pictorial to an architectural character. In 1900 he was given commissions for two houses to be built at the south end of Harrison Avenue in Kankakee, Illinois, on property bounded by a curve in the river from which the town derives its name. The larger house was for B. Harley Bradley and the smaller house was for his brother-in-law Warren Hickox *(§62)*. In actuality the two houses are a little farther apart than indicated in the sketch. They are Japanese in their intimacy with nature, inconspicuous entrances, and asymmetrical massing, as well as in the plastered terrace walls with wood copings, slender timber bands in stucco on the vertical planes of the houses, and reduplication of deep obtuse gables, which are thin and thrust outward at the peak as in some Shintō shrines, a type known in Japan as *kirizuma (§66)*. The driveway in the foreground of the photograph leads under a *porte-cochère* into a service court. The unit for cows, horses and hounds at the back is connected to the main house by a covered passage.

The leading in the windows had some affinity to Eastern latticework, but it also harkens back to the architect's infant training under the Froebel system, whereby the child learns through playing with geometric devices. Color was mixed into the plaster before it was applied to the interior walls, as in a Japanese house, setting the note for muted tonal schemes. The furniture—mission in style—was designed by Wright and executed by L. and J. G. Stickley, making for design unity throughout the rooms.

The Hickox house has the simpler plan. It is made up of a long suite of three rooms—dining room, living room and music room—toward the river side, the centermost opening out on a terrace; and the balance of the first floor is divided into an entry, kitchen and service room (§63). In substance this is the general layout of the typical Japanese house, as indicated by the plan from Morse's book (see §48). Being one-storied, a room used exclusively for sleeping was included in the Nipponese example.

In 1901 Wright designed a frame residence, Penwern, for the Fred B. Jones estate at Delevan Lake, Wisconsin. The house is a rambling two-storied affair, one wing with an open porch on the second floor over a wide arch bridging the carriage drive, and a small gabled turret at the end. The structure resembles a fortified city gateway in the Far East, which resemblance is even more pronounced in another structure down the hill at the edge of the lake; a boat house, fifty feet long and half as wide. The boat house also is frame, its battered walls covered with weatherboards above, flush boards with horizontal stripping below, and set on a boulder podium (§65). The deck is sheltered by a gently-pitched roof with wide eaves supported on four square piers and eight posts (§64). The gables slope outward at the apex, like those of the Kankakee houses. A gangway descends from the deck to the dock, where a shed extends out from the podium, and a wharf continues farther into the water. The individual members of the residence and boat house at Penwern are somewhat gross, having been left to the builder without supervision by the architect.

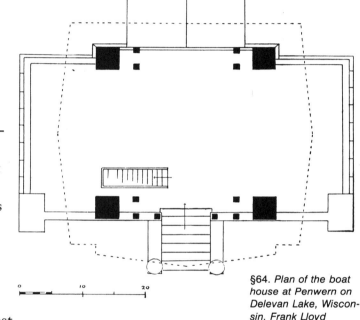

§64. *Plan of the boat house at Penwern on Delevan Lake, Wisconsin. Frank Lloyd Wright, architect.*

Frank Lloyd Wright briefly visited Japan in 1905. The trip was in pursuit of the Japanese print but Wright's interest

§65. *Sketch of the boat house at Penwern.*

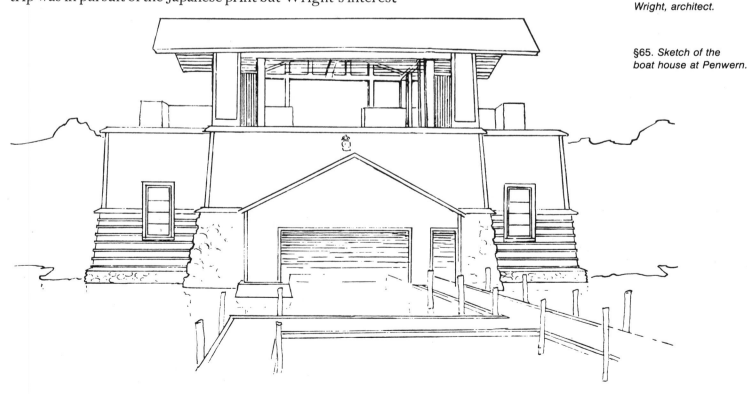

quickly shifted. "I saw the native home in Japan as a supreme study in elimination—not only of dirt but the elimination of the insignificant. So the Japanese house naturally fascinated me and I would spend hours taking it all to pieces and putting it together again. I saw nothing meaningless in the Japanese home and could find very little added in the way of ornament... [the equivalent of ornament being achieved] by bringing out and polishing the beauty of the simple materials they used in making the building...and strangely enough, I found this ancient Japanese dwelling to be a perfect example of the modern standardizing I had myself been working out. The floor mats, removable for cleaning, are all three feet by six feet. The size and shape of all the houses are both determined by these mats. The sliding partitions all occur at the unit lines of the mats...[and the] polished wooden posts...all stand at the intersection of the mats." Wright found even the utility rooms pleasant: "And the kitchen? Go down several steps to find that, for it is tiled flat with the ground and also goes high up into the rafters for ventilation. It is like a cool, clean, well-ventilated studio. Its simple appointments are of hand-polished concrete or fine hard stone. The kitchen is hung with a collection of copper kettles and lacquer-ware that would drive a Western collector quite off his head, and often has."[7] Frank Lloyd Wright liked the Japanese way of life that was enacted in these buildings; he liked sitting on the floor, and he liked the easily adjusted, loose Japanese clothes. It is interesting that after he went to Japan the tall, straight-backed chairs he had used disappear in favor of low seats. To Wright the elimination of the insignificant was grace and purity. That houses were planned from the inside out confirmed his conviction that the Japanese system was superior to the traditional method in the West. The Japanese related to Wright's concept of organic architecture, and he remarked in 1908 that in the Japanese language "there are many words like the word 'edaburi,' which, translated as near as may be, means the formative arrangement of the branches of a tree. We have no such word in English; we are not yet sufficiently civilized to think in such terms, but the architect must...learn to think in such terms...." Life is the essence of all art in the Far East. Frank Lloyd Wright had come to recognize the fact in Japanese prints and then in architecture, and it corresponded with his own first rule, namely that "buildings perform their highest function in relation to human life within and the natural efflorescence without...."[8]

Nowhere is organic architecture expressed more fully than at Taliesin, Frank Lloyd Wright's own house and studio. When Wright returned from Europe in 1911 he was determined to move out of the Chicago suburbs to the family home site near Spring Green, Wisconsin, where already he had erected a residence in the Silsbee manner for his aunts, the Misses Lloyd Jones (1887), the "Romeo and Juliet" windmill (1896), and the Hillside Home School (1902), later remodeled into part of the Taliesin Fellowship group (1933). The name of his new home, Taliesin (meaning "Shining Bow") came from the hero of an old Welsh epic. Establishing his headquarters at Taliesin signaled Wright's metamorphosis from an architect of the Chicago School to one maintaining an international practice. It was here the first drawings were prepared for the Imperial Hotel, begun in Tokyo in 1916 and completed in 1922, during which period Wright also conceived and built the Jiyū Gakuen School and several houses in the same city, residences elsewhere in Japan, and projected a country hotel at Nagoya. Wright's home at Spring Green, with its hipped "prairie-house" roof, was a low rambling building of stone and wood that merges with its setting (§67). The residence proper is in a section at the east end, separated from a long wing by an open loggia, the wing containing a drafting room, quarters for apprentices, and carriage house, stables and dairy beyond. Taliesin has been described as wrapped around a hilltop, which is quite different from being set on the apex of a hill, in the usual American manner; and in this, its use of low forms

dominated by roofs rather than walls, the lack of distinction between door and window openings, and the similarity of treatment throughout the various parts regardless of purpose, the house is reminiscent of the Far East. Taliesin has suffered from fires on several occasions and each time it has been enlarged in rebuilding, but the character of the initial scheme has persevered.

The living quarters at Taliesin achieve a free flow of interior space through irregular room shapes, sloping ceilings, lattices permitting glimpses into adjoining areas, and built-in furniture partitioning off parts of the room (§68). The structure in the right foreground of our view terminates the long inglenook seat alongside the big fireplace. Directly in front is the dining group. The kitchen is beyond the entry around the corner on the right, and the passageway leads back to the bedrooms. Glazed doors on the left open out on a terrace affording a vista over a stream and rolling hills beyond. One is struck by the quantity of Oriental art at Taliesin. It is not merely put on display, as in the Knapp house—nor is it an imitation of Oriental forms, as in the mantelpiece and cabinets of the Williams Japanese Room in Philadelphia. It consists of genuine objects incorporated into the décor. A painted screen is set into the wall behind the dining table, a carved Buddha becomes a finial to a post penetrating a horizontal slab of table height, prints are raised on special easels, and glazed ceramics lend touches of color. Furniture forms are kept low. Plastered walls are tinted, rather than painted, and wood is left natural. The plan of the Taliesin living room has remained substantially the same, but alterations after the various fires have developed the planes and space concept of the upper reaches of the room.

In 1912 Frank Lloyd Wright began the design of a house for Francis W. Little, Jr., to command a superb site overlooking Lake Minnetonka at Wayzata, Minnesota. The building of Northome, as it came to be called, started the following year. As originally conceived, it was to have had an arcade across the facade of the living-room pavilion, and banded windows under the eaves of the long, low bedroom wing, which contained dining room and kitchen on the lower level. During the course of construction Wright went back to Japan to start work on the Imperial Hotel. As Northome developed, the Italianate arcade of the main block was deleted and the living room acquired the articulation and airiness of a hall in a Japanese temple (§69). Although the living room is rather lofty it maintains a livable scale through the horizontal projections that cut across and encircle the top of the fenestration. Windows are along both sides, and one presents a view across the lake. Wood strips form patterns on the ceiling and enframe a skylight that is electrically lighted at night. Northome was completed in 1918 and furnished with pieces designed by the architect, some of which remain, mixed with later additions. Among them is a Chinese *k'ang* in the corner at the fireplace end of the room.

Frank Lloyd Wright was certainly the most colorful figure of the Chicago School, and he undoubtedly will go down in history as the most dynamic and creative architect of the group; but it is not to be forgotten that there were others who would have become more famous had they not been so much overshadowed by the brilliance of Wright. Some of these people, at one time or another, were associated with Wright, such as Walter Burley Griffin, Marion Mahony, and Herman V. von Holst. Walter Burley Griffin worked in Wright's office, and his houses reflected strong horizontals, prominent low-pitched roofs with gables thrust outward, and distribution of rooms similar to Wright's designs. These characteristics are shown in the F. B. Carter and Hurd Comstock houses at Evanston, Illinois.[9] His most pronounced Japanese influence figured in a sketch for a long two-storied residence labeled "A House in the Spirit of the Times," reproduced in the May, 1913, issue of *Country Life in America* (*pp. 38-39*). Griffin's wife, Marion Mahony, also was an architect, who worked on several proj-

ects with Herman V. von Holst. One was the D. M. Amberg house at Grand Rapids, Michigan, for which Frank Lloyd Wright had started preliminary drawings but had turned over the project to von Holst upon his departure for Europe in 1910. The brick-walled, tile-roofed L-shaped Amberg house is raised on a terraced corner lot, its entrance being through a channel leading to the basement level.[10] Also by von Holst and Mahony were the Adolph and Robert Mueller two-storied dwellings in Decatur, Illinois. The first had an L-plan and gables like the Amberg house, whereas the second was more compact and had a hipped roof.[11]

An active Chicago architect, whose early work had been tight and picturesque (as in his own home at 424 Warwick Road, Kenilworth, Illinois, built 1893), but whose later designs showed the liberating influences of both Sullivan and Wright, was George W. Maher. Some of his mature endeavors were also decidedly Japanese. One of Maher's finest essays was the Village Hall at Kenilworth, completed in 1907. The building is long, low and narrow, with extended eaves to its gently sloping hipped roof. Vertical timbers in sets of threes alternating with tall windows in the stucco wall suggest the Art Nouveau style. The entrance is in a brick-paved recession, where a pre-existing elm tree penetrates the overhead trelliswork (§70). Tall lanterns on brackets provide night illumination. The Japanese touch here tends to lighten the architect's normal heavy-handedness. Inside, washrooms were placed beyond the vestibule; on the right was a small library, with adjoining kitchen, and on the left a large assembly hall, with a stage across the far end. Later the entrance terrace was enclosed, but the elm continued to flourish, jutting through the roof.

Other contemporary members of the Chicago School who produced buildings of kindred character include Arthur Heun, author of the self-consciously Japanese-type country house at Des Moines, Iowa[12]; Robert C. Spencer, Jr., who did the A. Magnus house at Winnetka, Illinois[13]; Richard E. Schmidt, architect of the Charles Thorne house at Winnetka, Illinois, who sometimes joined forces with Garden and Martin, as on the large vacation house built at Glencoe, Illinois[14]; and Tallmadge and Watson, designers of Marigold Lodge on the Egbert H. Gold estate at Holland, Michigan.[15] Another team keeping abreast of the times was Louis Gunzel and William Drummond. They professed a great love for nature, but it was usually suppressed under paved outdoor courts incorporated in stucco or concrete constructions. However, in planning a home for aged persons of Danish descent, their ideal came to full fruition, at least on paper. They collaborated with the landscape architect Jens Jensen, and achieved a delightful effect in which three low pavilions, connected by pergolas, clung close to the ground and intermingled with the planting (§71). The layout was Japanese in all essentials, with tangible indebtedness to the Hōō-den. The domestic scale and intimacy with nature would have been a source of much pleasure to the elderly people assigned to such a home; but the directors evidently considered the design impractical and in its stead had erected a blocky, red-brick colonial-style building, cold and institutional in character.

The Chicago house was not confined to the lakes area; it spread across the breadth of America. A typical example on the West Coast was the Charles H. Clarke residence at The Highlands, near Seattle, Washington, designed by Willatzen and Bryne.[16] On the Atlantic seaboard an outstanding—yet modified—version appeared on Juniper Point at Woods Hole, Massachusetts, the work of Purcell, Feick and Elmslie. William Gray Purcell, a graduate of Cornell University, who had apprenticed to Sullivan, established an architectural practice with George Feick at Minneapolis in 1906, and three years later they were joined by George Grant Elmslie (also Sullivan trained), after which they maintained a branch office in Chicago. The firm believed in a functional approach to architecture but also indulged in romantic overtones. Their "Bungalow on the Point" was built in 1911 on the Charles R. Crane estate for

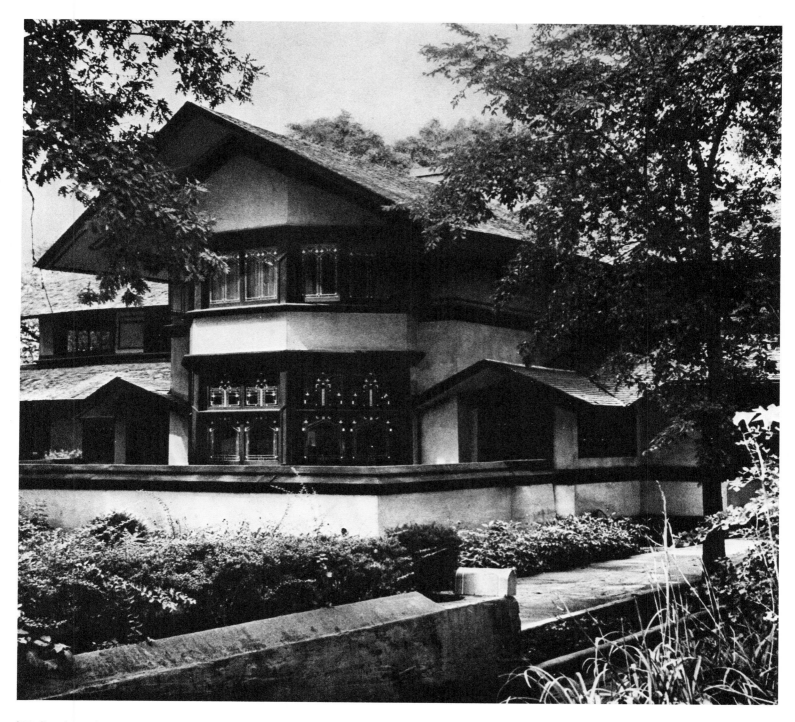

§66. *East front of the Bradley house, Kankakee.*

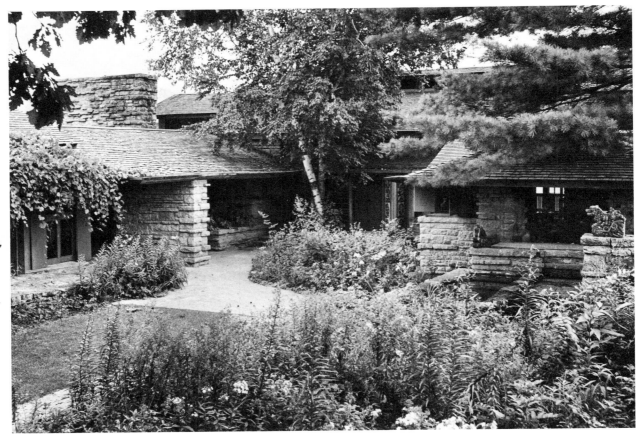

§67. *Exterior angle of the living quarters at Taliesin, Spring Green, Wisconsin. Frank Lloyd Wright, architect.*

§68. *The original living room at Taliesin.* (The Architectural Record, *October, 1911, p. 395.*)

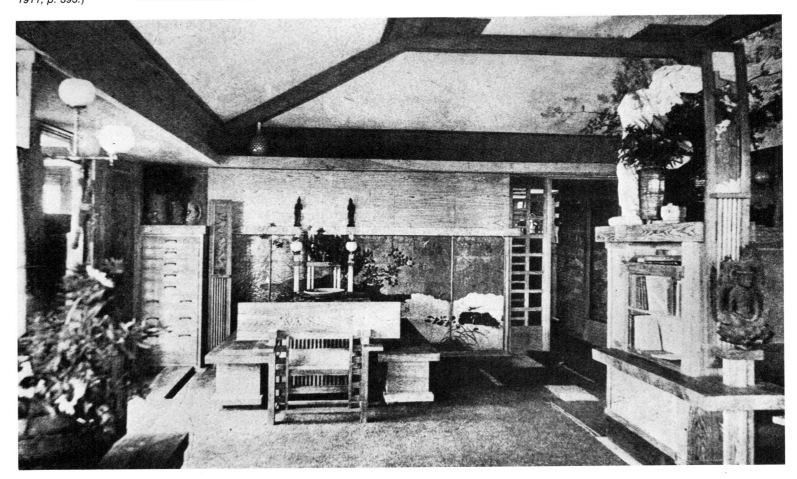

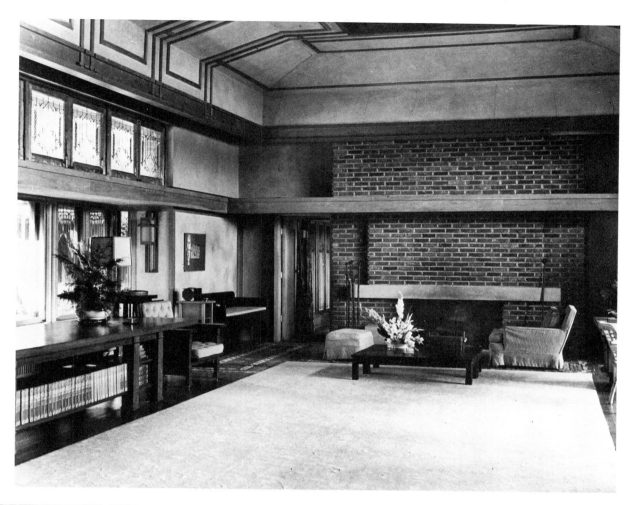

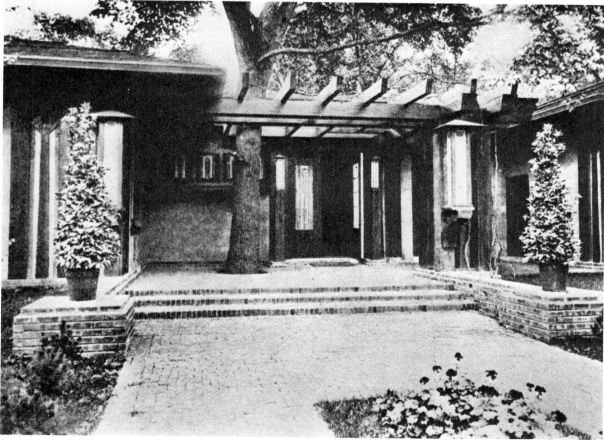

§69. *The living room at Northome, Wayzata, Minnesota. Frank Lloyd Wright, architect.*

§70. *Entrance detail of the Village Hall at Kenilworth, Illinois. George W. Maher, architect.* (The Inland Architect and News Record, *October, 1907.*)

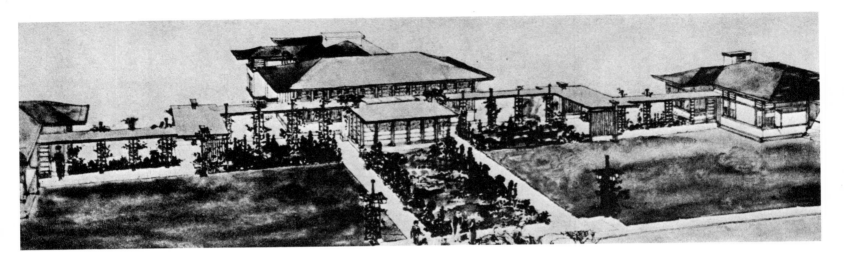

§71. *Perspective sketch for the Danish Old Folk's Home, Gunzel and Drummond, architects.*
(The Western Architect, *February, 1915, detail of Pl. XII.*)

§72. *"The Bungalow on the Point," Woods Hole, Massachusetts. Purcell, Feick and Elmslie, architects.*

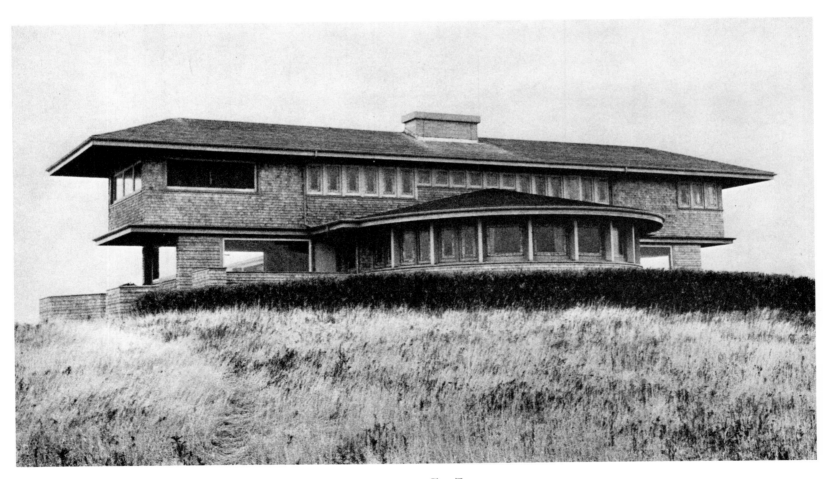

the client's daughter and son-in-law, Dr. and Mrs. Harold C. Bradley. The bungalow at the base of Cape Cod was endowed with a superb sea view on three sides. It had several traits in common with traditional New England architecture of the seventeenth century, such as the massive central chimney, leaded casement windows, overhanging ends and shingle siding; but it also departed radically from local orthodoxy through its T-plan, rounded living room, and the extreme projections of the second story and prairie-house roof (§72). The Midwestern features caused a storm of protest among conservative neighbors. Yet these features were not without precedent here; the living-room bow was prompted by the view, and the upstairs

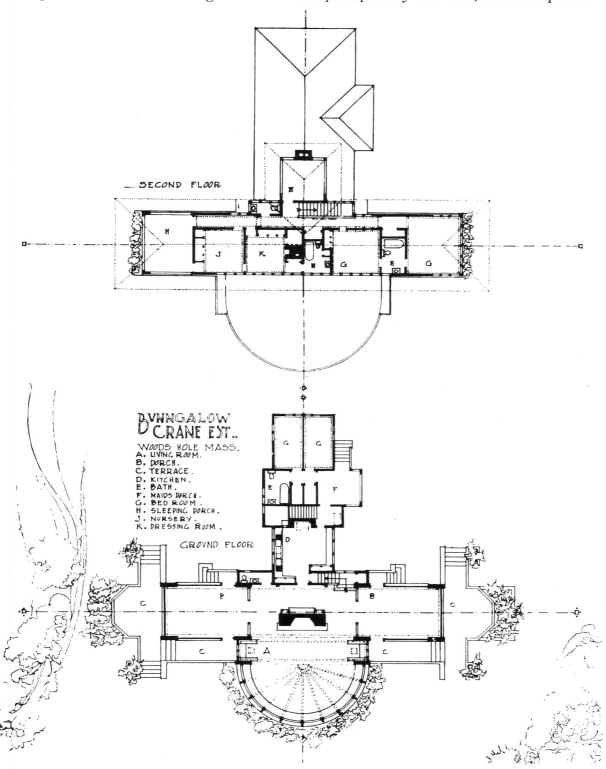

§73. *Floor plans of the "Bungalow on the Point."* (The Western Architect, *January, 1913.*)

cantilevered spaces served as sleeping porches. The kitchen, service and servants' rooms were in the stem of the T *(§73)*. The T-plan had been used often by Wright, beginning with the River Forest Golf Club (1901) and the Ward W. Willitts house (1902) in Highland Park, Illinois; and it was employed by many of Wright's colleagues. It had come to be referred to as the "aeroplane plan." But in reality, its ancestor was more venerable than the airplane—the legendary phoenix, materialized long ago in the eleventh-century Hōō-dō at Uji, and reincarnated at the World's Columbian Exposition, where it entered the repertory of the Chicago School. The bungalow at Woods Hole is as original in its way as the little temple at Uji. Its readiness for flight from the crest of the promontory is as believable as the soaring of its ancestor among the clouds mirrored on the surface of the surrounding lake. A literal Japanese construction stands on Juniper Point back of the Bradley bungalow. It is an open-timber pavilion with a flaring roof sheltering a large Japanese bell *(§74)*.

The rapid growth of Chicago, which had prompted the selection of the city for the scene of the fair, continued afterwards. Architects and builders were numerous, and all were kept busy constructing much-needed buildings. Many influences converged upon the work of these men, but it is significant that the Chicago style which developed was not at all beholden to the official architecture of the exposition; yet it was indebted in many respects to the little Japanese exhibit building. It was this transposed sample that whetted the curiosity of the leader of the Chicago School, Frank Lloyd Wright, to study Japanese building on its home soil, and indirectly offered Wright the opportunity of conceiving several important projects there. Traditional Far Eastern building and anti-traditional Western building of the Chicago group realized an affinity through their common adherence to the principle of organic architecture, though results differed in proportion to their individual requirements. A contribution of tremendous potential magnitude passed from the Island Empire of Japan to the American Midwest prairie through the importation of the Hōō-den, fanning out thence to the extremities of the United States. On the Atlantic coast it mingled with the persisting influence from the Japanese exhibits at the Philadelphia centennial, and, on the Pacific it met with another upward surge of enthusiasm that had started with the Chicago fair.

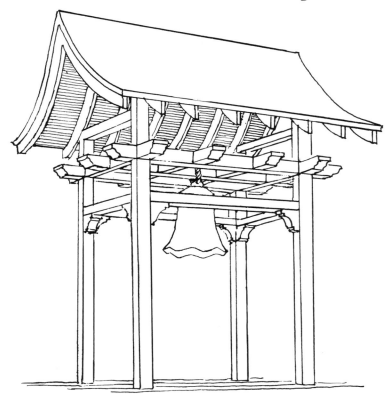

§74. Sketch of the bell tower on the Crane estate, Woods Hole.

The Japanese Village
at the
Midwinter Exposition

THE PACIFIC seaboard—especially California—was the landing place for people coming from Japan, whether Japanese immigrants or others who had become imbued enough with Japanese culture to have gone there. Compared to peoples from other lands the Japanese did not constitute a numerous colony. Only a few students, seamen and artisans skilled in special crafts had entered prior to 1882, the year the first of the Asiatic Exclusion Laws was passed; and five years later less than 1,500 Japanese were residing in the United States.[1] The majority settled close to where they first set foot on American soil, and the concentration gave rise to a local labor problem, in turn creating a series of anti-Japanese outbreaks in San Francisco, beginning in 1890. By 1900 the number of Japanese in this country was about 12,700. Before this a noticeable use of their talents was being made in gardening in California; but the cultivation of the Japanese vogue in that state was in the hands of Americans, and its inauguration can be traced to a former British subject reared in the Eastern Hemisphere.

George Turner Marsh (1855-1932) was born in Richmond, Australia, the year after Commodore Perry concluded the treaty between Japan and the United States. While in his teens Marsh left home to become a ship's cabin boy, and in the course of events he reached Japan, where he remained about five years. He learned to speak the Japanese language fluently, and acquired a knowledge of the fine points of several areas of Japanese art. Also he assembled a collection of art objects. He then embarked for America, arriving in San Francisco in 1876. In this year he opened a shop for the exclusive sale of Japanese art goods in the luxurious Palace Hotel, popularly referred to as the "Bonanza Inn" (§75). During 1876 the East Coast received its first taste of Japanese art in the official exhibit at the Philadelphia centennial, and it was appropriate that the West Coast should be given an introduction to the same field at the same time, in the emporium of the enterprising young man from Australia. G. T. Marsh and Company prospered, and its proprietor became a permanent resident of California. The shop moved to 214 Post Street in 1900. After the Great Earthquake and fire of 1906 it was located on Van Ness Avenue for a short while. It then went to the corner of Polk and California Street, and subsequently to 522 Sutter Street. Marsh expanded his business by opening two branch shops, the first at Santa Barbara in 1923 and the second at Monterey in 1928. Buildings for both were designed by a son, Hale I. Marsh, who conducted the branch at Santa Barbara. A daughter, Lucy Marsh Wickoff, was at Monterey, and another son, Lucien A. Marsh, succeeded to the management of the San Francisco store.

George Turner Marsh's first home in San Francisco was on the corner of Twelfth Avenue and Clement Street, in a district below Mountain Lake that came to be called Richmond after his birthplace. His second home was built in Mill Valley, Marin County, across the famous straits known as the Golden Gate. This house in the country was in Japanese style, and it is said that workmen were brought from Japan especially for its construction. The house burned many years later and no pictures of it are known to exist.[2]

During the mid 1880's Bruce Price, the architect of Tuxedo Park, was engaged in a commission for a large rural residence at San Mateo, California, and also drew the plans for "A House near San Francisco," the front elevation of which was dated "Oct 15 [18] 86" (§76). As in the Japanese Cottage in Tuxedo Park, the first-story walls of this project were stone, and there were plaques between the exposed timber framing of the upper part. Lattice panes filled the windows. A front porch extended into a *porte-cochère* at one end, and a service wing was attached to the opposite corner of the house. The first-floor plan was fairly conventional, containing a parlor and dining room in equal balance to left and right of a central hall in the main block, a small library and stairhall behind, and a service entry connecting to pantry, kitchen and servants' hall in the wing. Notably Japanese were the sliding screens between the central hall and adjoining rooms. On the second floor were five bedrooms, two dressing rooms and a bath (§77). A stairway ascended to the third floor, which presumably was divided into chambers for the domestics. There were eleven open fireplaces in the house and outside the tall chimney stacks cut awkwardly through the flaring roofs. Bruce Price's design may have been conceived for Marsh, though a son informed the author that the constructed residence did not correspond with these plans. At any rate they were contemporaries and both associated with the Bay Region.

A depression in 1893 caused the closing of eighteen banks in San Francisco. In an effort to facilitate a rejuvenation of business, the leaders of the community proposed holding a fair in Golden Gate Park, bringing to it some of the more interesting exhibits and star attractions (such as John Philip Sousa's band) from the World's Columbian Exposition then in progress. The proposal met with favor in Chicago, particularly with M. H. de Young, Second Vice President of the exposition and a Californian, who later became President of the San Francisco fair. De Young began soliciting foreign exhibitors, and within a month the mechanics of the project had been accomplished.[3] The California Midwinter Exposition was less ambitious than the Chicago display, but San Francisco only had a population of about 300,000, little more than one-fourth that of Chicago. Its site for the fair—a short while before a waste of drifting sand—was composed of sixty acres, or one-tenth the size of Jackson Park. Five pavilions were built to house the offices and exhibitions. They were the Administration, Fine Arts, Mechanical Arts, Manufacturers and Liberal Arts, and Agricultural buildings. Although resembling the edifices of the White City in form, the style of architecture of the California fair halls was Saracenic, with arcades of pointed or horseshoe openings, saucer or bulbous domes on axial or end pavilions, and tall flanking minarets or corner turrets. Consistent with the stylistic affiliation, the buildings were painted in rich Oriental colors. Designs were by local architects, including A. Page Brown and Edward R. Swain,[4] and the building fund of $500,000 was subscribed to largely by San Francisco citizens. The California Midwinter Exposition opened on January 27, 1894. Transportation about the grounds was provided by jinrikishas, but the convenience was accompanied by moments of ill feelings brought on by the stigma of servitude felt by the Japanese who pulled them.

One of the backers of the fair was George Turner Marsh, who also undertook to create a Japanese garden on one acre of the exposition lot. Marsh had kept in close contact with Japan through frequent visits, and having an innate interest in horticulture and gardening had made a close study of Japanese landscaping. He planned the hill-and-water garden himself, with advice from John McLaren, currently the Park Superintendent, and a Japanese authority, T. Aoki. Workmen and materials were imported from Japan, and when completed the attraction was billed as "The Japanese Village."

The "village" contained only five buildings. At one corner was a bazaar entered through a

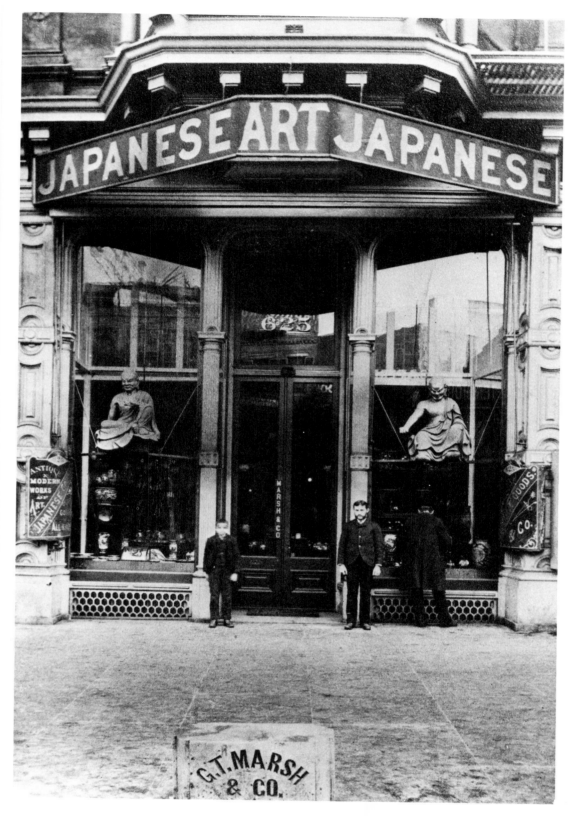

§75. *Japanese art shop in the Palace Hotel, San Francisco. (Photograph courtesy of Lucien A. Marsh.)*

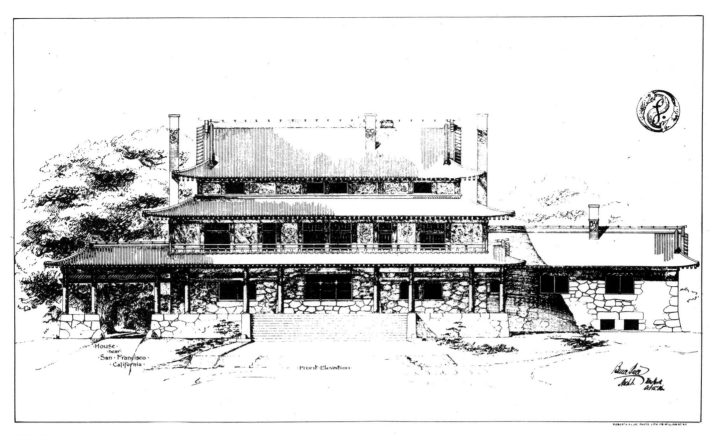

§76. *Front elevation for a ''House near San Francisco, California.''* (Building, *March 19, 1887.*)

§77. *Plans for a ''House near San Francisco.''* (Ibid.)

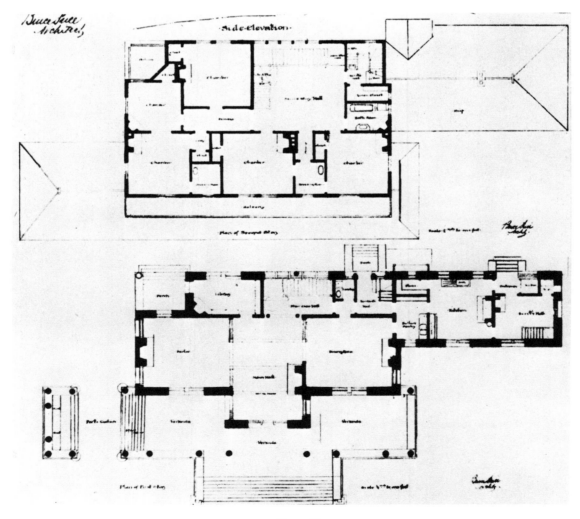

§78. *General view of the Japanese Village at the California Midwinter Exposition.*
(The Monarch Souvenir of Sunset City, *San Francisco, 1894.*)

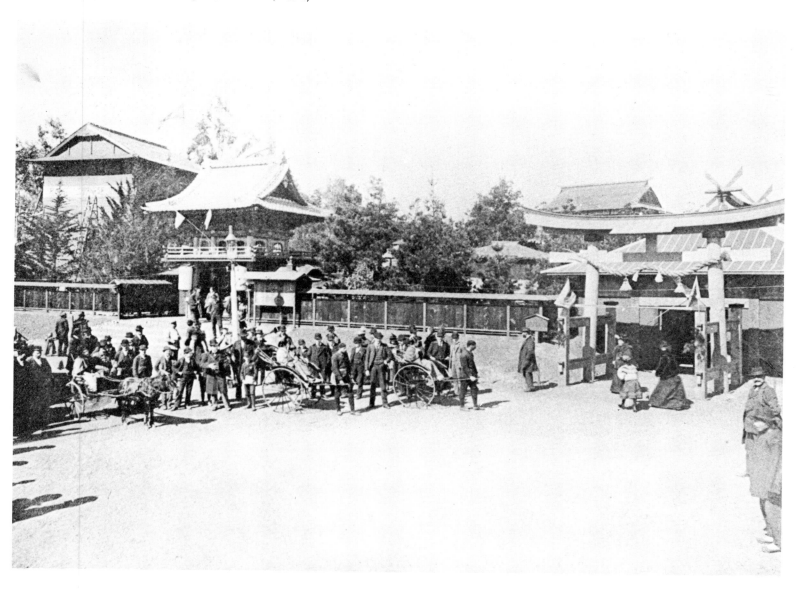

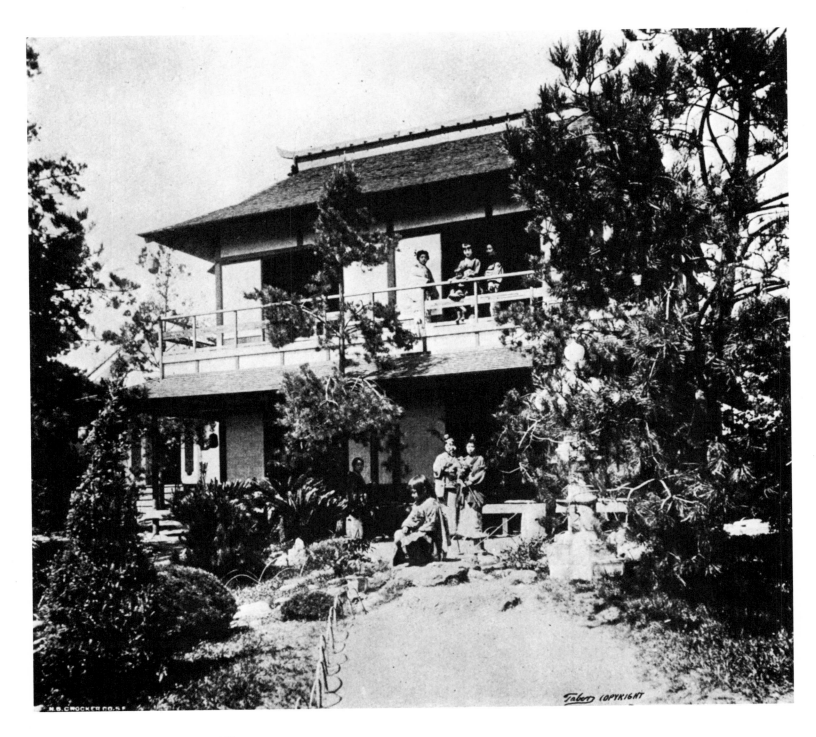

§79. *A balcony scene in the Japanese Village.*
(Official History of the California Midwinter International Exposition, *San Francisco, 1894, p. 211.*)

detached *torii* or Shintō gateway. A wooden fence enclosed the area and the main entrance was a two-storied *rōmon*, gateway, covered by a heavy tile roof (*§78*). A large frame building, visible on the left behind the gateway in the exposition photograph, served as a small theater in which Japanese acrobats and jugglers presented regular performances. A thatched-roof open tea shelter was on a line with the gateway, and at the top of a small rise stood a *zashiki*, or two-storied dwelling (*§79*). The house had *tatami* on the floor, a *tokonoma* for flower arrangements, *shōji* windows protected by solid wood *amado*, and a shingled *irimoya* roof. Other features in the garden were a wooden drum bridge and several stone lanterns. The embellishments and planting were handled in such a way as to give the garden a long-established look. The Japanese Village antedated the exotic architecture of the famous San Francisco Chinatown by more than a decade, the latter not putting in an appearance until after the earthquake of 1906.

At the close of the fair the theater was moved to the Marsh estate in Mill Valley. The bazaar and *torii* apparently did not long survive, but the improved acre otherwise intact was presented to the City of San Francisco and was henceforth called the Japanese Tea Garden. It was maintained by the Park Commission. A gift shop was established in the *zashiki*, and in 1910 the concession was turned over to Makoto Hagiwara, who brought his family to live in a dwelling added to the rear of the *zashiki*. The Hagiwaras fulfilled their obligation gracefully until the War Department relocated people of Japanese descent living on the West Coast in 1942. The garden was extended shortly after 1915 to incoporate elements from the Japanese group at the fair celebrating the opening of the Panama Canal, which was held in nearby Presidio Park, but many persons think the enlargement spoils the effect achieved by the original designer. Around the turn of the century Marsh conceived other Japanese gardens in California, among them the tea garden in Pasadena and another at Coronado (*Chapter Seventeen*), both destroyed.

The Japanese exhibit at the California Midwinter Exposition, although constructed by Japanese and made up largely of elements brought from Japan, was planned and sponsored by an American born in Australia. George Turner Marsh earlier introduced the arts of Japan to San Francisco through his specialty shop, opened in the Palace Hotel in 1876, which was the first concern in the United States devoted exclusively to the sale of art goods from Nippon. Marsh built a Japanese-style home in Mill Valley, and created several semi-public Japanese landscapes in southern California. By the middle of the twentieth century the example in Golden Gate Park had become the oldest existing Japanese garden in America. It formed the third important link in the chain of Japanese exhibits to span the continent, and like its predecessors at Philadelphia and Chicago the Golden Gate Park Japanese microcosm engendered a widespread regional influence felt strongest in the domain of house building.

Japanese Contributions
to the Development
of the California Bungalow

TOWARD the end of the nineteenth century residential architecture was propagated and developed at a greater pace in California than elsewhere in the United States, including the Great Lakes region. This was due in part to the enormous influx of two kinds of home builders. One was a class of people who came west to seek their fortune, and the other was a group who had already made their money and sought to settle down in retirement to enjoy it. Both desired something different from the conventional house then in general use throughout America. The radical departure in style and planning of the Midwest prairie house had not yet come into being. The preexisting Spanish colonial *rancho* and *hacienda* (farm) houses in the locale, most of which dated from the thirty-year period prior to California's becoming a state in 1850, were thick-walled adobe constructions, with heavy tile roofs, that received no appreciation from the first Americans in the region. Anyway, California builders had a flair of their own, and they chose to forge ahead independently. Their problem was substantial, yet the challenge was met with determination. The type of house that was fabricated to meet the need was called a bungalow. It was described in its day as an unassuming dwelling containing "no more than an absolutely necessary number of rooms," having "no attic, or second story, and no cellar. Its characteristics are: simple horizontal lines, wide projecting roofs, numerous windows, one or two large porches, and the woodwork of the plainest kind."[1]

The term "bungalow" was borrowed from the English, who used it to signify native shelters in India as early as the end of the seventeenth century, and later applied it to caravanserais, or rest houses, built by the Indian government for travelers along the highroads at twelve to fifteen-mile intervals. The modest structure in question was described about 1825 as one "built of unbaked bricks and covered with thatch, having in the center a hall...the whole being encompassed by an open *verandah*."[2] To the British in South Asia the bungalow was not an ideal living place. It struck J. Lockwood Kipling, father of the poet and raconteur of jungle tales, as a structure "about as handsome as a stack of hay," which provided "the 'irreducible minimum' of accommodation."[3] His comments were illustrated by several sketches and diagrams of authentic examples. Even in those with compact plans, all the rooms opened onto porches, with outside doors and windows—including a clerestory under the main eaves—furnishing cross-ventilation *(§80)*. The Indian bungalow was, as Kipling remarked, "a purely utilitarian contrivance developed under hard and limiting conditions."

The affinity that the California bungalow came to have for the Indian version was coincidental, prompted by similarities in local conditions and intent rather than direct derivation of physical aspects. The weather along the southern and middle Pacific coast lacked extremes in temperature and therefore was not as demanding upon comfort requirements as most of the rest of the United States. Two human factors contributed to the formation of the bungalow. In chronological order these were, first, the willingness of home dwellers to content themselves with nearly the barest necessities in a house, and second, the desire on the part of

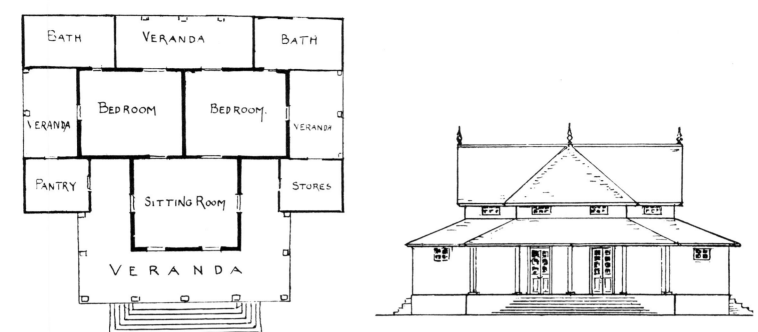

§80. *Plan and elevation of an Indian government* dak *or posting bungalow.* (Country Life in America, *February, 1911, p. 309.*)

designers and constructors to achieve a mode of building that was at once original and artistic, without being expensive. An article published in *The House Beautiful* in 1914 attempted to sketch "The Evolution of the Bungalow" in our westernmost state:

"In the beginning was the barn. Persons of small means when they first came to California often found it desirable to put all their money into land and the young orchards which were to make their fortunes. They decided to live themselves in a small structure which should be the barn of the future house. These barns were at first constructed with Eastern solidity, with heavy posts and beams, and completely finished on the inside as barns, with stalls, mangers and other like fittings. The human tenant generally decorated the carriage house with burlap or 'Old Government Java' coffee bags, held in place by split bamboo strips; and this with a rough fireplace, a few good pieces of furniture, and the shadows of the rafters overhead, made a really delightful living-room. The great barn doors were generally left open, giving an out-door effect very grateful to the lovers of sun and space.

"The next step was to build only the outside shell of a barn, dividing it into rooms with temporary partitions. . . .

"Later, travelers from distant lands noticed the resemblance between these wide-spreading, one-story houses and the East Indian 'bungalow' and thenceforward these dwellings ceased to be temporary; but putting on wide verandas and a dignified name, sprang up in every direction, as intentional homes."[4]

The paragraphs quoted cover a broad topic in a few words. They imply that the California bungalow got its start as a converted dependency temporarily fitted up for human habitation, the merits of which later were appreciated and reproduced for serious residential purposes. The relationship between this kind of house and the Indian bungalow became established afterwards, and constituted a definite stage in the flowering of the California residence. The J. D. Grant bungalow built at Burlingame during the early 1890's exemplified this phase (*§86*). It was designed by A. Page Brown, who also planned the Manufacturers and Liberal Arts Building at the California Midwinter International Exposition. The roof pitch and en-circling porch of the Burlingame house strike a chord responsive to corresponding elements

of the East Indian posting station previously shown *(compare §80)*. The hilltop site, however, necessitates a high basement, which is a châlet characteristic not to be found in a roadside caravanserai. Another California example was constructed on the flat desert at Palm Springs about a decade later. It was recognized as showing "a close resemblance to its prototype in India." The long summers of southern California prompted the use of authentic Hindustan measures for circulating air : "The roof is double, ventilators extend all around, and the inside doors are supplied with large transoms."[5]

The California bungalow progressed beyond the stage of its close resemblance to the East Indian model from which it derived its title. The article on "The Evolution of the Bungalow" goes on to say :

"Eventually some great man discovered that as there was no snow and really no violent storms in California, a house could be made to stand up without a frame, that it could be built of nothing but upright boards reaching from sill to plate, with scantling as cross-ties. . . .

"Most of the best bungalows are made of broad redwood boards with weather stripping, and are mill finished inside."

It was stressed that wood was left in its natural finish, or perhaps given a stain, one of the cheapest consisting of asphalt dissolved in hot turpentine. A lump six inches square could stain a whole house.

The "great man" credited with originating the bungalow of upright boards was not a single individual but a team, two brothers, fifteen months apart in age, who worked as a single man. Charles Sumner Greene (1868-1957) and Henry Mather Greene (1870-1954) were born in Cincinnati and reared in Saint Louis, where they prepared for their future vocation at the Manual Training High School operated by Washington University. Advanced study was pursued at the Massachusetts Institute of Technology, from which they graduated in 1891. Charles Sumner worked for the Boston architectural firm of Winslow and Wetherell, and

§81. Perspective sketch of the bungalow for Arturo Bandini, Pasadena, California. Greene and Greene, architects.

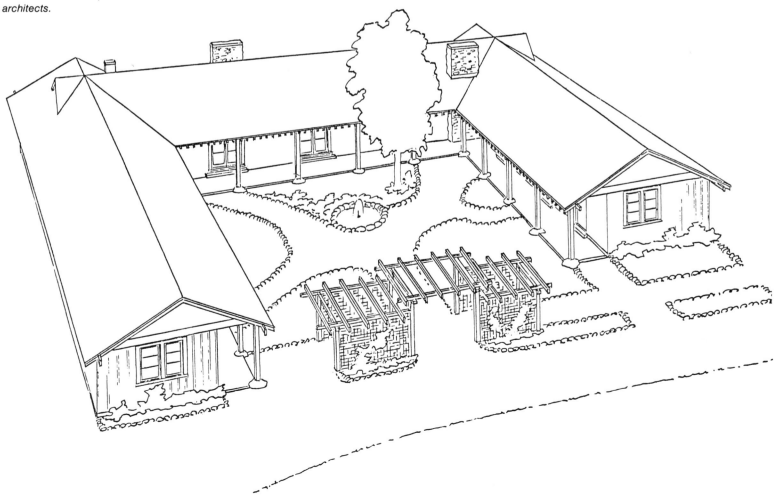

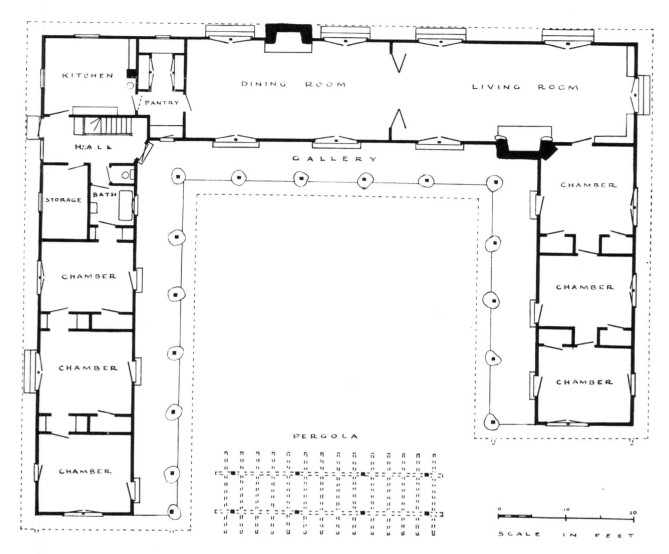

KITCHEN

PANTRY

DINING ROOM

LIVING ROOM

HALL

GALLERY

STORAGE

BATH

CHAMBER

CHAMBER

CHAMBER

CHAMBER

CHAMBER

CHAMBER

CHAMBER

PERGOLA

SCALE IN FEET

§82. Plan of the Bandini bungalow.

Henry Mather for Chamberlin and Austin, as well as for Shepley, Rutan and Coolidge. Their parents moved to southern California in 1893 and the brothers decided to join them. The area seemed promising so they opened an office at Pasadena in 1894. For several years the young architects tried their hand at using the popular styles of the times, including "Queen Anne," Spanish mission, Old English and American colonial. They came to realize that adherence to styles limits free expression, and in 1903 they hit upon an unaffected type of wood house that gave them what they wanted. The first was built in Pasadena for Arturo Bandini, who had specified that it should reflect the patio plan of the homes of his forebears here. The result was a U-shaped dwelling having a gallery around three sides of a court, with a pergola forming a screen across the open end *(§81).*[6] Construction was simple and inexpensive, consisting of redwood boards set upright, the joints both outside and inside covered with three-inch strips. The batten walls were stained on the exterior and given a "thin light oil finish to prevent spotting of the wood and yet retain as nearly as possible its natural color" within. The exposed cobblestones of the chimneys were brought into the rooms, and simple shelves served as mantels. The interior provided "much room and comfort and artistic possibilities at comparatively small outlay."[7] Living and dining rooms were located at the base of the U-form *(§82).* Both units were about twice as long as wide, and with the folding doors between them opened back, the effect was of a single hall fifteen by sixty-five feet. Kitchen, pantries, service rooms

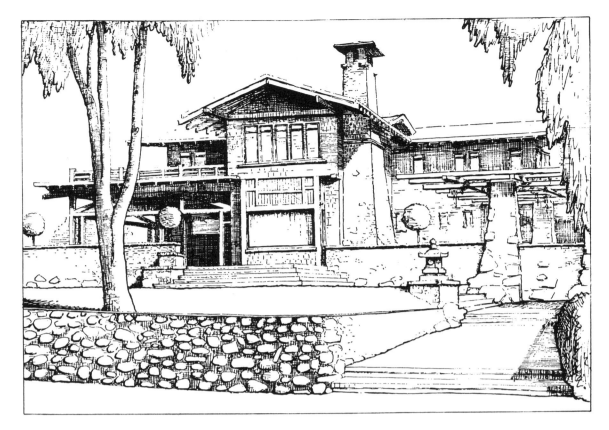

§83. *Entrance front of the Theodore Irwin house as completed in 1907 at Pasadena. Greene and Greene, architects.*

§84. *Perspective sketch of the Irwin house.*

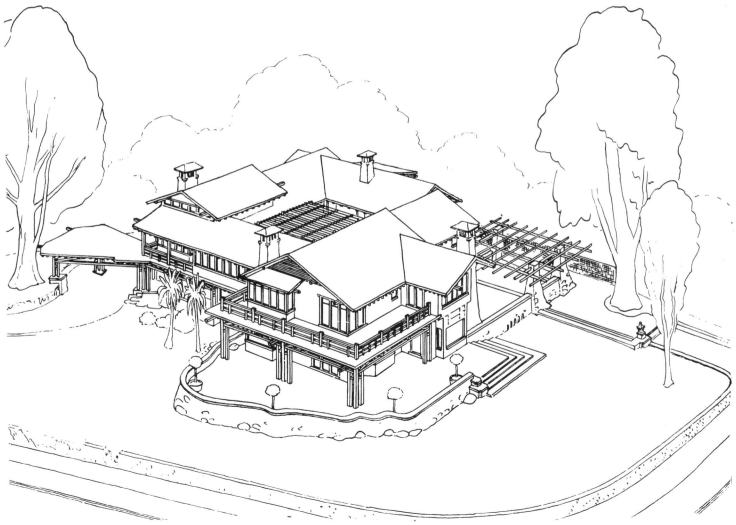

and a bath were in one corner, and three bedrooms were in each wing. The arrangement may have been borrowed from Spanish colonial antecedents, but the house was unconstrained by the enclosed feeling one gets from their thick adobe walls. The lightness of construction came from Japan. Charles Sumner and Henry Mather Greene had visited the Columbian Exposition at Chicago in 1893, the Midwinter Exposition at San Francisco the following year, and at both were impressed and delighted by the Japanese exhibits. The architects never visited the Far East but collected photographs of Japanese buildings, many of which were still preserved in the Carmel studio of the late Charles Sumner Greene at the time of the author's visit there in 1954.[8] Unmistakably Japanese was their practice of resting the bases of posts, used to support exposed beams and roof rafters, upon rounded stones half sunk into the ground, as in the Bandini bungalow gallery. A similar porch was applied along two sides of a patio in the C. W. Hollister house built at Hollywood by Greene and Greene two years later.[9]

Japanese influence came to the fore in the Greene brothers' work beginning in 1906. Two outstanding undertakings begun this year were Mrs. A. Tichenor's house in Long Beach and the Theodore Irwin house in Pasadena. The Tichenor residence at Ocean Boulevard and First Place, facing the sea, was composed of a two-storied block of timber and brick capped by an *irimoya* tile roof and low wings at the back embracing a garden containing a tea house and an arched bridge over a stream. The two houses were discussed and illustrated in *One Hundred Country Houses* by Aymar Embury, II, who characterized them as "the utmost limits to which Japanese architecture could be stretched, and still meet American requirements."[10]

The Irwin residence at the corner of North Grand Avenue and Arroyo Terrace was separated from the Charles Sumner Greene property on the east by the old covered Pasadena reservoir. The house was located near the south line of the lot, as far as possible from the street side, and only enough space was allowed for a walk between the building and the rustic lattice division fence. It was the enlargement of an earlier dwelling on the site, and the accompanying bird's-eye view represents the house as completed by the Greenes in 1907 (*§84*). A serpentine brick and stone parapet around the living room terrace responds to the boulder retaining wall skirting the public walk. The driveway at the left leads under the fan-shaped *porte-cochère* to the motor court and garage, and a corner of the roof over the drive is cut away for a great eucalyptus tree. A second large eucalyptus stands alongside the brick-paved main walk entered from North Grand Avenue. Halfway up this walk are two steps, and there are three others at right angles ascending to the front terrace. Both sets are lighted by a Japanese stone lantern placed on a socle at the angle of their conjunction (*§83*). Visitors went around the trellised porch, passed a little water garden and mounted five steps to the entrance in the stairhall or the reception hall; or they could go directly to the main terrace and living porch on the northwest corner of the house. The submergence of the entrances was a most harmonious Japanese feature in this irregular construction of open timberwork and deep eaves. Inside was an enclosed court with a pool in the center, shaded overhead by a trellis (*§85*). The inclusion of the court may have been suggested by a Moorish example, perhaps one from Tetuan, Morocco, or from a Spanish-colonial type of house at Winters, California, but the treatment of the elements involved is Japanese.[11] The building is divided into many little rooms—an inheritance from the smaller house it absorbed—and therefore lacks the interior spaciousness of other Greene and Greene works. This condition later prompted the extension of the north wall of the living room into the porch area. Another change occurred in the approach. Steps were placed between the piers at the front of the porch and the original ones at the side were removed, with appropriate alterations to the parapet walls. Chimneys of clinker brick and stone were somewhat pagoda-like in form, though there are no archetypes for smoke

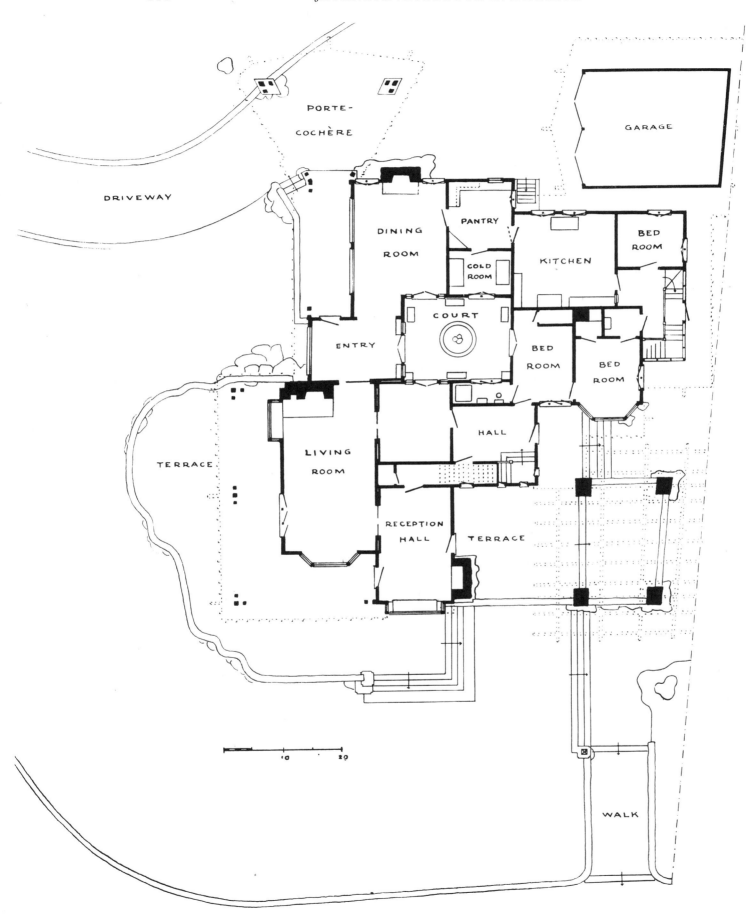

PORTE-
COCHÈRE

DRIVEWAY

GARAGE

DINING
ROOM

PANTRY

BED
ROOM

COLD
ROOM

KITCHEN

COURT

ENTRY

BED
ROOM

BED
ROOM

HALL

TERRACE

LIVING
ROOM

RECEPTION
HALL

TERRACE

WALK

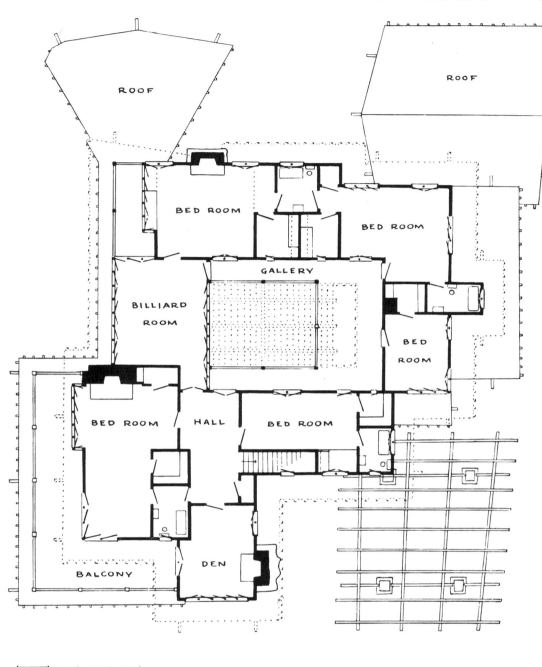

ROOF

ROOF

BED ROOM

BED ROOM

GALLERY

BILLIARD ROOM

BED ROOM

BED ROOM HALL BED ROOM

BALCONY DEN

§85. *Plans of the first and second floors of the Irwin house as completed in 1907.*

conduits in Japan, other than open gables in primitive farmhouses, hardly applicable here. A contemporary magazine article gave prominence to the Irwin house in tracing "The Trail of Japanese Influence in Our Modern American Architecture"; and pictures of it were captioned "Bungalow in Japanese Style" and "Japanesque Bungalow."[12]

Reference to the two-storied, twenty-room Irwin house as a "bungalow" may seem to be stretching the definition of the term, but other houses equally as large were similarly labeled. Greene and Greene designed a number in the style of the Irwin house, two of which were erected in the neighborhood in 1908. Both are on Westmoreland Place: No. 2 was commissioned by J. A. Cole and No. 4 by David B. Gamble, retired tycoon of the Procter and Gamble Ivory Soap empire. The Cole house, at least, was called a bungalow when pictured in the April, 1909, edition of *The Western Architect*. The houses are asymmetrical, though the first has a stronger central axis because of its projecting *porte-cochère* and an exceedingly wide

frontal gable to the main roof that shelters all of the mass save for a few projections. In both, the second story is larger than the first, resulting in occasional overhangs. The Gamble house, especially, is well endowed with upstairs sleeping porches, the supports and railings of which are outgrowths of the main structural system (§87). Much of the charm of these houses accrues from the irregular spacing of the exposed timbers, their subtle curves and rounded corners. The planting, whether in the ground or in urns or tubs, ties in sympathetically with the architecture. A spacious hall with staircase to one side forms the core of each house. The halls are joined to front and rear terraces by groups of glazed doors. The entrance doors in the Gamble house are filled with leaded glass depicting a Tree of Life motif in tones of yellow and amber. Following Japanese custom the living rooms are at the back, where advantage is taken of the view across the Arroyo. Also at the rear are the dining rooms, with pantries linking them to the kitchens (§89). No. 4 Westmoreland Place is the larger house, affording a bedroom suite in front of the service rooms. A library or study occupies the opposite front corner. The corresponding rooms in the two houses are in inverted positions. Interior fittings and furniture were designed and finished by the architects and built by Peter Hall, a craftsman of Scandinavian descent whom the brothers persuaded to go into business for himself. A cipher in script reading "Sumner Greene, His True Mark" is incised in the underside of movable pieces. The fireplace recess or inglenook in the Gamble living room has built-in seats facing one another, and book cases with adjustable shelves to each side of the chimney-breast (§88). Woodwork here is mostly of finished teak, with some redwood, rather carefully dovetailed at the corners and held together by wooden pegs. Reliefs of conifers are carved in the frieze around the upper part of the wall, and a beam spanning the front of the inglenook is keyed into brackets and curved braces. The metal and glass suspended lamps, fireplace tiles and even the rug woven in China were also Greene and Greene designs. The end of a piece of driftwood seen on the mantel is another reminder of an unusual ornament adopted from the Japanese. The construction cost of the Gamble house was $55,000.[13]

A slightly larger residence, but belonging in the same category as the last three, and considered by the Greenes to have been their masterpiece, is the R. R. Blacker house at 1177 Hillcrest Avenue, Pasadena, dating from 1909. The ample corner lot (approximately 400 feet square) was carefully landscaped in an informal manner, providing an appropriate setting for the house, with a pergola on a line with the southwest wing, garage, gardener's cottage and greenhouse. The Blacker residence is a balanced scheme, though not strictly symmetrical. The *porte-cochère* juts out at an acute angle over the circular driveway, and the outer end of the cantilevered roofs is supported on a stepped pylon (§90). The plan of the house is U-shaped, with the commodious paneled stairhall at the base of the figure, the kitchen (in front), service rooms, dining room and sun room in the left wing, and the living room and master bedroom suite in the right, or east wing, with porches off the living room and hall (§91). This plan, in all its essentials, was borrowed from one delineated by Myron Hunt and Elmer Grey for R. R. Blacker not later than 1907.[14] It was to have had a rather plain mission exterior, involving large flat areas of stuccoed walls pierced by traditional fenestration. The Greene and Greene version sought the utmost in picturesque inventiveness, suggesting the clue for Blacker's substitution of architects.[15]

The Greene and Greene mode of building was at its best applied to the true bungalow that was low and rambling, rather than to larger structures. One of the finest bungalows produced in America was that of Charles Pratt on Foothill Road near Ojai, California, built in 1909-11. The Greenes conceived the residence as a narrow crescent making six bendings along a rocky ridge endowed with a sweeping vista across Ojai Valley. The motor court adjoins the entrance

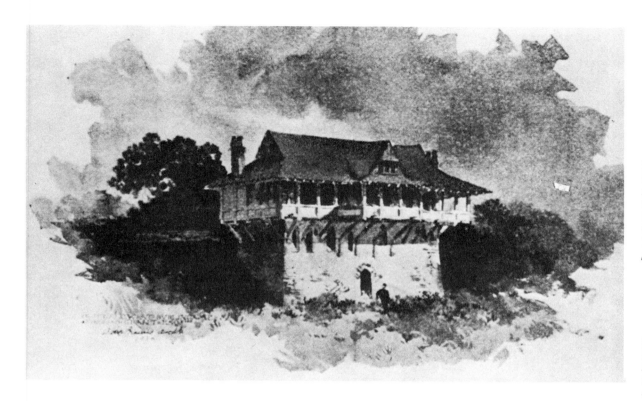

§86. *J. D. Grant bungalow at Burlingame, California. A. Page Brown, architect.* (The American Architect and Building News, *June 8, 1895, p. 95.*)

§87. *Facade of the David B. Gamble house, Pasadena. Greene and Greene, architects.*

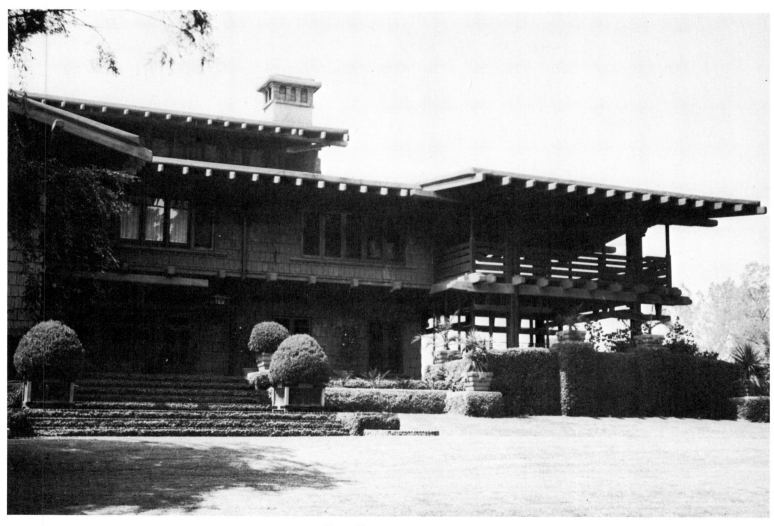

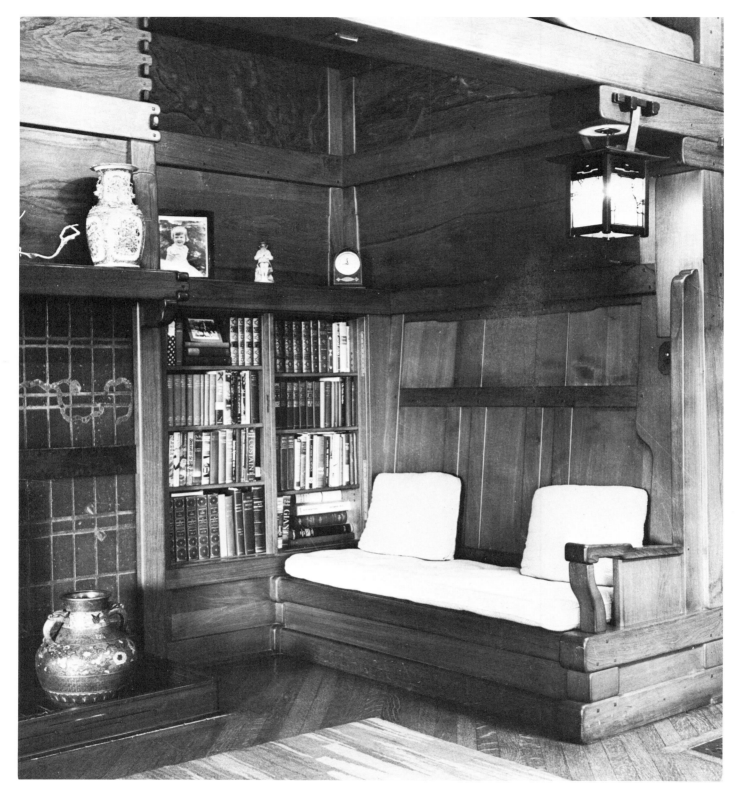

§88. *Detail of the inglenook in the living room of the Gamble house.*

terrace centered on the convex side of the house, and brick retaining walls form undulating tiers for plantings that enframe the curved entrance steps (*§93*). The living hall is fan-shaped. It opens through onto a porch, which is sheltered by a trapezoidal roof, and which expands onto terraces both right and left (*§92*). The east wing of the house contains two large bedrooms, baths, and a sleeping porch on each of two floors. The motif repeated throughout the Pratt bungalow is the changing angle. Directional variety is achieved as the form winds around the ridge. The effect is dynamic, and nowhere more intense than in the abstract relationship of low-pitched gables hovering in juxtaposition on nearly diagonal axes above the flat deck over the living hall (*§94*). The ends of the projecting girts are encased in copper sheaths for protection from the weather, as in some Japanese temples. Outside braces, describing rigid triangles, also are a device borrowed by the Greenes from Japanese domestic building (*§98*). Shifting shadows cast by these diversified shapes transfigure the house into

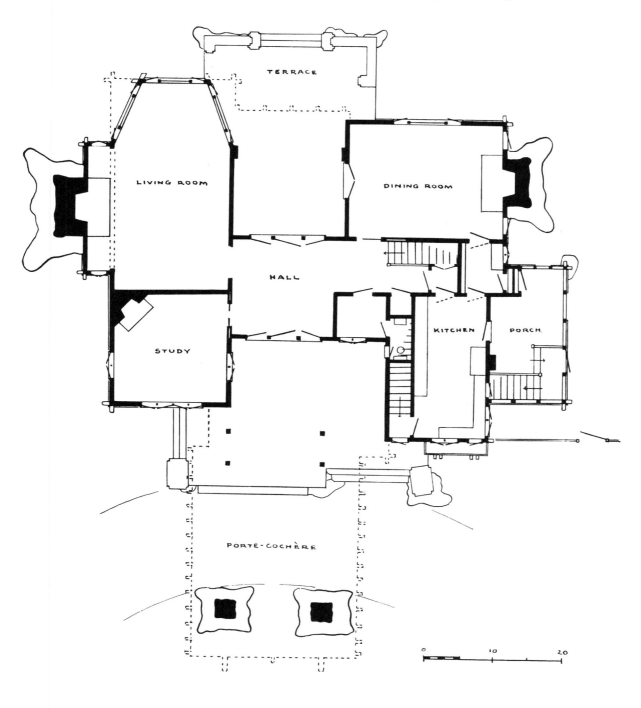

§89. Plan of the first floor of the J. A. Cole house in Pasadena. Greene and Greene, architects.

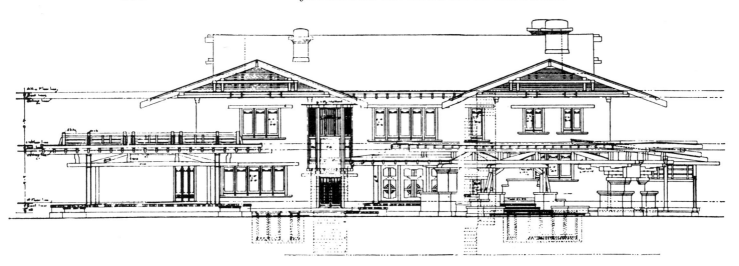

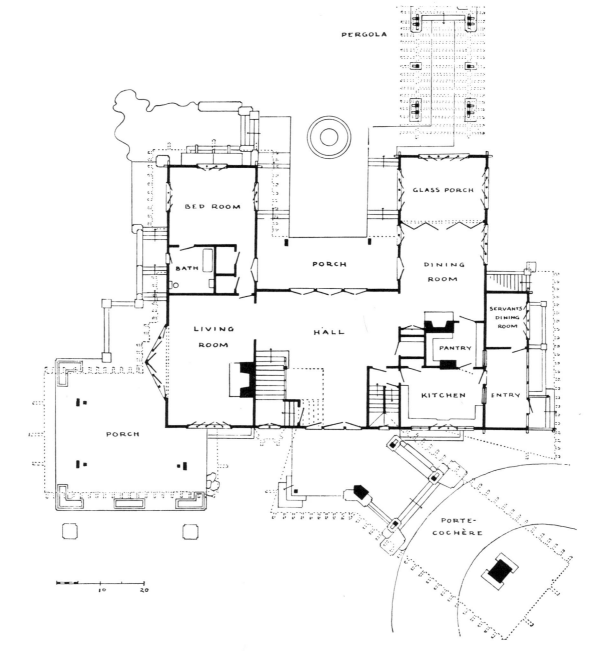

§90 & §91. *Sketch of the front elevation and a plan of the first floor of the R. R. Blacker house, Pasadena. Greene and Greene, architects.*

a sentient being that changes its moods with the hours of the day or night. Removed from the affairs of the world, it is a place where one can find contentment sitting by the fireside and listening to the wind, the rain, or the quietude of a calm afternoon. The architects of the Pratt house also designed the furnishings, which, as in the Gamble house, are well proportioned, skillfully executed, and beautifully finished, some enriched with delicate inlays.

The professional partnership of Greene and Greene was dissolved about 1916, when Charles Sumner built a studio and home in the budding artists' colony of Carmel-by-the-Sea on the Monterey Peninsula. During the twenty-two years of their association the architects brought into being about 540 buildings. Becoming dissatisfied with unprincipled competition and the lowering of craft standards the elder brother decided to settle down to a life devoted to music, painting, the crafts, the study of Buddhism and incidental design projects. Henry Mather, who remained in Pasadena, also engaged in architecture only occasionally. But, just as there were creditable architects in the Chicago School besides Frank Lloyd Wright, so there were other contemporary builders in California whose works would have attained greater recognition had Greene and Greene never existed. The Los Angeles firm of Albert R. Walker and John Terrell Vawter built bungalows resembling those of the Greenes. The low, spreading, T-shaped residence of Frank C. Hill, dating from about 1912, was said by one

§92. *Plan of the first floor of the Charles Pratt bungalow, Ojai, California. Greene and Greene, architects.*

reviewer to have "taken the feeling of the Japanese architecture as the basis...[of its] design. The detail, however, is not carried out with quite so delicate a feeling of lightness and with such true sense of honest construction as in the Hollister house."[16] The Hollister house was mentioned earlier as being similar to the Bandini bungalow. Charles Sumner Greene, writing in 1915, reacted favorably to Walker and Vawter's endeavors. His article, entitled "Impressions of Some Bungalows and Gardens," was illustrated with two photographs of the Hill house and two of a pair of unidentified bungalows (§95). He says of the first that it "attests the skill and care of the well-trained designer. The selection of materials is excellent. The harmony of split shakes and rough bricks is not to be questioned. The carefully rounded timbers and well-proportioned piers and buttresses combine the feelings of elegance, with adequate sense of support." The other examples are adjudged to have: "The same harmony of line..."; and Sumner Greene calls special attention to the sensitivity used in "placing the house in relation to the sycamore trees. The harmony and picturesqueness are admirable."[17] The sloping site also is an asset to these little wooden houses that are typically Japanese in their massing. As in Wright's Kankakee houses the gables are thrust outward at the apex.

A flat-roofed bungalow at 629 South Grand Avenue in Pasadena was designed and built by John C. Austin about 1908. Constructed entirely of wood, except for foundations and chimney of smooth boulders, the small cubic house looks rather prickly because of the projecting ends of beams and interlocking square timbers articulating the walls (§96). A picture of it in *House and Garden* (June 1916, p. 209) has attention called to the fact that it "displays a remarkably daring utilization of modified Japanese motives." A singularly similar scheme printed in *The Bungalow Magazine* (February, 1910, pp. 349-341) is accompanied by the statement: "The Japanese love of simple lines effectively proportioned is present in this design." However, the interpenetration of horizontal and vertical members seems to be more indebted to ancient buildings in Lycia, Asia Minor, than to the Japanese. An essay on the Mediterranean remains, illustrated by reconstruction drawings in *The American Architect* in 1908, perhaps suggested the image to John Austin (§97). The living room of the bungalow is at the front, dining room and kitchen are on the far side, and bedrooms at the back. The chimney and adjacent porch were removed about 1950 and replaced by a broad deck over a carport.

It was not only in the small-house field that Greene and Greene were confronted by many competitors. Substantial commissions went to rival architects as well. About 1913 Arthur S. Heineman of Los Angeles constructed for J. A. Freeman a sizable home at 1330 Hillcrest Avenue, Pasadena, not far from the R. R. Blacker residence. The Freeman house, unlike the other California examples we have seen, has stucco walls with half-timber effects, delicately applied (§100). The Greenes also built in this manner, as exemplified in the L. A. Robinson house at 195 South Grand Avenue and the small bungalow at 400 Arroyo Terrace. The unusual feature of the Freeman house is the undulating gable that creates a slow, gentle wave-like movement across the facade. The main entrance is to the left of the front chimney. A square hall opens through onto a rear terrace, and the big living room on the left has a fireplace inglenook, as in the Greene and Greene houses on Westmoreland Place. The dining room is located back of the stairhall and a projecting den is in front. Breakfast room, kitchen, service rooms, maids' quarters and a screened porch complete the first floor layout. Bedroom suites with baths are on the second level. The fence enclosing the property was strongly reminiscent of Far Eastern woodwork. By 1950 the fence had disappeared, the window boxes were removed, and the timbering and stucco walls alike were painted a yellow ochre.

Many other California architects of this period concocted domiciles in a vein approximating the ones shown. A partial list includes the names of Sylvanus Marston,[18] George A. Clark and

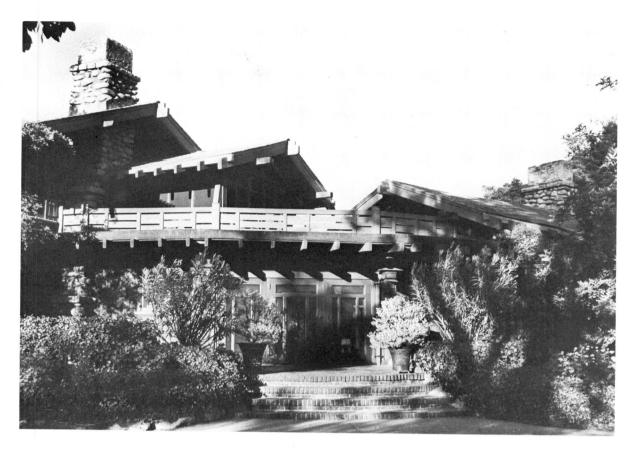

§93. *Detail of the entrance of the Pratt bungalow.*

§94. *Gables on the sleeping porch and the high-ceilinged dining room of the Pratt bungalow.*

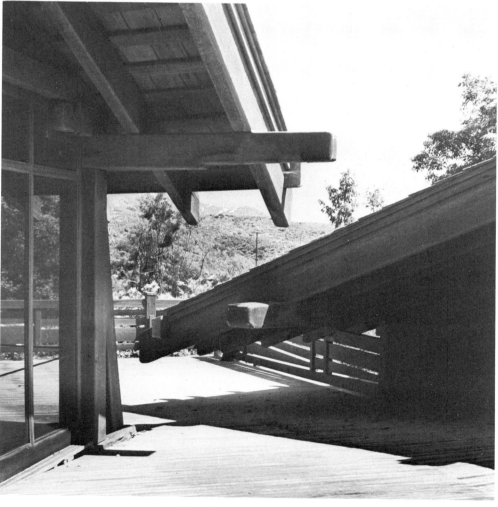

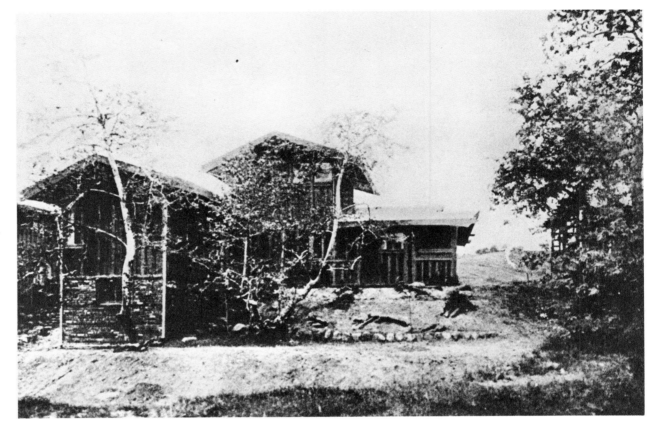

§95. *Bungalows in southern California designed by the architects Walker and Vawter.* (The Architect, *December, 1915, p. [159].*)

§96. *Bungalow at No. 629 South Grand Avenue, Pasadena, John C. Austin, architect.* (The Western Architect, *June, 1909.*)

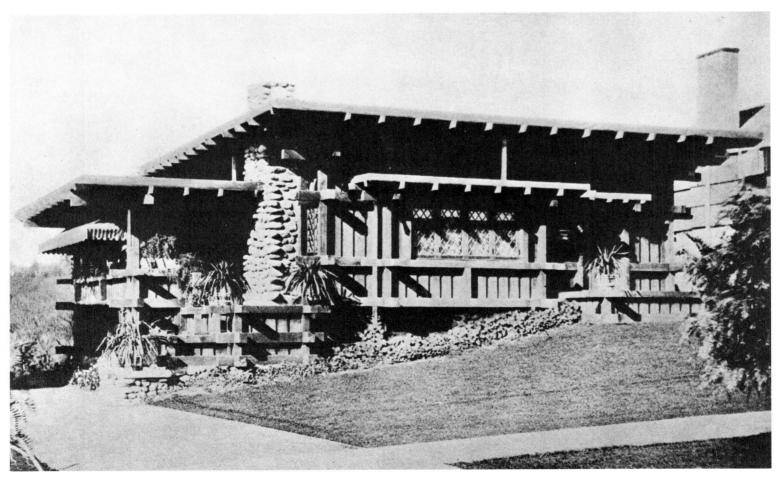

L. du P. Millar,[19] J. F. Kavanaugh,[20] E. B. Rust,[21] Arthur R. Kelly[22] and F. A. Brown,[23] in the Los Angeles area, and Louis Christian Mullgardt[24] and Bernard Ralph Maybeck[25] in San Francisco. Amateur builders, motivated by the crafts movement, also fabricated a few notable bungalows for their own use, such as that of Frank Underhill[26] near Santa Barbara.

On the West Coast, no less than on the East, attempts were made at literal reproduction of Japanese architecture. The most lavish was Yama Shiro (Mountain Castle), that stands on a hill overlooking America's movie capital, Hollywood *(§101)*. It was constructed in 1913 for two brothers, Adolph L. and Eugene Bernheimer, earlier residents of Staten Island, New York. Franklin M. Small designed the building in the elaborate style of the Tokugawa Period as the proper setting for the extensive collection of Japanese fine arts and decorative pieces owned by the clients. Yama Shiro is reached by a long flight of steps leading up the hill to the south portal, or by a road that enters the rear of the seven-acre estate. A garage is opposite the gateway, and the drive circles the main house. The residence proper forms a quadrangle 116 feet square around a 40-foot inner court. Chambers and guest rooms are distributed in perfect symmetry across the front and along the sides of the building. The drawing room is at the end of the west wing and the dining room is in a corresponding position in the east wing. A narrow gallery or tea room spans the north side of the court. Large figures in kimono were painted on the panels constituting the long wall facing the *shōji*. The tea gallery was furnished only with Japanese cushions, low tables and lamps, whereas the other rooms contained Occidental pieces, such as upholstered seats, cabinets and beds. Interiors had coffered ceilings of carved and gilded wood, wainscoting, and embroideries or painted murals on the walls. Service rooms were behind the tea gallery. The house was built of native timbers set on reinforced concrete foundations, and the eight-foot overhanging eaves of the blue tile roof were supported by a system of corbels. Along the south slope of the hill was planted a miniature landscape, with dwarf trees and water courses, and scattered about were small models of Japanese bridges, gateways, dwellings, pagodas and other pavilions. The Bernheimer brothers commissioned another Japanese house that was a sort of lavender Trianon de Porcelaine built on a bluff high above the Pacific Ocean at Santa Monica, near the termination of Sunset Boulevard. During the early 1950's it was falling into ruin, and Yama Shiro had been converted into an apartment building.

§97. *Reconstructed drawing of a dwelling in Lycia, Asia Minor. (The American Architect and Building News, September 30, 1908, p. 106.)*

§98. *A traditional Japanese exterior brace. (Morse, Japanese Homes, Boston, 1886, Fig. 13.)*

Not all attempts at imitating Japanese architecture were as sophisticated as the great villa on the hill above Hollywood. A version built as a vacation house on Lake Steilacoom in Washington State allowed many digressions (*§102*). It was planned by the Los Angeles architect I. Jay Knapp for Leo H. Long, and was described as "not a Shintō temple from the Island Empire of Japan, but an original idea for a Summer cottage among the pines...."[27] The reduplication of dipping gables might have been compared better to those of a fortified castle rather than to a Shintō shrine (*§99*). The shapes of these exotic conceits were only mildly original as compared to the more unique "idea" of using them on a summer cottage in the northwest woods. The tin roofs curl up at the outer edges to such a degree that draining would be limited to the gable ends. The ridge poles are given an open treatment suggestive of "Queen Anne" cresting, and the chimney has horn-like protuberances at the corners. A final touch of quaintness is the rustic fence in front of the porch, matching the stick armchair placed on the lawn in the foreground.

The appearance of the Japanese influence on the West Coast not only completed the circuit of its march across the American continent but signaled its culmination. In the California bungalow the Japanese influence received its heartiest reception. Although the name bungalow came from a similar structure in South Asia the type was closer to Nipponese building. This is borne out by a contemporary critic writing in 1906: "We are aware that the American bungalow derives more of its characteristics from Japanese models than it does from buildings erected in tropical countries.... It has... already become an extremely popular type in the temperate climate of California, and it is there that bungalows are being built more and better than anywhere else in the country."[28] The article from which the quotation was taken dealt with the Greene brothers and contained an illustration of the Bandini house, the first work in which they reached their mature stride. This bungalow was followed by more ambitious

§99. Sketch of Nago-ya Castle.

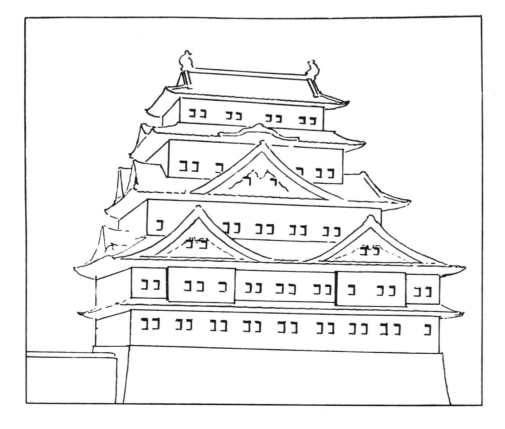

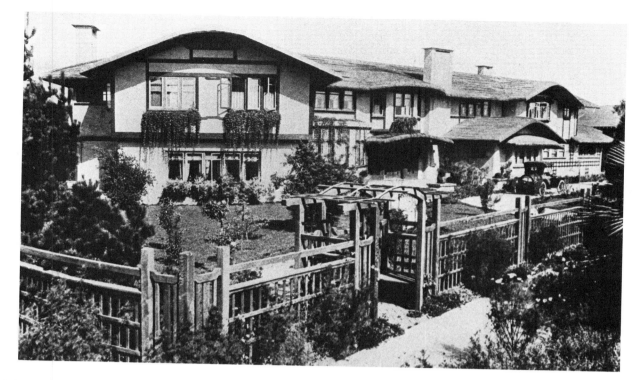

§100. *J.A. Freeman house, Pasadena. Arthur S. Heineman, architect.* (The Western Architect, *August, 1914.*)

§101. *Panoramic view from the rear of Yama Shiro, Hollywood. Franklin M. Small, architect.* (Country Life in America, *March, 1922, p. 48.*)

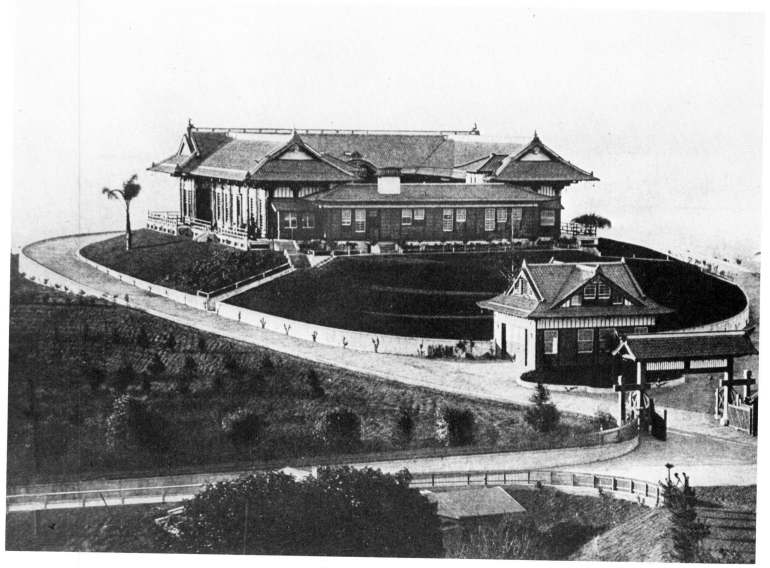

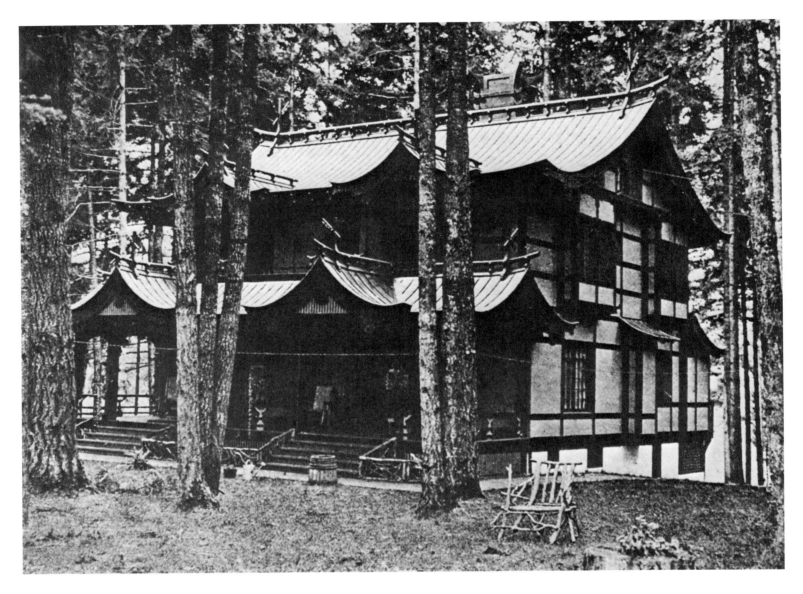

§102. *Vacation house on Lake Steilacoom, Washington. I. Jay Knapp, architect.*
(The Architect, *November, 1915, p. 245.*)

undertakings in which landscaping, house, dependencies and furnishing were planned and manually finished by the architects. Their most personal style was strongly tinged by the Japanese. A host of other California bungalow builders also sought the same source of inspiration. Overshadowed only by the dramatic magnitude of the skyscraper, the bungalow became one of America's most distinctive forms and has sheltered a large percentage of the population for several generations. As the tall building expresses the enterprising spirit of America, so the bungalow is the symbol of her love of casual homes. Innocent of extraneous architectural details, it is planned informally, providing comforts and conveniences rather than luxuries, and the accent is on its function as a setting for a normal, wholesome, cooperative and companionable family life.

The Japanese Bungalow
East of the
Mississippi River

THE self-conscious imitation of Japanese styling found in Hollywood's Yama Shiro and the summer house on Lake Steilacoom had a precedent in an earlier manifestation at Brooklyn, New York. The architect's preliminary rendering for this house, reproduced in the June 7, 1902, edition of *The Brooklyn Daily Eagle*, shows a heavy tile roof with curved gables and upturned eaves supported on brackets, a pillared porch, railings around the front terrace, and lanterns atop posts flanking the front steps (*§105*). In spite of these unmistakably Japanese features the plate is entitled "An East Indian Bungalow at Prospect Park South." The confusion is carried further in the accompanying article, which relates the proposed building to be: "One of the most unique houses ever built in America.... The house will be in the form of an East India bungalow as closely as the climatic conditions will allow." The error regarding its style undoubtedly stems from calling the house a bungalow—a relatively new term in 1907—and its etymological association with the caravanserai of tropical India. The house was to be built by Dean Alvord, a New York realtor who anticipated that the exotic dwelling would "prove to be a good seller."

The house as built at 131 Buckingham Road in Brooklyn was altered slightly from the original scheme. The second story was extended over the front porch, an encircling balcony replaced the porch roof, and the arched gable of the front hood roof was eliminated to permit garret windows in the gable (*§106*). There were also dormers at the sides. Dean Alvord certainly knew that the style derived from Japan, for although the building was designed by the American architects John J. Petit and James C. Green, three Japanese were engaged to impart authentic touchs. They were Saburō Arai, contractor; Shunsi Ishikawa, decorator; and Chogoro Sugai, gardener. A Japanese gateway originally stood on the right side of the front walk as an entrance to an evergreen garden. Half a century later this area had become a plain lawn with only a pair of cast-stone lanterns recalling the former picturesque landscaping. The front door of the house opened into the living hall, which had ceiling panels with hand-painted Japanese designs. An inglenook contained seats adjoining the chimneybreast with latticework to each side permitting glimpses into the dining room beyond (*§103*). The dining room had a stained-glass dragon window opposite the fireplace, and the parlor was separated from the living hall by a screen of columns. A stairhall was behind, leading to a back entry, kitchen and rear porch. Six bedrooms and a bath were on the second floor, and a billiard room and servants' quarters were in the garret. In July of 1903 the house was advertised for sale in *Country Life in America (page 169)*, and the price was set at $26,500. Later changes include the conversion of the inglenook seats in the living hall into plant boxes, the removal of the columns separating the parlor from the living hall, and an enclosed front entry projected onto the porch.

At the far end of Brooklyn a tract was reserved for the recreation of New Yorkers weary of the workaday world. This place was called Coney Island, and here, in compounds known as

amusement parks, people disported themselves in innocent though somewhat boisterous frivolities. These were strange parks, as devoid of trees or grass as Times Square or Wall Street, yet they did blossom at night with brilliant multicolored electric lights. One of the three famous amusement parks at Coney Island was Dreamland, opened to the public in 1904, a rival to Steeplechase and Luna Park. Dreamland sported bizarre effects through each building's partaking of a different architectural style. John J. Petit designed some of them and most likely was responsible for the one that was Japanese, known as the Air Ship Building (*§107*). In December of 1903, Orville and Wilbur Wright had succeeded, for the first time, in raising a self-powered, heavier-than-air contraption off the ground at Kitty Hawk, North Carolina. The flight of the aeroplane (as these machines used to be called) received hardly any notice in the press, but was just the thing to ignite the imagination of people seeking diversion in an amusement park. The building housing the air ship was located on the lagoon occupying the center of the midway quadrangle, and near the east end of the bridge across the base of the shoot-the-chutes, down which plunged flat-bottomed boats filled with screaming revelers. The exhibition hall was as remarkable as the exhibit inside. Its entrance pavilion was crowned by a four-storied pagoda with balconies at each level and flaring roofs, the topmost surmounted by a tall spire. Railings and brackets and other details were similar to corresponding motifs on the Alvord house only a few miles away. The Air Ship Building was destroyed with the rest of Dreamland in the devastating fire that swept Coney Island on May 26, 1911.

The linking of the American flying machine with Japanese architecture makes an odd combination. However, it has come into our story earlier in the so-called aeroplane plan used by Frank Lloyd Wright two years before the Wright brothers rose above terra firma, and derived, as we have seen, from the Phoenix Hall at Uji (*Chapter Nine*). A most startling amalgamation of the two elements takes us once more across the continent to the Japanese-Aeroplane Bungalow done by the De Luxe Building Company of Los Angeles about 1915. It was a low, frame house with cobblestone chimneys and porch piers, and exaggerated, reduplicated fluttering eaves; the second story in the center of the pile contained "flying" bedrooms and sleeping porches.[1] The Japanese-Aeroplane Bungalow was a heterogeneous concoction prompted by rank commercialism, seeking sales through appeal to two fads that chanced to be raging at the same time. One wonders whether—as anticipated for the Alvord house—it proved to be a "good seller."

§103. *Plan of the first floor of the Japanese bungalow on Buckingham Road, Brooklyn. Petit and Green, architects.*

An exotic building at an amusement park, as at a world's fair, seen by multitudes of people, would be expected to foster offsprings having a hereditary resemblance to it. The Dreamland pagoda begot such a one for Blanche Sloan, otherwise known as the Queen of the Air. Miss Sloan, however, was not an aviatrix, but an accomplished trapeze performer, or aerialist, recently returned from a professional tour of the British Isles. The highlight of her act was feigning a fall by means of a slack rope. Daring and showmanship ran in the family. Her

brothers were both famous jockeys, Tod Sloan in America and Cash (Cassius) Sloan in Russia, riding for the Tsar. Blanche Sloan's home was built in 1909 at Cedar Manor, Jamaica, Long Island, a vernal colony of actors and entertainers, and the house itself was christened Oaka Lodge from the oak trees on the property. It was a small, squarish tower-like bungalow of three stories, a deep balcony around the second level sheltered by a subsidiary roof, and an open top story under a sagging hipped roof with overhanging eaves (§108). An outside chimney on one side pierced both roofs. Half of the first floor was divided into a living room and the other half partitioned into a bedroom, kitchen and bath. The second level contained a single room with a raised platform for a piano at the head of the stairs and a disappearing bed on the fireplace wall. The top floor was a fresh-air retreat. Miss Sloan helped build the house from her own plans, though she gave credit to Henry Wilson of Los Angeles for having made the design "practical."[2]

Blanche Sloan's vocation made her conscious of health, and provision for fresh air was evidenced in her home by the open top story and disappearing bed on the intermediary stage. A few years earlier Captain K. Tamura, of the Imperial Japanese Army, was championing the importance of breathing fresh air; and, speaking before a meeting of United States military surgeons, he pointed out that whereas window glass prevented ventilation the paper panes in Japanese houses not only allowed fresh air to pass through but strained out 97 percent of the germs.[3] Americans countered with the sleeping porch, which became part of the bungalow tradition.[4] We have come across it in several Greene and Greene bungalows, but for those who could not devote porches exclusively to sleeping, Yankee ingenuity provided substitute convertibles. One solution was known as the Oscillating Portal Wall Bed, consisting of a bed that could be shoved back and forth between porch and adjoining bedroom through hinged wall panels.[5] Another model corresponded to the disappearing bed at Oaka Lodge. It was an indoor-outdoor arrangement, built in the wall, and equipped with a roll top (§104). During the day the top could be pushed back for it to serve as a seat in the room, and at night, after the occupant was inside, the top could be rolled over to the room side exposing the sleeper to

§104. *Indoor-outdoor bed with roll top.* (Architect and Engineer, *March 1914, p. 391.*)

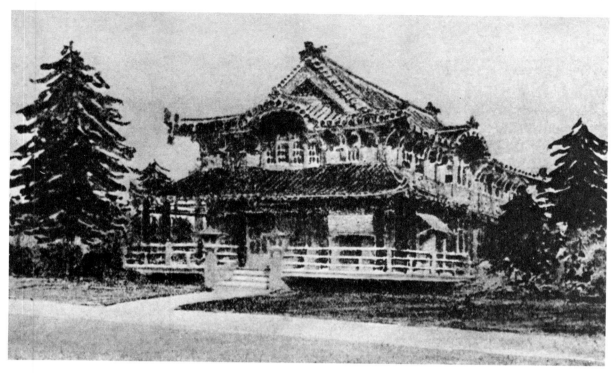

§105. *"An East Indian Bungalow at Prospect Park South."* Architect's rendering. (The Brooklyn Daily Eagle, June 7, 1902, p. 11.)

§106. *Japanese bungalow on Buckingham Road.*

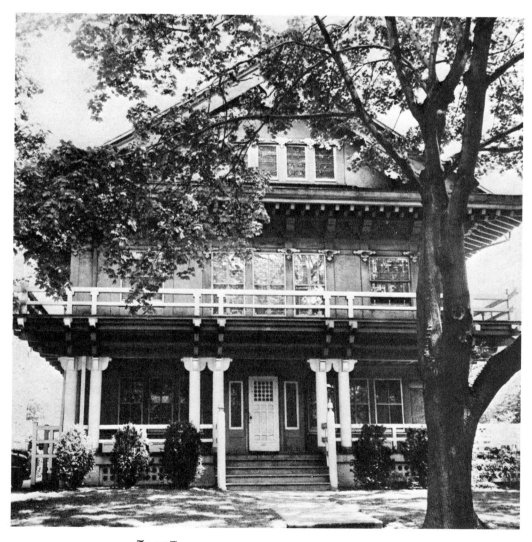

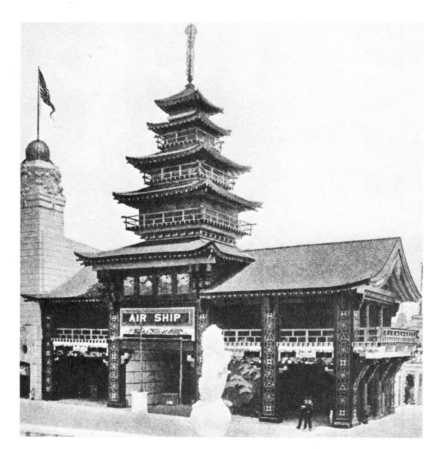

§107. *The Air Ship Building at Dreamland, Coney Island.* (Architects' and Builders' Magazine, *August, 1904, p. 500.*)

§108. *Oaka Lodge at Cedar Manor, Long Island, New York.*

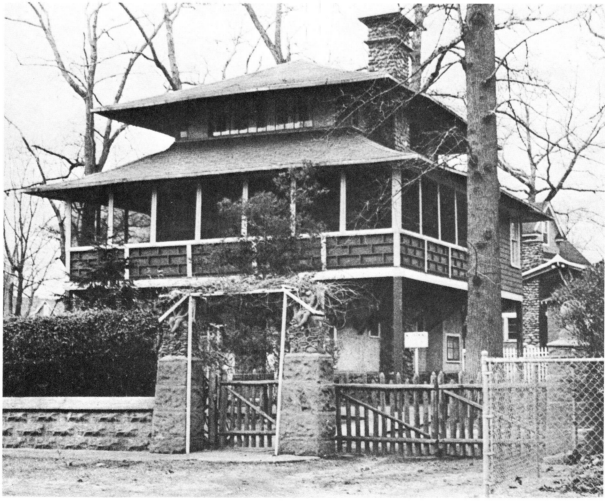

the out-of-doors. Such a bed would assure early rising, no sleep being possible once the birds were up and about. The balcony on Oaka Lodge could hardly have been utilized for outdoor sleeping, but, as stated in the advertisement, the roll-top couch was a "Wall Bed and a Sleeping Porch in one."

Blanche Sloan's home was featured in the January, 1910, issue of *The Bungalow Magazine.* A perspective cut of the house was stamped in brown ink on the tan cover, and an article with floor plans appeared on pages 321-322 (§109). The Japanese stone lantern and arched bridge in the foreground of the view were imaginary accouterments. Oaka Lodge was called "A Japanese Torri," the last word obviously meant to be *"torii,"* which, indicating a gateway in Japan, made no particular sense here. It was identified as belonging to "Miss Blanche Sloan, the actress, whose artistic temperament required a summer house that not only provides all of the requirements of Occidental life, but also embodies much of the refinement that is invariably present in the architecture of the land of the Mikado." To extend the theme further the owner filled the house to overflowing with Oriental furniture and bric-a-brac. The author commented that this was one of the most "unusual designs" he had seen, and it was Henry Wilson, the publisher of the magazine, who had made the plans for Oaka Lodge "practical." Blanche Sloan lived here until she met with a subway accident that fractured three ribs in 1918. Although not permanently injured she decided to retire and dispose of Oaka Lodge. Then she set out on an extended non-professional tour of the world. After her regime, posts were added under the corners of the balcony, which was screened in, and the top story was enclosed.

The Bungalow Magazine came out monthly from March 1909 through March 1918, at first in Los Angeles and later (beginning 1914) in Seattle. The price rose from a dime to a quarter per copy at the time Henry Wilson gave up the editorship. Many home and architectural periodicals printed articles and pictures of bungalows—from which stock the quotations and some of the plates for the preceding chapter have been taken—and even magazines having little to do with the subject encouraged bungalow living. The Curtis Publishing Company, for instance, presented two Frank Lloyd Wright designs in the *Ladies Home Journal* for Feb-

§109. *Cover of* The Bungalow Magazine, *January, 1910.*

§110. *Advertisement for bungalow plans by F. G. Brown of Los Angeles.* (The House Beautiful, *May 1908, p. 50.*)

ruary and June of 1901. The first, and larger, of the two was a typical prairie house, with low hipped roofs over a cruciform plan of unequal arm lengths. The second design had roofs extending into "Japanese" gables, as on Wright's two Kankakee houses of 1900 (*Chapter Nine*). The various magazines also carried advertisements for a flood of booklet catalogues of bungalow plans, issued inexpensively as an incentive for ordering sets of working drawings that sold for five dollars upward. Many originated in California, especially Los Angeles, and were responsible for disseminating the bungalow all over the country.

As an example, a young professor at the University of Kentucky and his wife, Dr. and Mrs. Ralph N. Maxson, were attracted by the illustration publicizing a portfolio of two dozen bungalow plans by F. G. Brown of Los Angeles, offered in *House Beautiful* for May, 1908, (*§110*). The portfolio sold for a dollar, which could be deducted later from the purchase price

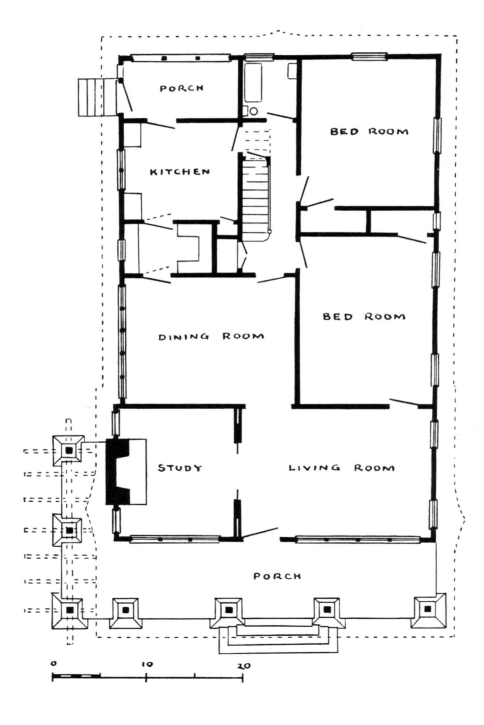

§111. *Plan of the first floor of the Dr. Ralph N. Maxson bungalow at Lexington, Kentucky.*

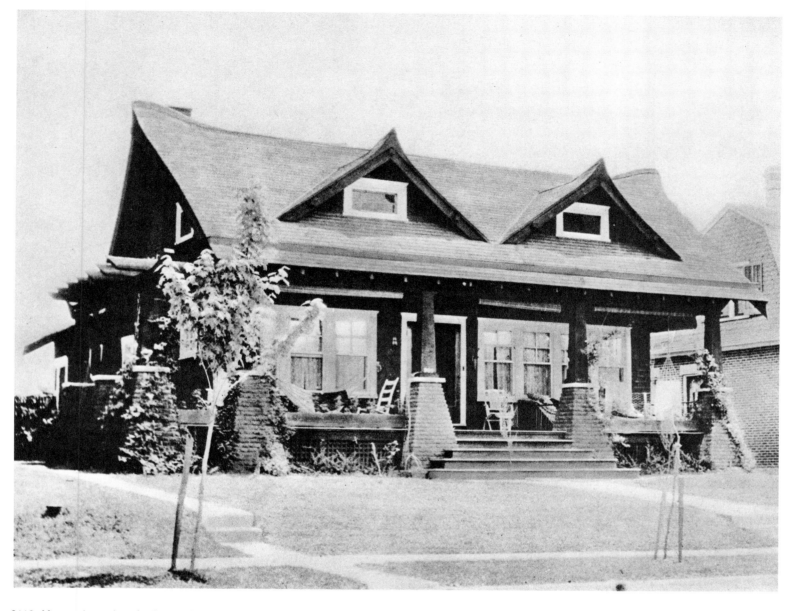

§112. *Maxson bungalow, Lexington, Kentucky. (Photograph ca. 1910, courtesy Mrs. Jessie T. Maxson.)*

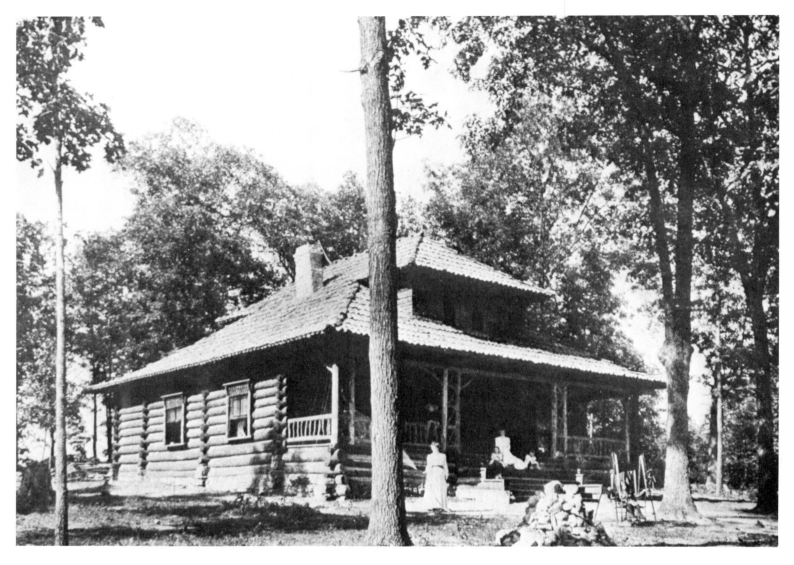

§113. *The Charles Basham house at White Bluffs, Tennessee. D. V. Stroop, architect. (The Western Architect, October, 1907.)*

§114. *Shōsōin of the Tōdaiji at Nara, Japan. (Supplement to* Tōyō Bijutsu, *Nara, 1930, Pl. 2.)*

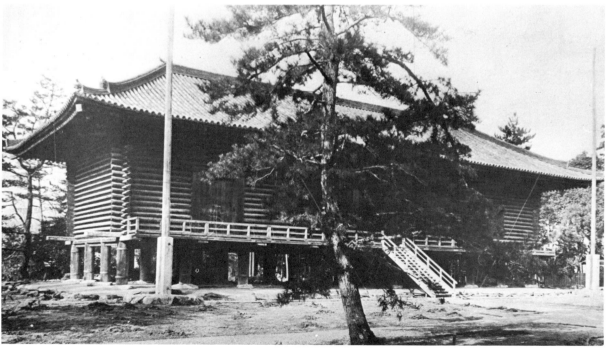

of measured drawings. The Maxsons liked best the bungalow illustrated, design no. 18 in the portfolio, and proceeded to build this $2,200 house in Transylvania Park, Lexington, near the University (§112). The plan was reversed so that the porch would extend around the right instead of the left side, and the living room, originally intended to span the whole front of the house, was divided by a partition with sliding doors, making a small study at the fireplace end of the room to be used by Dr. Maxson for interviewing students (§111). A dining room was connected by the pantry to the kitchen and porch beyond. A stairhall in the center, two chambers and a bath also occupied the first floor. Bedrooms were finished upstairs at a later date. The Maxson bungalow was unique in a community where colonial cottages were considered more fashionable. Deep eaves and curving gables give the house some Japanese flavor. The architect stated that ten years' experience in the Eastern States qualified him "to prepare specifications and make structural details suitable for building these houses in cold as well as in warm climates," an important consideration in Kentucky, which—for a southern state—gets more than its share of snow directly from the Great Lakes region.

Many people throughout America spoke not of bungalow alone but of *California* bungalow. That the house type properly belonged to California was indicated by the heading to the F. G. Brown advertisement, noting that the designs were "Direct from Bungalow Land." Other Los Angeles concerns offered books with such titles as *Representative California Homes, West Coast Bungalows* and *California Bungalow Homes*.[6] A Grand Rapids company, following the trend, entitled its publication *California Bungalows: The Book of the Real Bungalow*.[7] Another, in Minneapolis, issuing *The Plan Shop Bungalow Book*, declared that the "designer is a Californian and knows the bungalow by heart." The following year the "Californian" moved on to Boston.[8] Most of the plans were necessarily simple, because they had to be entrusted to local builders, who may never have seen a bungalow before undertaking to build one. To all intents and purposes these bungalows remained California products, merely transplanted, notwithstanding their being built of indigenous lumber instead of West-Coast redwood.

There was one species of bungalow that did not come from California. It belonged to the eastern half of the United States, the Atlantic seaboard together with the whole Mississippi River Valley. It was rustic, involving wall construction of rough logs. A patriotic note prompted the log theme, because of a prevalent notion that the earliest homes in America were log cabins, although this was not actually the case. The first English settlers went straight from bark-covered "wigwams," resembling Indian shelters, to frame buildings, such as they had known in Britain. The Swedes colonizing along the Delaware River during the second quarter of the seventeenth century introduced the log house to the New World, and it was adopted by the English after the beginning of the eighteenth century. Walls of horizontal logs locked together at the corners required no additional support up to the rafters, and because of readily available materials, the log cabin became the ideal frontier dwelling; Germans, French, Irish and even the American aborigines recognized its merits and built their own versions. A revival of the log house was a by-product of the bungalow movement, deemed especially suitable for vacation retreats in the mountains, and D. V. Stroop built a number of log bungalows for clients in the vicinity of White Bluffs, Tennessee. A typical example was the Charles Basham house (§113). The walls were of spruce logs, retaining the bark outside, and doors and roof shingles were of split cedar. The nearly square plan included an open gallery across the front and a recessed porch between a pantry and bath at the back. A long transverse living and dining hall (18 × 28 feet) occupied the center, flanked by four equisized rooms, consisting of a kitchen and three bedrooms. A stairway entered from the rear porch led up to the dormitory over the hall. The house differs from early pioneer cabins in having a high base-

ment, a complex arrangement with partition joints showing, and an overhanging hipped roof with curved eaves. In these characteristics the Basham bungalow bears a resemblance to the eighth-century Shōsōin, the famed treasure house of the Tōdaiji (monastery) at Nara, Japan (*§114*). The Nara treasury is one-and-a-half times as wide and four-and-a-half times as long as the Tennessee bungalow. However, it is doubtful that the similarities can be attributed to anything besides chance.

The bungalow craze in the eastern United States was influenced by Japanese architecture as much as it was on the West Coast. Where the style was most pronounced it was most superficial, the elements being borrowed from elaborate Japanese types and scaled down to fit small American buildings. The voluminous literature on the bungalow that poured out of California and elsewhere resulted in a sprinkling of unadulterated Pacific-coast houses on the Atlantic side of the Mississippi River Valley. A regional oddity also appeared in the bungalow of log construction. It purported to reflect a type of pioneer house built here a century earlier, but as we have just seen, Asian features proper to the bungalow came to the fore and related it instead to a Japanese treasure house over a thousand years older. Coexisting with these bungalows of nebulous sources of inspiration was a closely-knit group of buildings traceable to the first great American world's fair of the twentieth century, held at a point closer to the exact center of the United States than any of its predecessors and commemorating one of the largest territorial additions to the nation.

The Imperial Japanese Garden
at the
Louisiana Purchase Exposition

THE California Midwinter Exposition at San Francisco, which could not compare for size or importance with its immediate predecessor, the World's Columbian Exposition at Chicago, was followed by several fairs of similar character. In 1898 the Centennial Exhibition was held at Nashville, Tennessee, and featured a full-scale copy of the Parthenon as a permanent monument. Also in 1898 Omaha, Nebraska, presented the Trans-Mississippi and International Exposition. In 1901 Buffalo, New York, sponsored a return of festivities to the Great Lakes region in its Pan-American Exposition, the first fair at which color figured in the lighting. The buildings were distributed along the Court of Fountains, an avenue of water displays terminating at the tall, light-bulb studded Electric Tower, and on its right was the stadium, balancing the midway on the left. Here, in the entertainment area, was a thatched-roof Japanese tea house where native girls in kimono served tea, and in the garden stood a tile-roofed house with a bazaar on the lower floor for selling inexpensive souvenirs (§117). The Pan-American Exposition was the largest of the fairs staged during the decade following the Columbian Exposition, but the Buffalo show occupied less than half the acreage of the Chicago exhibition and was concerned only incidentally with the world outside the Americas.

The next anniversary of a national historical event of sufficient moment to warrant an international celebration was the centennial of the Louisiana Purchase of 1803. Acquisition of the Louisiana Territory from France, made during the administration of Thomas Jefferson, added 825,000 square miles to the United States, almost doubling the size of the existing country and equalling about one-third of its final magnitude. All or parts of fifteen states west of the Mississippi River were carved out of the $15,000,000 investment. Saint Louis was appointed host to the one-hundredth anniversary exhibition, and 1240-acre Forest Park was provided for a fair site. This was close to twice the size of the area occupied by the World's Columbian Exposition and over five times that of the Philadelphia Centennial. The designers of the Louisiana Purchase Exposition chose a more Baroque version of the classic style than that of the Chicago fair for the exhibition halls. The main buildings, or "palaces," were disposed around a gigantic fan-shaped labyrinth of lagoons radiating from Grand Basin, with fountains spouting to a height of seventy-five feet. The background was a great hemicycle of cascades, and on the summit of the hill stood domed Festival Hall, with the Fine Arts Building behind. The vast layout was circumnavigated by public conveyances in the form of boat, train and motor car. The state buildings were grouped in the southeast corner of the park, and most of the foreign displays were in the western section. The Philippine Islands were allotted one of the largest tracts, but it was far from the middle of things, beyond Arrowhead Lake near the west boundary of the grounds. The native village here was made up of thatched-roof huts. More civilized forms of eastern buildings were the Shanghai Restaurant (on The Pike), the Palace of Pu Lun, a Siamese *wat*, the "Temple of the Tooth" from Ceylon, a reproduction of the Tomb of I'timad-ud-Daula at Agra, India, and the Mosque of Omar in Jerusalem, a com-

pound located close to the geometric center of Forest Park. Adjoining this on the west was the Morocco Village, north of which was the Japanese group.

The official exhibit from Nippon was called the Imperial Japanese Garden. Its site provided a slight incline toward the southeast corner. The Japanese at first proposed constructing a replica of Nagoya Castle and incidental tea houses, but the outbreak of war with Russia curbed such an ambitious undertaking. Instead the Imperial Japanese Garden was landscaped with meandering paths among picturesque planting and highlighted with several frame buildings. It attracted its share of public attention (*§115*).

A small body of water wound through the center of the garden. Stepping stones crossed the west end, and an island was in the middle, reached by an arched bridge from one shore and by a plank bridge from the other. A tall bronze crane and a squat stone lantern shared the island. The building nearest the water was a facsimile of the Kinkaku, the three-storied Golden Pavilion near Kyoto, built for the Shōgun Yoshimitsu upon his abdication in 1395 (*§116*). It was a square building encircled by open galleries, which were supported by slender posts, and sheltered by dipping hipped roofs with deep eaves. The first story represented the type of architecture known in Japan as *shinden-zukuri*, in which the whole interior was without permanent partitions and could be divided into rooms by sliding screens. The floor was laid with *tatami*. This was the living space. The middle story was in a mixed style, with decorated ceiling, used by Yoshimitsu for musical and literary parties and other entertainments. The superstructure was set back; its single room was finished in the restrained Zen manner, for an oratory, and entirely surfaced with gold leaf, which gave the building its title. On the apex

§115. Sketch of the Imperial Japanese Garden at the Louisiana Purchase Exposition, St. Louis.

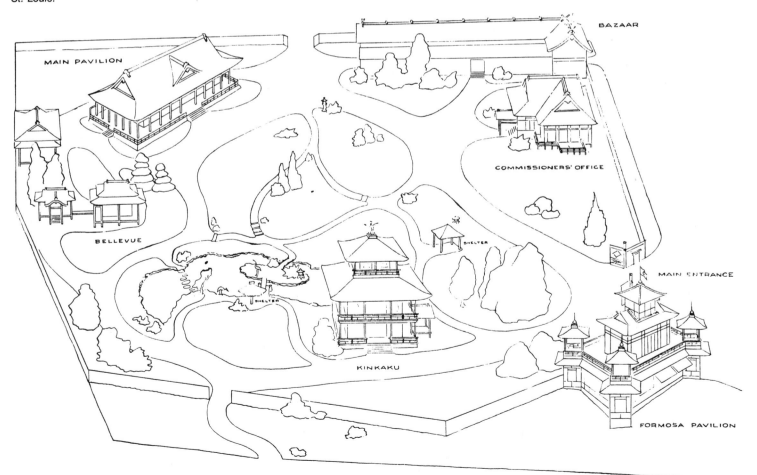

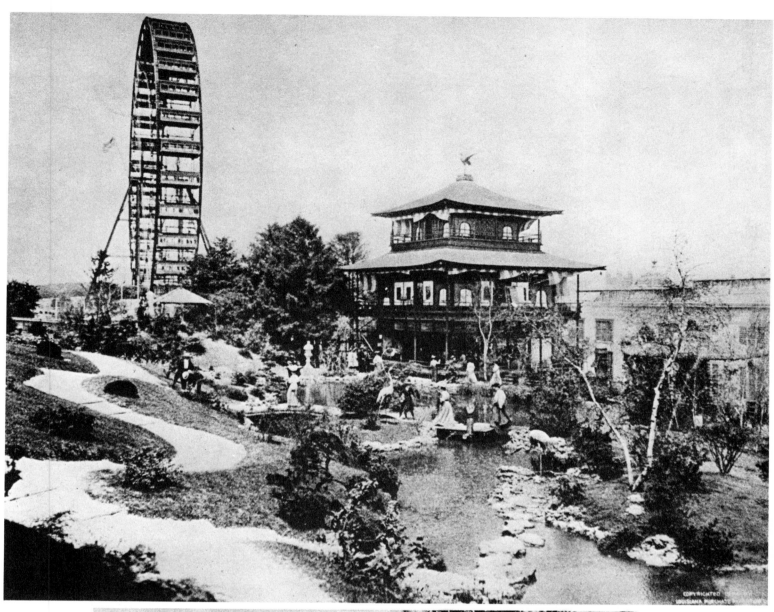

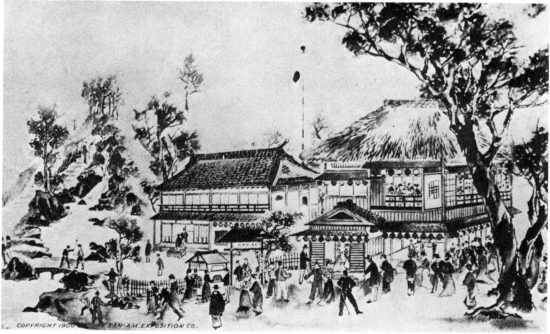

§116. *The Kinkaku at the Louisiana Purchase Exposition. (Stevens,* The Forest City, *St. Louis, 1904.)*

§117. *''Gay Japan,'' a sketch of the Japanese Tea House and Garden at the Pan-American Exposition at Buffalo. (Walden,* With Pen and Camera at the Pan-American Exposition, *Portland, 1901.)*

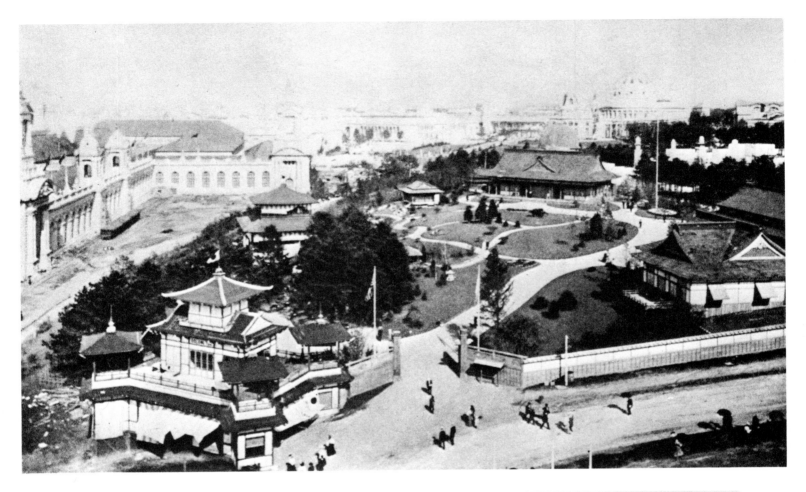

§118. *View of the Imperial Japanese Garden from the observation wheel. (Francis,* The Universal Exposition, 1904, *St. Louis, 1913, vol. II, p. 51.)*

§119. *"The Spider Play in Fair Japan,"* Louisiana Purchase Exposition. *(Memories of the World's Greatest Exposition, St. Louis, 1904.)*

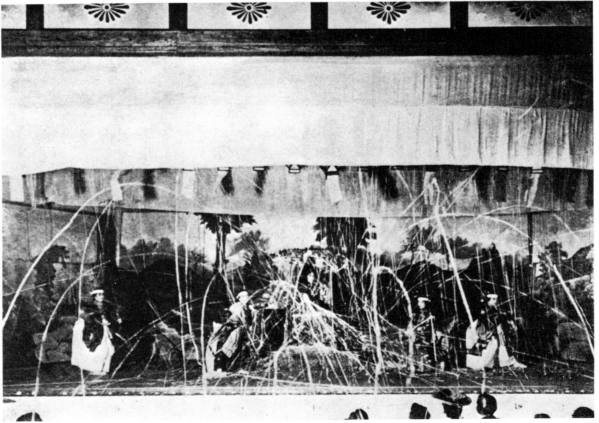

of the roof perched a bronze phoenix bird with outstretched wings. The Saint Louis version apparently was faithfully copied in all details. The original at Kyoto burned in 1950 but has been rebuilt.

A panoramic view of the Imperial Japanese Garden was to be had from the top of Observation Wheel situated near its northwest corner (*§118*). The angle of Machinery Hall enframed the garden on the left, and the domed Festival Hall rose beyond the southeast corner, with the representation of Jerusalem in between. In the foreground was the main entrance to the Japanese area. The Formosa Pavilion was on the slope just north of the gateway (Formosa had been ceded to Japan at the close of the Chinese-Japanese War in 1895), and the building was rectangular with small flankers at the corners. An upper deck expanded into square summerhouses set on the diagonal over the flankers, and in the center was a small hall with a lookout on the roof. Among the trees beyond the Formosa Pavilion could be seen the roof of the Kinkaku. The small structure up the hill to the right was known as the Bellevue. It was composed of many different kinds of woods, no two pieces from the same species of tree, and had been exhibited the previous year by the Forestry Bureau at the Osaka Exposition in Japan.

The Main Pavilion in the Imperial Japanese Garden stood on the highest point in the enclosure, facing the principal entrance opposite. The building was an abridgement of the Reception Hall or Shishinden (Purple Dragon Hall) of the Imperial Palace at Heian-kyo, Kyoto, dating from the end of the eighth century. The Shishinden looked out on a vast flat sanded court used only on ceremonial occasions, the starkness of which was relieved by an orange and a cherry tree planted in square tubs. Two rows of round posts supported timber-framed walls of plaster forming *hisashi-no-ma* (galleries under the eaves) around the throne room proper. The Saint Louis modification had a porch around three sides of a single interior with a small platform centered on the side across from the entrance. The single gable in front, breaking the long plane of the *irimoya* roof, was not on the Kyoto Reception Hall.

The building next in importance was the Commissioners' Office, located halfway between the west and south gates of the garden. It was a compact, L-shaped frame house, with batten siding below windowsill level and half-timber and stucco above. There were carved ornaments in the gables and at the ends of the ridge boards. An unexpected feature adopted from the West was the glass casement windows. The building contained two passages and five rooms. Alongside the Commissioners' Office, to the south, was the long, barn-like bazaar, of no particular architectural interest. It had entrances on the north side and east end inside the Japanese compound, whereas its principal door in the west end opened on The Trail.

Japan was allotted exhibition space in the Agriculture, Forestry, Transportation, Varied Industries, Electricity and Machinery, Educational, Manufactures, Mines and Metallurgy, Liberal Arts, and Fine Arts buildings. There was also an unofficial group of Japanese buildings in the amusement area, near the north entrance to the midway, called The Pike. Here were two gateways. One was an ornate specimen modeled on the Yōmei-mon of the seventeenth-century Tōshōgū Shrine at Nikko. It was an abominable reproduction, with an abbreviated mezzanine, of a gaudy archetype. It appeared in the guide books labeled "The Temple of Nekko." The other was a well proportioned and beautifully detailed two-storied gateway to a Buddhist temple three hundred years old. It stood by a canal providing boat rides. An outside staircase was added for ascent to the balcony level where, presumably, the visitor was rewarded by some kind of an exhibition.[1] The Pike group also included a bazaar and a Japanese theater. At the San Francisco fair only acrobatics had been offered in the theater, but at Saint Louis audiences were treated to a classic of the Japanese stage. It was the Kabuki version of

Tsuchigumo. The guidebooks called it "The Spider Play," and the chants of the actors were translated into English. At the climax of the play the four elaborately costumed heroes—Raikō, Taishō, Kintoki and Tsuna—come upon Tsuchigumo's mound in the forest and close in to slay the monstrous spider, who throws out strands in all directions *(§119)*. Undoubtedly most Americans who witnessed it remember the scene in terms of a New Year's celebration with string confetti.

The Louisiana Purchase Exposition of 1903-04 was by far the largest and most spectacular of American world's fairs held up to that time. Although in a state of unrest and under economic strain due to war with Russia, Japan submitted its most varied display, consisting of a gardened space containing six or seven pavilions, exhibits in ten of the great galleries, and an unofficial set of buildings on the midway. One of the pavilions in the Imperial Japanese garden represented the eleven-hundred-year-old Reception Hall of the palace at Kyoto, and another reproduced the Golden Pavilion, also in the Kyoto vicinity, dating from the end of the fourteenth century. The Golden Pavilion typifies an important milestone in the evolution of architecture in the flexibility of its first story; and it is significant that a facsimile was shown at the first important American fair of the twentieth century. The building opened up in close communion with its hill-and-water garden setting. On The Pike fairgoers could attend a live Japanese theatrical entertainment and purchase refreshments and Japanese souvenirs if they felt so inclined.

Progeny & Transmigrations of the Japanese Buildings for the Saint Louis Fair

THE Kinkaku, or Golden Pavilion, at the 1903-04 fair in Forest Park, Saint Louis, held some features in common with earlier indigenous architecture in the lower Mississippi River region. A type of dwelling built by the French prior to 1762, and afterwards by the Creoles of varied ancestry up through the first quarter of the nineteenth century, was compact, encircled by open galleries with slender supports, and covered by a hipped roof. Because of the saturation of the soil in the lower valley such houses were given a high basement, the first floor being raised a full story off the ground. Some of the later versions showed vestiges of the classic trend, then in vogue throughout America, in columns, cornices and doorways, so that the Kinkaku seemed a return to the functional purity of the original form. Though a foreigner the Kinkaku was not a stranger in this architectural society.

A highly individual residence indebted to the Kinkaku was the home of Captain M. Paul Doullut built in 1905 at the river end of Egania Street in the east suburbs of New Orleans (§121). The three-storied house is rectangular with severed corners, the first two levels surrounded by porches. The walls and posts of the ground story are of white glazed tile or terracotta; the structure above is of wood. The lower floor contains a central transverse stairhall flanked by dining room and kitchen on one side and master bedroom and bath on the other. The main floor has a living room over the dining room, parlor above the chamber, and two bedrooms on the land front (§120). Windows at this stage are tall, supplemented by little elliptical openings filled with colored glass in the splayed corners. The posts outside have wooden balls, graded in size like pearls, strung between them on steel wires. A pressed steel cresting embellishes the eaves and the rooms have pressed steel ceilings and wall revetments, undoubtedly originally polychromed. The general contours and proportions of the house recall those of the Kinkaku and are related to a slightly lesser degree to the earlier regional style. The Doullut house also displays a set of elements that stems from the builder's occupation of piloting boats along the Mississippi, America's great inland waterway. Steamboat characteristics include modified (rather than square) corners, decks, ample outside staircases, narrow inside corridors and gangway stairs, a pilothouse belvedere on top and metal smokestacks. With the possible exception of the tall funnels these appendages of the floating-palace style had been in use in dryland architecture for half a century.[1] The dipping roof gives the Doullut house a dis-

§120. *Plan of the main floor of the Paul Doullut house in New Orleans.*

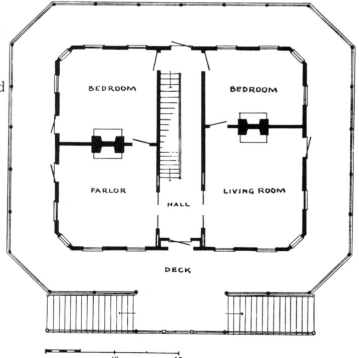

tinctive bungalow flavor. A replica of the residence was erected across the street for a son. The Kinkaku-steamboats made one short voyage—when they were moved back from the river a hundred yards at the time the levee was extended along this stretch of the Mississippi. A bath room was installed in the front of the upstairs hall of the older house about 1950, and the recessed entrance replaced by a little square window.

Going farther afield, the superstructure of the Dreamland Air Ship Building at Coney Island and Blanche Sloan's bungalow at Cedar Manor (*see* §§*107-108*) bear similarities to the Kinkaku. They are square in plan, have encircling balconies, and are covered by multiple hipped roofs with deep, flaring eaves. From the standpoint of chronology the two Long Island buildings could have been derived from the Golden Pavilion at the Louisiana Purchase Exposition.

The two-storied gateway of a former Buddhist temple in the Japanese group on the midway at the Saint Louis fair was taken to Fairmount Park, Philadelphia, where it was re-erected in December, 1905, on or near the site of the Japanese Bazaar at the Centennial (§*122*). This monument was purchased by John H. Converse and Samuel M. Vauclain at the close of the Saint Louis exposition and presented to the City of Philadelphia.[2] The gateway showed off to infinitely better advantage in its park setting than amidst the amusement buildings at the fair. It was originally the main entrance to Taikosan Seionji at Furumachi Village in Hitachi Province, and had been built by Lord Satake Giobu-no-Tayu in memory of his father three hundred years before its removal.[3] The tile roof had a deep blue glaze and some of the wood was painted in red lacquer with bits picked out in white. In compartments to either side of the entrance passage were masterfully sculptured wood figures of heroic size representing the two Ni-ō or guardians, Misshaku and Kongō. They are attributed to Chūin Fujii. At the heads of the posts are carved protomes of lions, elephants and phoenixes, probably by the same sculptor. Paintings on the ceiling were by Tokinobu Kanō.[4] An essay on "Artistic Japanese Features for Gardens and Country Estates" in *House and Garden* in 1907 reproduces a photograph of the Fairmount Park gateway and recommends its second story as ideal for "an outdoor sitting-room or studio."[5] The article relates that this one had been reassembled by Japanese workmen. A snow-viewing stone lantern stood on the next rise behind the gateway and a drum bridge nearby off to one side. One of the great art losses to Philadelphia was the destruction of the gateway by fire on May 6, 1955.

The precedent for Japanese-style dwellings in the Catskills, set by Bruce Price at Tuxedo Park during the mid 1880's, was revived shortly after 1900 with the construction of Grey Lodge near Denning, New York, some sixty-five miles north of the Lorillard estate. Grey Lodge was the summer home of Alexander Tison, whose property extended a mile and a half along the east branch of Neversink Creek, which originates on the southern slope of Slide Mountain, the highest peak in the Catskills. Alexander Tison had been Professor of Law at the Imperial University in Tokyo from 1889 to 1894, and afterwards had resumed the practice of law in New York. He began serving as a director of Japan Society in 1908, the year after the organization was founded, and was President from 1929 through 1931. Grey Lodge was under construction from about 1900 to 1904. Due to the isolation of the site as much use as possible was made of indigenous materials, including chestnut timbers and boulders from the creek bed. The house was planned by Mrs. Tison and built by Joseph Ertz, a local carpenter. An old pencil sketch shows it to have been conceived originally as a bungalow, with the eaves at the first-story level, and a tall living hall with a gallery around the upper part projecting through the roof as a wide dormer (§*123*). Piazzas were recessed to right and left of the living hall, and dining room, kitchen, three bedrooms, a small gun room and two stairhalls

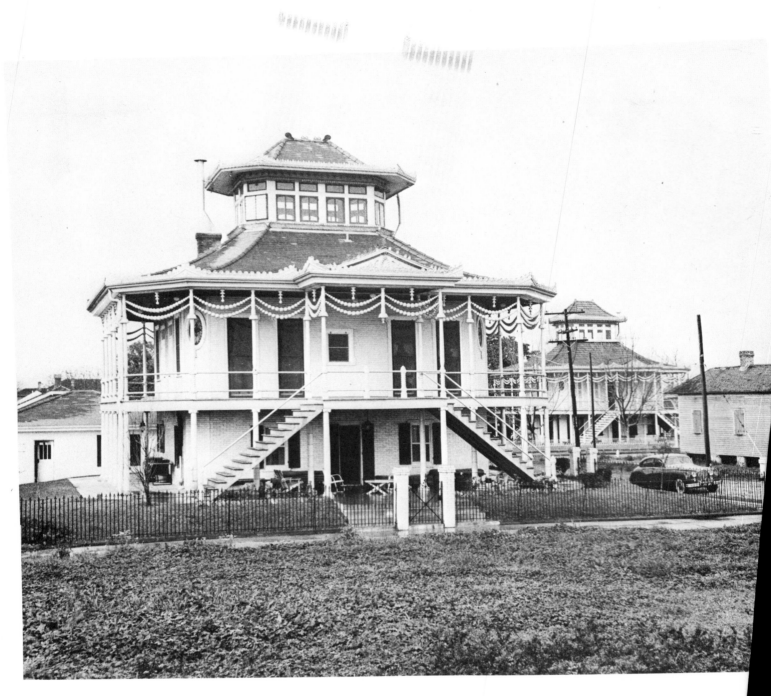

§121. *The Paul Doullut houses, New Orleans.*

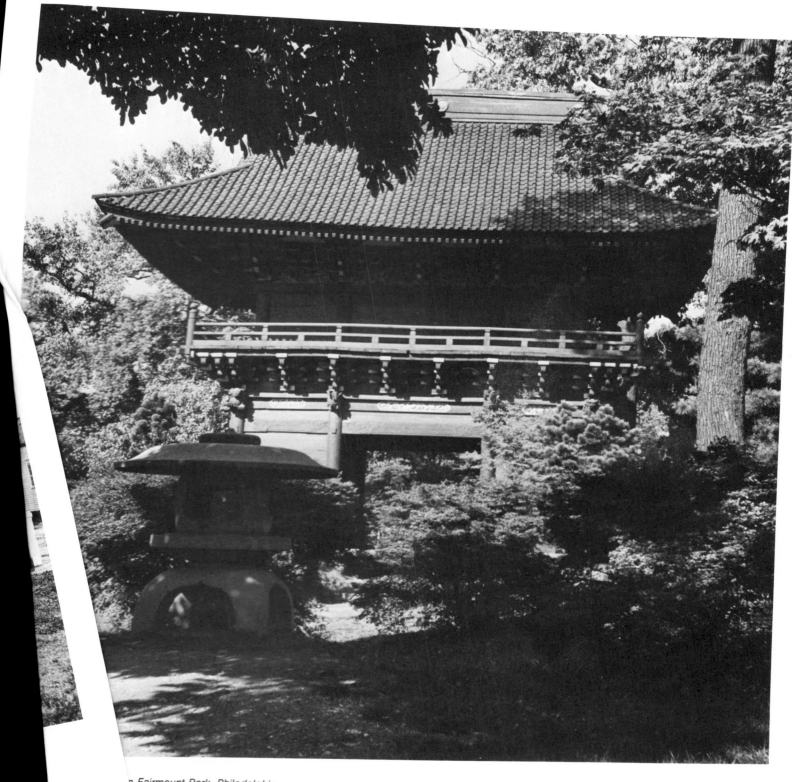

n Fairmount Park, Philadelphia.

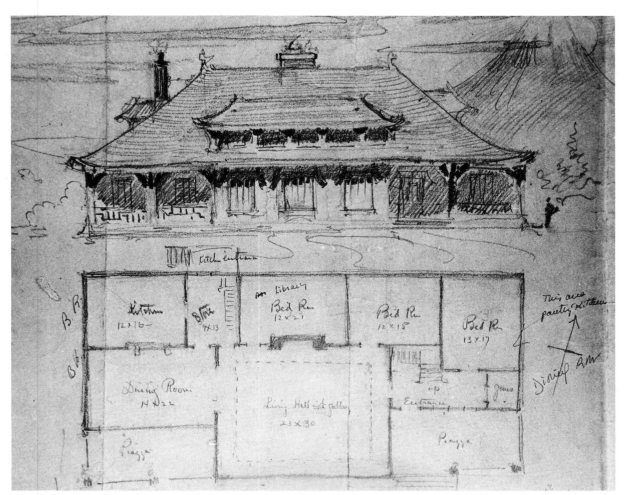

§123. *Sketch elevation and plan for Grey Lodge, bungalow version. (Courtesy Mrs. Helen Hines Caskey.)*

§124. *Grey Lodge near Denning, New York.*

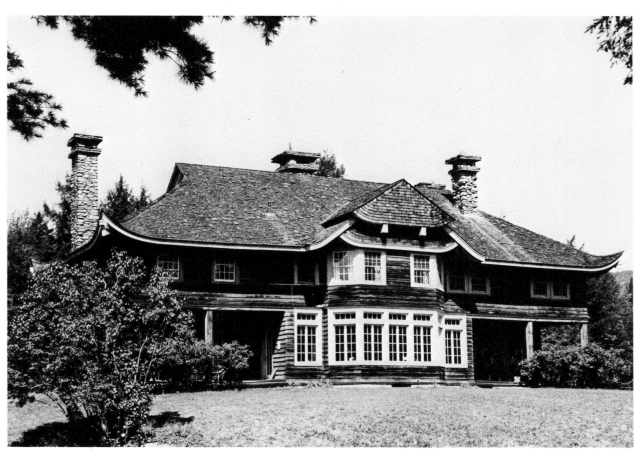

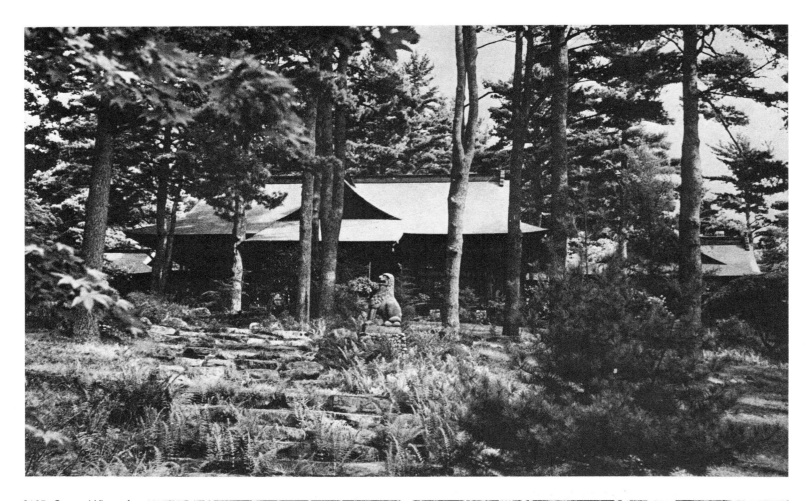

§125. *General View of Shō-fu-den, Merrie-wold Park, near Monticello, New York.*

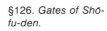

§126. *Gates of Shō-fu-den.*

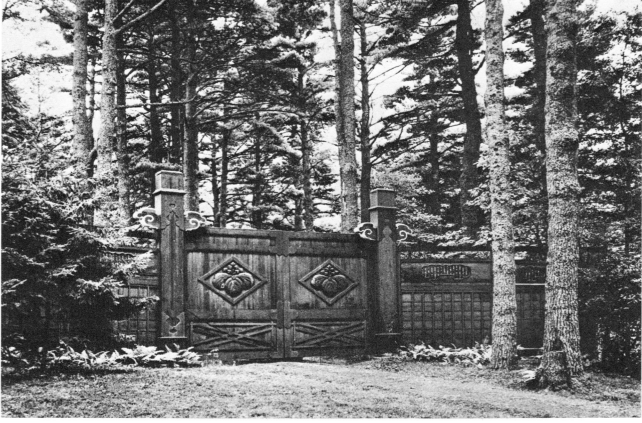

completed the first-floor plan. Several additional bedrooms were to have been located up-stairs.

As built Grey Lodge acquired a short ell at the back and a full second story extending out over the front piazzas (§124). The living room has a more complex shape because of the polygonal bay window and exposed posts and beams, and a library is behind the big central chimney. The dining room is at the left side of the house with the service wing at the rear, and a stairhall and two bedrooms on the first floor occupy the other end of the house. There are seven bedrooms, three maids' rooms and three baths on the chamber floor. The exterior of the constructed house looks more Japanese than the pencil elevation of the bungalow version. The chimney tops have an outline akin to those of the Irwin and Gamble houses in Pasadena. The hipped roof is modified by gables at the top, thus putting it in the *irimoya* category, and the eaves curve upward at the corners rather severely. The double hood over the central bay is a feature unique to the builder. Mrs. Tison wanted a Japanese name for the house, but the next house to it, painted red, was called Red Lodge, and the neighbors started calling the Tison place Grey Lodge, which the owners themselves finally accepted. The brook is land-scaped in the Japanese manner (*Chapter Seventeen*).[6]

Three pavilions in the Imperial Japanese Garden at the Louisiana Purchase Exposition were reconstructed in the Catskills. They were given to the eminent Japanese scientist Dr. Jōkichi Takamine. Dr. Takamine first came to the United States in 1884 as a commissioner to the New Orleans World's Industrial and Cotton Centennial Exposition, and returned in 1890 to apply in the distilling industry the starch-digesting enzyme *Takadiastase* that he had developed. In 1901 he isolated adrenalin from the suprarenal gland, which earned for him an international reputation. During his visit to the Saint Louis fair he learned that the Japanese exhibits were not to be preserved, and he requested several of the structures and some of the stones and plants for his estate at Merriewold Park, a few miles south of Monticello, New York. The residential site has a front of about five hundred feet on the turnpike and is three times as deep. The house was placed near the end farthest from the road (§127). It was com-posed of the Saint Louis Main Pavilion, to which was appended a new service wing at the back, the Bellevue attached to the right flank for a reception room, and the Commissioners' Office converted into a bedroom wing connected by an open gallery to the left rear corner of the principal block (§125). Several driveways led to the house, and the west gates from the Imperial Japanese Garden in Forest Park were installed on the drive nearest the entrance facade (§126). A footpath meandering through the woods from the intersection of Merrie-wold Road and the Monticello Turnpike turned into rough stone steps on the incline in front of the portal. Beyond the house were several service buildings in Japanese style, and on the lake to the west stood a polygonal tea house. The Takamine retreat was called Shō-fu-den, meaning Pine-Maple Villa, from the abundance of trees here.[7]

The noticeable external change to the main pavilion after its reconstruction at Merriewold Park was the extension of a section of the front roof, supported on a pair of posts set several feet in front of the original range, and a corresponding stepping forward of the gallery plat-form. For its new role as a residence the pavilion was divided into three interiors: a central living hall, a dining room on the north side and a parlor or smoking room on the south. The living hall is high and spacious, and richly decorated with pine and maple motifs painted on an antique gold background, the ceiling designs in circular panels being worked into the checkerboard of wood beams. An ornate chandelier with delicately cutout metal parts and numerous pendants hangs from the center. At the side opposite the entrance is a deep ingle-nook, with built-in seats facing one another, and a low ceiling formed by a balcony across this

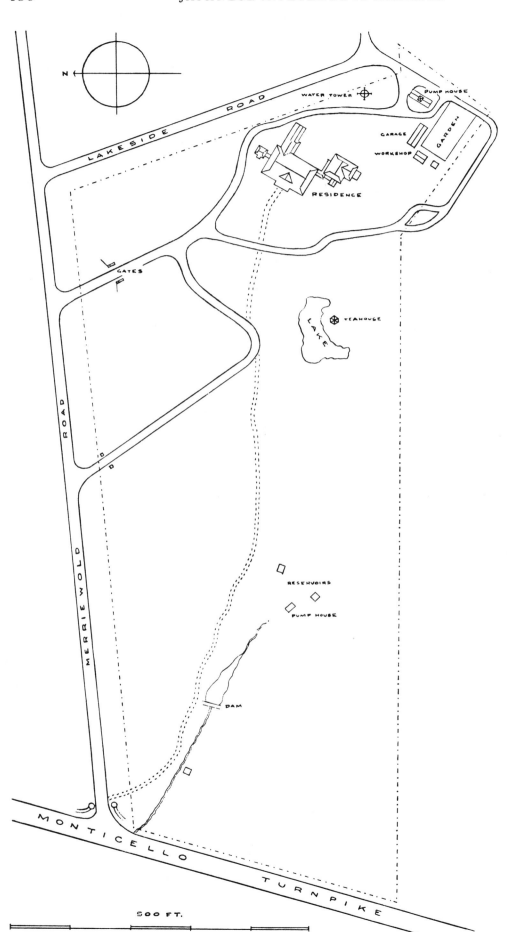

§127. *Ground plan of Shō-fu-den.*

end of the room. The fireplace alcove is a cozy place for intimate conversation. Around the corner is a recess for art objects with a figure in a courtly kimono and a landscape sketched on the backdrop (§128). The room is exceedingly formal, its furnishings including replicas of the imperial coronation chairs, made in Japan by special permission. They were received in 1907 at the time the Emperor's cousin, Prince Kuni, and his princess, came by on their way to Europe, and the chairs were hastily unpacked to be first used by the royal couple. No *tatami* were laid on the floors at Shō-fu-den.

The dining room likewise has a high ceiling and a gallery across the east end over the inglenook. Gold leaf covers the walls, but in place of gnarled tree forms the patterned areas are confined to allover floral swirls and simple geometric devices, repeated on the Western-style chairs (§129). The chandelier is a more severe shape than that in the living hall, in keeping with the residue of the décor of the dining room.

On the other side of the living hall is the parlor or smoking room. It has a lower ceiling than the other two rooms, providing for a sizable garret over it, entered from the end of the east balcony. The parlor, which was taken from a room displayed at the Saint Louis fair by the Tokyo Chamber of Commerce, is a spring room, featuring cherry blossoms. Its mate, an autumn room, is said to have been installed in Dr. Takamine's house on Riverside Drive in New York City. Shō-fu-den contained five master bedrooms and two baths, a kitchen, pantries, laundry, maids' sitting room, four servants' chambers, servants' bath and six storerooms.

Dr. Takamine added substantially to his holdings at Merriewold Park so that within ten years he had an estate of fifteen hundred acres.[8] A large garage, workshops, gardener's dwelling, ice and spring houses and a pump house were near the residence, and additional farm buildings were erected farther off to the north, on land later divided into a separate farm. In front of a beautiful mile-long lake stood a large cruciform barn with curved gables (§130). The south arm of this structure has been demolished. A short distance from the barn is a smaller building of similar shape that served as a poultry house. At one end of the lake was a Japanese boat house, afterwards towed across the water and added to for a vacation cottage.

The town residence of Dr. Jōkichi Takamine at 334 Riverside Drive was built seven or eight years after Shō-fu-den. Although outwardly like its neighbors—in the manner of contemporary Parisian residences—the interiors of the two main floors of the five-storied building were decorated in Japanese style. Professor Makino, of the Kyoto College of Applied Arts, was responsible for the designing of this part of the house, and some of the paintings here were executed by Seigorō Sawabe, who was connected with Kawashimaya, a celebrated art-textile firm of Kyoto.[9] The inner doors of the vestibule were bronze grilles inspired by the eighth-century lantern standing before the Daibutsu-den of the Tōdaiji at Nara. The hall had murals between the round posts that supported the cross-beamed ceiling on prominent brackets. Several steps at the back rose to the inner hall containing the main staircase. The stairwell was decorated after the style of the Phoenix Hall at Uji.

At the front of the second story was the drawing room, which also was inspired by the Hōō-dō, not only in its styling but in the painting on the *fusuma*, which pictured two representations of the famed temple as the setting for a ceremonial scene (§131).[10] The treatment of the upper part of this room is exceptionally well scaled and pleasant. As at Shō-fu-den no *tatami* overspread the floor; instead it was covered by a large rug of Kyoto weave and several smaller Chinese examples. Chairs were stiff and square and formal, but light coming from outside was softened by rice paper in the windows. The dining room on this level was similarly endowed; the cornice was identical, but an inner grille replaced the painted ceiling panels.

The three upper floors were treated in Western style after designs by John Van Pelt, Professor of Architecture at Cornell University and a cousin of Mrs. Takamine, the former Caroline Hitch of New Orleans. Mrs. Takamine sold the Riverside Drive mansion soon after her husband's death in 1922, and five years later fire ruined the Japanese interiors beyond repair.

The third Catskills retreat in the Japanese style of the opening years of the twentieth century was the Frank Seaman estate, located about fifteen miles below Grey Lodge and twenty-five northeast of Shō-fu-den, near Napanoch. The Seaman place was given the name Yama-no-uchi, "Home in the Mountains," by a personal friend, Marquis Itō. Buildings on the thousand-acre estate were constructed in 1907-08. One of the two entrances was a Japanese gateway, composed of intersecting posts and cross beam with shaped finials and having double batten leaves that swung inward across the driveway, and a small pedestrian door to one side. A freestanding post in front supported a lantern under a miniature gabled roof.[11] Most of the buildings were constructed in the Japanese manner, the walls composed of flush horizontal boards held in place by vertical wood strips, protected by deep overhanging eaves, but they had normal Western sash windows and boulder chimneys that spread wide at the base (*§132*). In some respects these buildings resemble the Greene brothers' contemporary houses in southern California. The stables at Yama-no-uchi were like a Japanese castle, set high on a battered stone podium and with upturned roof corners.[12] An elevated tea house, set behind an open timber fence containing a tiny roofed gateway, was one of the most faithful reproductions of Eastern building forms here.[13]

Mr. and Mrs. Seaman had visited Japan in 1902-03. Their tour was for the purpose of collecting ideas about the niceties of hospitality, that later they were to apply at Yama-no-uchi. They entertained many visitors on the estate, often between one hundred and two hundred persons at a time. The visitors were paying guests, who were lodged in rustic surroundings, but given a sumptuous cuisine and ample services. Guests had to be recommended, and a club-like atmosphere was maintained. Rates were fixed, with no additional charge for extras, whether champagne for dinner or a permanent wave. The establishment had its own trout hatchery, Jersey dairy, and poultry houses, the last of which acquired a nationwide reputation for a special breed called Yama Black Minorcas.[14] The house servants and farm workers were Japanese.

The Seaman residence itself was not architecturally Japanese. It was a low and spreading log dwelling with tall cobblestone chimneys. However, the principle of simplicity used throughout was admittedly Japanese. Along the edge of the mantel shelf of the living room fireplace was inscribed a passage from Okakura's *The Book of Tea*: "Let us linger here in the beautiful foolishness of things." Another inscription expressing the philosophy of Yama-no-uchi was engraved on a copper plate set into the chimney above. It was composed by the venerable naturalist John Burroughs, a frequent visitor, and read: "I come here to find myself; it is so easy to get lost in the world." Frank Seaman presided over the resort for thirty years, and after his death Mrs. Seaman remained for another fifteen, until her passing in 1954.[15] During the heyday of Yama-no-uchi the nearby town was sometimes referred to as "Nipponoch."

The association of Japanese domestic buildings with the Hudson River country was brought out in a hypothetical way in 1916 through a competition for a house to be designed in Japanese style for this locale. The contest was sponsored by Yamanaka and Company, importers of Eastern art objects to America since the early 1890's, and was open to young architects and draftsmen in Japan. Specifications called for a suburban residence of two stories, with garret

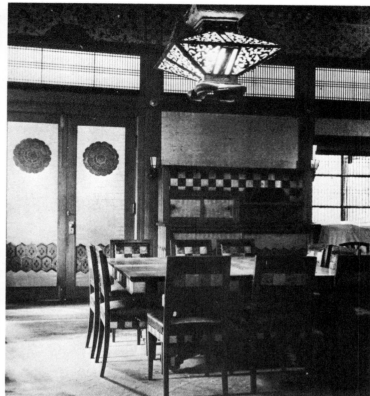

§128. *Detail of the living hall, Shō-fu-den.*

§129. *Dining hall at Shō-fu-den.*

§130. *Exterior of the barn at Shō-fu-den.*

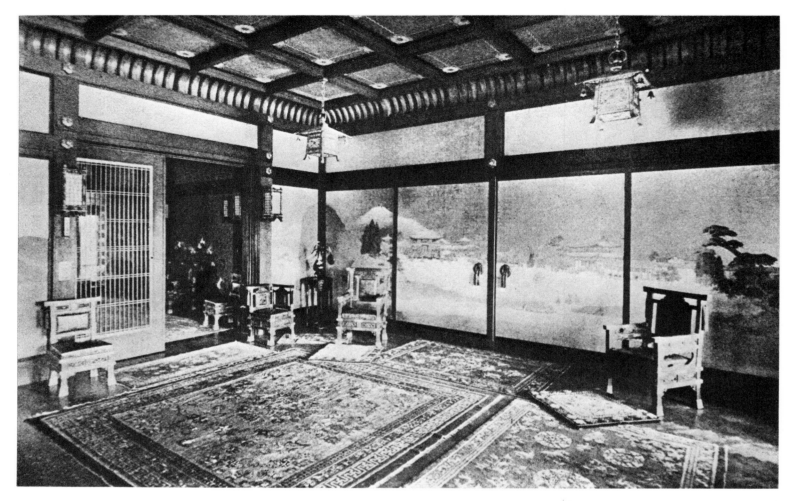

§131. *Drawing room in Jōkichi Takamine's Riverside Drive home, New York City.* (Arts and Decoration, *April, 1914, p. [216].*)

§132. *Office and lodge building at Yama-no-uchi, Napanoch, New York.*

and basement, to contain living and dining rooms, library, kitchen, pantry, four bedrooms and bath, and to cost no more than $20,000. Although it was to be Japanese throughout, an exception was made in that no *tatami* were to go on the floors. The house was to be placed on a lot measuring 100 by 150 feet, lying between a highway and a large river. Entries had to be submitted in Japan by August 31, or would be accepted by the Yamanaka Gallery at 254 Fifth Avenue, New York, up to October 15, 1916.

The first prize, accompanied by a purse of 300 yen, was awarded to Iwao Shimizu of Tokyo. In this design the house was situated about halfway back and near the north boundary of the lot (*§133*). The residence was compact and pleasingly articulated, of frame construction and crowned by a roof of slight convexity. The first floor consisted of the foyer and library at the front, the living room behind the stairhall on the south side, and a verandah and dining room across the back, overlooking the river. A pantry, kitchen, service stairhall and lavatory occupied the middle area between the dining room and library. The upstairs, which was mostly encircled by a balcony, contained three bedrooms, a sleeping porch, two baths, dressing rooms and closets. The staircase around a square well was an especially attractive interior feature. The third-prize design in the Yamanaka competition chanced to look somewhat like the Japanese Dwelling at the Philadelphia Centennial.[16]

The contributions to American architecture made by the Japanese buildings at the Louisiana Purchase Exposition at Saint Louis were due in part to their own aesthetic and structural merits, in part to their affinities to pre-existing building forms, and in part to circumstances. The design of the Kinkaku mirrored a local type in the Deep South, and in turn itself was reflected in the New Orleans suburbs in combination with belated Mississippi steamboat and

§133. Yamanaka Competition first prize design by Iwao Shimizu. (Architecture, February, 1917, p. 32.)

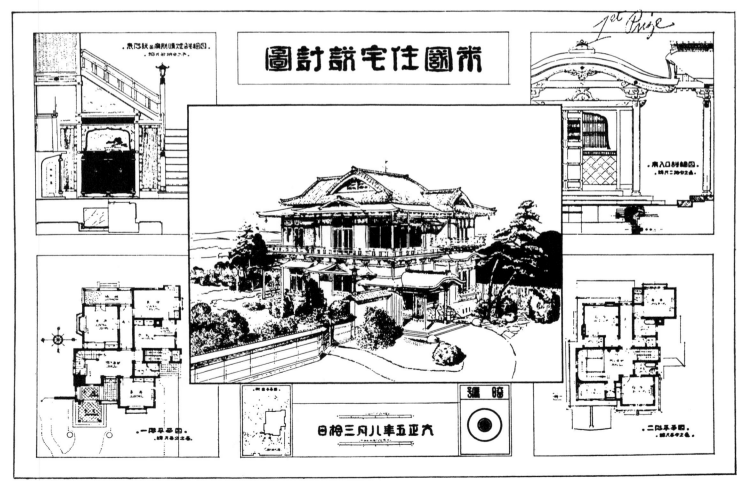

contemporary bungalow elements. A three-hundred year old Japanese temple gateway exhibited at Saint Louis in 1903–04 was purchased privately and set up as a public monument near the site of one of the first buildings from Nippon in America, the Bazaar at the Centennial in Fairmount Park. Three pavilions from the Imperial Japanese Garden at Saint Louis also came eastward, and were reassembled as a villa in the Catskill Mountains, where the Japanese style had been implanted by Bruce Price at Tuxedo Park in the mid 1880's, and where an American barrister and former professor of law in Japan recently had erected a sizable summer lodge in the same style. The reassembled villa, accompanied by many farm buildings on a vast estate, formed the country seat of the scientist Dr. Jōkichi Takamine. A newly constructed counterpart twenty-five miles away on another large tract was a hostelry and profitable farm, run by an American couple with Japanese help. More than mere coincidence was involved in the repeated linking of Japanese architecture with the Catskills and the Hudson Valley, for the picturesqueness of the style suited the rusticity of the setting. The area bordering the Lordly River has long been a retreat for people with romantic tendencies, and the Japanese style housed them adequately during its term of popularity.

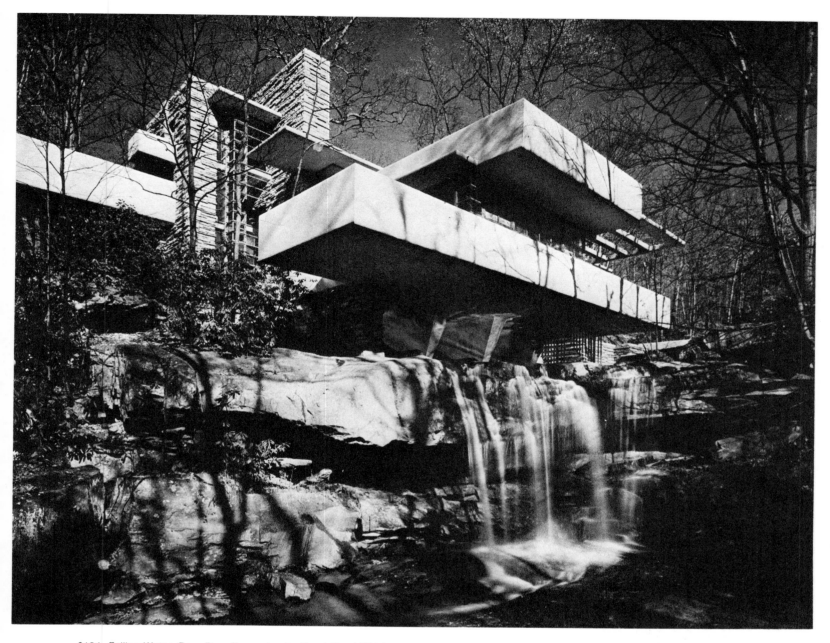

§134. *Falling Water, Bear Run, Pennsylvania, Frank Lloyd Wright, architect. (Bill Hedrich, Hedrich-Blessing.)*

§135. *The plunge at Falling Water. (Bill Hedrich, Hedrich-Blessing.)*

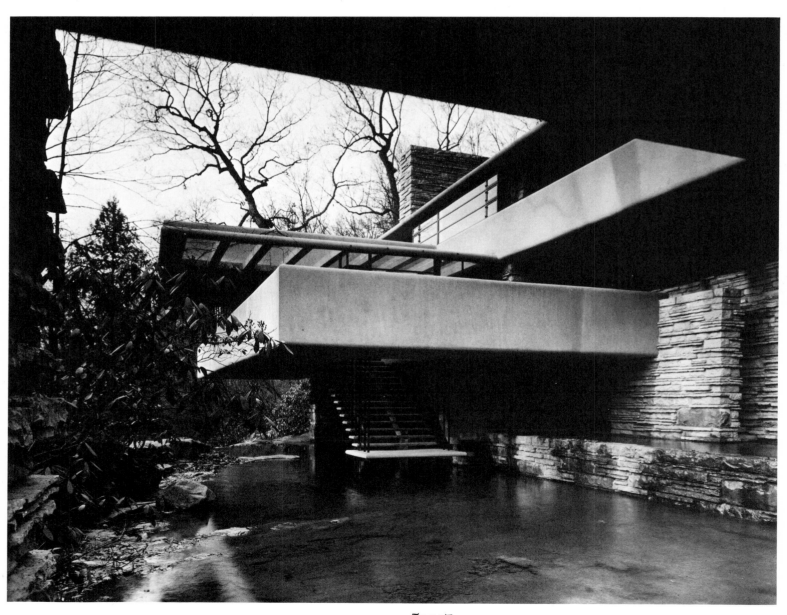

The Influence of Japan
upon Modern Architecture
in the Eastern States

THE cataclysm into which the globe was thrown by World War I was discernible in architecture no less than in any other field of human endeavor. The violence and turmoil of this war had the effect of sweeping away certain previously held ideas and values and left a vacuum which had to be filled with ideals that could come to terms with the new attitudes toward the nature of mankind. The emotional fervor that fed, and in turn fed on, the war was necessarily counterbalanced by a pure rationalism that in building took the form of solid geometry. Thus was developed the International Style—out of self-conscious antecedents, it may be added, which go back to a particularly severe phase of Art Nouveau at the beginning of the century.[1]

As the name implies the International Style aimed at something universal, something that transcends ethnic characteristics, periods and superposed modes. The keynote of the International Style was functionalism, and this had to do with the specific use of the building, which was considered in conjunction with forthright construction. In 1921 Le Corbusier proclaimed: "The house is a machine to live in," thereby linking the dwelling with the most purely utilitarian of man's devices, voiding it of architectonic design as had been known previously, if not completely dehumanizing it. The result was that the house was made like a factory. Planning and the handling of space were treated with economic intent, and traditional-looking materials were scorned in favor of uncompromising planes and cubes of concrete. Houses no longer had catch-all places such as garrets and basements—as if people were not supposed to keep anything they could not immediately use. The triumph of the intellect succeeded in giving the habitation an antiseptic realism. But it was not long to be endured. The new ideology had to be re-evaluated. People began turning an appreciative eye once more toward earlier models, ranging from New England saltboxes to California bungalows, Spanish colonial *ranchos* to Pennsylvania stone barns, and Southern raised cottages to Chicago prairie houses. Yet the International Style had left its mark of external restraint and had established firmly the principle of organic architecture. This last had been the familiar watchword of the early Chicago School, that Europe had learned in part from Frank Lloyd Wright.

Influence from the Far East played as much of a role in American architecture during the two decades following World War I as it had during the same period preceding. In some cases it was as readily recognized as before, but in others it was manifested in an analytical and more abstract manner. This can be seen especially in the postwar work of Wright. His roofs had gone through a metamorphosis from the outward-sloping gable kind, to low-pitched hip roofs, to flat slabs; and his walls of half-timbering were changed to brick, "textile block" and eventually poured concrete. By the mid 1930's Frank Lloyd Wright's architectural art was fully developed. It was organic, and the precedent was Farther Asia; yet it no longer depended upon the outward appearance of Japanese buildings. Organic architecture, Wright had come to realize, was traceable back to a venerable figure of the Chou Dynasty in China. He thus recorded his discovery of the real source of the idea:

"Although I did not know it then, the principle now at the center of our modern movement was very clearly stated as early as five hundred years before Christ by the Chinese philosopher Lao Tze...that the reality of the building consisted not in four walls and a roof but inhered in the space within, the space to be lived in...my own recognition of this concept had been instinctive; I did not know of Lao Tze when I began to build with it in mind; I discovered him much later...quite by accident...and...for some time I felt as a punctured balloon looks."[2]

Lao Tze, an older contemporary to Confucius, has but one short essay attributed to him. It is composed of about 5600 characters and called the *Tao-tê-ching*, the Reason-Virtue Canon. The passage referred to occurs about one-eighth of the way through, in verse number eleven according to divisions made at a much later date. The verse states that the usefulness of certain things depends not upon that which tangibly exists but upon what does not exist, citing the axle-hole of the wheel, the hollow inside of the clay pot, and the empty volume of a house. As the testament of Taoism the *Tao-tê-ching* became well known to all the peoples of Eastern Asia who adopted the reading and writing of Chinese characters, and its terse wisdom became deeply ingrained in their thinking. The West was not open to accepting a concept of architecture so radically different from its own during the period of Chinese Taste, but got it from the Japanese (instinctively or otherwise) at a later date. As we have seen, Wright traced it exclusively to the Japanese when writing in 1908 *(Chapter Nine, note 7)*.

The most distinguished modern house in America, and the American modern house most famous throughout the world, is Falling Water, the retreat of Edgar J. Kaufmann at Bear Run, Pennsylvania, built by Frank Lloyd Wright in 1936. It is placed over a stream near a waterfall, in a ravine that had been a favorite haunt of the owner *(§134)*. The situation presented baffling practical and aesthetic problems, but the architect proved himself sufficient engineer and artist to solve them magnificently. Vertical piers of stone rise from the rock bed of the stream and the cliff behind the house, and anchored to these rough uprights are smooth concrete horizontals that extend outward suspended in space. The combination attains a rare compositional perfection of harmonious contrasts. The shapes that make up the Kaufmann house are simple yet complex, sturdy yet light as air, studied yet casual, well defined yet intangible and functional though somewhat elusive and unreal. Conventional house parts— wall and window, door and roof—have been laid aside for ascending and hovering solids of pure design. The design imitates and continues in abstraction the forms that Nature has provided here. The building is so well suited to the setting that it becomes an integral part of it.

Falling Water is spacious without being roomy, the main story containing a large living room that expands into several recesses. Facing the entrance is a great fireplace with a hearth of natural stone *in situ*. The farther end of the room is practically dissolved into glass and opens out onto uncovered terrace balconies. A kitchen has a separate entrance stairs from the driveway. On the second floor are one bedroom and bath off the landing and two master bedroom suites off the hall. The third story includes a gallery and another bedroom and bath. The bedrooms have their individual terraces and some are connected by outside staircases between levels.

The unusual site of the Kaufmann house is like that of certain buildings in the Orient, recalling a Lamaist monastery perched high above a mountain pass, a pagoda with roofs fluttering over a sea of cherry blossoms, the Phoenix Hall on an islet in a lake, or a Cantonese merchant's mansion on a navigable waterway *(§138)*. The dramatic impact of Falling Water is three-dimensional, involving the integration of inside volumes with outer forms and the spatial relation of the house to surrounding landscape. A flat elevation drawing—that can

impart the full design intent of a traditional Western building such as a Greek temple or Renaissance palazzo—would be practically meaningless here. This is equally true for buildings of Farther Asia, or, one might say, for organic architecture wherever it happens to be. As opposed to the static property of classic Occidental building, the organic is dynamic and even romantic. In the Kaufmann house this is expressed in a contemporary vernacular, conscious of cantilever, plane and trellis, textured stonework and reflecting glass (§135). A suspended staircase descending from the living room to the plunge is enigmatic as to its purpose. With the waterfall at the edge of the house on the left, a boat could not be used here, and the swimming pool, a few feet away, has its own steps from the balcony between the stone walls farther to the right. The prototype for the feature in question may have been the main entrance stairs to the Hiunkaku (Flying Cloud Pavilion), a lodge erected by Taikō Hideyoshi at Kyoto in the sixteenth century. The stairs can be reached only by boat. One comes up into the *funairi-no-ma* (entrance hall) through sliding panels in the floor (§139). The building is in the Teki-suien (Garden of Trickling Verdure), which is in the precincts of the Nishihonganji, and is a monument available to the public. The suspended staircase of the house at Bear Run is evidence that the late phase of organic architecture was not wholly within the realm of functionalism, however much the two may seem to correspond.

Frank Lloyd Wright built a guest house and swimming pool next to the garage on the hill above Falling Water in 1939. The low-lying structure was connected to the main house by a roofed-over curved walk with intermittent stairs. The two buildings relate in identity of materials more than anything else. Wright applied the hovering balcony motif of the Kaufmann house to a number of projects during the 1940's, although carried out in materials other than concrete. More often than not they were of lapped wood siding. The genius of Wright comes through in his ability to achieve a great work of art using base materials and an insignificant scale. The John C. Pew house at Shorewood Hills near Madison, Wisconsin, offers tangible evidence of his brilliance. The little two-storied house was erected in 1940 on

§136. *Sketch of the John C. Pew house, Lake Mendota, near Madison, Wisconsin. Frank Lloyd Wright, architect.*

the slope overlooking Lake Mendota *(§136)*. A stone chimney and foundation piers stabilize the otherwise wood construction. The open carport and entry are on the upgrade side. Adjoining the chimney is the staircase, and the living room and balcony are beyond. The dining area and work space (as Wright called integrated kitchens) are around to the right. The square upper story accommodates three small bedrooms and a bath; its hall opens out onto a roof terrace over the living room. The scale of the Pew house is Japanese: except for a raised panel above the hearth in the living room the ceiling height of the main story is less than seven feet.

The combined engineering and poetic proficiency of Wright is nowhere shown to better advantage than in the Johnson Wax Administration Building in Racine, Wisconsin, begun the same year as Falling Water and completed in 1939. The main office space is a vast room with alignments of slender round piers tapering outward to support broad disc caps. Daylight filters through lozenges of green-tinged glass tubing between the discs, creating below the effect of being underwater in a lily pond. Similar tubing forms a clerestory at the junction of wall and ceiling, thereby negating the wall of all structural significance. Ten years later Wright was called upon to build an adjoining research laboratory for the same concern. He decided to avoid the usual dark experiment station depending entirely upon electricity for illumination, and conceived the new structure as a many-storied tower clothed in a glass garment *(§140)*. A central supporting shaft was left hollow for circulation and utilities, and the floors were alternately square and round. The glass dress was tubing identical to that used in the administration building. The research solarium was called the Helio Laboratory. An

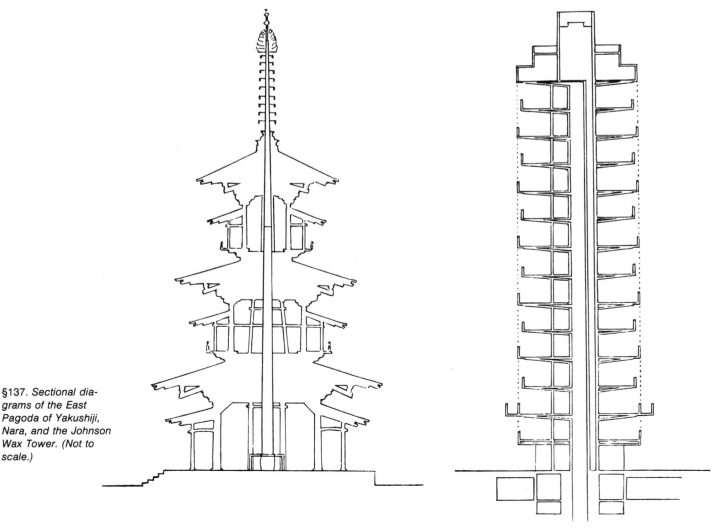

§137. Sectional diagrams of the East Pagoda of Yakushiji, Nara, and the Johnson Wax Tower. (Not to scale.)

§138. *House of a Chinese merchant near Canton. (Wright,* The Chinese Empire Illustrated, *London, [1858/59], Vol. I, facing p 78.)*

§139. *Entrance hall of Hiunkaku, Nishi-honganji, Kyoto, Japan. (Emori,* Cha-shitsu, *Osaka, p. 83.)*

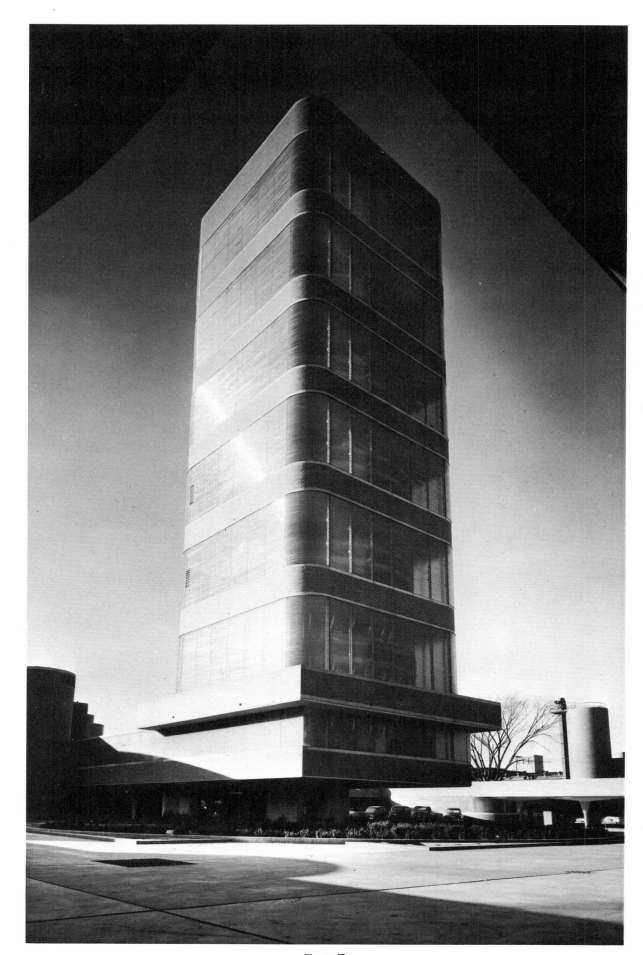

§140. *Johnson Wax Research Laboratory Tower, Racine, Wisconsin. (Ezra Stoller.)*

analogy may be drawn between the floors cantilevered from the central shaft of the Johnson tower and the mast construction employed in Japanese pagodas. A good example for comparison is the eighth-century East Pagoda of the Yakushiji at Nara, which has roofs and floor levels of interchanging projection depths (*§137*). The central posts in Japanese pagodas, however, do not support the structure.

As a romantic tendency colors the modern architecture of Frank Lloyd Wright, a classic predisposition flavors that of Philip Johnson. In Johnson's work every element is placed in symmetrical response to some other and each bears a close and logical relationship to the total design. This is not to say that Philip Johnson belongs to the functional school, because, like Wright, he is far too much concerned with aesthetics, as regards both whole effects and minute details. His buildings are characterized by great restraint. This is clearly in evidence in Johnson's former home at 9 Ash Street, Cambridge, Massachusetts, built in 1942 (*§141*). The almost square corner lot was enclosed by a nine-foot plywood wall, which was conspicuous because it was in the midst of a typical new England neighborhood of conventional houses surrounded by open lawns. The flat-roofed house occupied a strip at the back, two-fifths the depth of the property, and was separated from the stone-paved forecourt only by clear glass, with doors into vestibule and living areas. Curtains provided privacy, but interior space and court were virtually one, forming a microcosm shielded from the outside world, like a Japanese house with its walled garden. Less evident, but no less important a Japanese characteristic, is the use of a standard unit of measure throughout the Ash Street residence. It determines the proportional relations of house parts in the same way that the *ken* assures the Japanese builder of pleasing visual effects.

Sophisticated simplicity is the keynote to the guest house on East Fifty-third Street in New York City designed by Philip Johnson for Mrs. John D. Rockefeller, 3rd, and built in 1950. The narrow facade has the front door centered in a brick wall of lintel height, and translucent glass above is held in a framework of metal flanges. A servant's room and bath are upstairs. The main story consists of an entry, kitchen and incidental stairway on the street side, and a living room behind. The living room opens onto a terrace and a court-pool, with square slabs crossing the water to the bedroom suite in a separate unit (*§142*). A graceful maple tree rises

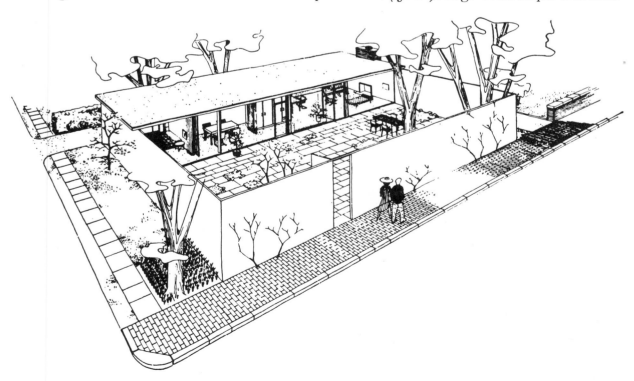

§141. *Perspective Sketch of the Philip Johnson house, Cambridge, Massachusetts. (Mack,* Built in USA, *New York, 1944, p. 47.)*

from a drum in the water and ivy climbs on the wall behind. The window end of the living room is sheltered by a canopy of white glass transmitting diffused daylight such as comes through rice paper, and a similar quality is achieved in the flush ceiling lighting panels at night. Although without literal translations, the effect is thematically Japanese. The Rockefeller guest house was given to the Museum of Modern Art in 1955.

The Japanese influence upon American architecture underwent a purist phase during the middle years of the twentieth century. This was brought about by a resurgence of interest in Japanese building, due in part to two publications and an imported building, the presentation of which in itself was an impressive recommendation. Both publications date from 1936. The first is a thirty-six page booklet with cardboard covers by Bruno Taut, a Prussian, who, during the 1920's, had been an engineer and designer of housing communities in Germany. In 1933 Taut went to Japan as an authority on architecture and industrial design. He spent some of his time investigating and re-evaluating Japanese architecture, and on October 30, 1935, he disclosed his conclusions in a Lecture Series on Japanese Culture sponsored by the Kokusai Bunka Shinkōkai (Society for International Cultural Relations) at the Peers' Club in Tokyo. The talk with twenty-five illustrations was published the following year in essay form, under the title *Fundamentals of Japanese Architecture*. Bruno Taut took the position that the West misled the Japanese into thinking the peak of their architectural attainment was the ornate sanctuaries at Nikko. In actuality, he said, Nikko shows an undigested conglomeration of borrowed elements that are not Japanese at all. Sure, simple native taste is to be found in the early Shintō shrines at Ise, in medieval Japanese farmhouses, and especially in the Katsura Villa near Kyoto, the last of which was planned and built during the second quarter of the seventeenth century. Unlike the contemporary group at Nikko, weighted down by the "ostentatious architectural conceptions of the war-lords," the Katsura expresses a freedom of design "in which harmony arises from absence of coercion," thus becoming "a completely isolated miracle in the civilized world." The author reveals his background by labeling his favorite villa "international" and "eternal." The Katsura Villa was a return to innate Japanese artistry, after centuries of being deluded by foreign imitations, brought about by the stabilizing force of Zen ideals that eschewed extraneous ornamentation and abnormalities of proportion. Buildings referred to in the text are represented among the plates at the back of Taut's book, and these include an elevation of the Hiunkaku, of which the staircase leading up from the lake has been compared to the suspended flight of steps at Falling Water.

The second publication of 1936 was Jirō Harada's *The Lesson of Japanese Architecture*, issued at London and Boston. C. Geoffrey Holme, writing in the Introduction, states that the "Lesson" is intended for the Western world, and may be "summarized briefly as standardization, variety in unity, conformity to a mode of living, connexion with nature, simplicity and, of course, usefulness to purpose." Harada's text consists of three chapters, entitled, "A Short Historical Survey," "General Observations," and "The Japanese House Today." They are accompanied by seven diagrams and 158 plates. The chapter of most concern is the second, in which Harada gives the following characteristics of Japanese architecture. Japanese buildings are built of wood, and they are dominated by the roof, which has deep eaves; branched brackets occur on religious edifices, and the members, usually, are left unpainted. The Japanese love of nature demands the use of natural materials. Japanese taste may be summed up in the word *shibumi* (or *shibui* as we now spell it), which stands for all that is "quiet, delicate and refined...austerity in art without severity." Buildings in Japan are laid out according to a convenient unit called the *ken*, a six-foot measure originally applied to the bay between building posts. Squared, it is called a *tsubo*. Mats (*tatami*) are made the length of a *ken* with half

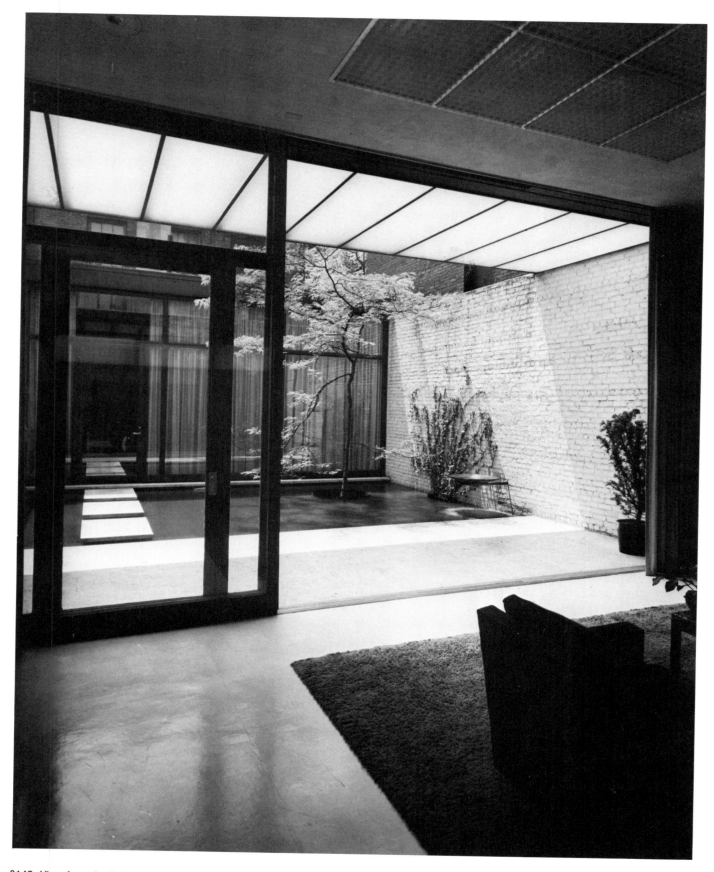

§142. *View from the living room into the court, Rockefeller Guest House, New York City. Philip Johnson, architect. (Robert Damora.)*

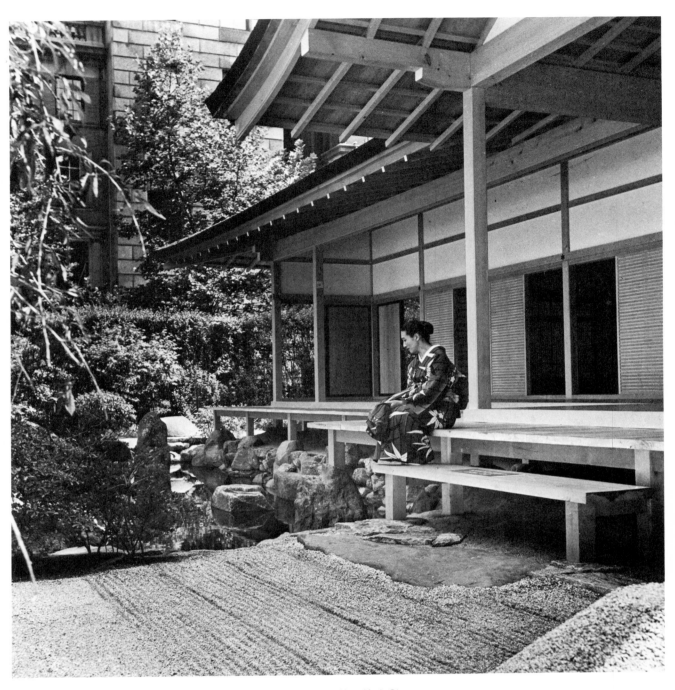

§143. *The Japanese Exhibition House, The Museum of Modern Art, New York City.*

the width. Timbers are finished in multiples of the *ken* plus a little extra to allow for dressing. Proportions have been carefully studied and standardized for unerring visual effects. Changes in one dimension must be accompanied by corresponding changes in every part of the building in order to avoid discord. The focus of the Japanese house is the *tokonoma*, or recess for the display of art objects, usually adjoined by the *toko-waki* (*tokonoma*-side) with *chigai-dana* (shelves on different levels) and small cupboards with sliding doors. The two recesses are divided by the *toko-bashira*, which is the most important pillar in the house (for determining proportions) and usually this is a natural log, somewhat crooked, but highly polished. The photographs reproduced were selected with an aim to "improving living conditions," which meant making Western homes more attractive—in the manner of the Japanese. In 1954 *The Lesson of Japanese Architecture* was brought out in a revised edition.

Another native European architect already in Japan at the time of Taut's arrival was Antonin Raymond. Born in Czechoslovakia and a naturalized American, Raymond had apprenticed to Frank Lloyd Wright during 1916-17, and in 1920 had followed him to the East. He remained to practice in the islands. Some of his work there resembles that of Auguste Perret and Le Corbusier, and some—especially the smaller houses—relates to indigenous building. The weekend cottage of Shirō Akaboshi at Fujisawa, Mr. Oka's cottage in Karuizawa, and the architect's own thatched-roof summer quarters nearby at the foot of Mount Asama are typical.[3] The last was a mixture of International Style and Japanese. In the living room the ramp up to the draftsmen's dormitory and studio was inspired by a Le Corbusier design in a South American mountain home, whereas the walls, ceilings and floors of the rooms were of wood, with fibre mats in the bedrooms. The summer quarters exemplify Raymond's objective of conserving "as much as possible... (Japanese) mobility by using sliding partitions, windows and folding-screens."[4] Antonin Raymond returned to America during the late thirties, remodeled an old stone house for a home at New Hope, Pennsylvania, and opened an office in New York. His buildings continued to be predominantly wood. Raymond wrote an article on "The Spirit of Japanese Architecture," published in the December, 1953, issue of the *AIA Journal*.

In 1939 the Japanese erected a building at the New York World's Fair, commemorating the 150th anniversary of the inauguration of President Washington. The fair had the largest foreign participation of any exposition up to this time, with sixty-three nations exhibiting. The Japanese pavilion, designed by S. Uchida and Y. Matsui, was a severe three-part composition in the style of a Shintō shrine, housing modern works of art, mostly paintings and silk tapestries. Compared to its predecessors neither the building nor its contents made a very deep impression, in part due to the gathering international tension.

In 1949 the Museum of Modern Art in New York authorized the construction of a small contemporary house in a corner of its garden. Another was erected on the same site in 1950. Both were by American architects and were meant to serve as guides to better taste in building. The museum's third House in the Garden was Japanese. It was of the *shoin-zukuri* type, belonging to the sixteenth or seventeenth century, and related to the style of the first story of the Kinkaku (*Chapter Thirteen*). The implication of its sponsorship was obvious and was perhaps the greatest tribute yet paid to Japanese domestic building for its "unique relevance to modern Western architecture." The Japanese Exhibition House was opened for inspection on June 20, 1954. It was the design of Junzō Yoshimura, who, with Tansai Sano, also planned the gardened setting, the chief builder being Heizaemon Itō. The house was presented by the America-Japan Society of Tokyo, on behalf of the people of Japan, and backed by private citizens in Japan and the United States. Made in Nagoya in 1953, it was shipped to America in

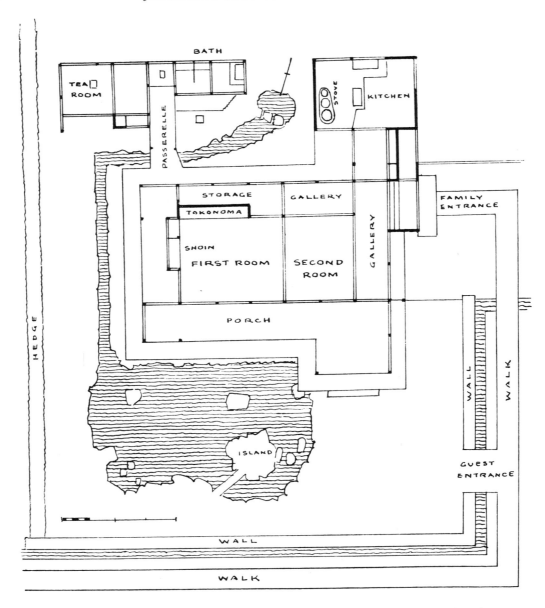

§144. *The floor plan of the Japanese Exhibition House, The Museum of Modern Art, New York City. (After a drawing by Dale Byrd.)*

736 crates, together with lanterns, fences, stones and coarse white sand for the garden. The building was inspired by the Kyaku-den *(ca.* 1601) of the Kōjō-in at the Onjō-ji in the city of Otsu.[5]

The main part of the Japanese Exhibition House is L-shaped and surrounded by a platform, with a porch across the front and right flank, and a projection at the south end of the front constituting a deeper garden vestibule *(§143).* The plan is expanded on a six-foot-six-inch *ken,* or module, from post center to post center. The light appearance of the building is due to the scarcity of upright supports at seemingly strategic points, such as the angle of the front porch, with some of the overhead elements suspended from above. The *irimoya* roof is covered with *hinoki* (Japanese cypress) bark shingles. The family entrance is on the south side *(§144).* One comes first into a transverse gallery of seven *tatami.* A ten-mat room opens from the gallery, and beyond this is the principal room of fifteen mats. This room contains the *shoin,* or writing alcove, that characterizes this kind of house. A *chigai-dana* is next to it, and on the adjoining wall is the long *tokonoma.* The backgrounds of the *tokonoma* and *fusuma* have landscapes painted in *sumi* technique by Kaii Higashiyama. A bamboo design embellishes the doors in the second room; and above them the open *ramma,* in this instance a grille of delicate verti-

cal strips of wood, permits the circulation of air from one room to the other. A narrow storage space extends across the rear of the main house. Kitchen and service rooms are in a wing back of the family entrance. A separate pavilion containing a tea-ceremony room and preparation room is connected to the house proper by a passerelle, and on the opposite side are the bathing facilities. The passerelle bridges a stream originating in the rear court, which skirts the right flank of the house and garden vestibule. The many visitors to the Japanese Exhibition House were given paper slippers upon checking their shoes before entering. The building attracted so much attention that it was kept on display a second year, after which it was removed to Philadelphia and reassembled on the site of the Temple Gate in Fairmount Park.[6]

The influence of the Museum of Modern Art exhibit, like that of its ancestor the Japanese Dwelling at the Philadelphia Centennial of 1876, tended to be felt in vacation houses, especially those overlooking water. The range of influence of the later example was much wider because of the growth of the country and improved facilities in communication and transportation. A building that succeeded in capturing the spirit of the original was a summer retreat at Holland, Michigan, on the east side of Lake Michigan (§145). It was built in 1956 by Obryon and Knapp for Hollis M. Baker, Jr. The plan of the cottage is an irregular U-shape, with the master bedroom suite in the shorter stem, two additional chambers along the base, and the living-dining room, kitchen and maid's room in the large south wing. The entire lake side of the house has sliding doors between posts. They are mostly of clear glass in the living-dining room, whereas elsewhere rice paper is applied to the inner side of the glass to simulate *shōji*. Much of the wood for the interior was imported from Japan, the ceiling of the main room being of *sugi* (cryptomeria), and the exposed posts and beams of *hinoki* (cypress). The rooms have matting on the floors and are furnished with modern, low, Chinese-style Baker pieces and some authentic Japanese *tansu* (chests of drawers). This was a period of intense imitation of both Chinese and Japanese in interior decoration (*Chapter Eighteen*).

In the Catskills—a region already primed for acceptance of the Japanese style—the Japanese Exhibition House made an impress upon a group of lodges. At Ramapo Pass, twenty-seven miles north of New York City, the coming together of sixteen lanes of major highways suggested to entrepreneur Robert Schwartz an excellent place for a motel. The roads monopolize the level ground, so Schwartz turned his thoughts to building the caravanserai on a hill, having seen inns perched on such promontories in Japan. Robert Schwartz obtained an elevated site of fifty acres and secured the services of Japanophile Harwell Hamilton Harris to design guest units, and of Junzō Yoshimura, at the time engaged on the house at the museum, for an overall plan. Yoshimura studied the problem and decided to treat the hill and valley below as a unit, tied together by a winding driveway on the valley side, rather than at the back, where a more natural roadbed exists. The guest houses were placed around the outer side of a contour drive that follows the crest of the hill, well above the din of highway traffic, where there are vistas across the surrounding countryside, including glimpses of the skyscrapers of Manhattan on clear days. The buildings are cantilevered out on thick laminated wooden beams supported on four-inch steel posts sunk into the rock core of the mountain, and television antennas are tucked out of sight under the structures (§147). Walls are of Douglas fir and roofs are sprinkled with white marble chips from Bolivia. Guest units are connected by roofed-over walks leading to the apex of the layout, a two-storied restaurant planned by Yoshimura (§146). It embraces a pool on the high or west front, and the east side is built over the hillside on a series of supports suggesting the seventeenth-century main hall of the Kiyomizu Temple on Higashiyama near Kyoto.

Even a brief sketch, dealing with only a few key examples of modern buildings in America

influenced by Japan, could not be considered adequate without mention of the features of the skyscraper that are related to Far Eastern architecture rather than traditional Western architecture. In doing so one runs the risk of pronouncing the obvious, but be that as it may, at least a simple analysis seems advisable. First of all, a skyscraper does not have weight-bearing walls, for it is supported by an internal skeletal system of standardized units. Secondly it does not have permanent partitions shutting off one area from another, with the exception, of course, of utilities and conveniences clustered around elevator shafts at its core. The usable space is kept flexible for whatever needs may arise, and these vary from one floor level to the next, the tall building being the supreme example of planning from the inside out. Contemporary skyscrapers are without any feeling of massiveness but seem to remain suspended in air. Functioning elements combine into a design needing no external ornamentation. By 1950 their "new look" was determined by the glass wall, which meant the greatest possible sheathing of glass and the least amount of interruption by supporting armature. The idea is Gothic, but as employed the flat planes of towering office buildings acquire the appearance of much-enlarged *shōji* (*§148*). Wanting a better name, perhaps this phase could be referred to as the *shōji*-manner.

The seeming fragility of Japanese buildings was eschewed in the West after World War I because man's insecurity at that time demanded something more firm and solid in appearance. The International Style that arose in Europe in response to this feeling resorted to square-angled, blocky forms in concrete with steel supports that fulfilled the basic requirements of housing, but little more than that. The priority given to the plan in building design, which Wright referred to as organic architecture, relates to an idea expressed 2,500 years ago by Lao Tze in China, and the austerity of functionalism keys in with the Japanese Zen principle of eliminating the non-essential, in design as in other departments of life. Applied to architecture, simplification can become cold and forbidding unless tempered by an innate artistry on the part of the builder. American architects tended to personalize it. Frank Lloyd Wright's versions of the 1930's were organic and romantic. Philip Johnson's of the 1940's were restrained and classic in essence. Yet both were abstractions of Japanese prototypes. A literal interlude of Japanese architecture was launched in the mid 1950's following the erection of the Japanese Exhibition House in the garden of the Museum of Modern Art. Like the Japanese Dwelling at the Philadelphia fair it begot offspring on shore and hill; and after its hour of glory in New York the Exhibition House settled permanently in Fairmount Park.

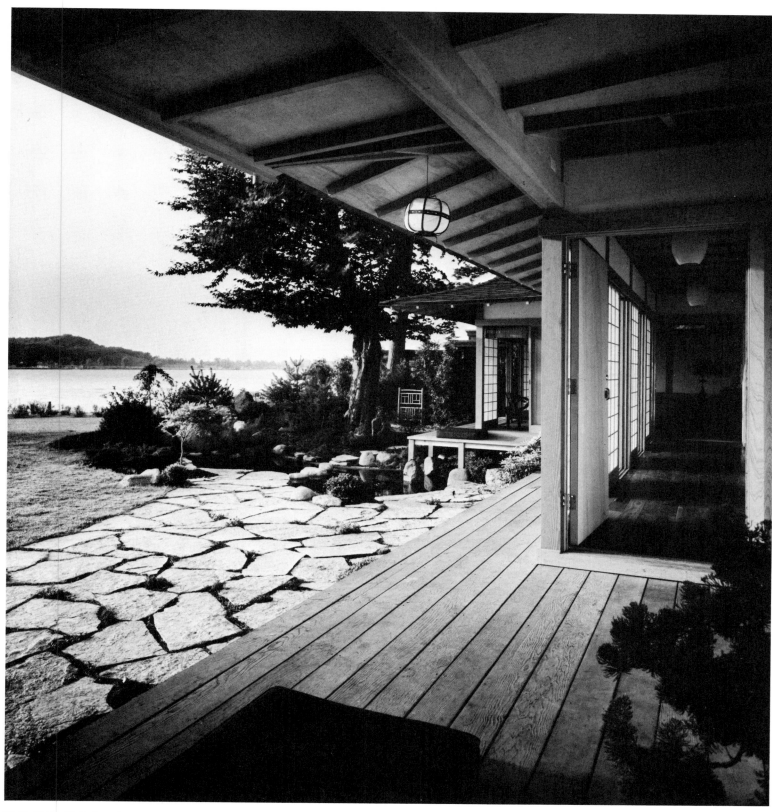

§145. *Hollis M. Baker, Jr., vacation house at Holland, Michigan. Obryon and Knapp, architects. (Ezra Stoller.)*

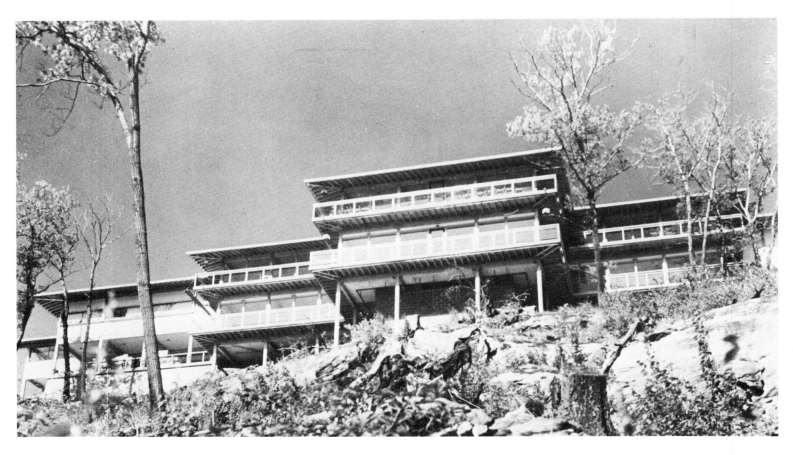

§146. *Restaurant of the Motel on the Mountain, Ramapo Pass, New York. Junzō Yoshimura, architect. (Photograph courtesy of Robert Schwartz.)*

§147. *Guest units of the Motel on the Mountain. Harwell Hamilton Harris, architect. (Photograph courtesy of Robert Schwartz.)*

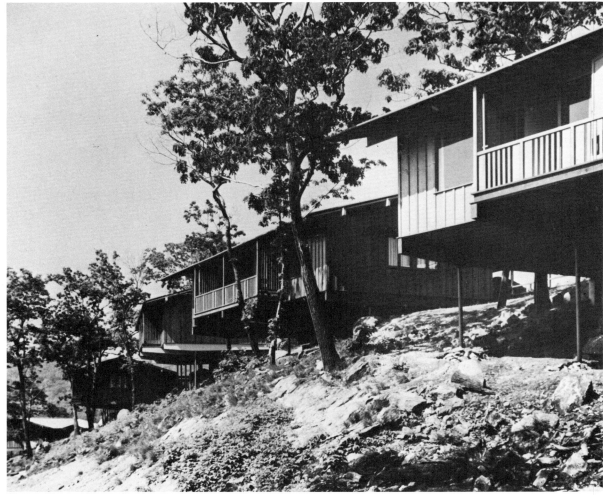

§148. *First National City Bank of New York, Uptown Headquarters, 399 Park Avenue, New York City. Completed 1961. Kahn and Jacobs, Carson and Lundin, associate architects.*

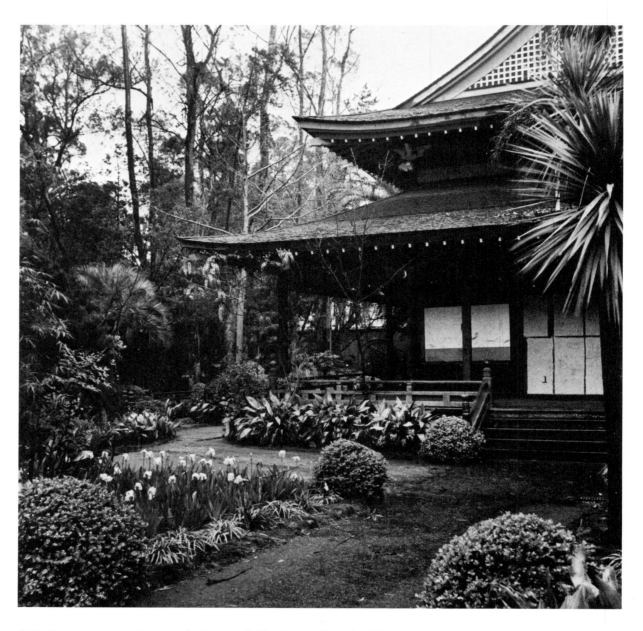

§149. *The Japanese tea house at the Panama-California Exposition, San Diego.*

CHAPTER SIXTEEN
Japanese & Contemporary Buildings
in the
Western States

THE next important international fair west of the Mississippi River after the Louisiana Purchase Exposition at Saint Louis was the Alaska-Yukon-Pacific Exposition at Seattle, Washington, in 1909. It was held in a park wooded with Douglas firs and lying between two lakes, with Mount Rainier looming in the background. The concave facade of the domed Government Building terminated the north end of the main avenue, and beyond Circular Basin, toward the south end, gushed a fountain near which stood the Japanese pavilion *(§150)*. The two-storied structure was square, with cubic flankers at the corners, connected by lateral galleries. Olmsted Brothers planned the landscaping, and Howard and Galloway supervised the designing of the exhibition halls, some of which were erected as permanent buildings to house the University of Washington after the fair. Another building at the Seattle exposition bore some resemblance to the Japanese pavilion. Called the Hoo Hoo House, it was designed by Ellsworth Prime Storey for a lumberman's fraternity and stood next to the Natural Amphitheatre. The half-timber structure was a symmetrical, compact form, about equal in size to the Japanese pavilion, with deep eaves, the central mass crowned by an *irimoya* roof, and the twin wings by roofs with end gables.[1] Both of these buildings have been destroyed.

Point Defiance Park on Puget Sound at Tacoma, Washington, comprising 637 acres, was laid out in 1911 by Hare and Hare of Kansas City. Its various buildings, such as streetcar stations, shelters, field houses and animal houses in the zoo, were built in Japanese style, with curved gables and upturned ends to the eaves of the roofs.[2] It seems likely that the style was suggested by the Japanese pavilion at the Seattle exposition.

Two fairs held simultaneously in California in 1915 were the first to celebrate a current rather than a past event. The occasion was the opening of the Panama Canal on August 15, 1914, which made possible the passage of traffic between the Atlantic and Pacific oceans without the long voyage around South America. The larger of the two fairs was called the Panama-Pacific International Exposition, and it was presented in Presidio Park at the northern tip of the San Francisco peninsula. The site is marked by Bernard Ralph Maybeck's Palace of Fine Arts, a domed rotunda stationed on an island concentric with the colonnaded hemicycle of the gallery proper. The tinted plaster splendor of this building outdid the marble grandeur that was Rome; Japanese art occupied a suite of eight rooms in the southeast end of the building. To the south of the Palace of Fine Arts lay the three-acre Imperial Japanese Garden. It was landscaped by H. Izawa

§150. *Sketch of the Japanese pavilion at the Alaska-Yukon-Pacific Exposition at Seattle, Washington. (After a drawing in* The Architectural Record, *July, 1909, p. 27.)*

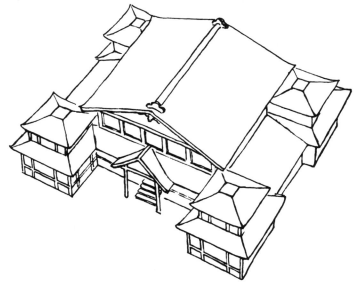

and contained buildings designed by Ryūtarō Furuhashi, Shōsaku Monna, Bunshirō Itō, Mitsuo Kobashi and Goichi Takeda. The five major buildings were the Commissioners' Office near the gateway, the square Reception Hall, the long Main Pavilion and the Formosa and Japanese tea houses (*§152*). The Commissioners' Office, which was one-storied, was a somewhat enlarged version of the Commissioners' Office at the Saint Louis fair. The Reception Hall resembled the Kinkaku also reproduced at the 1903-04 exposition. It too was larger than its predecessor, but without the third story. The Reception Hall was built mostly of *hinoki* wood left unpainted, except for the twenty-eight-foot high ceiling which was richly decorated. The Main Pavilion had shallow wings projecting forward at each end, and both it and the tea houses were crowned with *irimoya* roofs. Incidental structures included a small tea house erected by the Central Tea Association, containing a nine-foot square *cha-no-yu* room, and there were several shelters, a garage, and a roofed gateway.

The Japanese exhibit was formally opened to the public on February 24, 1915. Jirō Harada, who later wrote *The Lesson of Japanese Architecture*, gave the oration. The day's festivities ended with music, fireworks and Japanese sports in the stadium. In addition to the displays in the Palace of Fine Arts and the Imperial Japanese Garden, Japan was represented in the Manufacturing, Agriculture, Food Products, Horticulture, Mines and Metallurgy, Education and Social Economics, Liberal Arts, and Transportation halls, and cultivated an area of 12,400 square feet in the Horticulture Garden.

The Japanese imports were dismantled and taken away after the exposition, but some of them reappeared elsewhere. The gateway was moved to Golden Gate Park to become an entrance to an extension of the Marsh garden, and the portico of the Commissioners' Office was set up as a gate next to the *zashiki* on the hill. Several stone pieces also were taken to the older garden. Portions of the Main Pavilion were incorporated in the Swift house at Belmont, eighteen miles south of San Francisco, which was later converted into a restaurant.

The second California fair of 1915 was more modest and lacked international pretensions. It was held in Balboa Park at San Diego and went by the name of the Panama-California Exposition. The exhibition buildings were designed by Bertram G. Goodhue uniformly in the Spanish colonial manner. However, much in evidence because of its stylistic distinction was the Japanese Tea House between the Botanical Building and the Restaurant (*§149*). The Tea House was situated in a small garden through which flowed a stream forming a pond to one side. A low-arched bridge crossed the stream on an axis with the main entrance to the building, and a drum bridge connected to an island in the pond. Bits of both bridges may be seen amidst the planting to the left of the pavilion in the accompanying picture taken in 1954, at which time the Tea House was boarded up and not being used. The former exhibition halls had become a public library, museum and art center.

Some of the Japanese living in California have constructed buildings in their native style, with parts imported from Japan. At Mount Eden, on the lower eastern side of San Francisco Bay, Zenjūrō Shibata, a cultivator of hothouse flowers, had a guest pavilion built in a garden adjoining his conservatories in 1931 (*§154*). It was constructed by Einosuke Itō, who had worked on the buildings at the Saint Louis fair. The main block of the house, covered by a *shichū*, or hipped, roof, contained a long entertainment room divided into two square sections, the front half featuring the *tokonoma*. Open galleries were on two sides. After the war the family decided to make this their home and added a wing at the back. Rugs were spread on the floor and the rooms furnished with overstuffed chairs and low tables. Mrs. Shibata, the daughter of a priest of the Shinshū Sect in Japan, is active in Buddhist circles in America and many religious leaders have visited in her home.

Another Japanese dwelling, built as such in 1940, is the Kiyoshi Hirasaki house near Gilroy, about thirty miles south of San Jose. It stands in a compound among flowering trees and evergreens, surrounded by a fence, outside of which is an immense truck farm. The living-room pavilion is similar to the main block of the Shibata house, but the two square rooms are crowned by an *irimoya* roof and the outer galleries have glazed sliding panels and thin draw curtains operating on a ceiling track. The interior is thoroughly Japanese in feeling, despite the ceiling lighting fixture and a clock on the *chigai-dana* (§153). *Tatami* are on the floor. The *tokonoma* has a dark background, and the window to the side has little wedges between the uprights describing the outline of Mount Fuji. In place of rice paper, silk has been used in the *shōji*, with a wide band of clear glass at seated eye level for a view of the garden.

Almost as Japanese as the homes of the Japanese themselves is the small house architect Harwell Hamilton Harris built for his own use in 1935 on a hillside in Fellowship Park, at the northeast corner of Los Angeles (§155). The building hardly seems to have disturbed either the rocks or planting on its site. The downhill corner is raised upon slender square posts that support also the overhanging gently-pitched hipped roof. All but the end posts are reinforced by triangular braces, a device illustrated in Morse's *Japanese Homes* (see §98). The entire house measures only twelve by thirty-six feet, two-thirds of which constitutes the living room, the balance divided into a dressing area, bath, kitchen and utilities closet. Fibre matting is on the floor and the house is sparsely furnished. The Japanese folding screen is a necessary item for providing privacy when the *shōji* are removed during the summer months. A similar building in back, with a skylight on top and a floor below for storage, serves as a studio-drafting room. While training for an architectural career during the 1920's Harris spent his spare time poring over books on Japanese building in the Los Angeles Public Library.[3]

Harris' work for clients usually was more compromising. The year before building his own home in Fellowship Park he designed a house for Pauline Lowe at Altadena. A garage opens on the street and a covered passage leads between it and the bedroom wing back to the main entrance at the inner angle of the L-shaped plan, facing a square court (§151). Each of the two bedrooms has its private garden, beyond which is a service lane to the kitchen. The living and dining room across the rear adjoins a terrace surrounded by planting. Outdoor areas are made accessible by walls of sliding glass panels. Recesses flank the fireplace in the living room. Many features in the Lowe house are found in other projects of this period by Harris, such as the two-storied house for Helen Kershner at Los Angeles.[4] One of his more interesting designs showing Far Eastern flavor is the Chinese restaurant in Chinatown, Los Angeles, constructed during the early 1940's.[5] Instead of the usual treatment of carved teakwood screens, gilded dragons and colored lights in silk lanterns, the architect conceived a simple spreading building of redwood, which was spacious without being of great magnitude. An exceptional work by Harwell Hamilton Harris, that is even more Japanese than his own home, was built during the late 1940's on the East Coast, at Redding, Connecticut. It was a retreat for Mr. and Mrs. Gerald M. Loeb—virtually a one-room building, inasmuch as living, dining and sleeping spaces flow together, although dressing, bathing, cooking and recreation activities take place behind sliding doors. Inside one finds a *tokonoma* and open *ramma* above the lintels. The *shōji* are protected on the exterior by wooden night panels, or *amado*, that fit into attached storage boxes (*to-bukuro*).[6] Harris has gone to the Japanese with a keen sense of appreciation and has incorporated his borrowings into a spontaneous whole. From the point of view of time the Loeb house was an intermediary between the buildings brought from or influenced by the Saint Louis fair and those stimulated by the Museum of Modern Art's Japa-

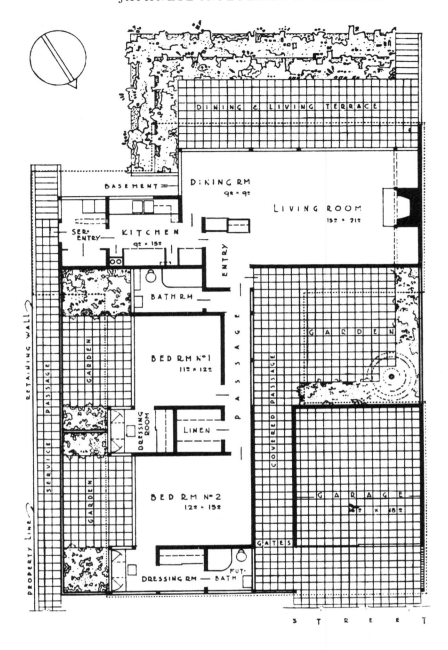

§151. *Plan of the Pauline Lowe house, Altadena, California. Harwell Hamilton Harris, architect.* (The Architect and Engineer, *December, 1935, p. 43.*)

nese Exhibition House, which would include the guest units by Harris at the Motel on the Mountain.

The San Francisco counterpart to the New York World's Fair of 1939 was called the Golden Gate Exposition. Buildings at the fair on Treasure Island in San Francisco Bay combined the beauty and drama of the architecture of both hemispheres. Japan was represented in the Pacific Basin area by a feudal castle in the style of the period prior to the restoration of the Imperial House in 1868. It was two-storied and composed of a pair of long pavilions enframing adjacent sides of a square cove, with projections into the water, and a pagoda-tower at the angle of intersection. An arched bridge spanned the channel opposite, and nearby stood a square, two-storied house crowned by a *hōgyō* (pyramidal) roof and resembling the Commissioners' Office in the Panama-Pacific Japanese garden. The buildings were encircled by galleries and connected by passerelles. The influence of the Japanese group at the Golden Gate Exposition was no more than that of the concurrent New York fair and for the same reasons.

A guest house on Lake Arrowhead near San Bernardino in Southern California was built

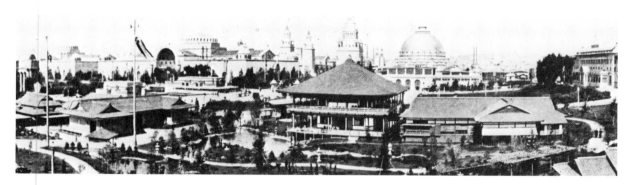

§152. *Panorama of the Imperial Japanese Garden at the Panama-Pacific International Exposition, San Francisco. (Buchanan, ed.,* History of the Panama-Pacific International Exposition, San Francisco, 1915, *p. 193.)*

§153. *The main room in the Kiyoshi Hirasaki house, Gilroy, California.*

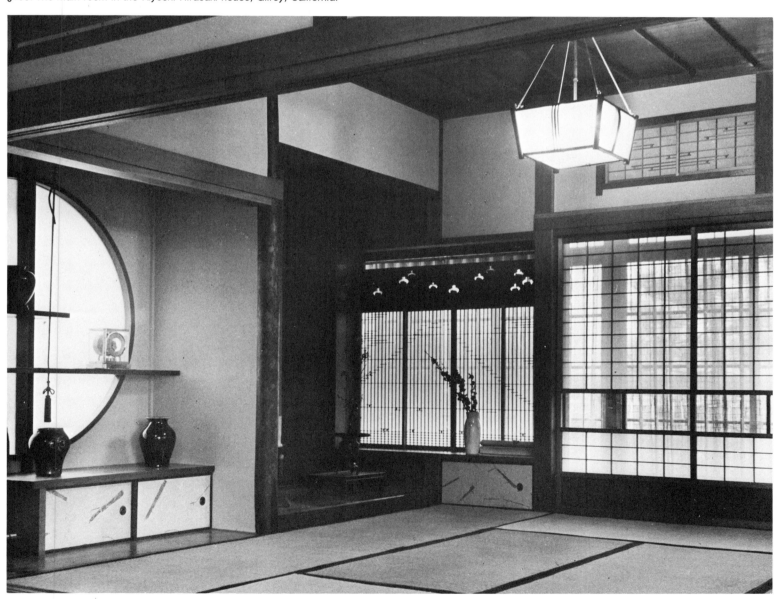

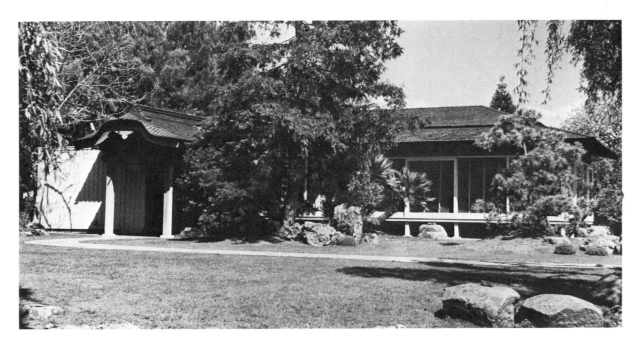

§154. *Zenjūrō Shibata house, Mount Eden, California.*

§155. *The Harwell Hamilton Harris house, Fellowship Park, Los Angeles. (Fred R. Dapprich.)*

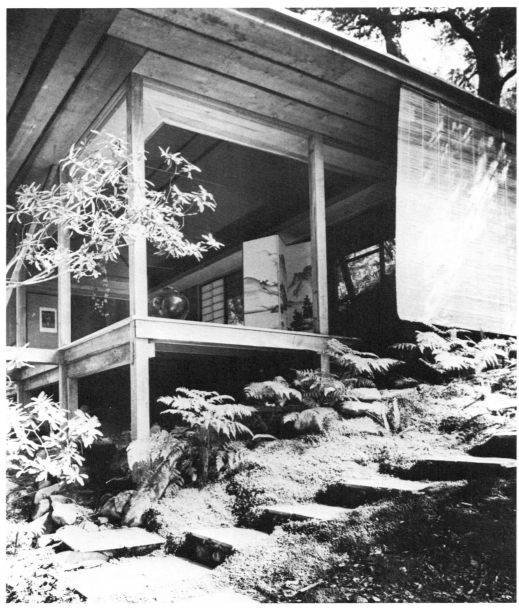

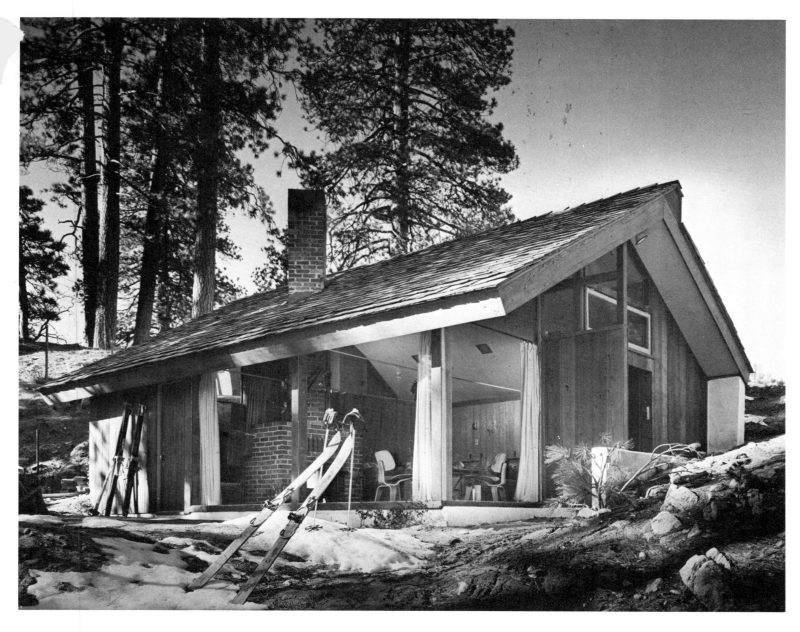

§156. *John Lockheed guest house on Lake Arrowhead, California, Hicks and Raport, architects. (Julius Shulman.)*

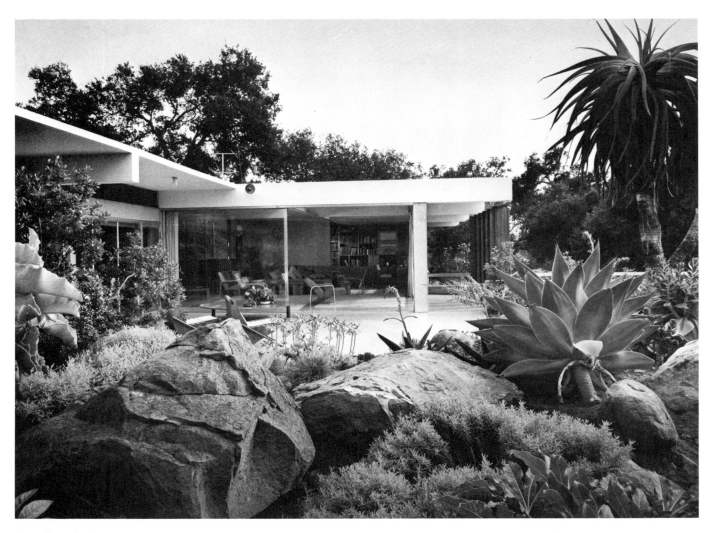

§157. *Tremaine house at Santa Barbara. Richard J. Neutra, architect. (Julius Shulman.)*

§158. *View from within the Troxell house at Pacific Palisades, California. Richard J. Neutra, architect. (Julius Shulman.)*

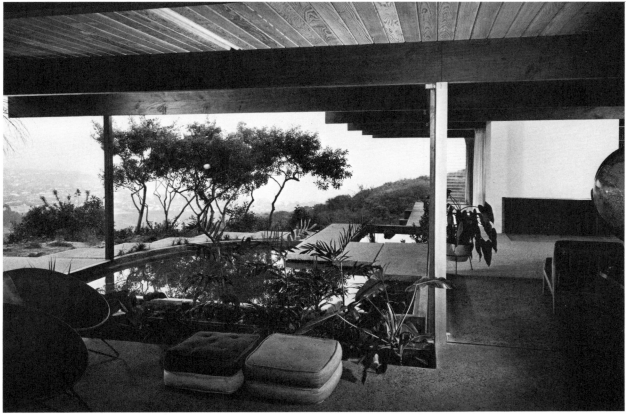

for John Lockheed in 1947 by James Hicks, Jr., and Lucille Bryant Raport (*§156*). The architects have made the most of the small volume, placing the kitchenette and bath to the side away from the view, and separating the living-dining area from the bedroom by the fireplace and a curtain that slides on one of the tie-rods checking the outward thrust of the rafters. Bulkiness of the roof, light construction below, and the external post centered on the gable end relate the California guest house to the form of an early Shintō shrine, such as the Yoshida-jinja at Kyoto (*§159*).

The California bungalow type of the early 1900's persisted with slight modifications during the second quarter of the century under different labels. One of these, that considered the bungalow's layout yet ignored its construction, was "ranch-house." Lewis Mumford invented another in a *New Yorker* article published October 11, 1947. The term was "Bay Region Style." It was applied to the California redwood house that was the "product of the meeting of oriental and occidental architectural traditions." At that time the vicinity around San Francisco Bay was mushrooming with houses all of a kind, and the title seemed apropos. The October, 1948, British publication *Architectural Review* featured two Marin County houses and picked up Mumford's label, calling them "Bay Region Domestic." One was the newly-built Dettner house by Albert Henry Hill. The narrow U-shaped house and an open roofed extension on one side encloses a court with a swimming pool at the far end. The house has plank walls or floor-to-ceiling sliding glass panels, and it is sheltered by a gently-sloping shingled roof having eaves of normal porch depth but without post supports.

The San Francisco Museum of Art sponsored an exhibition of photographs of "Domestic Architecture of the San Francisco Bay Region" from September 16 to October 30, 1949. Fifty-two houses were included. The purpose of the show was to repair "a serious omission in the existing histories of American architecture," according to a statement made by Lewis Mumford writing in the museum brochure. Several local architects also contributed articles, and that by Clarence W. W. Mayhew was called "The Japanese Influence." Mayhew was conversant with this influence in his own work, as in the Harold V. Manor house at Soule Trace, California.[7] He says that contemporary builders in California have good reason to develop similar forms and to take suggestions from the Japanese : "The problems of topography and the climate conditions of both California and Japan are very much the same, thus it seems quite logical that there shall be similar architectural conclusions and a borrowing of ideas of design and materials. The Japanese have been designing for these conditions for so long a

§159. *Sketch of the Yoshida-jinja Shrine, Kyoto.*

time that they have reached many admirable solutions which are easily adaptable to our local conditions." The assimilated elements listed include : the use of wood in modular construction, standardization of sizes, the unification of house, grounds and view, flexibility through sliding screens, exposed structural elements, simple and natural materials, built-in furniture, and the achievement of a restful atmosphere. Examples in the exhibition ranged from a big apartment house in San Francisco to little weekend houses at Carmel, and from a bungalow-châlet with projecting beams, balcony and sloping roof to flat-topped International Style houses. Most utilized redwood; but the validity of a single Bay Region Style is questionable. Architectural characteristics found here mostly developed elsewhere, and certainly transcend the locality. Designating them more generally as Californian might have been more fitting.

A revival of interest in the West Coast's foremost Japanophiles of the early 1900's, Charles Sumner and Henry Mather Greene, began in the late 1940's, adding fuel to the Japanese fervor. The Southern California Chapter of the American Institute of Architects presented a Special Certificate of Merit to the brothers in 1948, the same year they received recognition in two publications. The May issue of *Architectural Record* had a three-page review entitled "A New Appreciation of 'Greene and Greene'," and the October issue of *The Architectural Forum* carried Jean Murray Bangs' ten-page article entitled "Greene and Greene." L. Morgan Yost published an article of similar length in the March-May, 1950, edition of the *Journal of the Society of Architectural Historians*, which was slightly condensed when reprinted in the September, 1950, *AIA Journal*. Both were called "Greene and Greene of Pasadena." On October 14, 1951, the *Home Magazine* of the *Los Angeles Times* brought out a special number on Greene and Greene buildings. The lead article, written by Jean Bangs, was called "Los Angeles...Know Thyself." In 1952 the American Institute of Architects bestowed a Special Citation upon the brothers for their "contributions to the design of the American home," which has "made the name of California synonymous with simpler, freer and more abundant living."[8]

"Young architects, forget Rome, go to Japan!" exclaimed Walter Gropius after his return to Cambridge from the Far East in the early 1950's. The American Institute of Architects took him at his word and made up what they called a Trek to Japan in 1956. Sixteen members of the Institute landed at Tokyo on May 22 and met four others already there. They were entertained by three Japanese architectural societies and toured the islands under the guidance of their native hosts.[9]

The West Coast, no less than the East Coast, claimed its share of the International Style. The first notable monument was the home of Dr. Philip Lovell near Los Angeles, designed by Richard J. Neutra and completed in 1929. The architect, who was born in Vienna in 1892, studied there and in Zurich and practiced as a specialist in housing and city planning in the Balkans and Germany. Neutra came to America in 1923, worked in New York for a time, and later went to Holabird and Roche of Chicago. Here he became acquainted with Frank Lloyd Wright and spent several months at Taliesin. He then moved to Southern California. Following the Garden Apartments at Los Angeles, the Lovell house was his second important commission in California. Its construction involved a light-weight steel frame of standard sections erected on a unit plan, like that of a skyscraper *(§160)*. The uniformity of the framework was the controlling factor in the design of the three-storied building, with solids of concrete stretched arbitrarily in horizontal bands, like pieces of fabric on a loom. The broad window areas permitted a wide view of the surrounding hills and the admission of much sunlight. The sharp, geometric planes of the building set in the rugged countryside recall that prototype of the modern skyscraper-apartment house, the vihara-lamasery of Western China, known to the

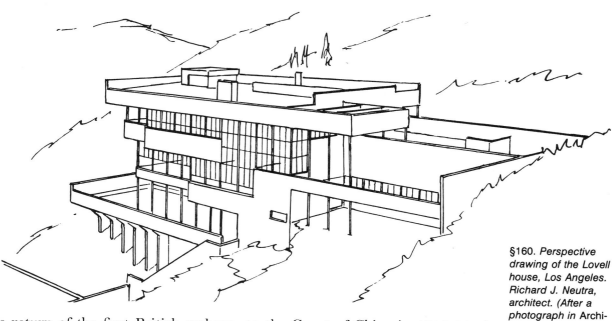

§160. *Perspective drawing of the Lovell house, Los Angeles. Richard J. Neutra, architect. (After a photograph in* Architectural Record, *May, 1930, p. 436.)*

Occident since the return of the first British embassy to the Court of China in 1792-94. A sketch of the eleven-storied Potala at Jehol was made on the expedition and reproduced many times.[10] The Lovell house is an open rather than a closed form, but no less severe. It was considered the most advanced residence in America at the time it was built, an exact contemporary of Le Corbusier's Villa Savoye at Poissy-sur-Seine in France, and preceding by one year Mies van der Rohe's Tugendhat House near Brno, Czechoslovakia, to name two world-famous European examples of International Style architecture.

In 1930 Richard Neutra made a lecture tour to Japan. He had been invited for being considered the best fitted of modern architects to indicate the way of adapting Japan's age-old handicraft building techniques to the Machine Age. Neutra had published two books, *How America Builds* (1926) and *America, New Building in the World* (1929), and a third came out in Japan in 1932, the first monograph on his own work. He lectured in Europe, Mexico and the United States before returning once more to his practice. Some of Neutra's finest houses date from the mid 1940's, such as the flat-topped Edgar Kaufmann residence in the desert at Palm Springs, California.[11] The house spreads out close to the ground amidst huge jagged rocks and scanty desert vegetation, the landscape resembling a Japanese *hira-niwa* or flat garden of raked gravel. The Tremaine house at Santa Barbara belongs to the same period (*§157*). It embraces two sides of a polished outdoor terrace that recalls the white plaster floor in the Seiryōden, the Emperor's private apartments adjoining the Shishinden at Kyoto.[12] Planting enframes the outer two sides of the terrace.

The synthesis of the best of Eastern and Western accomplishments in building, which Richard Neutra undertook to speak on in Japan, came out more forcefully in his later work in America. It involved the integration of two seemingly dichotomous elements—Nature and geometric structural forms. The importance of bringing the two together, Neutra said, was introduced to him early in his career by Gustav Ammann in Zurich, and was intensified and enlarged upon by his travels in Japan. A successful unification of architecture and environment is illustrated by the Troxell house built at Pacific Palisades in 1957 (*§158*). From the fireplace end of the living room, stepping stones lead across the pool, establishing a link between the house and out-of-doors. A thicket of trees around the pool and the sky behind are reflected in the plane of water, making the foreground intangible through seeming to pierce the hill. We are reminded of a Far Eastern landscape painting in which soaring mountains

rise out of mists concealing their bases. To further unite the house to its setting, the planting enters the area of the building. The ceiling of the Troxell house is of raw wood. Neutra was perhaps the first Westerner to call attention to the pleasant sounds and smells that can come from architecture. This is especially true for the Japanese house, in which faint aromas emanate from natural substances left unpainted, and these same materials muffle rather than reverberate sounds at full intensity. An article on the subject, by Neutra, appeared in *Progressive Architecture* in November, 1949, and reappeared in a book of collected writings published in 1954, entitled *Survival Through Design*.

The western states received ample incentive to continue application of the Japanese manner to their architecture through imported buildings erected at the fairs in 1915 and houses built by Japanese people who had settled along the Pacific coast. Memorable exhibition pavilions were those in the Imperial Japanese Garden of the Panama-Pacific International Exposition at San Francisco, and parts of these structures were preserved elsewhere than on the fair site. The Japanese pavilion at the Panama-California Exposition at San Diego was kept intact in its small garden. Japanese living in rural areas, engaged in raising flowers or vegetables, built dwellings faithful to those in the homeland, perhaps containing Western-style furniture, even as one finds in many houses in Japan today. In essence the California bungalow of the first decades of the present century continued to be built in spite of being called by other names. The best-sounding one was Mumford's the "Bay Region Style," defined as the meeting of Eastern and Western traditions, but a term with a wider geographic connotation would have been more accurate. The International Style was implanted in California during the 1920's by Richard J. Neutra, and his houses of the 1940's and 1950's keyed in especially well with the arid topography between the Pacific shoreline around Los Angeles and the great American desert, in some measure due to suggestions gained from the Japanese. Neutra first pointed out the subtle effects of sound and smell in Japanese houses, thus opening up a new source of appreciation for architecture in the West.

Japanese Gardens & Landscaping in America

THE JAPANESE garden belongs to the informal or natural type of landscape, the exact opposite of the geometric and highly conditioned traditional garden of Europe. The natural park appeared in the West under the aegis of Romanticism, beginning in the eighteenth century, and was admittedly inspired by the Chinese. The earliest form was the English park, or the *jardin anglo-chinois*, as it was called on the continent (*Chapter Two*). Transplanted to America, it prepared the soil for the Japanese. The most influential exponent of landscape design in the United States was Andrew Jackson Downing (1815-1852), who wrote and lectured extensively on this subject, as well as on horticulture and architecture. Downing himself was a landscape gardener of the Hudson River Valley. He was a romantic, and his taste veered toward the picturesque. He liked the English park and its prototypes in the Orient, and he expressed his preferences in *Rural Essays*, published at New York in 1853:

"The parks of the Persian monarchs, and the pleasure gardens of the Chinese, were characterized by the same spirit of natural beauty which we see in the English landscape gardens, and which is widely distinct from that elegant formality of the geometric gardens of the Greeks and Romans. . . ." To prove how sound were the principles of Chinese taste, he (quoting Humboldt, in *Cosmos*) gives us a quotation from an ancient Chinese writer, Lieu-tscheu, which might well be the text of the most tasteful improver of the present day, and which we copy for the study of our own readers:

" 'What is it,' says Lieu-tscheu, 'that we seek in the pleasures of a garden? It has always been agreed that these plantations shall make men amends for living at a distance from what would be their more congenial and agreeable dwelling-place—in the midst of nature, free and unconstrained. The art of laying out gardens consists, therefore, in combining cheerfulness of prospect, luxuriance of growth, shade, retirement and repose; so that the rural aspect may produce an illusion. Variety, which is the chief merit in natural landscape, must be sought by the choice of the ground, with alternation of hill and dale, flowing streams and lakes, covered with aquatic plants. Symmetry is wearisome; and a garden where every thing betrays constraint and art, becomes tedious and distasteful.'

"We shall seek in vain, in the treatises of modern writers for a theory of rural taste more concise and satisfactory than this of the Chinese landscape garden."[1]

It is curious that Downing, who appreciated the Chinese handling of nature and advocated the integration of house and setting, should have shunned Chinese architecture as wholly unsuited and not adaptable to mid-nineteenth-century American needs. But not having been to the Far East himself, he was acquainted only with the Western intepretation of the Chinese house, and this at best was greatly artificial. The natural garden was related to the landscape near Newburgh where Downing lived, which was idealized by a group of capable contemporary painters—among them Thomas Doughty, Thomas Cole and Asher Durand—known as the Hudson River School.

However, as we have seen *(Chapter Five)*, Chinese-type buildings existed in appropriately landscaped areas in America, such as the Pagoda and Labyrinth Garden (1827) at Philadelphia, featuring Haviland's pagoda modeled after Chamber's "Tower near Canton." The contemporary private garden of Valcour Aime, fifty miles upstream from New Orleans on the west bank of the Mississippi River, had a pagoda set on a mound containing a grotto. Authentic notes in these gardens were the plants introduced from China, including regal lily, peony, camellia, hollyhock, China aster, blackberry lily, chrysanthemum, clematis, forsythia, ginko and ailanthus trees.

The first Japanese garden in America was at the Centennial International Exhibition of 1876, in Fairmount Park, Philadelphia. It was located in a corner of the lot to the side of the Japanese Bazaar, near the main entrance to the fairground *(see §35)*. The garden was described in the *Centennial Portfolio:*

"The little piece of ground which surrounds this building has been enclosed and fixed up in Japanese garden style. The flower-beds are laid out neatly and fenced in with bamboo. Screens of matting and dried grass divide the parterres. There is a fountain guiltless of *jet-d'eau*, from which the water trickles. At the southern entrance a queer-shaped urn of granite on a pedestal, shows marks of great age, being weather-worn and dilapidated. It must have done garden service years before Perry opened Japan to the Western nations. . . . The garden statuary is peculiar. Bronze figures of storks 6 to 8 feet high stand in groups at certain places, and a few bronze pigs are disposed in easy comfort in shady places."[2]

The "flower-beds" are unusual for a Japanese garden, and probably were included in the display as a demonstration of the raising of certain plants. The source of water, of course, was not meant to be a fountain but a spring. The "queer-shaped urn of granite" apparently was the stone pedestal lantern that shows in the *Historical Register* view, reproduced here in §35 above. Considered as a whole the treatment of the lot alongside the bazaar was far from that of a typical Japanese garden. The temple gateway from the Saint Louis fair was erected on this site in 1905, and half a century later the Japanese Exhibition house from the Museum of Modern Art was reassembled on the same spot. The landscaping here has remained Japanese, in one way or another, from the beginning of the last quarter of the nineteenth century to the present day.

The English-speaking world first learned the principles of Japanese gardens from the British architect Josiah Conder (1852-1920), mentioned earlier *(Chapter Seven)* as having gone to Japan in 1877 to join the faculty of the Engineering Department of the Imperial University in Tokyo and to design buildings in Western style for the government and members of the nobility. Josiah Conder built his own home at Tokyo in 1903. The residence was half English and half Japanese, the latter half intended mostly for the use of Mrs. Conder, a native Japanese. Conder produced two books having to do with traditional Japanese arts dealing with plants. The first, published in 1891, was *The Flowers of Japan and the Art of Floral Arrangement*. It was illustrated by line cuts and color woodblock prints. The second came out two years later under a Tokyo-London imprint and was called *Landscape Gardening in Japan*. This book gives a historical sketch of the development of the Japanese garden, and discusses such elements as garden stones, lanterns, pagodas, water basins, enclosures, wells, bridges, arbors, the decorative use of water, and vegetation. Of special interest are the analyses of the five types of gardens recognized in Japan : (1) hill-and-water garden, (2) flat garden, (3) ceremonial tea-house garden, (4) passage garden (in narrow approaches) and (5) fancy gardens. The volume was illustrated with lithographs by E. Koshiba, modeled mostly after woodcuts from an early-nineteenth-century Japanese garden treatise, *Tsukiyama Teizō-den (§§161-162)*.

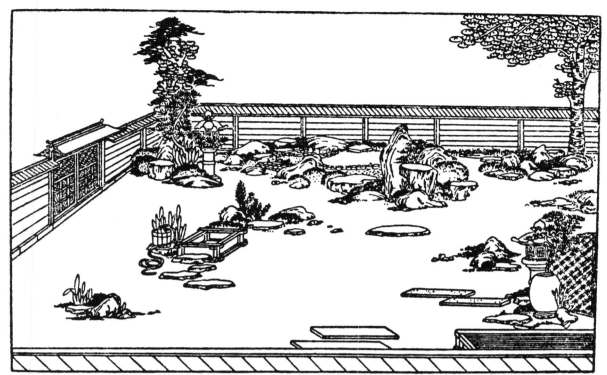

§161. *Woodcut illustration of a flat garden. (From* Tsukiyama Teizō-den, *reproduced in Tatsui,* Japanese Gardens, *Tokyo, 1936, facing p. 34.)*

The example shown here is a *shin* (elaborate) style of *hira-niwa* (flat garden), enclosed by a wall. The lithograph version omits the edge of the porch floor in the foreground, the extension platform by the vase-shaped water basin on the right, and the gateway on the left. Stone and plant groupings miss the clarity of space between them achieved in the woodcut rendering. A supplement to the Conder book, also published in 1895, contains forty collotype plates of photographic views taken by K. Ogawa in famous gardens of Japan.

Josiah Conder's material was picked up and re-evaluated by other authors, especially in periodicals. The July, 1908, issue of *House and Garden* carried an article by Edmund Buckley captioned "Landscape Gardening in Japan," which amounted virtually to a review of the Conder opus. Six lithographs illustrating the article were facsimiles of plates in the book, the frontispiece to the magazine review being Plate XXV *(§163)*. The legends have been removed from the sides and set up in type below the scene. It is a *sansui* (hill-and-water) garden, which, Buckley says, is a favorite in Japan because people there like to vacation in the mountains, which are recalled in reduced scale in the gardens outside their houses. As in the picture of the flat garden, the plank flooring of the porch in the woodcut prototype of the hill-and-water garden is left out of the lithograph. The Buckley text mentions the moods conveyed by Japanese gardens, as well as the symbolism of their parts, and brings out the fact that they are planned for year-round rather than seasonal enjoyment. Not only imitation Japanese gardens but the American rock garden originated from these ideas, in reaction to the normal Western garden with beds of fast-fading flowers.

K. Honda, a member of the Japanese Horticulture Society, read a paper on "Japanese Landscape Gardening" in Washington, D. C., on December 14, 1900. It was printed in the March, 1901, edition of *The Inland Architect and News Record* (pp. 11-15) together with twelve plates. The following year it reappeared in the book, *European and Japanese Gardens*, edited by Glen Brown. This was a composite work and the succeeding chapter was "Notes on a Japanese Garden in California" (pp. [158]-162) by C. H. Townsend, dealing with the Japanese Garden in Golden Gate Park. Ralph Adams Cram wrote an article on "Japanese Temple Gardens," for *House and Garden*, that came out in February, 1902 (pp. 77-90). The same

magazine printed Anne H. Dyer's "The Iris Garden at Horikiki," in January, 1903 (pp. [32]-38), Anna C. Hartshorne's "Famous Gardens of Japan," in the June, 1903, issue (pp. 167-172), and another by T. Karasawa on "The Art of Japanese Gardening," in May, 1904 (pp. 145-149). Mrs. Hugh Frazer got together an illustrated piece called "Of Gardens in Japan," for the November, 1906, number of *The House Beautiful* (pp. 32-34). A somewhat different kind of publication from the above, but with similar contents, was a booklet called *Gardening Lessons from the Japanese*, offered free on request by the American and Japanese Nursery Company of Baltimore, Maryland, in 1908.[3]

Periodicals not only furnished illustrated material about Japanese gardens, providing incentive to build them, but also contained advertisements of builders and suppliers. In *Country Life in America*, October, 1903, H. H. Berger and Company of New York City offered: "Bamboo for bridges, kiosks, stone lanterns, porcelain pots, dwarfed plants, etc. Japan lily bulbs, maples, paeonies [*sic*], iris, etc." The firm claimed to be "the FIRST importers of Japanese plants in the United States." The advertisement was illustrated by a cut of the Kinkaku. In August, 1904, the Japanese Construction Company of Orange, New Jersey, presented itself as "Builders of beautiful and picturesque Japanese houses with all American accommodations, and unique tea gardens." Later, in January, 1911, T. R. Otsuka of Chicago characterized himself as a "Japanese Garden Constructor Purely in Quaint Japanese Style." His motto was not without appeal: "To enjoy the Garden is to enjoy the Greatness of Nature."

Among Japanese gardens predating 1900 in the Mid-Atlantic States none exerted more influence than the tea garden at Atlantic City, New Jersey. Atlantic City was then a popular seashore resort for Philadelphians and others; and holiday visitors enjoyed not only liquid refreshments in the tea house, but also the adventure of discovering the high-arched bridge, the dwelling, the stone and porcelain lanterns, and the curious rocks and imported plants. Unfortunately the tea garden was not a financial success and the project was abandoned. The materials were sold and reassembled on a village lot in Pennsylvania belonging to Matthias Homer. The work was done by the original gardeners, S. Furukawa and A. Kimura.[4] Furukawa likewise built a Japanese garden for Charles J. Pilling at Lansdowne, one of the largest of its period.[5] A third private Japanese garden in Pennsylvania was that of Louis Burk at Olney. Located back of a stone residence, it was enclosed by a fence of reeds and bamboo and was entered through a picturesque gateway guarded by bronze warriors. Bridges crossed the stream and among the hills were a bamboo tea room, a long bamboo palm house, and stone lanterns.[6] An example that survived past the mid-mark of the twentieth century is at Wallingford, a short distance west of Philadelphia (*§164*). It belonged to Horace Howard Furness, a Shakespearean scholar and member of the bar, who had visited the Far East and seen Japanese gardens on their native soil. His own included an open tea house, bridges, lanterns, stones, pine-needle paths, an island in the pond, dwarf evergreens, maples, irises and other imported plants.[7] The garden has suffered from long neglect.

New England has possessed Japanese gardens contemporary with and comparable to those of Pennsylvania, and also has allowed them to deteriorate to the same degree. At the corner of the front terrace to the classic mansion on the Larz Anderson estate at Brookline, Massachusetts, is a small area enclosed by a stucco wall capped by a flaring shingled roof. A gateway is at the far side from the house. The garden's attractions included a life-size bronze eagle with outstretched wings perched high on a stump, a stone Buddha and several lanterns. The gardener who built the little garden was known as Onchi-san.[8] The estate was given to the township of Brookline in 1948 and now goes by the name of Anderson Park. The sculptures have been removed and nature has taken its course.

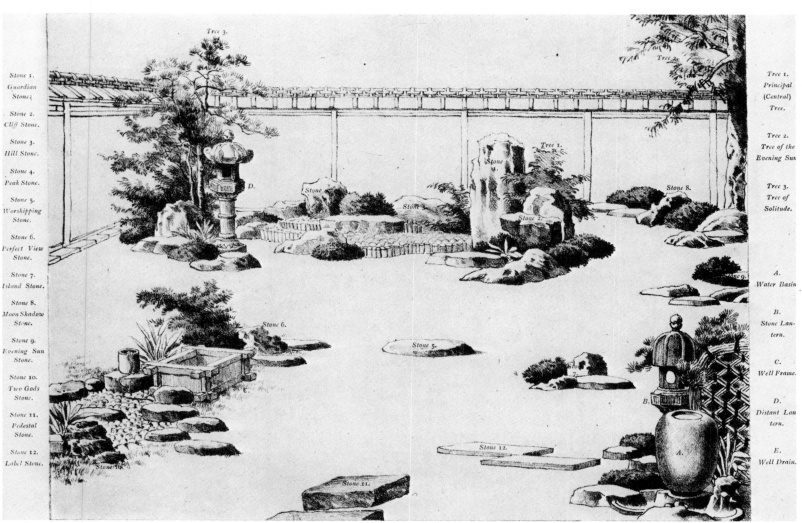

Stone 1. Guardian Stone.
Stone 2. Cliff Stone.
Stone 3. Hill Stone.
Stone 4. Peak Stone.
Stone 5. Worshipping Stone.
Stone 6. Perfect View Stone.
Stone 7. Island Stone.
Stone 8. Moon Shadow Stone.
Stone 9. Evening Sun Stone.
Stone 10. Two Gods Stone.
Stone 11. Pedestal Stone.
Stone 12. Label Stone.

Tree 1. Principal (Central) Tree.
Tree 2. Tree of the Evening Sun.
Tree 3. Tree of Solitude.
A. Water Basin.
B. Stone Lantern.
C. Well Frame.
D. Distant Lantern.
E. Well Drain.

§162. *"Flat Garden—Finished style."* (*Josiah Conder,* Landscape Gardening in Japan, *Tokyo and London, 1893, Pl. XXVIII.)*

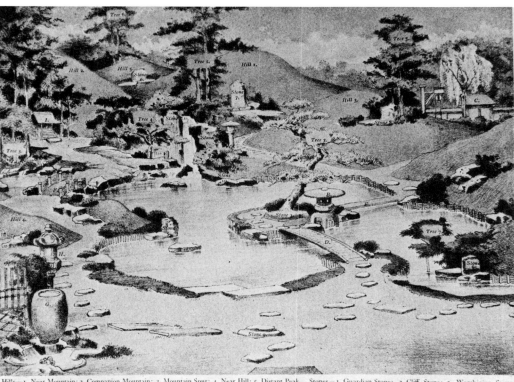

Hills—1, Near Mountain; 2, Companion Mountain; 3, Mountain Spur; 4, Near Hill; 5, Distant Peak. Stones—1, Guardian Stone; 2, Cliff Stone; 3, Worshiping Stone; 4, Perfect View Stone; 5, Waiting Stone; 6, Moon Shadow Stone; 7, Cave, or Kwannon Stone; 8, Seat of Honor Stone; 9, Pedestal Stone; 10, Idling Stone. Trees—1, Principal Tree; 2, View-Perfecting Tree; 3, Tree of Solitude; 4, Cascade-Screening Tree; 5, Tree of the Setting Sun; 6, Distancing Pine; 7, Stretching Pine. A, Garden Well; B, Snow View Lantern; C, Garden Gate; D, Boarded Bridge; E, Plank Bridge; F, Stone Bridge; G, Water Basin; H, Lantern; I, Garden Shrine.

§163. *Hill-and-Water Garden reproduced from Conder,* Landscape Gardening. . . , *Pl. XXV. (House and Garden, July, 1908, p. [21].)*

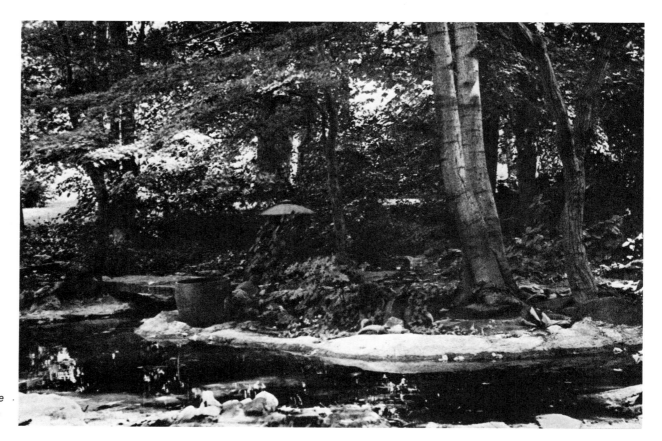

§164. *The Horace Howard Furness garden, Wallingford, Pennsylvania.*

§165. *The Homer Gage garden at Shrewsbury, Massachusetts.*

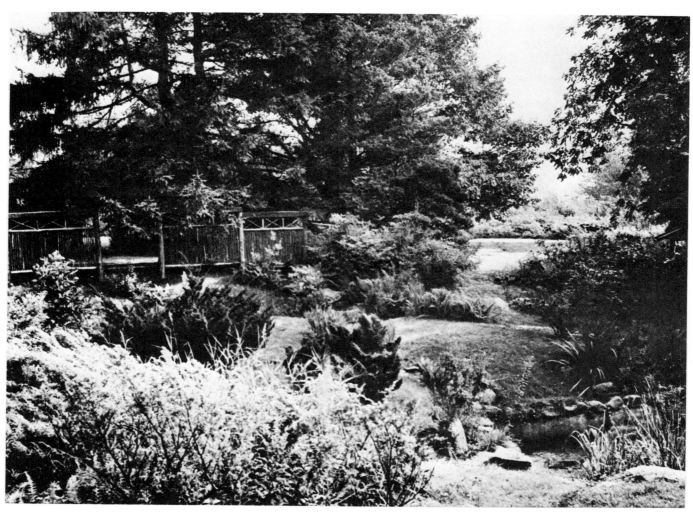

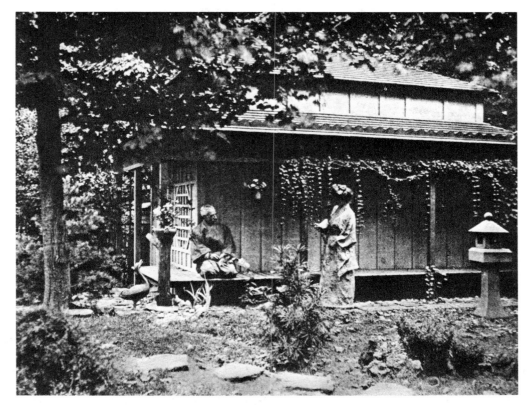

§166. *The "Tea-House" in a Japanese garden in New England.* (Country Life in America, *March, 1905, p. 495.*)

§167. *Tea house at Grey Lodge near Denning, New York.*

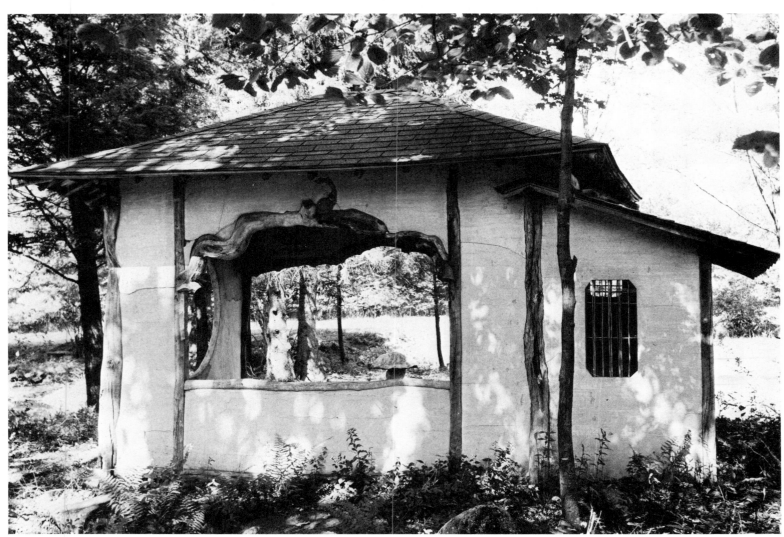

§168. *Farmhouse group in the miniature Japanese garden designed by Takeo Shiota. (Newark Museum.)*

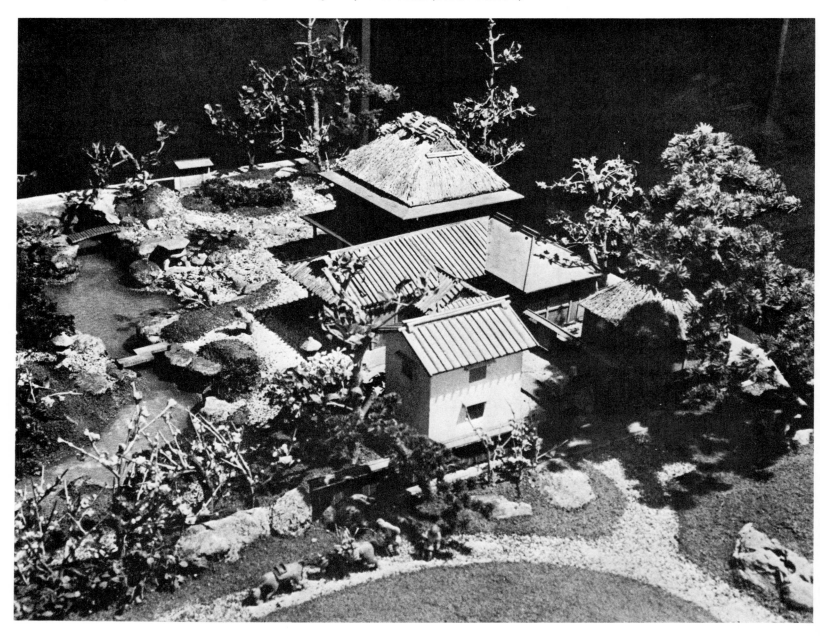

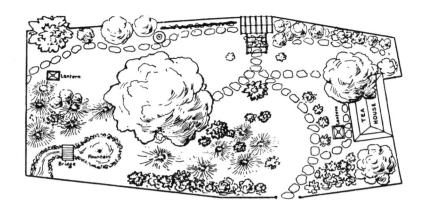

§169. *Plan of a Japanese garden in New England. (Country Life in America, March, 1905, p. 493.)*

A quarter of an acre on the Homer Gage estate at Shrewsbury was converted into a hill-and-water landscape by the gardener Kiota during the first quarter of the century. Encircled by an open-work fence, it made use of rounded hills and projecting rocks, with a stream running through their midst (*§165*). The object of most interest was the ceremonial tea house, brought over from Japan and set up on the edge of the pond. The tea house had rice paper in its *shōji*, and a sunken box for the brazier in the floor. Adjoining it was a wisteria arbor.[9]

Around the turn of the century a young woman from New England spent a year in Japan and found in the Japanese garden what she considered to be her ideal—"not the formal kind, nor one too wild from neglect, but where the natural and artificial are harmoniously blended." Upon her return home she set about to adapt a few Japanese features in a bit of woodland that was part of her father's property. The irregular site chosen measured about 50 by 100 feet. In the center stood a large oak tree, in whose branches two platforms already had been built. With the assistance of Koshiba, the Japanese house boy, she added a pool, a miniature Fujiyama, and transplanted shrubs, flowers and rocks from elsewhere in the woodland (*§169*). They made lanterns out of wood, and these were painted and sprinkled with sand to resemble stone. The "tea house" was built after a design by the young woman's father (*§166*). He is shown seated in Japanese fashion on the porch, and the daughter stands nearby. Both are clad in kimono. The scalloped cresting and latticework on the lefthand side were the builder's original creations. The structure was situated at the extremity of the garden, and the young woman commented upon its other unorthodox feature: "Father, who, being of a practical turn of mind, decided to utilize its interior as a house for our poultry, the side not shown facing the hen-yard."[10]

The best assortment of early Japanese gardens on the East Coast is to be found in New York State and northeastern New Jersey. One of the first was at Manlius, near Syracuse, built by William Verbeck (1861-1930), who was made head of Saint John's School (later Manlius School) in 1888. His father had come from the Netherlands to America in 1852, and seven years later had gone to Japan as a missionary for the Dutch Reformed Church. There William was born and brought up, and as a boy he accompanied his father on visits to many old gardens of the daimyō (feudal nobles). After settling in the United States William Verbeck longed for a Japanese garden and began it on high ground behind the school. He built a house fifteen feet square with authentic *tokonoma* and *chigai-dana*, but with ground glass in place of rice paper in the *shōji*. Construction was of seasoned pine, oiled for an appearance of age. The walls inside were finished with plaster of paris having cloud patterns impressed near the ceiling and waves near the floor. A fifty-foot square space in front was made into a flat garden, with a brook-bed winding through it, strewn with white pebbles, and

bordered with rocks and ferns. A bamboo fence and rustic bridge completed the ensemble. The gardener said he wanted to see and hear real water, and for this reason he moved the house down to a site below the school and added a moon window. The new garden was carried out in the hill-and-water style. It contained a fifty-foot pond with an island reached by a bridge, and there were two other bridges—one of them having a high arch—a variety of trees, hills, rocks, three stone lanterns and a dozen wooden post lanterns that were electrically lighted at night, a summerhouse, bamboo fences and a thatched-roof gateway. The total cost, Verbeck said, was about a thousand dollars.[11] The graves of William Verbeck, his wife, and their son Guido F. Verbeck, who succeeded his father as head of Manlius School from 1930 to 1940, are in the Japanese garden, which is no longer sustained.

A group of Japanese gardened landscapes, to which we have been introduced already through the houses they belong to (*Chapter Fourteen*), are to be found in the Catskills. At Grey Lodge, the summer place of Alexander Tison, built shortly after 1900 near Denning, the stretch of Neversink Creek running past the house was treated in the Japanese manner. A Japanese gardener named Muto and an assistant improved the stream with channels and waterfalls, widened it into a little lake containing islands, and planted it with flowering trees and shrubbery.[12] As in the case of the main house, because of the isolated location, much use was made of indigenous materials. Lanterns were built up of cobblestones instead of being carved from larger pieces. A tea house facing the lake was built of rustic timbers, with plastered walls between (*§167*). A circular window in one wall frames the view of the lodge beyond the water course.

The landscaping of Shō-fu-den, Dr. Jōkichi Takamine's home at Merriewold Park, assembled from three pavilions in the Louisiana Purchase Exposition at Saint Louis, has been discussed in connection with the buildings themselves. Yama-no-uchi, the nearby estate of Frank Seaman at Napanoch, has not been maintained and therefore little can be said about the Japanese character of the grounds. A tea house that was elevated on a stone podium was separated from the drive by a screen fence and probably the area around it was gardened in a somewhat Japanese manner.[13] Another example of attempted Japanese landscaping in the Hudson Valley, which succeeded only in a rather rustic and heavy-handed fashion, was that of John A. Staples in the vicinity of Newburgh. The lodge was low and spreading, and a brook alongside it was spanned by several arched bridges with pedestal lanterns stationed at each end.[14]

Credited with the greatest number of Japanese gardens on the Atlantic Seaboard, if not in the United States, is Takeo Shiota (1881-1946), who was born in a little village forty miles east of Tokyo. As a boy he was fond of roaming around in the country, which in that part of Japan was wild and picturesque and spotted with old castles, temples and shrines. From these rambles he acquired a love for beautiful scenery. Upon graduating from high school he set out on foot to see the famous sights of his native land, and afterwards settled down with a teacher to study the formal and practical aspects of the art of gardening. But Takeo Shiota felt that he could learn more from nature, and he spent five more years journeying to scenic places. He came to the United States in 1907 to practice his art, fired with the ambition of creating the most beautiful garden in the world. Crossing the continent he made his headquarters New York City.[15]

A relatively long-lasting work, for a landscape designer, is Takeo Shiota's project for the Newark Public Library. It is an artificial miniature landscape one-seventy-fifth life-size, that was executed in the Yamanaka workshop in Japan. At one end, among rocky hills, stands a temple consisting of four tiny structures, a two-storied gateway, a main hall, a bell tower, and a five-storied pagoda. A road aligned with the bridge in front of the gateway leads through

level country. On one side are rice-paddies in which figures wearing big straw hats wade knee-deep in water setting out rice plants. Farther along the road, on the other side, is a farm group *(§168)*. Inside the gate is a two-storied *kura*, or fireproof storehouse for valuables, with stucco walls and tile roof. The residence gives the impression of having been built in various stages. It has a two-storied square block covered by a thatched roof, a one-storied wing attached with a roof of cypress bark, and a second low wing at right angles having a tiled roof. Two subsidiary buildings are thatched. The house faces a pebble-strewn terrace, with lanterns, bridges over a stream, and a hilly garden beyond. The model, measuring four by six feet, was assembled and installed in a glass case in the entrance hall of the Newark Public Library in 1915. Later it was removed to the basement of the Newark Museum. Some restoration was done in 1957 and the miniature landscape was exhibited during the summer of 1958.

Takeo Shiota laid out a full-scale garden featuring a tea house at Georgian Court, the George Gould estate at Lakewood, New Jersey *(§171)*. A quiet retreat from the formality

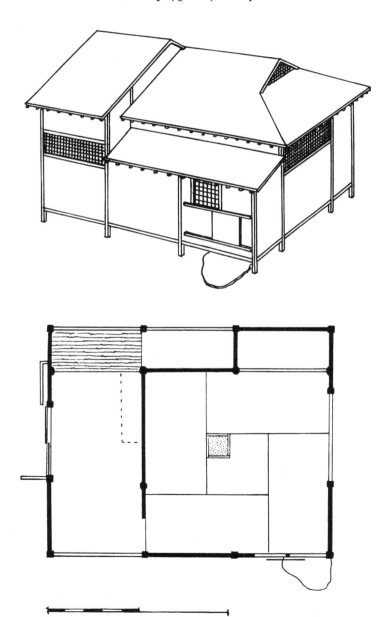

§170. *Perspective sketch and plan of the* cha-seki *in the Scofield garden, Tuxedo Park, New York. Takeo Shiota, designer.*

10

of the palatial mansion and its axial landscaping, the garden is entered through a hooded gateway in a stick fence. Several stone lanterns are placed near a brook that meanders among the planting at the far side of a clearing. The square tea house close to the gate has a low-pitched roof and *shōji* along the sides toward the garden. The house originally was cluttered inside with exotic oddities, the *tokonoma* being hung with silk draperies and bunches of artificial wisteria and piled with silk cushions like an old-fashioned cozy-corner.[16] One can be certain Takeo Shiota was not responsible for such additions. After George Gould's death the Lakewood estate became Georgian Court College in 1923. The mansion provided classrooms, and the stables became a dormitory.

Takeo Shiota conceived a similar garden adjoining the Scofield house in Tuxedo Park. It is enclosed by a board fence and the gateway is more pretentious than that at Georgian Court. The most noteworthy item in the Scofield garden is the tea house, an authentic *cha-seki*, composed of a $4\frac{1}{2}$-mat tea room, with a depression for a brazier in the square center mat, a *tokonoma* opposite the *nijiriguchi* (crawling-in door), and a preparation and storage room having a section of bamboo flooring in one corner (*§170*). Both of these gardens containing tea houses have suffered from lack of attention, and a third, on the Hoyt property at Oyster Bay, Long Island, has totally disappeared.

The grounds of the home of P. D. Saklatvala, a Parsee dealer in Oriental art, at Plainfield, New Jersey, are favored with an abundance of water, and in planning a garden here Takeo Shiota played up this natural advantage. The wide stream is crossed by a long and gently arching bridge. By the water's edge on the far side is a small shrine in which reposes a life-size hammered-copper bust of the owner's mother, a member of the industrialist Tata family of India. Beyond it stands a rustic summerhouse. Farther upstream and inland a two-storied pavilion overlooks a pool that reproduces the shape of the State of New Jersey (*§172*). The pavilion was damaged by fire during the early 1950's and was boarded up. Here were taken some of the scenes of the Adolph Zukor film of *Madame Butterfly*, starring Mary Pickford, released on November 8, 1915. At that time the movie industry was centered at Fort Lee, New Jersey. A stone memorial figure and several lanterns are in the garden. There is also a gateway that does not measure up to the standards of Takeo Shiota and probably was a later addition. Another private garden by Shiota was on the Salisbury estate in Plainfield, now extinct. Yet another, in a ruinous condition today, was built for C. Brown on Emerson Hill, Staten Island.[17]

Takeo Shiota's masterpiece is the Japanese landscape in the Brooklyn Botanic Garden south of the Brooklyn Museum. It was the gift of the late Alfred T. White to the Botanic Garden and was opened to the public on June 6, 1915. The garden centers upon a small lake the outline of which describes the Chinese character for "heart" or "mind." Stationed in the water is an exquisitely proportioned *torii*, inscribed with the Japanese words *dai myō jin* (Great Illuminating Deity), indicating the dedication to the Shintō God of the Harvest.

The viewing pavilion is built over the water on the farther shore, and a roofed waiting-bench faces the path that follows the contour of the lake. A simple drum bridge crosses to a tiny island with a snow-viewing lantern by the water, and a more elaborate bridge spans an inlet having for a backdrop a rocky precipice with a waterfall. A path, that develops into rough stone steps leading up the steep slope, ascends to a pedestal-type lantern and winds around to the Harvest Shrine on the promontory near the west gate. The original shrine burned in 1937, but was rebuilt in 1960. Most of the flora are authentically Japanese, including cryptomeria, pine, Japanese maple, flowering cherry, azalea, barberry and flowering quince. During recent years the garden has been under the capable care of Frank Okamura (*§173*).

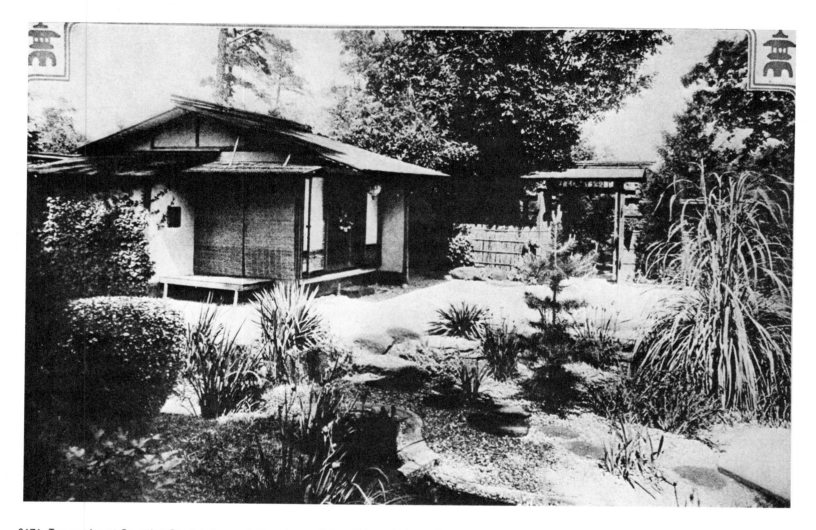

§171. *Tea garden at Georgian Court, Lakewood, New Jersey. Takeo Shiota, designer.* (House and Garden, *December, 1916, p. 14.*)

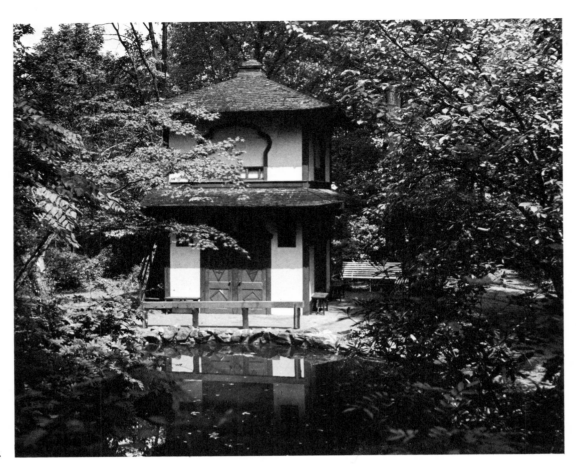

§172. *The P. D. Saklatvala garden, Plainfield, New Jersey. Takeo Shiota, designer.*

§173. *Japanese Landscape in the Brooklyn Botanic Garden. Takeo Shiota, designer.*

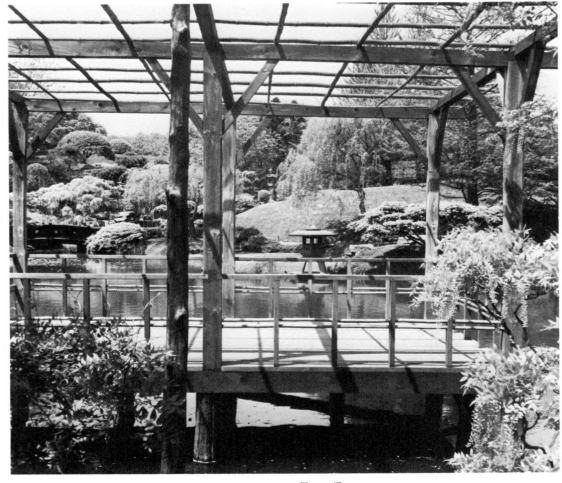

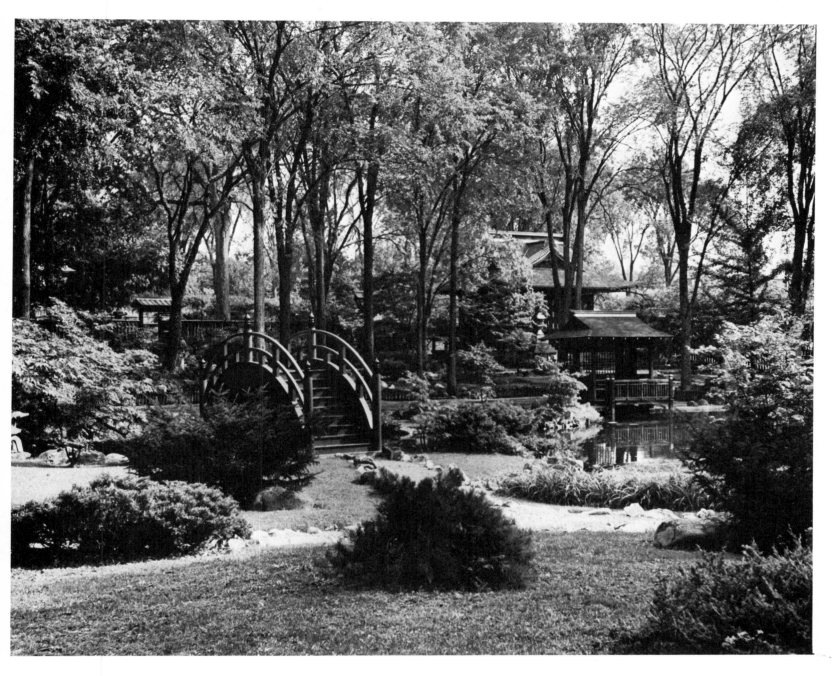

§174. *Panoramic view of the Japanese garden in Clemson Park, Middletown, New York, Lindsey and Ikeda, architect and gardener.*

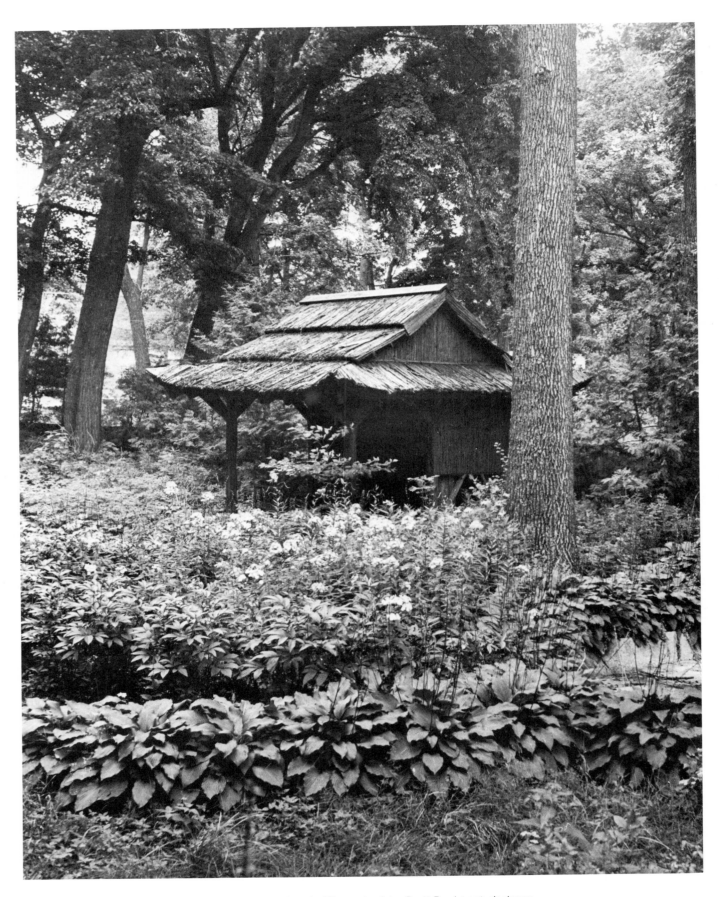

§175. *Remains of the Japanese garden at Minnetonka Beach, Minnesota. John Scott Bradstreet, designer.*

In the 1920's Takeo Shiota formed a partnership (Rockrise and Shiota) operating at 366 Fifth Avenue, and in the 1930's he became a florist at the Astor Hotel, where he designed the North Garden on the roof. His pleasure was being with nature, and he made it a practice to go to Virginia or North Carolina to tramp through the woods for three months each year.

On the estate of John D. Rockefeller at Pocantico Hills, two miles east of the Hudson River and within view of New York City on a clear day, there is a stream gardened in the Japanese mode. It issues from below the outermost terrace of the house built in 1909, and forms a series of waterfalls and pools bordered by gravel paths and crossed by bridges, with here and there a stone lantern. Overlooking the largest expanse of water is a twelve-mat tea house with a Tokugawa curvilinear gable to the portico. Mahogany wood was used throughout and the *shōji* contain rice paper. The stream continues its course, finally emptying into a large pond far from its source.[18] William Welles Bosworth was the architect of the tea house, and the landscaping was the work of Takahashi and Uyeda.

Perhaps the largest private Japanese garden well cared for in the United States is that in Clemson Park at Middletown, New York. Mr. and Mrs. George N. Clemson were in Japan in 1908, and in 1910 added a Japanese-decorated room to their Highland Avenue mansion. Three years later Mrs. Clemson enlisted the aid of her architect, F. J. Lindsey, and M. Ikeda, a gardener brought from Japan, in laying out a two-acre landscape behind the residence. The garden is enclosed by a board fence, in which the side gateway is flanked by a pair of giant bronze lanterns. In the corner off to the right is a two-storied house encircled by open galleries on both levels, each sheltered by a supplementary roof. Clear glass instead of rice paper is in the *shōji*. In the vicinity of the house are a *torii* and a stone pagoda lantern. A peripheral walk leads to the little tea house, which is said to have been copied from one at Osaka, and which resembles the Bellevue pavilion that originally came from the Osaka Exposition by way of the Saint Louis fair to Shō-fu-den *(Chapter Fourteen)*. A series of lakes intersperses the center of the garden *(§174)*. At one point a viewing pavilion overhangs the water and at another a small drum bridge arches a narrow channel. Inside the main entrance is a facsimile of the Sacred Bridge at Nikko. The two bridges are painted a brilliant red. The walk from the Nikko bridge to the shrine (in the corner formed by the two sides containing gateways) passes the signature stone, in which are incised the three characters giving the Japanese name of the garden and a romanized transliteration, *raku-bo-yen* (Happy Mother Garden), together with the date 1913. The slab is balanced by a stone pagoda lantern slightly larger than the one near the house. The square temple shrine is elevated on a terrace and furnished with lacquered folding campaign chairs and an exquisitely carved and gilded Buddhist cabinet altar made in Japan especially for the building.[19]

One can hardly imagine anything more contrasting than spacious Raku-bo-yen and the Japanese tea garden novelty installed in New York's elegant Ritz-Carlton Hotel on Madison Avenue between Forty-sixth and Forty-seventh Streets. The hotel was operated under the same management as the Ritz and Carlton Hotels in London, the Ritz in Paris, the Excelsior in Rome and the Plaza at Buenos Aires. Debutantes of leading New York families were expected to be presented to society in the sumptuous ballroom of the Ritz-Carlton. The Japanese tea garden, opened in June, 1919, was on the main floor adjoining the elliptical dining room.[20] The garden itself was triangular, with a pagoda at the apex towering behind a Buddha image, whose pedestal was a fountain. A brook meandered among lanterns and dwarf pines and firs, and under a series of little arc bridges. The garden was encompassed by galleries set with tables for patrons and guests. These were illuminated by paper lanterns in the evening.

A perennial delight, attracting an estimated 200,000 viewers, is the Japanese cherry blos-

som display each April on the Tidal Basin in Washington, D. C. The original trees were produced at the Okitsu Imperial Horticulture Station and presented by Japan to the American capital. The first tree was planted in 1912 by Mrs. William Howard Taft, several hundred yards west of the John Paul Jones statue at the south end of Seventeenth Street, N. W. The First Lady took a personal interest in these trees, having admired flowering cherries earlier in the Philippines and having expressed the wish for some to beautify Washington. Her gown for the Taft Inaugural Ball in 1909 had been specially embroidered in Japan for the occasion. The second cherry tree was planted by the Viscountess Chinda, wife of the Japanese Ambassador to the United States. The first tree was marked by a bronze tablet, and a twenty-ton stone lantern, a gift of the Japanese government, was installed between the two trees in 1954.

In Brooklyn Botanic Garden, near the Japanese Landscape, is another magnificent display of flowering cherry trees. It contains over thirty species and varieties, making it one of the most significant horticultural collections in the world, not excluding Japan itself.

The Midwest has participated less vigorously than the East Coast in the Japanese garden movement. T. R. Otsuka, mentioned earlier for advertising himself as a Chicago "Japanese Garden Constructor" in a 1911 magazine, four years later had changed his title to "Japanese Landscape Architect"; and from a practitioner in "Quaint Japanese Style," he had become adept in "All styles, with a specialty to harmonize American Ground."[21] During the interim he had learned that the hinterlands remained relatively provincial in the matter of accepting imported modes. Nevertheless, Japanese gardens did invade the area, perhaps under the influence of the Wooded Island and Imperial Japanese Garden groups at the Chicago and Saint Louis expositions of 1893-94 and 1903-04. At Burlington, Iowa, within a decade after the Saint Louis fair, E. P. Eastman sponsored a Nipponese landscape built in the heart of the city. Its highest hill rose fifty feet above the level of the street. A pagoda with a red-tiled roof stood out among the evergreens on the hill and a torrent flowed down to a miniature lake. The "inevitable tea-room" had a "thatched, umbrella-shaped roof."[22]

The most enthusiastic proponent of Japanese art in the Midwest was John Scott Bradstreet of Minneapolis. Bradstreet was primarily a crafts and decoration man, and as such he will be discussed in more detail later (*Chapter Eighteen*). Much of his work was in the Japanese manner. He employed Japanese craftsmen in the Bradstreet Crafthouse, and every second year he traveled to the Island Empire collecting art objects and inspiration. During the early 1890's Bradstreet had been conducted through some of the celebrated gardens of Japan by no less an authority than Josiah Conder. When the Bradstreet Crafthouse was remodeled part of the yard was made into a garden to harmonize with the Japanese gateway and side porch on the building. The new landscaping included an artificial mountain of stone, evergreens among large boulders and incidental Japanese screen fences. The garden was a modified *hira-niwa*.

At his own home John Bradstreet constructed a hill-and-water garden, which contained a thatched-roof umbrella-shaped shelter and a bridge that had been at the Saint Louis fair, made of planks from an old junk. The garden also incorporated two stone lanterns and a figure of Jizō, a bronze dragon's head and pair of storks, a bamboo screen and gate, two centenarian dwarf cedars and a cryptomeria Bradstreet brought back from Japan.[23] He planned other private gardens for clients, among them one on the John Burkholz property at Minnetonka Beach (*§175*). Now it is overgrown, the stream has dried up, the lanterns are toppled over and broken, and the bark-roofed summerhouse is in a dilapidated condition.

John Scott Bradstreet's fondest dream was of a large-scale park with Japanese features for Minneapolis. The city is mostly surrounded by water. To the east is the Mississippi River—separating the city from Saint Paul—and along the south and west sides extends a series of

lakes and watercourses. The uppermost body of water of any size is called the Lake of the Isles. It belonged to Bradstreet himself, and he presented it to Minneapolis shortly after 1900, with the intention of its being converted into a reproduction of Japan's Inland Sea. A *torii* flanked by stone lanterns was to mark the landing on the main island, and a three-storied pagoda was to surmount the summit of the hill. Other pavilions were to be placed at picturesque spots, with an arched bridge connecting an outlying islet.[24] Bradstreet wished to carry out the work himself and sent sketches and proposals to the park commissioners, but the Oriental conversion never materialized.

There may have been Japanese gardens on the West Coast antecedent to the one in Golden Gate Park prepared for the California Midwinter Exposition of 1894, but to all intents and purposes—this one being the first opened for general public inspection—the Pacific seaboard group began with this example. Known at the fair as "The Japanese Village," it has been described before *(Chapter Ten)* as containing a two-storied gateway, two-storied dwelling, thatched-roof tea pavilion, a drum bridge, several stone lanterns, a theater and a bazaar, all but the last two structures becoming part of a permanent display. The acre garden was planned and sponsored by George Turner Marsh, proprietor of the Japanese art shop in the Palace Hotel.

George Turner Marsh designed several other Japanese gardens in California. In the Bay Region, his own home in Mill Valley looked out upon a hillside landscaped in the Japanese idiom, which, because of its situation, neighbors and visitors could see and enjoy equally with the Marsh household. The Japanese public garden on the Silver Strand, adjoining the grounds of the Hotel del Coronado, across the bay from San Diego, attracted the most attention of Marsh's endeavors, except for the one in Golden Gate Park. It was built about 1904 and in many respects resembled the contemporary Japanese compound at the Louisiana Purchase Exposition, with serpentine paths winding over the rolling ground to the various pavilions. The selection of buildings, however, was more closely related to that at San Francisco. There were the usual summerhouses and rustic shelters, a theater for Japanese acrobatics and a tea house with a tile-roof entrance vestibule *(§176)*. The gateway was not elaborate, and bridges were unassuming, but a note of special interest was the inclusion of a strange, tall, circular blue and grey ceramic lantern.[25] Another garden for which Marsh was responsible was the Tea Garden in Pasadena. Nothing remains of these examples.

Among the earliest of private Japanese gardens in the lower half of California was that of Admiral McCalla at Santa Barbara. Near the residence Japanese craftsmen erected a tea house on the edge of the bluff overlooking Mission Canyon. Stone steps descend to the creek, with rustic bridges affording passage to a rare fern and palm garden on the far side, and stone lanterns lighting the slope.[26] Another garden of the same vintage belonged to Mrs. Randolph Miner of Los Angeles. This one, with several small summerhouses and stone and metal lanterns, tended to be somewhat quaint.[27] In this regard it was outdone by the garden on the estate of G. W. Wattles at Hollywood, where a bizarre effect was attained by narrow, precipitous paths scored in a hillside bristling with weird rocks, numerous stone lanterns, lantern-pagodas and topiaries, and *torii*, the last guarded by lions at the foot of a flight of steps rising to the portal of a Shintō shrine. The architectural embellishments were by Elmer Grey.[28] Also at Hollywood was Yama Shiro, the Bernheimer villa in Tokugawa style built on a hill, on the south crest of which was implanted a miniature village of dwellings, pagodas, shrines and other pavilions, bridges and lanterns.[29] The other Bernheimer estate was at Santa Monica *(Chapter Eleven)*. Its planting was greatly damaged by blight during the early 1950's. In the formal English garden of Mrs. Fowler, on Orange Grove Avenue, Pasadena, a

Japanese tea house served the double duty of school room for the children and tea room for family and friends.[30] The ruins of what was once a very appealing Japanese garden were fenced off from the street on Arlington Drive, near Orange Grove Avenue, Pasadena, in 1954. In the adjoining town of San Marino is the Henry Edwards Huntington estate, famous for its art treasures, library and expansive landscaping. A section of the grounds was made into a Japanese garden in 1913, and it features a two-storied Japanese house.

Horatio S. Stoll, writing on "Japanese Gardens" for *House Beautiful* in 1914, said that the most extensive landscape of this species in California was on the Eugene De Sabla country place, El Cerritofi, at San Mateo. The garden was the result not of improving upon nature as it exists, but of literally starting from scratch:

"Before the Japanese gardeners started on this beauty spot it was perfectly flat, like the rest of the highly developed grounds. But in all typical gardens of the Mikado's realm there is a little cascade or waterfall and this in turn necessitates a hillside, down which a tiny streamlet may meander. It took hundreds of tons of dirt and rock to provide a pretty background for the De Sabla Japanese garden, but as expense was not considered, the ingenious Japanese landscape artists found it comparatively easy to prepare a Japanese garden which, in detail, surpasses anything I have seen in California."

In articles about gardens on the West Coast, unlike those about the Eastern states, the names of the Japanese gardeners are consistently omitted. The author enters the garden through "the high gateway, flanked on each side by wings that join the rustic fence." *(§177)*. "Every little nook and corner contains some pleasant surprise." He describes the center of the garden:

"From the tea-house you note to the left a substantial yet artistic bridge, then a hillside pathway, marked with irregular flat stones that serve as steps, leading past a beautiful stone lantern to a fragile bamboo fence and fringe of pines and wide-spreading oaks. You see delicate shrubs sprouting from rocky crevices, and little trees, twisted into most impossible curves and angles, jut from the banks of the lake. Strange little creeping vines and wild flowers seek the edge of the water, and if you will walk past the waterfall to the farther end of the garden, you will find several small lotus ponds filled with floating pads and blossoms. Beyond is a wonderful bed of iris, surrounded by a wild tangle of verdant shrubs and native trees....

"On a warm summer's night, the scene is like a dream of fairyland come true. The tiny waterfall is illuminated with cleverly concealed electric lights. Colored lanterns in the tea-house make pretty reflections on the dark, placid lake. The trees and shrubs look as if they were the haunt of fireflies, and the ground seems sprinkled with glowworms."[31]

Having previously described and illustrated the 1894 exposition garden in Golden Gate Park, Horatio Stoll ends the article with a few words about the forthcoming landscape that was to be installed in Presidio Park for the Panama-Pacific International Exposition.

The Imperial Japanese Garden, which was near the south end of the Palace of Fine Arts, covered more than three acres and contained the buildings listed in the preceding chapter, of which the principal ones were the square Reception Hall based on the form of the Kinkaku, the long Main Hall on one side, and the Commissioners' Office on the other *(§178)*. The buildings were grouped more or less in a line along the length of the trapezoidal plot. A watercourse encircled the Main Hall and became an irregular lake in the middle. Traversed at narrow places by bridges or stepping stones, it contained islands where it was wide, and it extended under one corner of the Reception Hall. A broad walk cut across the width of the area, from which serpentine paths led out through the garden. Imported from Japan were seven rocks weighing upwards of three tons each, 257 weighing over a ton, and many smaller

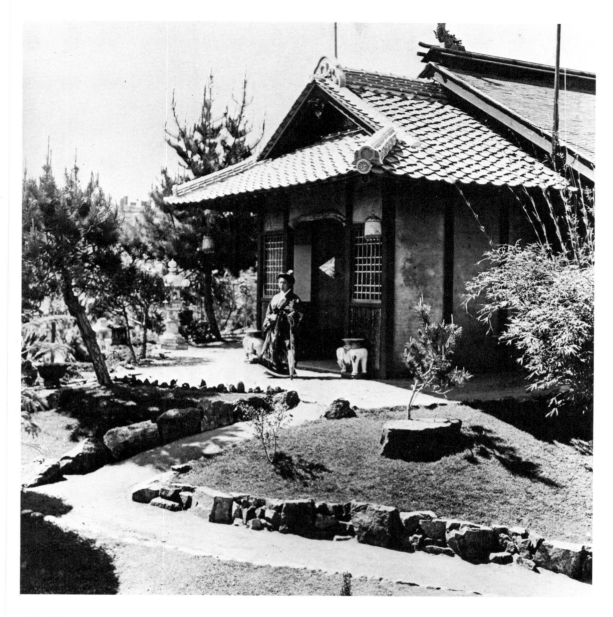

§176. *The house in the Japanese garden on the Silver Strand, Coronado, California. George Turner Marsh, designer.*

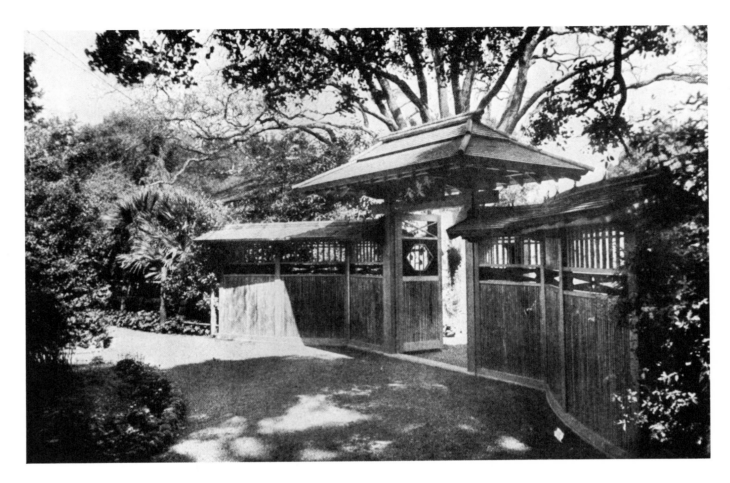

§177. *The entrance gates to the De Sabla garden, San Mateo, California.* (The House Beautiful, *July, 1914, p. 45.*)

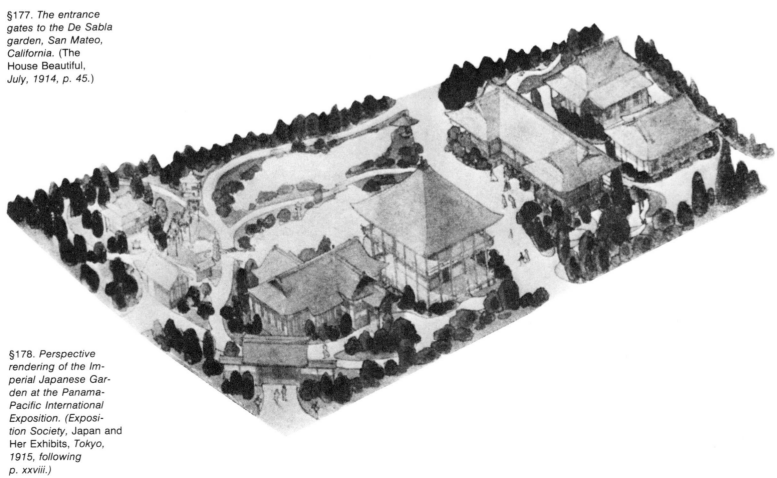

§178. *Perspective rendering of the Imperial Japanese Garden at the Panama-Pacific International Exposition. (Exposition Society,* Japan and Her Exhibits, *Tokyo, 1915, following p. xxviii.)*

§179. *Entrance gate to the Japanese garden in Golden Gate Park, San Francisco.*

§180. *Gateway to the extended Japanese garden in Golden Gate Park, formerly at the Panama-Pacific International Exposition.*

stones and gravel. Also from across the Pacific were shipped 1,360 trees—consisting of 36 species—4,400 smaller plants—of 21 varieties—and 25,200 square feet of turf. Art ornaments included bronze Buddhas, pagodas, stone and iron lanterns, and storks.[32] The garden was designed by H. Izawa, the landscape engineer who built the Japanese Gardens in London. Although intended for a permanent exhibition in Presidio Park, it was not kept intact after the fair. Some of its components were installed in the Japanese landscape in Golden Gate Park (such as the portal to the Commissioners' Office), and others went into an addition to this garden, the most prominent one being the main gateway that stood in the corner nearest the Commissioners' Office (§180).

Other Japanese gardens in California previously mentioned were that of the tea pavilion at the 1915 Panama-California Exposition in San Diego, and those of the Shibata and Hirasaki houses at Mount Eden and Gilroy. These, like most of the Japanese gardens in the United States, are of the hill-and-water (tsukiyama-sansui) variety. A few are modified tea-house gardens (cha-niwa). Both employ water—usually a rivulet originating from a spring and emptying into a pond—terraced places and promontories, rocks, trees and shrubs, stone lanterns and basins, occasional sculptures, walls, fences, gateways, bridges, shelters and a main architectural focus. They reproduce natural scenery, though presenting it in an idealized manner.

A more abstract, sophisticated, restrained, imaginative and unique type of Japanese garden is the flat garden or hira-niwa. Josiah Conder defined and illustrated it in his book published in 1893 (see §162), and William Verbeck's first garden above the school at Manlius, New York, was of this kind. Verbeck's garden, however, was probably dismembered before 1900, when the lower garden came into being. The treatment of the yard of the Bradstreet Crafthouse at Minneapolis was somewhat akin to the flat garden, and the landscaping of some of Richard Neutra's residences built in southern California during the 1940's-50's is clearly inspired by the hira-niwa. Like many dwellings in Japan the Museum of Modern Art's Japanese Exhibition House had an area of raked fine white pebbles in front of the deep open vestibule at the left end of the facade (see §143). In this instance, however, the main points of the setting were derived from the same source as the architecture itself, the Kyaku-den of the Kōjō-in Temple in Shiga Province, in which trees surrounded the irregular gravel bed.

The strict hira-niwa is set apart from everything else by being enclosed with a wall. The classic example is the flat garden of the Zen temple Ryōanji in Kyoto, where fungi and mosses clinging to the rocks are the sole plants. This garden was laid out in a seventy-five by thirty-one foot yard alongside a house built for a new superior in 1499. The building burned during the eighteenth century and a new one was erected, but the garden has remained unaltered. Coarse white sand on the level ground is raked in tiny furrows resembling waves, out of which rise fifteen dark rocks of diverse size and shape, arranged in five groups of from two to five stones. A shallow trench made of cut stone provides a neat border. The Ryōanji garden is an object of contemplation in sympathy with Zen practice. It can be viewed only from the verandah and adjoining rooms of the building that forms one of its borders. The background beyond the low enframing wall is a forest unspoiled by man-made devices. No sound disturbs the peace of this place; only silent rocks, in groups widely separated by flat whiteness, convey a message. Tradition attributes the Ryōanji garden to the artist Sōami, famous for his landscape paintings in abbreviated style and known to have been a gardener.

In 1960 a decision was made to create a facsimile of the Ryōanji garden in America. The idea originated with George S. Avery, Director of the Brooklyn Botanic Garden, during a visit to Japan. Dr. Avery was on the lookout for a new feature to perpetuate the Japanese

theme that the Garden has subscribed to for many years both in its displays and educational program. The thought occurred to him that inasmuch as American art forms have turned to abstraction in many other fields, why not in gardening as well? The excellence of the Ryōanji arrangement has gone practically unchallenged for almost five hundred years, and therefore offers as good a model for sure taste as any one could hope to find. Arrangements had been made with the Japanese landscape architect Takuma Paul Tono, trained at Cornell University as well as in Japan, to conduct several short courses on the design and construction of Japanese gardens in Brooklyn. Tono seemed the person best qualified to act as consultant on the reproduction of the Ryōanji. The site was selected and the work begun in the fall of 1961. It was hoped that stones resembling the Ryōanji group could be found in America, but after a fruitless search they had to be selected and brought from Japan. A reasonable facsimile of the coarse sand or crushed stone bed of the garden was obtained by combining several sizes of poultry grit from North Carolina. A replica of the viewing platform of the adjoining buildings was constructed for overlooking the enclosure. The Brooklyn Botanic Garden's *hira-niwa* and the Museum of Modern Art's Japanese Exhibition House have a common denominator in that both duplicate ancient Japanese models as an inspiration and guide to future work in America.

A course on a subject related to Japanese landscaping, given at the Brooklyn Botanic Garden annually since 1954, is that of *bonsai*, or the art of growing dwarfed potted trees. The term *bonsai* means "tray tree," and although the word has been used in Japan only during the last century, the practice of developing stunted trees in containers goes back many hundreds of years. The object is to make the miniature plant resemble venerable gnarled trees, such as are admired in the mountains or by the seaside in Japan. The favorite plants for *bonsai* are the evergreens, such as Japanese white pine, Japanese larch, Sargent's juniper and Yeddo spruce, but deciduous trees such as Japanese beech, grey-barked elm, trident maple, and the flowering Japanese peach, apricot, quince and crabapple may be used. The list also includes rhododendron, azalea and wisteria. In eight years, over 1,200 Americans have taken courses on *bonsai* offered by the Botanic Garden. Kanichirō Yashiroda was the first specialist given a short-term fellowship to teach the class, and four years later (1959) Yūji Yoshimura filled the same post.

Japanese gardens stress the formation of the land and the arrangement of rocks, water, green plants and architectural ornaments, yet have very little to do with flowers, other than flowering trees. Flowers receive their just deserts through being given the place of honor inside the *tokonoma* of the house, in the flower arrangement, or *ikebana*. Flower arrangement began in Japan as altar offerings at Buddhist shrines, a practice that came from the continent. The symmetrical style of arrangement—*shin* (elaborate)—was prevalent until about the Momoyama Period (1568-1615), after which the simple or irregular—*sō* (abbreviated)—manner became popular. There is also a type in between—*gyō* (intermediary)—of which some use is still made. The change in style accompanied the shifting of the art from the exclusive prerogative of the aristocracy to the general practice of *ikebana* among the common people. Another classification of flower arrangements divides them into the Formal and Natural Schools. The early "correct" style was called *rikka* (standing), which followed a prescribed form consisting of seven, nine or eleven parts, afterwards simplified to three, the *ten-chi-jin*, or heaven-earth-man arrangement. The second type is called *nageire*, or the thrown-in style, and was developed especially for display at the *cha-no-yu*, or tea ceremony. This natural arrangement is capable of unlimited flexibility and creativity, and hence has gained widespread adherence, especially in America, because it is not encumbered by symbolism, as is *rikka*. Containers can be of diversified form, made of metal, pottery, wood, gourds or bamboo, and be placed on a stand or suspended from a beam or post. Their contents may include practically

anything that grows: flowers, blossoming branches, evergreens, vines, reeds, leaves, or any such like.

To summarize, the way for the Japanese garden in America was prepared—as with architecture and decoration—by a previous acceptance of the Chinese mode, which came from England. The Japanese garden never replaced the *jardin anglo-chinois*, or English park, in the Old World, and yet it far outnumbered examples of its predecessor in the New. First introduced into the United States in an odd corner of the lot belonging to the Japanese Bazaar at the Philadelphia Centennial of 1876, it had begun to propagate on the East Coast before the turn of the century. The type favored in America is the hill-and-water garden, which follows most closely the earlier Chinese landscape, though on a reduced scale. A special variety from the Island Empire is the *hira-niwa*, or flat garden, a constrained, abstracted microcosm made up of white sand raked in geometric delineations, dark rocks, and perhaps a few plants or man-made embellishments. The landscaping of some modern American desert houses has taken on the quality of the *hira-niwa*. The most nearly perfect flat garden of Japan, at the Ryōanji in Kyoto, was reproduced in full scale as a temporary exhibit at the Brooklyn Botanic Garden, which has specialized in offering courses in Japanese garden design and horticulture, and which possesses a permanent hill-and-water landscape considered by many to be the finest of its kind in America.

CHAPTER EIGHTEEN

Japan and
Applied Arts & Decoration
in the United States

DECORATIVE arts in the United States have followed closely the trend that architecture has taken. In so doing they have been led a merry chase, because nowhere, and at no other time, has there been as quick a stylistic turnover as here since the last quarter of the eighteenth century. The Western World was just then entering a romantic phase, and America was young and vigorous and growing rapidly. After simmering for a while in the tame Classic Revival, hardly discernible from the pre-Revolution Georgian, American design rushed head-long into Greek Revival, the Italianate, Renaissance, Gothic and Romanesque Revivals, Euro-pean Eclecticism and exotic Oriental styles. All of them appeared within a few decades of one another, and most of them were raging at the same time. The Oriental, at that time, was sub-divided into two main types, the Saracenic (ranging from Spanish Moorish to Indian Mughal) and the Chinese. The Chinese Taste or *chinoiserie* was an interlude of the late Baroque and Rococo modes in Europe *(Chapter Two)* that came to America in the middle of the eighteenth century, manifesting itself mainly in houses in the South and around Philadelphia *(Chapter Five)*. It was the prelude to the Japanese that came later. It is interesting, and significant, that the Chinese influence came to America from all the way around the world via Europe, whereas the Japanese arrived directly from across the Pacific.

The long history of Japanese-American relationships is nowhere recorded more tangibly than in the collections of decorative arts existing in the New World. The surreptitious visit of Captain Devereaux to Nagasaki at the close of the eighteenth century is memorialized by pieces of lacquered furniture made in Japan now in Salem depositories *(beginning of Chapter Three)*. The signing of the treaty with Commodore Perry at Yokohama in 1854 was accom-panied by gifts of lacquers, porcelains and textiles that are kept in the Smithsonian Institution at Washington. Edward Morse, during his sojourn in Japan from 1877-83, collected ceramics and terra-cotta artifacts that were later divided between the Peabody Museum in Salem and The Boston Museum of Fine Arts *(Chapter Seven)*. Among these prizes were the first pre-historic Japanese terra-cottas to come to America *(§181)*. The Peabody Museum, of which Morse became the first director in 1880, presents a remarkable array of these artifacts, espe-cially representations of human figures. Edward Morse became Curator of Japanese Ceramics at the Boston Museum in 1882, and the catalogue of the collection there, issued in 1901, is still one of the best available accounts of Japanese potteries. It is to be remembered that Morse and several of his colleagues strongly urged the Japanese to preserve their own arts, both historic treasures and traditional skills of production. In this they were joined by an Englishman, Christopher Dresser, who accompanied a gift of English manufactures to Japan during the mid 1870's and spent four months touring the country, only to recognize the reign of bad taste that Europe had induced. Dresser pleaded with high Japanese officials to maintain a conservative policy if they wished to retain the interest of the West.[1] Dresser also formed a collection of Japanese ceramics, and carved jades, which was later auctioned at the Clinton

Hall sales rooms in Astor Place, New York, in 1877. Christopher Dresser's book, *Japan: Its Architecture, Art, and Art Manufactures*, was published at London in 1882. Another Englishman, an army officer, Captain Frank Brinkley, whose services were engaged by the Japanese government in 1871 as a military adviser, also assembled a quantity of Japanese pottery. It was brought to America when Captain Brinkley later made his home here. These objects were offered at public sale in New York after their owner's death in 1885.[2] Brinkley wrote *Japan: Its History, Arts and Literature* (Boston and Tokyo, 1902) of which Volume VIII was on "Keramic Art."

An American whose early collection not only covered a wider range of subjects than the foregoing but has also remained intact, was George Walter Vincent Smith of Springfield, Massachusetts. The museum bearing his name, completed in 1894, contains Japanese bronzes, armor, jades, crystals, ivory and wood carvings, lacquered chests and other furniture, porcelains and potteries, paintings and costumes.[3] Another collector was Charles Lang Freer of Kingston, New York, who, from about 1900 to 1917, purchased all sorts of Oriental art and built the Freer Gallery (completed in 1923), adjoining the Smithsonian Institution in Washington, for exhibiting them. The Metropolitan Museum of Art in New York started the nucleus of its Far Eastern department after its removal to the present location in Central Park. It occupied the old red brick and stone pavilion now forming one of the back wings of the extended building. In the early 1890's a group of Japanese ceramics was given to the museum by Mr. and Mrs. Edward C. Moore, Mr. and Mrs. Samuel Colman and Mr. and Mrs. Charles Stewart Smith. Later gifts of minor arts have included *netsuke* presented by Mrs. Russell Sage (1910), various decorative arts by Mrs. H. O. Havemeyer (1919) and Mr. Howard Mansfield (1936), and lacquers by Mrs. George A. Crocker (1938). The above collections are only a few that have stimulated public interest in the items represented.

Distributors of Japanese art wares have shared equal credit for popularization of Japanese applied arts with the museums. Perhaps the first specializing in Japanese art was George Turner Marsh of San Francisco, who opened his emporium in the Palace Hotel in 1876 *(Chapter Ten)*. Contemporaries on the East Coast handling Oriental art were Rowland Johnson in Beaver Street, New York, and Vantine's at 879 Broadway, with branches in Boston and Philadelphia.[4] The Japanese Bazaar at Broadway and Thirty-fourth Street was established by Japanese in 1904. Yamanaka and Company of Osaka opened a store at 254 Fifth Avenue in 1893 and another at Boston in 1895.[5] By 1900 shops selling Japanese imports had become shopping attractions in many of the larger American cities and resorts.

§181. *Ancient Japanese pottery in the Morse Collection.* (The American Architect and Building News, *May 28, 1887, p. 225.*)

The cluttered taste of the last quarter of the nineteenth century was conducive to extensive purchase of Japanese manufactures. However, pieces procured in America were not likely to be of equal calibre with the older objects obtained in Japan, because of relaxation of craft standards in things made for export. Often the chief difference between a collection and an accumulation was specialization as against diversity of kind. Quality is a matter of small consideration in the practice of exotic acquisitions. As we have seen *(beginning of Chapter Six)* rooms containing Japanese decorative pieces were usually typically Western in every respect but for the miscellaneous importations. A few interiors having simple architectural treatment

were spoiled through overloading with bric-a-brac. The Japanese Room in the Vanderbilt mansion on Fifth Avenue and Fifty-first Street and the reception hall in the H. Victor New-comb shore house at Elberon illustrate the point (*see §40*). Only in a design in which an attempt was made to be ethnically correct, as in the tea house of the Knapp residence at Fall River, did simplicity prevail (*see §47*). Of course simplicity in itself is no guarantee of fidelity —as a matter of fact many items of Japanese art are extremely elaborate—but in the characteristic Japanese house simplicity predominates.

Louis Comfort Tiffany's apartment on East Twenty-sixth Street in New York City had a library containing imported cabinets and shelves around the fireplace to hold books and ceramics, and a delicately carved *ramma* over the doorway to the next room; wall surfaces were divided into compartments and filled with leaf patterns taken from the *ramma*, and the effect was somewhat Eastlake, somewhat Japanese, and of course mostly Tiffany.[6] Louis Comfort Tiffany (1848-1933) was the son of the founder of Tiffany and Company and a gifted designer and creative artist, who fostered a spirited revival of applied arts in America. He attained fame in the field of glass, both stained glass for windows and decorative glassware called Favrile, but was only of slightly lesser stature in the departments of metalwork, jewelry and glazed tiles. Tiffany maintained workshops employing skilled craftsmen. He liked the soft textures of aged materials, and in his own output he achieved iridescent effects in glass and artificial patination on bronzes. In this regard he was Japanese. He was Japanese also in his love of nature, seeking inspiration among plant forms, primarily flowers, of which his two favorites were the Japanese wisteria and iris. In the Tiffany exhibition at the Museum of Contemporary Crafts, New York, in January, 1958, there was a stained glass window of an iris design. There was also a wisteria lamp made in the Tiffany studios though designed (about 1900) by another lover of the plant, Emarel Freshel (*§182*). The trunk and circular base are cast bronze, and the shade a leaded bonnet of opalescent lavender, amber and green glass, the form describing a wisteria tree. The light switch is a tiny button at the roots. At the time the lamp was made, incandescent electric bulbs were of clear glass, revealing the glowing filament, and had to be covered to diffuse the harshness of the light. The original of this lamp was designed for Mrs. Freshel's home in Chestnut Hill, outside Boston; and Tiffany reserved the right to duplicate it after a fifteen-year interim, which accounts for facsimiles such as the one in the Contemporary Crafts Show. For the same client Tiffany executed other accessories in metal and various media, among them silver trays inset with semi-precious stones. Some of these, like the lamp illustrated, may be classified as Art Nouveau.

When Mr. and Mrs. Albert Herter built their home on Georgica Lake at East Hampton, Long Island, soon after the turn of the century, they incorporated in it an Eastern flavor to harmonize with their own paintings and native treasures brought back from Japan during the previous decade. The living-room walls were covered with grass cloth on which Japanese prints and paintings were hung. A carved-wood standing Amida centered on the mantel shelf was flanked by rows of vases, some containing flowers. Furniture was teakwood, lacquer and wicker. The dining room was similarly decorated, except that over the fireplace was placed a painting of a white peacock by the master of the house.[7] Balancing one another across an open hall, the living and dining rooms had polygonal ends, with eight-sided sun parlors beyond, the entire suite facing the lake. In the foyer in front of the hall rose a staircase with a red-lacquered railing, and the walls provided a background of apricot satin for a group of narrow framed prints. The house changed hands and in the 1950's was owned by a painter and collector of non-objective canvases. Practically the entire interior was off-white, with the exception of the grey carpeting in the stair foyer and two octagonal conservatories, one of

which was painted yellow and black and the other orange and black. The form of the stair railing remains Japanese, and a flower arrangement in a bamboo container on the stand over the radiator recalls the design and color themes that once predominated the entire house (*§183*).

Isabel Perkins Anderson was another artist with a flair for things Japanese. She was the wife of the statesman Larz Anderson, who was Ambassador to Japan in 1912-13. Mrs. Anderson was interested primarily in books and plays for young people, but her second interest was Japan. On the Anderson estate at Brookline, Massachusetts, a Japanese garden was constructed about 1908. Its counterpart inside the great house was Mrs. Anderson's studio (*§185*). The central motif of the studio was a sunken semicircular lounge facing the fireplace. The floor and walls of the room were lined with natural wood. On the floor were a few Chinese rugs of *café-au-lait* backgrounds and blue borders and figures matching the designs on the upholstery of the curved lounge. The painted coffered ceiling, the *tokonoma*, and the carved openwork *ramma* that spanned the bowed end of the room were Japanese. Furnishings included a pair of folding screens, a folding table, *bonsai*, and metal and paper lanterns. Chairs were Queen Anne style or overstuffed. The studio maintained an uncluttered airiness and a sophistication that avoided formality.

The impact of the Japanese interior did much to make the stiff American parlor become the relaxed living room. An article entitled "Reflections of a Housewife, on Abolishing the Parlor," published in 1915, described old-fashioned parlors as having "a Sabbath-like aloofness from everyday affairs" and "an elegance and grandeur all their own." The author goes on to say:

"The change in the parlor from luxurious and formal to gay and friendly, was a step bound to be taken sooner or later. It was not, oddly enough, at first in the direction of beauty. It typified a social change toward ease and intimacy. Women began to conceive of their parlors as having romantic possibilities of amusement that should beguile family and friends thither in the evenings. That was the period of Yankee rococo,—of cozy corners and knick-knacks, of cat tails and gridirons and milking stools in places of honor. . . . Everybody got to put in it what everybody else was getting. . . .

"We had just got the parlor happily domesticated, when the professional decorator appeared, with advice to sell. His advent marked an epoch for housewives. . . . To satisfy these new aesthetic standards, and at the same time retain the hardly achieved homelikeness, was a task not easy for minds unaccustomed to think of Home in terms of the higher beauty. . . . The living-room answers a new social feeling. Life is too full to have patience with formalities. . . . The living-room is an intimate apartment, where people are at ease with one another; the surroundings suggest talk that is neither superficial nor impersonal. Perhaps the finest thing about it is that it is a man's room, quite as much as the woman's. . . . The parlor belonged to the woman of a household. The man entered it under pressure. . . more often than not seeking an early pretext for escape."[8]

Another pertinent observation from the same source is: "We are fast becoming a parlorless nation. . . . The apartment house began the movement; the bungalow developed it." The casual temper of the bungalow as a whole, of course, would qualify the main room in it. The role of the Japanese in the formation of the bungalow has been analyzed (*Chapter Eleven*).

In 1915 *The Craftsman* recommended the Japanese style for the American apartment. The sample interior discussed, designed by an Italian decorator and carried out by the Hoggson Building method, was pictured once as it was before and from three angles after the alterations. It was a square living room that was given a seat across the window wall, the windows

composed of sliding panels filled with rice paper. These were installed in the thickness of the wall to allow for night illumination from behind *(§184)*. A grasscloth dado of window-seat height, and a frieze of gold tea-box paper above the window, encircled three sides of the room. The fourth side was articulated into three alcoves, two of which have a low step and are called the *tokonoma* and *chigai-dana* in the caption, the last containing shelves. These depositories for art objects have "cleverly eliminated the unsightly mantelpieces" normally serving this purpose. The main wall areas are covered with ecru cartridge paper matching the silk on the *fusuma*. Woodwork is chestnut finished in natural brown-grey. Ceiling panels are of Japanese wood-fiber paper. Matting on the floor is edged with black linen.[9] The Chinese rug and two low tables skewed on the diagonal constitute a mannerism of the period not learned from the Japanese. The only seats being the window bench and cushions on the floor, one wonders that this chamber could fulfill the living-room requirement of putting the average American at ease; but the lack of chairs could promote intimacy.

Despite the claim for being an adaptation to a current American need the Hoggson remodeling was close in character to contemporary rooms that admittedly attemped to be authentically Japanese. One was the reception room in the Nippon Club, founded in 1905 and first occupying quarters at 44 West Eighty-fifth Street in New York.[10] The choice of interior style, having nothing to do with the five-story duplex brick and stone building in which it was installed, was appropriate to the use of the room, in which Japanese members of the club entertained friends. A similar design in a private house was the Japanese room in the Scofield residence at Tuxedo Park, which was already in existence when Takeo Shiota laid out the Japanese tea-house garden on the estate. The room was imported from Japan and installed adjacent to the entrance hall in the big stone, wood and stucco manor by Walker and Gillette of New York.[11] Except for a few choice art objects in the recesses the room was kept bare. It has been removed, the house having become a home for retired Episcopal ministers.

The organic principle of the Chicago School implies the pre-eminence of the interior over the exterior of the building, according to Wright's definition. As Wright came to understand its application better his plans changed from symmetrical layouts with well-defined room shapes of the early 1890's to informal plans in which rooms expand into neighboring spaces through wide openings. This was already in process in the Bradley and Hickox houses at Kankakee built in 1900 *(see §63)*. By the time of the first Taliesin (1911) the development was fairly far along; room shapes were irregular and space flowed around built-in forms and through open lattices *(see §68)*. It culminated in Wright's designs of the mid 1930's, such as Falling Water, where the main story is mostly an undefined living space, with a relatively small separate area for cooking, or even more so in the Willey house at Minneapolis, where the kitchen—called the "workspace"—is joined to the dining end of the living room.[12] It seems strange that Frank Lloyd Wright never made use of the flexibility a Japanese house achieves through sliding screen partitions, thereby allowing a single large interior to be divided into several smaller rooms for specialized uses. Perhaps he had an endemic dislike for sliding frames; his doors were invariably hinged and windows were of the casement rather than the sash variety.

The Minneapolis designer and decorator, John Scott Bradstreet (1845-1914), who was born in Massachusetts and educated at the Putmann Academy at Newburyport, started his business career with the Gorham Manufacturing Company at Providence, Rhode Island. In 1874 he moved to Minneapollis, which at that time was little more than a raw frontier town. Within five years he had urged a few friends to assist him in holding an art exhibition, and its success led to the establishment of an Art Institute, with Bradstreet elected the first presi-

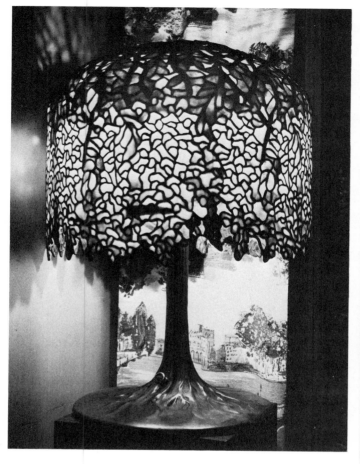

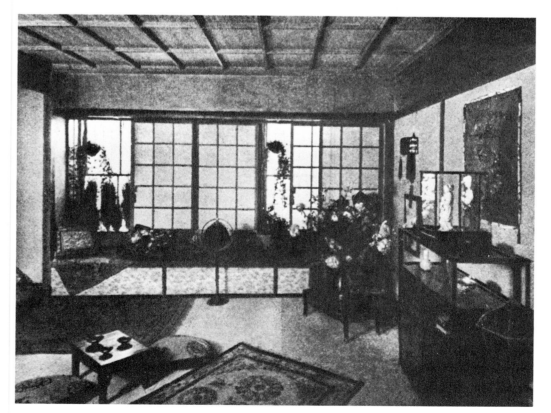

§182. *A wisteria lamp produced at the Tiffany Studios. Emarel Freshel, designer.*

§183. *Staircase in the Herter house on Georgica Pond at East Hampton, Long Island.*

§184. *A room in an apartment remodeled in the Japanese style.* (The Craftsman, *July, 1915, p. [359].*)

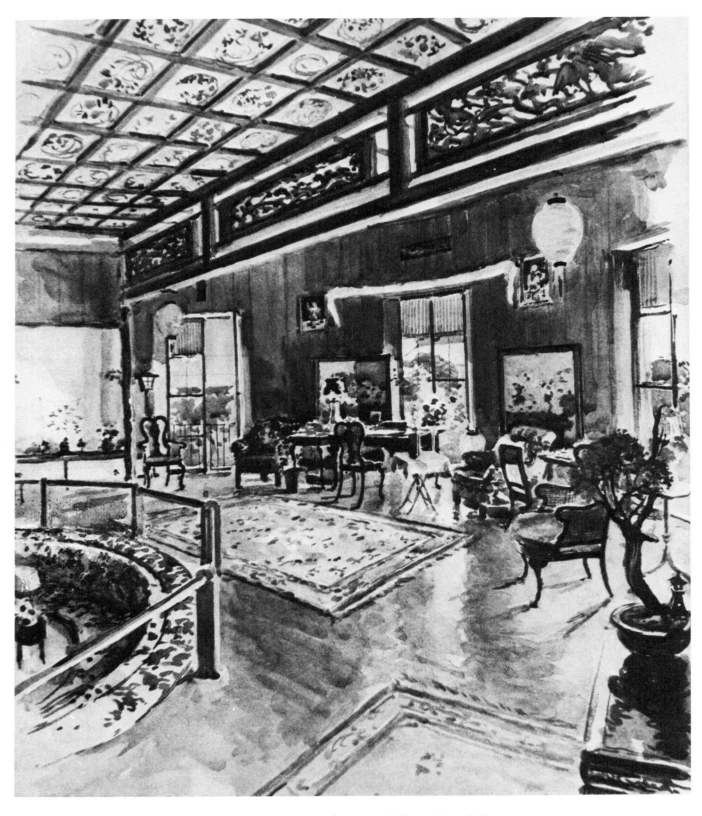

§185. *Isabel Perkins Anderson's studio, Brookline, Massachusetts. Painting by Vernon Howe Bailey.*
(Country Life in America, *December, 1920, p. 38.*)

dent in 1883. He opened a little shop in downtown Minneapolis and later formed several partnerships, but the crowning achievement of his professional life was a solitary venture known as the Bradstreet Crafthouse. Here he employed skilled artisans from all over the world, notably Scandinavia and Japan. John Scott Bradstreet made an initial trip to Japan in 1886 and was so charmed by it that he kept up biennial visits, going to Europe in alternate summers. From both places he brought back art objects that were used for study in the workshops and perhaps incorporated in decorating projects.

Around 1900 Bradstreet remodeled an Italianate villa on Fourth Avenue at Seventh Street as a permanent home for the Crafthouse. A side entrance was sheltered by a Japanese porch, off which was a flat garden of the kind spoken of in the preceding chapter. The grounds were entered through a Japanese gateway adorned with carvings (§186). Other Japanese details were around the front door. The vestibule was paneled in cypress, and a Japanese doorway led into the main showroom, a medieval-type hall lighted by skylights in the sloping ceiling that was supported by hammerbeam trusses. Here were displayed for sale decorative pieces from foreign lands, including Japanese bronzes, stone lanterns, carvings, screens and ceramics. These being unique pieces, the collection was constantly changing. Two smaller rooms also opened from the vestibule. One was the Oriental Room, featuring two windows of East Indian and Egyptian design, and the other was a textile room, with workshop behind. Bradstreet's private office was in front. Here in the director's sanctum sanctorum the Japanese theme reigned supreme, determining the treatment of walls and ceiling and a cabinet with flush-panel sliding doors (§187). Japanese flower containers and other decorative accessories were in evidence. The armchair was for clients; Bradstreet never sat on one and never allowed any in his home. The signature device for the Crafthouse was the *tatsu*, a dragon inscribed in a circle, symbolizing the "meeting of the arts."

The specialty of the Bradstreet Crafthouse was interiors. Its clientele extended to both coasts of the United States and up into Canada. No commission was too large or too small; the Crafthouse would undertake a whole opera house or a single feature in a private dwelling. A sample of the latter is the fireplace of the Bergman Richards house, a neighbor to the John Burkholz place (with the Bradstreet-built Japanese garden) on Lake Minnetonka (§188). It was remodeled about 1911. The background is surfaced with square glazed celadon tiles, to which has been attached a clock shelf, supported by a carved wood bracket representing an aquatic group. A heron is represented among arrowheads and a conventionalized swirl of water. The style of the piece indicates it could hardly have been executed by anyone other than a Japanese carver. To one side is a smaller bracket shelf, and directly underneath, the plain fireplace opening is covered when not in use by a small Chinese folding screen of enameled porcelain. An ornate gold and polychrome vase completes the ensemble. The pale green tile wall and carved shelves were not inharmonious with the simple architectural style of the Richards house. Far Eastern elements had become so much a part of Bradstreet's design vocabulary that he expressed himself in them effortlessly.[13]

Bradstreet—like Wright in the building line—influenced others in his profession to imitate the Japanese. At Saint Paul, the eastern section of the Twin Cities, Mark Fitzpatrick kept up with the times by adopting new design trends as they came along. In 1907 he conceived an art gallery and sales room for Brown and Bigelow Company in the Art Nouveau manner, and in the same year he designed interiors for Carling's Restaurant. The main dining room on the first floor was finished in dark weathered oak and dull gold. The banquet hall on the second floor combined white and gold and made use of Japanese motifs (§189). The ceiling was overspread with latticework hung with wisteria between great beams. A screen dividing

the room incorporated a *torii*, and the window end repeated the ceiling treatment. Side walls were divided into panels that were decorated with fibrous plaster reliefs of birds and flowering branches. Square electric fixtures suspended from wall brackets lighted the tables, and a larger version hung from the center of the ceiling over an enormous vase set on a carved four-legged table. Dining tables, bentwood chairs and hatracks were Occidental accoutrements necessary to the operation of the restaurant.

On the West Coast the Japanesque interior fitted into one of four main categories. The first was inspired by the beauty and artistry of the Far East, but was not—and was not meant to be—a copy. This type figured prominently in the bungalow, especially in those examples designed and finished by capable, conscientious architects like the Greene brothers. A teak-wood screen of three hinged sections, carved by Charles Sumner Greene in 1934 for one of his houses, shows the sensitive touch of a master craftsman (*§190*). The stylistic handling of the narrow panels at top and bottom revert to Art Nouveau, but the choice and treatment of the main motifs are unmistakably derived from the Japanese. The Japanese were first to see beauty in such homely vegetables as cabbage, cauliflower and squash and to interpret them with feeling. One has to look at the screen itself to appreciate fully the quality of the carving. It is in the studio on Lincoln Avenue in Carmel where Sumner Greene retired in 1916. Mrs. Greene told the author, during his visit there in 1954, that her husband would contemplate works of Eastern art for a long time before starting one of his own ventures. The Gamble house at No. 4 Westmoreland Place, Pasadena, one of the few residences by Greene and Greene to contain original and appropriate furniture, shows the touch of Nippon internally as well as externally (*see §87*).

The second type on the Pacific Seaboard was the sumptuous "museum" variety, in which architectural embellishments imported from Japan were built into rooms, which were then made comfortable by addition of Western furniture. In Hollywood the Tokugawa-style Bernheimer brothers' villa, called Yama Shiro (1913), is representative (*Chapter Eleven*). Most of the rooms grouped around the court are square. They vary in decoration from having Oriental friezes superimposed over Occidental wallpaper (as in the library and den) to walls covered with painted panels or made up of *fusuma* (the entrance hall, drawing room and dining room). Only the tea gallery, drawing room and entrance hall were innocent of Western furniture. Rooms in the Takamine house were an East Coast counterpart (*see §§128, 129, 131*).

The third category of interior was that which caught the spirit of the typical Japanese home. It was unassuming in scale and decor and sparsely furnished. This type was late putting in an appearance in the Western States—at least a quarter of a century after its equivalent across the continent. It exists rather obviously in native-type houses of emigrant Japanese, such as the Hirasaki house near Gilroy (*see §153*). It also may be found in the work of a California architect who had gotten to know the essence of Japanese building through study, as expressed in Harwell Hamilton Harris' own house in Fellowship Park, Los Angeles (*see §155*).

The fourth variety of the influence is in relatively recent buildings of exceptional restraint, whether partaking of the earlier local bungalow theme or European International Style tradition. It is exemplified in the work of Austrian-born Richard J. Neutra, whose training under Ammann abroad and Wright in America, as well as investigations made during lecture tours in Japan have brought about a synthesis of elements from three continents. His interiors (*see §158*) are not essentially different from those of Philip Johnson (*see §142*).

By the end of the 1940's the Far Eastern vogue in interior design had built up sufficient momentum to amount to a frenzy among decorators and clients in American population centers. The April, 1949, issue of *House and Garden* was devoted to Asian influence and made

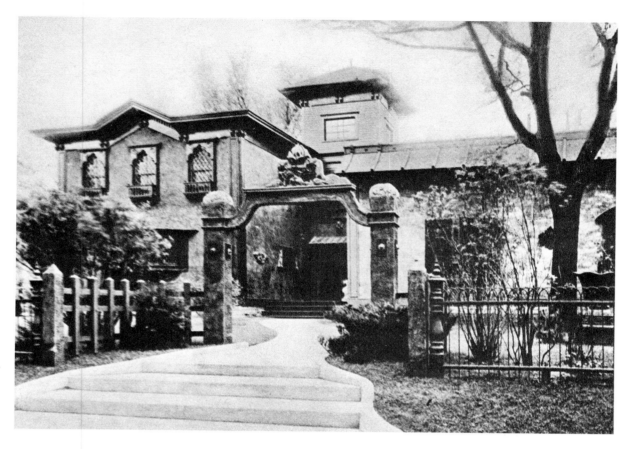

§186. *Main entrance to the Bradstreet Craft-house, Minneapolis. (Bradstreet Collection, Minneapolis Public Library.)*

§187. *Bradstreet's office in the Crafthouse. (The House Beautiful, June, 1907, p. [22].)*

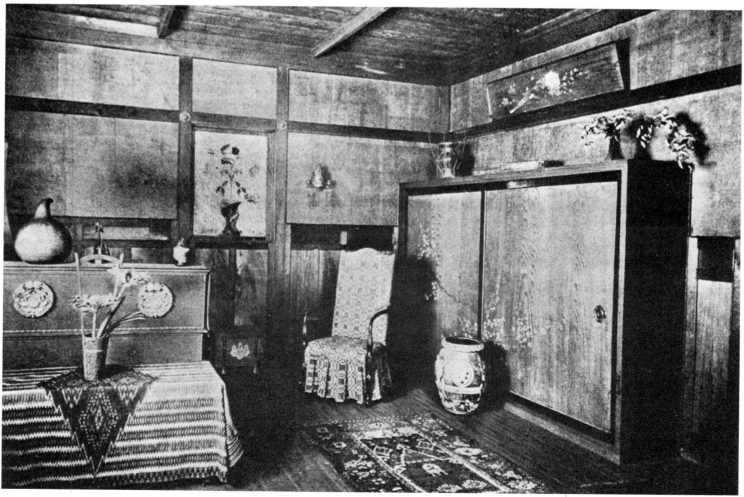

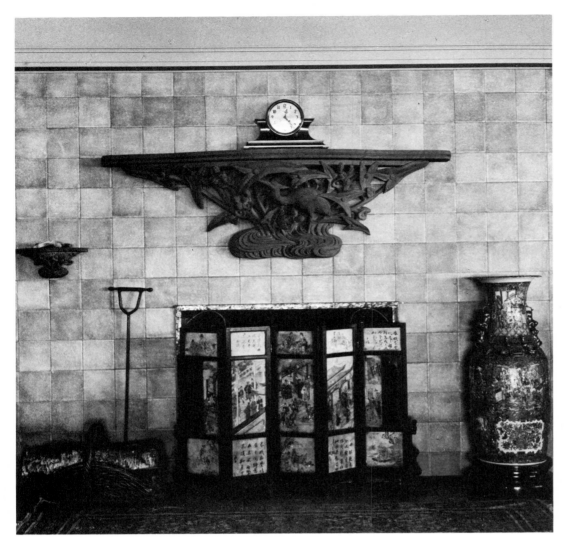

§188. *Living room fireplace in the Berg-man Richards house, Lake Minnetonka, Minnesota. John Scott Bradstreet, designer.*

§189. *Banquet hall in Carling's Restaurant, Saint Paul, Minnesota. Mark Fitzpatrick, designer. (The Western Architect, January, 1908.)*

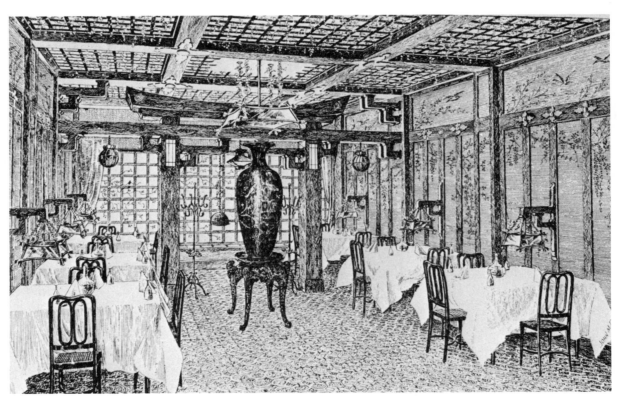

§190. *Teakwood screen by Charles Sumner Greene, 1934.*

§191. *Alcove in a Long Island apartment. Raymond and Rado, designers. (Photograph courtesy* The New York Times.*)*

§192. *Ceramic bowl and jug by Peter Voulkos. (Photograph courtesy* Craft Horizons *and Peter Voulkos.)*

evident the fact that mass-produced Grand Rapids reproductions of Asian pieces had met and were ready to supply an ample market. Most of the influence at that time was Chinese, but soon Japanese *tansu* and other forms became available. Practically every Sunday the home page in the Magazine Section of the *New York Times* was devoted to apartments, penthouses, or vacation houses that were Japanese in feeling. It was heralded as the "new look," but the so-called new look hardly appeared any different from the inside of the Knapp house tea pavilion at Fall River demolished a half-century earlier. The time lag is interesting, being greater than the measure of a generation. The craze remained in full force throughout the 1950's. Most of its results were superficial. The beauty of the interior of a Japanese house is due largely to its integration with the structural system of the building, achieving a kind of rational fulfillment, and to apply its extrinsic forms to an allotted space in a housing unit is to miss the whole point. Decorators usually have done worse by the style than architects, who put an element of construction back into it. An alcove in a Long Island apartment by Antonin Raymond and Ladislav Rado acquires a Zen mood through its utter simplicity *(§191)*. The area has a dropped ceiling of oak slats suspended from beams that span cabinets on each side. The doors of the cabinets are covered with brown and gold silk paper. A single painting on the wall, a spray of berries hanging from the ceiling, a tall vase and a small bronze figure riding a water buffalo on the floor, and *tatami* with a pair of pillows, small lacquered cabinet and tea service constitute the entire contents of the alcove. The main part of the room has Western furniture in it, and *shōji* at the windows, yet maintains the same uncluttered serenity as the alcove. Antonin Raymond was in Japan during most of the 1920's and '30's *(Chapter Fifteen)*.

The minor arts in the United States have enjoyed a phase of existence quite apart from their affiliations with interior decoration and architecture. The theme of independence here has been prominent, but it has not prevented American craftsmen from looking westward for guidance to Japan. This has been noted earlier in work from the ateliers of Tiffany and Bradstreet. The tendency was observed at the time of the Chicago Columbian Exposition in connection with silver. In a paper read before the Society of Arts in 1893, H. Townsend said: "Roughly speaking... the silverwork of England is a tradition, and that of America a discovery." He went on to explain that whereas artisans in the Old World were bound to prescribed patterns, those in the New were free to assimilate from anywhere and everywhere, and no matter what people thought about American crafts it could not be said that the products lacked interest. The American artisan has sought inspiration "not only among the archaeological dust-heaps of the centuries, but in the world of science of to-day, and the almost newly-discovered world of still living Oriental art. From science he has borrowed many a secret of metallurgy. From the East, and from Japan especially, he has learned many a lesson of form and color." Americans have taken over many beautiful alloys "which, under the names of shibu-shi and shakudo, the Japanese have known and cunningly worked for centuries; or... the equally beautiful effects gained by the same artifices through the use of patinas, which give to silver... a bloom as of a sun-kissed peach or ripened plum. The English have passed them by with timorous indifference; the Americans have spent large sums of money and an infinity of thought and care, and while deftly refraining from any servile copying, have adopted rather than translated these foreign arts into their own language." Townsend had samples of silver to illustrate his remarks, and although reaffirming their source of influence, he defended their originality: "I would beg you especially note that while the Japanese influence is strong, none of the pieces I have here could by any possibility be mistaken for examples of native Japanese workmanship."[14] Two Tiffany coffee pots of silver exhibited at the

Chicago fair were based upon Middle Eastern and Egyptian shapes and decorations but were not copied after specific vessels from these regions.[15]

Far Eastern ceramics have been acknowledged superior and therefore have been imitated in the Occident for over three hundred years (*Chapter Two*). Most of Europe's admiration was directed toward Chinese porcelains, but Japanese potteries received a fair share in certain periods and places, as for example Imari in Regency England. American potters did not participate noticeably in the Far Eastern influence during the Romantic era, but they climbed upon the band wagon at the beginning of the modern period, or in the last quarter of the nineteenth century. Mrs. Maria Longworth Storer took up making ceramics as a hobby and developed it into a thriving industry in the Rookwood Pottery at Cincinnati, Ohio.[16] A modest proportion of the output was in imitation of the Chinese. At the turn of the century the Merrimac Pottery, conducted by T. S. Nicherson at Newburyport, Massachusetts, specialized in forthright shapes and extraordinary colors and textures, such as "brownish red like some of the older Japanese pieces, the dull blacks like the costly Chinese vases, and the dull rose-colored lusters"[17] Just as the exquisite refinement of Chinese porcelains fitted in with the ideals of traditional Occidental ceramics, so the free and easy (*shibui*) manner of the Japanese goes hand in glove with the modern movement stressing self-expression. There was considerable interest in this branch of the crafts among amateurs during the early 1900's, and a new wave of enthusiasm arose at mid-century. Schools, clubs, camps and adult-education institutions have included clay-modeling and firing in their programs. The Los Angeles County Art Institute constructed a $75,000 building for its Ceramics Department, of which Peter Voulkos is head. The two pieces illustrated are by Voulkos (*§192*). He does not strive for perfection, because art, he believes, comes from the heart. The brushwork decorations have the same vigorous treatment as the shapes. The vessel on the left approximates a Japanese ceremonial tea bowl and the other a small-necked sake bottle. There were also Americans who became interested in pottery-making in the Japanese style while residing in Japan. An example is Bert B. (Mrs. S. M.) Livingston. Mrs. Livingston learned the craft in Yokohama during the early 1950's, at first in the studio of Shigeshi Karasugi, and later in that of Hajime Katō, in cooperation with the potter's son Tatsumi. The American has been given exhibitions of her work (*see §212*). She also engages in wash painting, discussed in the following chapter.

The obvious origin of the high-piled hairdo that crowned the head of the stylish woman during the first years of the twentieth century was confused by a costume that had nothing to do with the Japanese kimono. The influence from Nippon in milady's dress appeared later. In 1913, when Paris was considered the fashion center of the world, *The New York Times* sponsored a costume contest to prove the capabilities of American designers. The contest was divided into various departments having to do with types of dresses, and watercolor sketches of the winners were published in color in a special section of the February 23rd edition. First prize for an evening gown was awarded to Ethel Traphagen, whose design was described as having been inspired by Whistler's *Nocturne* in the Tate Gallery, London, a night view of Battersea Bridge (*§193*). The Whistler in turn was inspired by a Hiroshige print, *Fireworks at Ryōgoku*, in the Hundred Famous Views of Yedo series. The reference of the costume to the painting was in the color scheme. An opalescent effect was achieved through use of a sheer pastel-blue chiffon over a putty-colored undergarment. For contrast the girdle was a deep blue-green of Oriental embroidery, with bits of red and red-orange. Though the colors came from Whistler the sinuous lines seem derived from figures in the *ukiyoe* of the late eighteenth century, the wing shoulder treatment corresponding to long kimono sleeves, the train of ceremonial length, and the girdle a reasonable facsimile of the *obi*. Ethel Traphagen was then

§193. *Rendering of an evening gown that was awarded first prize in the costume contest sponsored by* The New York Times *in 1913. Ethel Traphagen, designer. (Reproduced courtesy Ethel Traphagen Leigh.)*

Sheer Fabrics for Lovely Summer Frocks

§194. *Illustration in a James McCutcheon and Company advertisement.*
(The House Beautiful, *March, 1922, p. 255.)*

a teacher of costume design at Cooper Union, and ten years later she opened her own school of fashion. It has an international attendance. Mme. Chiyo Tanaka of Osaka, founder and director of three schools of fashion in Japan and President of the Japan Costume Institute, studied at the Traphagen School. Miss Traphagen's costume collection contains many kimonos, acquired during a visit to Japan in 1936, and they are brought out of their chests to be displayed and lectured on from time to time. The year after the newspaper competition to prove that Americans could equal the Parisian modistes, a student of the French School of Fashion produced a design for a modern dress equally as Japanese as the premium evening gown, and the mannequin wearing it was represented dangling a parasol on her arm.[18]

The Japanese influence in women's clothes became popular during the ensuing decade. James McCutcheon and Company, located on Fifth Avenue across from the luxurious Waldorf-Astoria Hotel that stood on the site of the present Empire State Building, announced a sale of dress materials in one of the leading home magazines in 1922. The illustration for the advertisement has a central figure holding a parasol and wearing a low-waisted frock with a sash (§194). The bust line has disappeared and the face has a rose-bud mouth and eyes shaped like birds in flight—with the genuine article depicted out to the right. This was the period during which American women purchased thin imported Japanese kimonos to wear as lounging robes, and pictures of bathrooms advertising plumbing fixtures were not considered complete without including a model clad in one.

The avalanche of minor arts brought from Japan and given places of honor in public depositories or private settings touched off cravings for more Japanese surroundings that engendered further importations and considerable imitation. Development of the influence in one field encouraged it in others. The Japanese style was most successful and made its greatest contributions where it complied with the democratic ideal. The concept of casual, abstract beauty that permeates much of Japanese art coincides with the trend that aesthetics has taken recently in America, and it was the art of Japan that helped to instigate its formulation.

The Imprint of Japan
upon
American Fine Arts

THE PLACE of painting and sculpture among the arts in the Far East is somewhat different from that in the West. On the whole the fine arts in Farther Asia are better integrated with the residuum of the space arts than in the Occident, where easel paintings are isolated by being put into frames and statues or mounted on pedestals. Indeed Frank Lloyd Wright complained that here "Art" was considered to be pictures hanging on the wall to the exclusion of all other forms. Though he was much more than an architect, Wright has never been given the credit he deserves for his innovations in fields outside of building. He devised some of the earliest and best cubist sculptures and non-objective murals of any American artist. Examples of the former were in the Midway Gardens (1914) in Chicago, and are in the Imperial Hotel (1916-22) in Tokyo and the Hollyhock House (1920) in Los Angeles; and an example of the latter is in the Edgar J. Kaufmann office (1937) at Pittsburgh.[1] Not only are these works excellent in themselves but they make good sense as Wright employed them in their architectural settings. In contrast, the normal piece of abstract art, framed or mounted in the conventional manner, seems somewhat shallow for its place of distinction.

In Japan, although paintings are not set apart in heavy moldings, all types are suitably mounted. There are seven major settings for Japanese paintings: (1) on folding screens (*byōbu*), (2) sliding screens (*fusuma*), (3) walls, (4) vertical scrolls (*kakemono*), (5) horizontal scrolls (*makimono*), (6) fans and (7) book illustrations. Each of these may be in the style of monochrome transparent ink painting (*sumie*), a technique imported from China, or the native opaque polychrome (*yamatoe*). Only the last three were meant to be looked at independently rather than as part of the Japanese interior. Paintings displayed in rooms are never overpowering—in the manner of Pompeiian or Tiepolo murals—but blend into the architectural scheme. Paintings on screens, often landscapes, give depth to enclosing planes. The *kakemono* fits into the place provided for it in the *tokonoma*, and another work of art set nearby complements the painting, be it a piece of sculpture or a flower arrangement. In the Japanese room paintings and art objects are not allowed to compete with each other. The householder keeps his collection of art stored safely in the *kura*, and brings out appropriate items singly for temporary display. Japanese visual arts, like Japanese music, are by nature quiet and contemplative, becoming forceful and dramatic only upon certain exceptional occasions.

Japanese fine arts became known to Americans through the same channels as decorative arts, these being museums and other places of exhibition, including fairs and private collections, shops specializing in Eastern art, and illustrated books. Edward Morse's books had concentrated on pottery and dwellings, but the works of his friends and colleagues dealt with the major arts. Foremost in this circle was Ernest Francisco Fenollosa (1853-1908), the son of a Spanish musician who had settled in Salem. Fenollosa was a Harvard alumnus and a postgraduate student at the newly founded school of the Boston Museum of Fine Arts. In

1878 he went to Japan and taught philosophy for eight years in the Imperial University at Tokyo. He became head of the Tokyo Fine Arts Academy and the Imperial Museum upon its establishment in 1888. While there Fenollosa formed his own collection of Japanese paintings. During this period William Sturgis Bigelow of Boston accompanied Edward Morse on his third trip to Japan in 1882, and remained seven years, collecting paintings with the Boston repository in mind. In 1886, Dr. Bigelow persuaded a wealthy friend, Charles G. Weld, who was visiting Japan, to purchase the Fenollosa paintings for Boston. In 1890 Fenollosa returned to the United States to become Curator of Oriental Art at the Boston Museum of Fine Arts. About this time Denman W. Ross of Cambridge began giving the pieces that make up the Ross Collection. In 1896 Fenollosa went back to Japan and taught English literature in the Imperial Normal School at Tokyo. It was after his return to the United States for the last time in, 1900, that he produced the books for which he is best remembered, *Hiroshige, the Artist of Mist, Snow and Rain* (1901), and the *Epochs of Chinese and Japanese Art* (1911), a two-volume work published posthumously, compiled by his second wife, Mary McNeil Fenollosa, from a rough pencil draft left by him. Ernest Fenollosa was so well thought of by the Japanese that they sent a cruiser to transport his ashes to Japan for burial.

After Fenollosa had given up his post at the Boston Museum in 1896, Arthur Wesley Dow became Keeper of Japanese Paintings and Prints. Kakuzō Okakura, author of *The Book of Tea*, joined the museum's staff in 1906, and on his recommendation many worthy pieces were added to its stores. Okakura had been associated with Morse, Fenollosa and Bigelow in securing the establishment in 1887 of the Japanese Bureau of Survey of Treasures, precursor of the Commission for the Protection of Cultural Properties, which still exists today. The present home of the Boston Museum of Fine Arts on Huntington Avenue and Fenway was completed in 1909, and the important Japanese section was housed in a dozen rooms in the southwest wing. Among its masterpieces are the *Kibi Deijin Scroll* (Bigelow Collection), ascribed to Mitsunaga, and the *Heiji Tale Scroll* (Fenollosa-Weld Collection) dating from the twelfth and thirteenth centuries. Two important loan shows from Japan held in the galleries were the Exhibition of Japanese Art Treasures presented in connection with the Tercentenary of Harvard University in 1936 and the Japanese Government Show of 1953. The second was assembled by the Commission for the Protection of Cultural Properties. It appeared also at the Metropolitan Museum in New York, and in Washington, Chicago and Seattle.

The Metropolitan Museum of Art Japanese collection was begun in the decorative field before 1900 *(Chapter Eighteen)*. Paintings and prints were included among the Havemeyer (1919) and Mansfield (1939) gifts, and prints alone constituted the Henry L. Phillips (1940) and Louis V. Ledoux (1949) acquisitions. The Ledoux collection is perhaps the most celebrated in the United States. Five monumental volumes reproducing prints from it were issued from 1942 to 1951. Favorite Japanese items belonging to the Metropolitan Museum are the set of three *Tenjin Engi Scrolls* of the Kamakura era and three pairs of screens believed to have been painted by Sōami, Kōetsu, and Kōrin, of the Ashikaga to Tokugawa periods. S. C. Bosch Reitz was the first Curator of the Department of Far Eastern Art. He served from 1915 to 1927, at which time Alan Priest succeeded to the chair.

Many Americans have become acquainted with the fundamentals of Japanese painting through Arthur Wesley Dow (1857-1922), who was born at Ipswich, Massachusetts, and studied art in Boston and Paris. As we have seen, he became Keeper of Japanese Paintings and Prints at the Boston Museum of Fine Arts in 1897. He had taught at Pratt Institute for two years before, and during the next seven had held a position at the Art Students' League in New York. In 1904 he gave these up to become Director of Fine Arts in Teachers' College,

Columbia University. Dow is best remembered for his book called *Composition*, first printed in New York in 1899, which explains certain factors pertaining to Japanese painting. The text considers the three main structural elements of design to be line, light-and-dark arrangement, and color. Line is discussed primarily in terms of Japanese materials and brush practice. For the second element, instead of using the hyphenated English phrase, light-and-dark, or the Italian compound word, *chiaroscuro*, Dow prefers the simpler Japanese, *nōtan*. In the section on the third element the dimensions of color are given as hue, intensity, and "nōtan of color," in place of the usual term, value. *Composition* went through thirteen editions by 1931, and because of its popularity art students throughout the United States became familiar with, and appreciative of, the lineal and tonal fine points of Japanese painting. *Nōtan* became a classroom word. A number of full-page plates show Japanese artists' application of the principles, both in landscapes by name masters and flower pieces by unknown decorative artists *(§195)*.

Another American recognizing the artistic vistas of Japanese painting and transmitting its principles by means of a publication was Henry P. Bowie of San Mateo, California. He visited Japan in 1893 to learn something about its art and culture, and remained nine years, becoming proficient with the Japanese language and thoroughly conversant with Japanese customs, thoughts and ideals. He learned character writing from Kinza Hirai as a prelude to studying painting under several artists in Kyoto and Tokyo, including Tōrei Nishigawa, Beisen Kubota, Sekkō Shimada and Bokusen Shimada. Bowie achieved acclaim for his own paintings in Japan, and examples of his work were acquired by the Emperor and Empress. After his return to America he lectured before universities and societies on the West Coast, and in 1911 he published the substance of these talks in a book entitled *On the Laws of Japanese Painting* (San Francisco). In it Bowie gives some of the background to art education in Nippon and reviews the various schools of Japanese pictorial art. He says there are seventy-two laws governing the methods and effects of Japanese painting. The chapters on technique are concerned with the implements and materials (mainly brush and ink), the rules governing conception and execution, the canons of aesthetics, subjects for paintings arranged by the seasons and remarks on signatures and seals. The book contains sixty-six plates. The fifty-seven that illustrate points made in the text were sketched by one of Bowie's teachers, Sekkō Shimada. *On the Laws of Japanese Painting* is available now in an excellently printed paperback.

Dow and Bowie were mainly interested in Japanese art for what it could contribute to Western painting as a whole, rather than solely for application in their own work. They were primarily teachers and not creative artists. But they had been preceded by passionately creative Americans who had turned to Japan for inspiration. The roster begins with James Abbott McNeill Whistler and includes Mary Cassatt, both of whom discovered Japanese art and practiced in Europe *(Chapter Four)*. They were followed by many others, most of them educated in Europe, where they acquired their initial taste for the Japanese. A few pursued it directly in the Orient itself. This was true for the first of the group to be discussed, a woman, who, like Mary Cassatt, became entranced by *ukiyoe*.

Helen Hyde (1868-1919) was born in Lima, New York, and spent her childhood in San Francisco. She began her art training in California and continued it abroad, in Holland, Berlin and Paris. One of her teachers in the French capital was Félix Régamey, Director of the Musée Guimet, whose enthusiasm for Japanese art made a lasting impression upon the young American. Discouraged when the painting she submitted to the Salon was rejected, Helen Hyde returned to America. Back in San Francisco she discovered a new world of subject matter in Chinatown, which turned her thoughts and eventually her footsteps toward the

§195. *Designs by Japanese artists. (Arthur Dow,* Composition, *New York, 1899, p. 61.)*

§196. *Helen Hyde, The Bamboo Fence, color woodblock print. (Print Collection, New York Public Library.)*

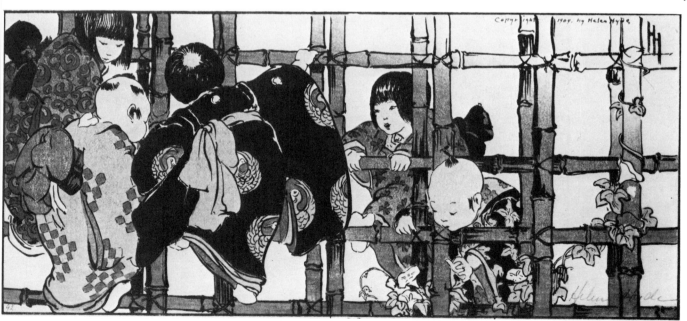

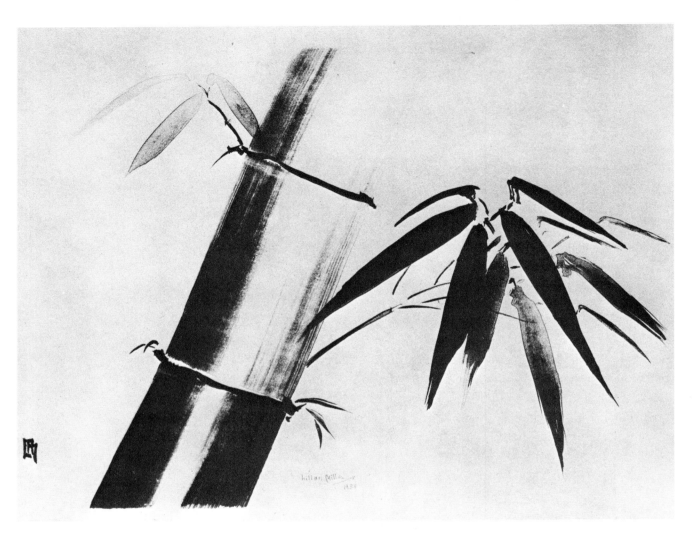

§197. *Lillian May Miller,* A Spray of Bamboo, *lithotint. (Collection of the Library of Congress.)*

§198. *Albert Herter,* The Flower-Cart, A Study of Japanese Ceremonial Costume. (The Monthly Illustrator, *July, 1895 p. 4.*)

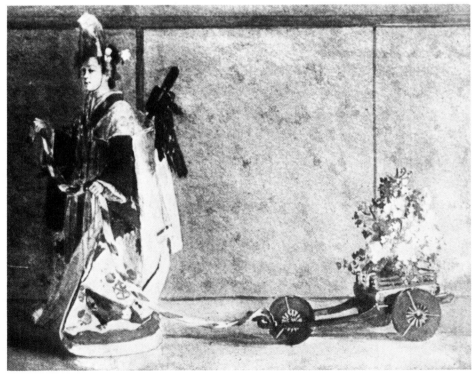

§199. *Panel by Edith Emerson*, The Tribute of the Athenian Youths, *The Little Theater of Philadelphia.* (The American Magazine of Art, *May, 1918, p. [282].*)

§200. *Thornton Oakley, Shinto Pilgrim.* (The American Magazine of Art, *August, 1919, p. [372].*)

§201. *Henry Dearth, The Persian Book.* (The American Magazine of Art, *April, 1919, p. 197.*)

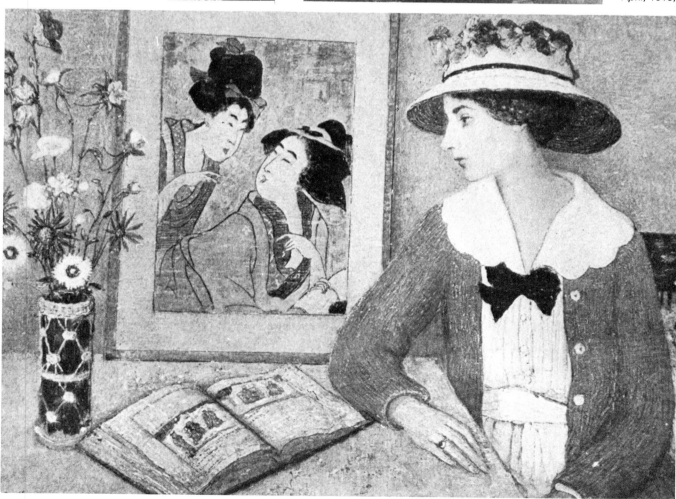

§202. *Mark Tobey, Pacific Circle. (Courtesy of the Willard Gallery, New York City.)*

Far East itself, only to Japan, not China. Helen Hyde arrived in Japan in 1899, expecting to stay six months but instead remained fifteen years. At Nikko she converted a building formerly belonging to a temple into a studio and worked under the guidance of the last member of the Kanō School, Tomonobu. Invited to exhibit along with Japanese artists in Tokyo she sent a painting called *The Monarch of Japan*, representing a proud Japanese mother holding out her baby to another admiring woman. The picture won first prize, and Helen Hyde made a colored woodblock print of it. Thus began a long series of prints having to do with Japanese women and children, executed in hard or soft-ground etching, drypoint, aquatint, lithography or woodcut techniques. Etchings were printed first in black line; then the plate was cleaned and colors applied, and this was printed over the first impression as a monotype. No two were alike. Her favorite medium being the woodcut, Helen Hyde learned to cut the blocks herself, but usually she concentrated on the design and turned the cutting over to skilled Japanese artisans. Editions from 150 to 200 prints were run off in her studio with the help of an assistant, Murata-san. Her later home was at Akasaka, a district of Tokyo.[2] Helen Hyde is best remembered for her pictures of children, recorded with warmth and tenderness, immortalized during a moment of play, in an arrangement of engaging patterns and soft colors. Typical is the color woodblock print *The Bamboo Fence*, produced in 1904 *(§196)*. Although Japanese in subject and technique, the artist's Western heritage dominates in the drawing.

Another woodcut artist in the Japanese manner was Lillian May Miller (1895-1943). She was born in Tokyo, the daughter of the Honorable Ransford S. Miller, Consul General of the United States. Showing signs of unusual talent in art at nine she became a pupil of Tomonobu Kanō, who, a few years earlier, had instructed Helen Hyde. At twelve Lillian Miller's work was exhibited at the Imperial Salon. She came to America for higher education, and after graduating from Vassar College returned to Japan to study under Bokusen Shimada. Like Helen Hyde she learned the entire process of woodblock designing, cutting and printing. Most of Lillian Miller's prints were scenes in Japan. Some of the titles are: *Festival of Lanterns, Nara; Makaen Monastery, Korea; Rain Blossoms;* and *Nikko Gateway*. In 1927 she published a book of poems called *Grass Blades from a Cinnamon Garden*, and illustrated it by woodcuts. Her lithotint, *A Spray of Bamboo*, was issued as the sixth annual gift print by the Honolulu Print Makers in 1937 *(§197)*. Lillian Miller's cipher, like Helen Hyde's and Whistler's, resembles a chop character. Her Japanese professional name was Gyokka (Jeweled Flower).

In the distinctly Western medium of oil painting Americans originally followed the lead of Whistler's composition *The Golden Screen* rather than *The Pacific*. In other words they turned to Japan for exotic and colorful subject matter, but remained traditionally Occidental in their treatment of it. Walter Gay of Boston was one of the first to take his easel to Japan, and he returned with a set of conventional transcripts of Japanese landscape. Shortly following him were Albert and Adele Herter, who were in Japan in 1893 and later decorated their East Hampton home with Japanese accents and their own canvases *(Chapter Eighteen)*. Both were capable painters, and Mrs. Herter was especially interested in portraits, which were painted in a blond key typical of the period. Albert Herter showed more of a tendency to leave unfilled spaces in his canvases, as in *The Flower-Cart, A Study of Japanese Ceremonial Costume (§198)*. An elaborately arrayed *musume* stands on the lefthand side of the picture, facing outward, holding a white and scarlet ribbon tied to a three-wheeled cart bedecked with flowers. *Fusuma*, parallel to the picture plane, determine a shallow depth. Floor and *fusuma* are brightly lit except for shadows massed behind the figure. Unlike the models posed in kimonos in Whistler's and Monet's paintings, the Japanese girl in the Herter study is completely at home in her costume. Another painting by Albert Herter, produced during the same visit and

called *A Rest in the Woods*, combines a Manet *Déjeuner sur l'Herbe* composition with a Cézanne paint technique.[3]

Thornton Oakley (1881-1953) was born in Pittsburgh and received his Bachelor of Science and Master of Science degrees at the University of Pennsylvania in 1901 and 1902. Then for over a decade he wrote and illustrated magazine articles. The visual arts held the greater attraction for him, and in 1914 he returned to his alma mater as an instructor in drawing, later accepting the permanent position of Chairman of the Department of Illustration of the Pennsylvania Museum School of Industrial Art at Philadelphia. In a typical narrative style he conceived the *Shinto Pilgrim*, a white-clad figure wearing a broad hat in a picturesque setting, including two *torii* amidst angular pines and a misty mountain in the background (*§200*). The subject exhausts the limits to which the picture is Japanese. An Eastern artist would have shown more of a panoramic view, giving the pilgrim a wide landscape to explore, whereas the Western painter is content to portray his figure rooted to one spot. *Shinto Pilgrim* was awarded a silver medal at the Panama-Pacific Exposition in San Francisco (1915).

A colleague of Oakley's was Edith Emerson. She was born in Oxford, Ohio, in 1880, and acquired her training at the Art Institute of Chicago and the Pennsylvania Academy of Fine Arts. Her professional career was divided among being a muralist, an illustrator (especially for the Christian Science *Monitor*) and a teacher, both as a staff lecturer at the Pennsylvania Museum School of Industrial Art and in her own Philadelphia Atelier of Mural Painting. Edith Emerson was commissioned to decorate the walls of the Little Theatre of Philadelphia prior to World War I, and for it she painted a shallow panel over the proscenium arch and four tall panels, in pairs, on the side walls. The theme was the Greek myth about Dionysus (son of Zeus and a Theban princess) and Ariadne, the Cretan princess whom the demi-god rescued from the Island of Naxos. The story includes the Minotaur and the tribute of the Athenian youths to the King of Crete (*§199*). In the tribute panel the isometric perspective, stylization and overhanging roof of the main pavilion of the palace, the use of pine and maple trees, and the "wrinkled" handling of the rocks in the foreground all are Far Eastern. The observer has to look closely at the boat, the figures of the youths and guards, the sculptures and the solidity of the architectural forms to accept the scene as Mediterranean.

Henry Golden Dearth (1864-1918) was a New Englander, who studied art in Paris at the École des Beaux-arts and with Anné Morot. His first independent work, done during the 1890's, was painted with a thick impasto in a low color key. A change occurred in 1912 while working on the Brittany Coast, his canvases taking on a richer beauty derived from a greater vitality of surface and color. Dearth also was a collector, and in the Oriental hemisphere his taste gravitated to Persian miniatures and Japanese prints. These sometimes figured in his pictures, as in *The Persian Book*, painted about 1917 (*§201*). An analogy in style is to be noted between the painting and the collector's items in it. Dearth's composition is constructed of flattened shapes with definite outlines, the oils treated almost as though they were cloisonné enamels, and the main subject is conceived as impersonally as the figures in the Japanese print on the wall, the vase of flowers or the old Persian book on the table. The shapes comprising the model echo the contours in the print, and one's eye contemplates with equal interest the dark patches of chairback, bow tie, hat brim, coiffures of the Japanese, and flower vase. The painting transmits a quiet, Oriental mood.

By the time of World War I the United States had scraped just about everything off the surface of Japanese art and culture that it wished to acquire. Between the First and Second World Wars America began to realize that there was something intrinsically worthwhile *deeper*, and a few searching souls began to dig. The profound depth they found, that gave

meaning to the exterior of Japanese art and life, was Zen. Zen is a species of Buddhism of a very special sort, that brings out the most abstract peculiarities of Buddhist doctrine. It was developed in the Far East over a period of centuries, and yet it is considered by many to be a very pure (and therefore pristine) expression of the Buddha's teaching. The Japanese word *zen* is the equivalent of the Chinese *ch'an* and the Sanskrit *dhyāna*, which mean "meditation." The school is based upon the principle that inasmuch as the Buddha attained Enlightenment through meditation, others can reach this same blessed state only by the identical process. The object is to break the bonds of existence through recognizing the external world—and oneself in it—as a temporary illusion, and to absorb the individual ego into the Universal Reality which is Buddhahood. In America, the teaching has been much abused, because to the unitiated Zen sounds illogical, and it has been exploited for all sorts of superficialities. But it also has been the means of giving to many people a broader meaning to life and art than they had known heretofore. The keynote to Zen is directness and simplicity, thinking or doing something without hesitation, and eliminating the extraneous. The Zen monk lives frugally, not for the sake of denying himself but in order to attain a greater realization through limiting distractions.

Zen was introduced to America in 1906. In this year Soyen Shaku's *Sermons of a Buddhist Abbott* was published by Open Court in Chicago. Soyen Shaku was head of Engakuji and Kenchōji, two Zen monasteries at Kamakura. His sermons dealt primarily with the *Sūtra of the Forty-two Chapters*, and were generally Buddhist in tone and only slightly Zen. Also in 1906 the Zen monk Sōkei-an (Shigetsu Sasaki) arrived in this country. Sōkei-an spent twenty years of study in the United States and then returned to Japan, only to be charged by his master to establish a center for the teaching in the New World. In January, 1930, he founded the Hermitage of Sōkei at 63 West Seventieth Street, New York City, the first Zen temple in the Americas. Here he gave lectures on Zen in English two or three times a week for eleven years. His followers were consolidated as The Buddhist Society of America and later the name was changed to The First Zen Institute of America.

No one has done more to further the cause of Zen outside the ken of organization than Dr. Daisetz Teitarō Suzuki by way of his writings, mostly published in London or Japan, and his lectures in America. Suzuki was the translator of the Soyen Shaku *Sermons*, and the first of his own writings was the three-volume *Essays in Zen Buddhism* (1927, 1933, 1934), an unsystematic collection of scholarly papers that often leaves readers more mystified than conversant with the subject. To some extent this was rectified by Suzuki's *Introduction to Zen Buddhism* (1934). The door to Zen was opened wider by a native Englishman, who came to live and talk about this subject in the United States. His name is Alan W. Watts, and his first book, *The Spirit of Zen*, was launched at London in 1936. Other volumes of special interest have been: Suzuki, *Zen Buddhism and Its Influence on Japanese Culture* (Kyoto, 1938); R. H. Blyth, *Zen in English Literature and Oriental Classics* (Tokyo, 1948); and Eugen Herrigel, *Zen in the Art of Archery* (New York, 1953).

The foregoing digression upon the subject of Zen has been prompted at this time by way of introduction to an understanding of the next two painters to be discussed. Both were greatly influenced by Zen, and this comes out strongly in their work.

Mark Tobey, born in Wisconsin in 1890, self-taught in art, first worked for a fashion catalogue firm in Chicago, gave his first exhibition of portrait drawings at New York in 1917, and during the 1920's taught at the Cornish School in Seattle. After traveling in Europe and the Near East he settled down to teach once more, this time in England. Afterwards he journeyed to the Far East, and in 1934 he studied brushwork with the Shanghai painter Têng Kwei. He

also spent some time in a Zen monastery in Japan. Tobey became fascinated by calligraphy and in 1935 conceived *Broadway Norm*, the first of his "white-writing" paintings. From this time on most of his painting has derived from calligraphy. Mark Tobey often paints on tinted, textural backgrounds which suggest infinite space, the columns or tangles of automatically written figures advancing or becoming diffused in atmospheric movement. His paintings conjure up images of the genesis of a universe, the metamorphosis of constellations; and that his mind tends toward these subjects is borne out by the titles: *Above the Clouds*, *Outer Space*, *Migration, Crystalline Forms, Awakening Night* and *Pacific Circle* (§202). The last, a tempera measuring forty-four by thirty-four inches, consists of a ground of warm grey, with luminous opaque white suggesting a vortex out of which emerge characters in red, blue and black. The painting seems to relate the primordial formless Peace from which all creation arises (a Buddhist concept, as opposed to the Christian origin out of chaos) with the Peaceful Ocean, the Pacific, that laps the shores of both Orient and Occident and transports the interchange of goods and ideas that has transformed both into newly evolving worlds. Asked to speak on the subject of Oriental influence on American painting by the United Nations, Tobey said that the Japanese added to his knowledge of the meaning of the "abstract," and taught him "concentration and consecration" and the "blending of simplicity, directness and profundity."[4]

In response to the interest in Far Eastern calligraphy demonstrated by modern American artists such as Mark Tobey, Franz Kline and Adolph Gottlieb, the Museum of Modern Art sponsored a showing of abstract calligraphy produced by thirty-five Japanese artists during the summer and early fall of 1954, afterwards sending the exhibition out on tour to other cities. This collection assembled in Japan by Arthur Drexler, Curator of the Department of Architecture and Design, indicated the newest development in the Japanese calligraphy tradition, that of seeking to explore the pictorial values of the written symbols with little concern for their legibility. Characters may float on a white ground, or fit snugly in the picture area, executed in thin washes or thick impasto for textural interest (§203). The three examples shown in a corner of the third-floor gallery are (*left to right*): *The Deep Pool* by Gakyū Osawa, *Spring* by Shikō Kansaki, and *The Sun* by Imaji Kakeshi. The first and third, among others in the exhibition, were acquired for the Museum of Modern Art's permanent collection.

The American painter who has become most thoroughly imbued with the philosophic thought of Zen is Morris Graves. He is quoted as having said that Zen appeals to him because it "stresses the meditative, stilling the surface of the mind and letting the inner surface bloom."[5] Morris Graves was born in Oregon in 1910, and before he was twenty had made three trips to the Orient as a seaman or cadet on the American Mail Line. Japan was included in these voyages. During the early 1930's he stayed briefly in Los Angeles, Texas and New Orleans, then settled in the vicinity of Seattle. He did several works for the Federal Art Project, and for a while was associated with Mark Tobey. Graves' early paintings were in heavy oils, but later he painted in tempera and wax. At the end of the 1930's he became obsessed with certain phenomena of nature that offered a means of subjective expression, such as misty moons, snakes and especially birds. The manifestation was augmented by items of Eastern art with which Graves became familiar in the Seattle Museum. The now-famous *Inner Eye* series dates from this period. The gouache painting, *Moon Mad Crow in the Surf* (1943), is typical of his style (§204). A drenched crow gazes intently at the pale crescent veiled in its own nimbus in the turbid sky. The crow is oblivious of the wavelets that threaten to carry him out to sea. The moon, the sea, the sky have merged in oneness in the bird, and there is no external existence. His concentration is complete; he has attained *satori*, Enlightenment, Buddhahood. The humble creature has become the Buddha. A parallel to the Morris

Graves painting may be drawn with any of a number of Zen caricatures of the Ashikaga era showing tattered monks ecstatic with joy over some simple occurrence or view of a natural object, such as Hōtei watching a cock fight or Jittoku laughing at the moon. In a *kakemono* by Geiami in the Boston Museum of Fine Arts, the thrust of the body of Jittoku and the spatial relationship of figure to satellite equal corresponding elements in Graves' painting of the crow *(§205)*.

Morris Graves was anxious to revisit the Orient and in 1946 was awarded a Guggenheim Fellowship for study in Japan. He traveled as far as Honolulu, but the military permit for a civilian to enter Japan at that time was withheld. Graves remained in Hawaii for six months and painted the Chinese bronze series, in which ancient ritual vessels become animate, and tantric emblems perform magical acts of generation. The following year he built a new home near Seattle with the help of the Japanese painter Yone Arashiro. Graves got to Japan finally in 1954, and by then he was painting large pictures in oils. An example is *Flight of Plover* (1955) which measures three by four feet *(§206)*. The treatment of the *Plover* is more abstract than that of the *Crow* and pertains primarily to life and movement. Color plays an unimportant role, being limited to umber, black and white. *Flight of Plover* captures the rhythmic beat of numerous wings, the unity of purpose of many organisms that together make up a compact amorphous mass scurrying through the hollow sky. The subject resolves itself into tensile arcs precipitated in one direction at varying depths from the spectator, who, after moments of contemplation, begins to feel that he, too, is part of this feathered migration to unknown roosts. The theme—only of swallows instead of plover—is traditional with Japanese artists *(§207)*. An interesting intermediary, become more decorative, is a stylized Art Nouveau silk tapestry designed by an Englishman during the 1890's *(§208)*.

A dilettante lately influenced by Japanese painting is Sigismund Adler, who, in his seventies, acquired the technique of *sumi* painting. Long before, he had begun his art studies at the Art Students' League and continued them at Parsons' in New York, the Taos Valley Art School, and L'École de Chaumière in Paris. Then, after a business career, he took up his brush again under the tutelage of Fernand Léger in Paris. Subsequently he toured Europe, the Near East, India, Hongkong and Japan, painting along the way. In Japan Sigismund Adler studied the *sumi* method with Futo Atsumi, and began a series of landscape paintings *(§209)*. Regarding the new turn his work has taken Adler says: "I have always admired Japanese Art, and have been influenced by its simplicity, purity of line, and color, its absence of shadow and perspective, its emphasis on values and rhythm of line. Japanese painting, it seems to me, teases the imagination because it allows the spectator to fill the gaps of detail for himself. That is why one never tires of Japanese sumi painting. That too, I believe, is the growing interest shown in much of our contemporary art."[6]

An American woman, who like Adler had a background in Western art and acquired ink painting in Japan, and like Helen Hyde took up residence there, is Bert B. Livingston, mentioned in the preceding chapter with regard to her ceramics. Mrs. Livingston had learned sculpture in Paris under Maillol, Despiau and Wlerick, and was engaged in non-objective painting when she joined her husband on business in Japan about 1950. Six years later, after she had become conversant with pottery making, Bert Livingston met Shutei Ota and began lessons in *sumi* painting with her, later continuing with Doju Kusakabe. On the whole the work that followed reflected the broad *nanga* style of the Southern School of classic Chinese painting, though some of her paintings are more detailed *(§212)*. One notes in the illustration the four earlier paintings of rhythmic lines in the panel hung over the display of Mrs. Livingston's ceramics. The landscapes beyond are typically *nanga*. Her subjects are varied. She has said:

"The bamboo is the subject I like best to paint. When I paint it, I feel its suppleness. I also paint flowers...a flower has its own personality and variableness even as human beings do. When I paint flowers, I try to express the character of the flower. When I paint a landscape, I put myself completely into the picture, imagining myself following a small mountain path, resting a while halfway up the mountain under a pine tree, and then walking on...."[7]

Among her favorite Japanese artists are Sesshū, Kōrin, Sōtatsu, Tessai and Harunobu. Bert Livingston selects the mountings or mats and frames for her paintings, and signs them with two seals, one bearing the letters "LIVINGSTON" arranged vertically, and the other the Chinese characters *huo-shih—kyo-seki* in Japanese—a literal translation of "living-stone."

A native Japanese who spent most of his life in America, and created a name for himself as a considerable influence upon art here, was Yasuo Kuniyoshi (1893-1953). He was born in Okayama and came to the United States during his teens. At Los Angeles, where he went to school with children half his age, Kuniyoshi drew apples and cubes so well that the art instructor advised him to become an artist. Acting upon this counsel, Kuniyoshi worked his way to New York, where he studied in the studio of Kenneth Hayes Miller at the Art Students' League, and at the National Academy of Design. He continued his studies abroad, and returned to Japan for a visit in 1931. Soon afterwards he became an instructor at the Art Students' League, spent his summers at Woodstock, and was held in high esteem by his students at both places. Early Kuniyoshi paintings show a tendency to overmodel—acquired from Miller—whereas his mature work has a fluidity and textural interest, and a moodiness without great color contrasts, that seem derived from Far Eastern painting, though executed in oil rather than watercolor. His themes are Western, usually figures or still life.

Among Kuniyoshi's worthiest pupils is Hiroshi Honda, born in Hawaii in 1913, who spent eight years in Japan studying *sumi* painting in the Kyoto School of Art before enrolling at the Art Students' League in 1948. Honda paints in watercolor, oil and casein, but all of his paintings are begun with a wash, and, like those of his master, maintain a painterly character throughout. His subject matter is more closely related to that of Japan than Kuniyoshi's, nature predominating, for Honda is the introvert whereas Kuniyoshi was the sophisticate. An exhibition of Honda's watercolors and caseins began a projected series at Japan Galleries in New York City late in November, 1962, and, by coincidence, a showing of Bert Livingston's paintings had opened at the Nippon Club two days earlier.

No modern American artist attains a synthesis of East and West more thoroughly than Isamu Noguchi, brought about through parentage, training and feeling. He was born at Los Angeles in 1904 of a Scotch mother and Japanese father. Isamu spent his childhood from age two to thirteen in Japan. Back in the United States he lived in Indiana for four years, and in New York for a similar period. Then he went to Paris, where he apprenticed to the noted abstractionist Constantin Brancusi. Noguchi exhibited there as an abstractionist and supported himself as a portrait sculptor. He next visited China and Japan, was in England for a while, and during the 1940's lived in New York City. In 1942 he began to design settings for dancer Martha Graham. His fame in the theater became matched in industrial arts through his creations in furniture, lighting units, playground equipment, ceramics, and even toys. In spite of their being mass-produced, Isamu Noguchi managed to maintain a sculptural and craft character to them. During 1951 he was in Japan, where he designed two gardens, and planned bridges for Hiroshima. He decorated the Faculty Club Room at Keio University, Tokyo, as a memorial to his father, Yone Noguchi, who was for many years a professor at that institution. Noguchi built himself a studio in the country at Kamakura, where he produced a number of fired pottery pieces, among them a Karatsu-ware figure seven and three-eighths inches tall, called *Big Boy*

§203. *Exhibition of abstract Japanese calligraphy in The Museum of Modern Art, New York, 1954.*
(Photograph Soichi Suname, courtesy of The Museum of Modern Art.)

§204. *Morris Graves,* Moon Mad Crow in the Surf, *gouache painting.*
(Collection of Mr. and Mrs. Milton Lowenthal, New York City.)

§205. *Geiami*, Jittoku Laughing at the Moon. *(Boston Museum of Fine Arts.)*

§206. *Morris Graves,*
Flight of Plover.
(Whitney Museum of
American Art.)

§207. Flight of Swallows, *Japanese.* (*Bing,* Artistic Japan London, 1890, Vol. IV, p. 269.)

§208. *Swallow design for a silk tapestry, William E. G. Shaw, Macclesfield.* (Emporium, *Vol. V, April, 1897, p. 250.*)

§209. *Sigismund Adler*, Canal, Tokyo. *(Courtesy of the artist.)*

§210. *Isamu Noguchi,* Big Boy *Karatsu-ware figure. (The Museum of Modern Art, New York City.)*

§211. *Vase-sculpture by Peter Voulkos. (Photograph courtesy of* Craft Horizons *and the artist.)*

§212. *Exhibition of pottery and paintings by Bert Livingston at the Hotel New Japan Gallery, Tokyo, November, 1961. (Courtesy of the artist.)*

(§210). The simple handling of the clay, the subtle modeling of the abbreviated details and natural textural finish are reminiscent of ancient *haniwa* sculptures. The piece is owned by the Museum of Modern Art.

Another artist from the western states, who has climaxed his career at Los Angeles rather than starting out from there like Noguchi, is the ceramicist Peter Voulkos, some of whose pieces have been shown earlier *(see §192)*. Born of Greek parents at Bozeman, Montana, in 1924, Voulkos studied commercial art at Montana State College, where he decided to specialize in ceramics. After graduation he matriculated at the California College of Arts and Crafts in Oakland, and received a Master of Fine Arts degree in ceramics in 1952. Since then he has taught at the Los Angeles County Art Institute and become head of the Ceramics Department. During the late 1950's Voulkos created a series of large-scale vase-sculptures that combine wheel-turned and slab parts *(§211)*. The piece illustrated, twenty-four inches tall, superimposes bell and box forms with a primitive virility proper to *haniwa* pottery, first brought to America by Edward Morse *(see §181)*.

The selection of examples discussed above indicates the direction American fine arts has taken, due to Japanese influence, from about the middle of the nineteenth to the middle of the twentieth century. The basic pattern of Japanese contributions to painting was apparent as early as the 1860's, especially in the output of Whistler, painting in Europe and, briefly, in South America. This pattern had at its extremes the simple inclusion of Japanese subject matter and the thorough absorption of composition essentials derived from Nippon. Whistler had discovered Japanese art in Europe, as did a few other American artists like Mary Cassatt and Henry Dearth, but most of those who came under its spell learned about it directly, in Japan itself. A break in the art cycle that had been established came with the suspension of cultural activities during the period of confusion of World War I, and when the momentum built up again the trend was in an entirely different direction. Abstraction became the order of the day, and one of the prominent early participants in it, through his creation of architectural sculptures and murals in relief, was Frank Lloyd Wright. The new movement was given a deeper meaning in America through Zen concepts and art from Japan than abstraction had known in Europe, and Far Eastern calligraphy lent it additional significance and vitality here. America contributed to the abstraction movement through exploring and synthesizing principles and images come from both East and West.

Japanese Miscellany
and
a Summing-Up

THE MANIFESTATIONS of Japanese influence in the space or visual arts in the United States depended upon the implanting of a pleasing image of Japan in the American imagination. It was brought about in large measure by the imported exhibition pavilions and the ethnic and art objects put on public view that have been discussed. It was brought about also through the medium of literary reference, or descriptions in print. This phase of influence began, insofar as America is concerned, with Bayard Taylor's sketches written during the Perry visit. The sketches first appeared in the *New York Tribune* and then were published in book form under the title *A Visit to India, China and Japan* (1855). A year later there appeared Commodore Perry's three-volume *Narrative of the Expedition of an American Squadron to the China Seas and Japan Performed in the Years 1852, 1853, and 1854*. The Japanese mission sent to ratify the treaty participated in the parade up Broadway during June of 1860 that prompted Walt Whitman's poem "The Errand-Bearers" or "A Broadway Pageant." Soon afterwards several unimportant plays put the Japanese theme dimly in front of the footlights (*Chapter Three*). By that time the pattern was set for American consumption of things belletristic about Japan.

English-speaking travelers began penetrating Japan in droves during the last quarter of the nineteenth century. The scene of the Grand Tour began to be divided between Europe and the Eastern Archipelago. Many visitors sent back accounts of various aspects of Japanese culture and customs for publication, and most of them were glowing. From Britain came Josiah Conder, the architect and engineer, who wrote books on Japanese flower arrangements and gardens (*Chapter Seventeen*), Captain Frank Brinkley and Christopher Dresser, collectors of ceramics and authors of volumes on Japanese life and crafts (*Chapter Eighteen*). There were also two well-known British literati who contributed to the spread of information about Japan: Sir Edwin Arnold, whose collected essays originally printed in *Scribner's Magazine* were published in the book *Japonica* at New York in 1891, and Rudyard Kipling, who penned eleven articles on his first trip to Japan in 1889 and four more during his second in 1892. The American group included the familiar names of Edward Morse, Dr. William Sturgis Bigelow and Ernest Fenollosa, all three connected with the Boston Museum, and Arthur May Knapp and Ralph Adams Cram (*Chapter Seven*). Morse and Cram produced books on architecture, and Fenollosa on paintings and prints. Henry P. Bowie concentrated on Japanese painting and after learning the technique compiled his findings in *On the Laws of Japanese Painting*. Henry Adams and the artist John La Farge visited Japan in 1886 and sent back vivid reports of what they saw. Percival Lowell shipped to America quantities of Japanese art which fired the youthful imagination of his sister Amy. In addition Percival wrote about Japan so persuasively —notably in his book, *The Soul of the Far East* (Boston and New York, 1888)—that the most prolific Japanophile of all was induced to go and settle there. This was Lafcadio Hearn.

Patricio Lafcadio Tessima Carlos Hearn (1850-1904) was the son of an English-Irish

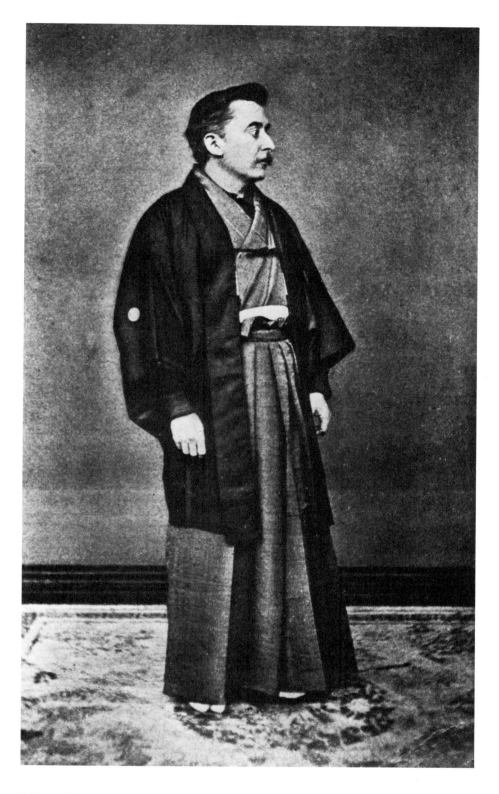

§213. *Lafcadio Hearn. (Bisland,* The Life and Letters of Lafcadio Hearn, *Boston and New York, 1906, Vol. II, frontispiece.)*

British army surgeon and a Greek (part Arab-Moorish) mother. Abandoned by his parents to the care of a great-aunt in Dublin, he was sent to a Catholic college to be trained for the priesthood. While there he met with an accident that caused loss of sight in his left eye. Being an omnivorous reader Hearn so overtaxed his right eye that it soon became enlarged, and he developed a complex over its repelling people. The great-aunt tired of her responsibility, and to relieve herself of it she paid Lafcadio's passage to America. Lafcadio was nineteen when he landed in New York, and he went on to Cincinnati, where he worked as a messenger, a peddler of mirrors, and finally was discharged from a public library job because he read too much and neglected chores. In 1873 his condition improved through his becoming a reporter on the *Cincinnati Enquirer*, but after four years of reporting his health broke, and he went south to New Orleans. The old Crescent City satisfied his longing for an exotic and colorful past better than any place he had known. New Orleans also had its unseemly side and furnished Hearn with material for articles about the evils of child labor, police extortion, vivisection and lynching. He also picked up a little money writing book reviews. His first books were published during this period: *One of Cleopatra's Nights* (translation of six Gautier stories, 1882), *La Cuisine Créole* (on New Orleans cooking, 1885), and *Some Chinese Ghosts* (1887). Next Hearn was in Martinique, where *Two Years in the French West Indies* and *Youma* (a novel of slave insurrection) were written. They were published in 1890, the year Hearn was back in New York translating Anatole France's *Le Crime de Sylvestre Bonnard*. He received one hundred dollars for the translation, and this fee was well spent on passage to the enchanted isles Percival Lowell had convinced him were to be his future homeland.

In Japan Lafcadio Hearn secured a position teaching in a school at Matsue. Later he moved south to teach in the Government College at Kumamoto. And beginning in 1903 he occupied the Chair of English Literature in the Imperial University at Tokyo. Meanwhile he had married a Japanese and become a Japanese citizen, using the name Yakumo Koizumi *(§213)*. Three sons and a daughter were born of this marriage. Hearn found in Japan a place that was more quaint and steeped in older traditions than New Orleans, and thus the more suitable milieu for his literary expression. The first major work on his newly adopted country was *Glimpses of Unfamiliar Japan* (1894), which transcends the usual traveler's report through its Impressionistic descriptions and lyrical prose style. A proposed series of lectures for Cornell University, which never materialized as talks, was published as a book called *Japan: an Attempt at Interpretation* (1904). Although Lafcadio Hearn never mastered the Japanese language he retold many Japanese tales, especially fairy stories for children, the telling of which made them classics in the West. Hearn surpassed all other writers in conveying a vivid picture of Japan. It was slightly rose-tinted, but at the same time remarkably astute.

Japan was represented often as fantasy. One of the most distorted images of the country distributed in English is that lightly concocted for Gilbert and Sullivan's popular opera *The Mikado*. It is said to have originated one day when William Schwenck Gilbert was trying to think up a plot and a samurai sword fell from the wall of his study and clattered on the floor. The play that Gilbert wrote was a satire on the English court peopled by stock Japanese theater types—the jolly Ko-Ko, the cruel Poo-Bah and the over-refined Yum-Yum—flaunting names unheard of in Japan. *The Mikado* was first performed in 1885.

Many plays laid in Japan have appeared since *The Mikado*, including Sir Edwin Arnold's *Adzuma: or the Japanese Wife* (1893). The story is about a slandered wife who allows herself to be decapitated in place of her husband by a desperate lover. The theme was related earlier by Arnold in *Japonica*, and used much later in the Japanese movie *Gate of Hell*.

The favorite of all plots involving the Japanese code of manners originated in America,

coming out first in 1897 as a novel by John Luther Long. It attracted more notice as a play produced by David Belasco at the Herald Square Theatre in New York, opening on March 5, 1900, and starring Blanche Bates. The play was *Madame Butterfly*, the heart-stirring tragedy of faithful Cho-Cho San, deserted by her imperious American husband who considers their marriage unbinding because of their racial difference. The play was presented without an intermission; the passing of Cho-Cho San's night of waiting was handled by changing lighting effects lasting fourteen minutes. So successful was the play in New York that Belasco produced it concurrently in London, where Giacomo Puccini saw the first performance and determined to make it into an opera. Puccini's version had its premiere at La Scala in Milan, on February 17, 1904, costumed in Chinese robes and with a hybrid setting. It was considered a failure, but three months later it was given at Brescia and became a hit. The opera has remained a favorite throughout the world ever since, and most people have forgotten it was ever a play or a novel. We have noted that Mary Pickford played Madame Butterfly on the screen, and part of the film was made in a New Jersey garden in 1914-15 *(Chapter Seventeen)*.

A vivid and sometimes fanciful impression of Japan in the English language has been available to youngsters since the end of the nineteenth century. Some of the earliest sources were soft books of crepe paper with Japanese illustrations in delicate lines and exquisite, graded colors, put together with silk thread and sporting little tassels on the front. The *Japanese Fairy Tales* series written by Lafcadio Hearn and published by Hasegawa of Tokyo had twenty booklets in the first series, and a few were issued in a second group. In America, Mabel Gillette's *Jingles from Japan* was published at San Francisco in 1901. Another woman who wrote for children and whose name is familiar to us was Mary McNeil Fenollosa. Mrs. Fenollosa helped her husband prepare two books on Japanese prints and compiled the *Epochs of Chinese and Japanese Art* (1911) from his rough draft. Her own charming book of poems called *Blossoms from a Japanese Garden* was published at New York in 1913. Its purpose was to transmit "for little people the spirit and love of Japan." One feels that it was conceived as an Oriental counterpart to Robert Louis Stevenson's *A Child's Garden of Verses* (first edition 1885). Among the titles of the poems in the *Blossoms* are "A Cherry Picnic," "Going to School in the Rain," "A Roadside Tea Party," "Kite Flying," and "The Mischievous Morning-Glory" *(§214)*. The illustrations are reproduced in color after paintings by a Japanese artist. The last poem is about a morning-glory that has wrapped itself around the bucket pole at the well, so that little Noshi-san, who has come at dawn to draw water, is in a dilemma over what to do. The purple blossom claims priority, and the little girl:

> . . . *sought a kindly neighbor's well*
> *and, laughing, told her plight.*
> *'Gift-water I must beg of you!'*
> *The neighbor's smile was bright;*
> *But, being Japanese, she thought*
> *The child exactly right.*

In 1912 Mary Fenollosa turned over to an enthusiastic young American poet certain of her late husband's manuscript notebooks. The literary heir was Ezra Loomis Pound. Born in Idaho in 1885, Pound had lately become the leader of the Poets' Club in Soho, where he learned from F. S. Flint the value of Japanese poetry. It was in 1912 that Pound composed his first short and now famous poem suggested by the traditional seventeen-syllable Japanese verse form called *haiku* or *hokku*. The poem was "In a Station of the Metro," abridged from a

§214. *"The Mischievous Morning-Glory."*
(From Mary McNeil Fenollosa's Blossoms from a Japanese Garden, *New York, 1914, facing p. 8.)*

thirty-line work destroyed a year earlier because it was considered unsatisfactory by the poet. The material left by Ernest Fenollosa made a lasting impression upon Pound and bore fruit in his adaptations of Fenollosa's translations of Nō plays, *Certain Noble Plays of Japan*, published in 1916,[1] and in the *Instigations* of 1920, a much disputed essay on the nature of the Chinese character. Another contact with the Japanese was through Whistler, whom Pound admired extravagantly. Pound's first poem in the initial issue of *Poetry* (October, 1912) was "To Whistler, American." Two years later, in an essay printed in the *Egoist* (June 1, 1914), Pound admonished his unseen audience: "I trust the gentle reader is accustomed to take pleasure in 'Whistler and Japanese.' Otherwise he had better stop reading my article until he has treated himself to some further draughts of education." It is from Whistler, he goes on to say, that the "world," *i.e.* "the fragment of the English-speaking world which spreads itself into print," has learned "to enjoy 'arrangements' of colours and masses." What Pound obtained from the Japanese, through Whistler and Flint and Fenollosa, that he could apply in his own art expression, was the importance of the picture created in poetry, the imagistic as opposed to the lyric. Hence faces in the metro station crowd are:

Petals on a wet, black bough.

In the *Cantos*, following the Fifty-first Canto, Chinese-Japanese characters are inserted frequently as super-pository images, or as symbols to be looked at but not read aloud, as elsewhere Pound uses Egyptian hieroglyphics or Romanized inscriptions inside geometric cartouches. The *Cantos* also contain references to Nō plays, and to Japanese art, history and culture in general. Ezra Pound continued to draw inspiration from Japan throughout his mature period. The latest set of *Cantos* came out in 1948.

Ezra Pound became secretary to William Butler Yeats in 1911, and excited the Irish poet to a keen interest in the Japanese. Yeats wrote the introduction to *Certain Noble Plays of Japan*, and modeled thirteen of his own dramatic pieces on the Nō, or "Noh plays," as he called them. Pound was also much interested in a number of American poet insurgents working under the sway of Impressionism. He collected their writings, which were published in 1914 as *Des Imagistes*. The outstanding figure among the Imagists was Amy Lowell, who espoused the Japanese among other sources in her writings. The objects sent back from Japan by her older brother, Percival, first aroused her appreciation at an early age. One set of Amy Lowell's poems is called *Pictures of the Floating World* (1919), a literal translation of *ukiyoe*, the term applied to Japanese prints.

On the scholarly level the culture and wisdom of Japan have been transported to America through the medium of Japanese books, some of which have gone into private and some into public or institutional libraries. The four largest collections of Japanese books in the United States are at Columbia University, Harvard University, the Library of Congress and the University of California. The three universities are strong in course offerings on Far Eastern subjects. The Japanese books and manuscripts at Columbia originally belonged to the Japanese Culture Center, conceived by the scholar Ryūsaku Tsunoda in 1926 and realized through a donation by Baron Koyata Iwasaki. In 1931 the collection was turned over to Columbia University with the understanding that the school would develop classes in this field. Tsunoda served as curator and teacher there until his retirement in 1954. At that time there were some 45,000 tomes and periodical volumes, in addition to newspaper files from 1921, painting scrolls, and other art and religious objects. These are housed in the East Asiatic Library located in the Low Memorial Library building.

A consciousness of Japan has been impressed upon a large segment of the urban population through the Japanese films shown in the United States since 1951. The first was *Rashōmon*, winner of the Grand Prize (Golden Lion) at the International Venice Film Festival, and in America given the Special Academy Award for the best foreign film of the year. In this picture the American public was introduced to the beauty and talent of Machiko Kyō, who was seen again teamed with Masayuki Mori in *Ugetsu*, another winner at Venice three years later. Soon afterwards followed *Gate of Hell*, again starring Miss Kyō, which proved to be the best received of the Japanese films, showing forty-seven weeks at the Guild Theatre in New York. It won the Grand Prize at the Cannes Film Festival, and in America was offered two Academy Awards, for the best foreign film and for the best color costume design. It was also given the New York Critics Award as the best foreign-language film of the year. Successors shown throughout this country have been *Samurai*, *The Golden Demon*, *The Phantom Horse*, *The Magnificent Seven* and *Street of Shame*, the last again featuring Machiko Kyō. She co-starred with Marlon Brando in the Hollywood version of *Tea House of the August Moon*. Interest created by these pictures led to the inauguration of a Japanese Film Week at the Museum of Modern Art beginning in 1957. In January, 1959, *Rashōmon*, adapted into a play in English, opened in New York with Claire Bloom in the leading role.

The dance has been another medium of gaining friends for Japan. The Kabuki *Tsuchigumo*, or The Spider Play, performed in the theater on The Pike at the Saint Louis fair of 1904, included dances *(Chapter Thirteen)*. This same number was performed again in the United States fifty years later by the Azuma Kabuki Dancers. The company, composed of ten men and women dancers and ten musicians, gave its premiere at the New Century Theatre in New York on February 18, 1954. Dancers and Musicians of the Japanese Imperial Household appeared at the New York City Center in the spring of 1959 with a ceremonial type of dance known as Gagaku. Also at the City Center, the Grand Kabuki began a three-week run on June 2, 1960. The all-male troupe of seventy dancers included female impersonators in traditional style and presented entire acts with dances, not extracted dances alone, as did the Azuma group.

Numerous American audiences have been introduced to the Japanese dance by an artist born near San Jose, California, of Japanese parents. Haruno Abey was sent to Japan for training at the age of eleven and spent seven years learning various aspects of her ancestors' culture, specializing in the classic dance. From Kansuke Fujima she earned her professional dance title, Sahomi Tachibana. She has also studied ballet and modern dance (from Martha Graham) in the United States. Sahomi Tachibana has a Japanese repertoire combining lecture, song—accompanying herself on the samisen—and of course a variety of dances. Her programs are given for clubs and institutions throughout the nation. In 1949 she instructed the participants in the first Bon Odori in New York, or folk-dance honoring the deceased, which was staged in front of the New York Buddhist Church on West Ninety-fourth Street. It has become an annual event, lately moved to the Dance Mall nearby in Riverside Drive Park *(§215)*.

One of the first societies formed in America to promote Japanese interests was the Nippon Club. Dr. Takamine helped organize it in 1905. It occupied quarters on West Eighty-fifth Street in New York City, the interiors of which were furnished in Japanese style *(Chapter Eighteen)*. The club was for Japanese, and its purpose was to improve their social status by providing a place where they could entertain their friends, especially Americans. The Nippon Club has changed its home several times and is now on East Ninety-sixth Street, off Fifth Avenue.

Specialized in another way, the First Zen Institute of America, organized in 1930 as The Buddhist Society, has a membership mostly of Americans and concentrates on the study and practice of the Zen way (*Chapter Nineteen*). Sōkei-an, the founder, published a periodical called *Cat's Yawn* during the early 1940's, and the Institute at present issues a monthly paper entitled *Zen Notes*. To intensify its work the First Zen Institute of America opened a branch in Kyoto at Ryōsen-an, a sub-temple of the Rinzai Zen Honzan of Daitokuji, in 1958, with Mrs. Ruth Fuller Sasaki ordained as *jūshoku* (priest). The new branch provides a place for Westerners to study close to the headquarters of recognized masters of Zen, and it publishes English translations of the major Chinese and Japanese Rinzai Zen texts and related reference works.

A third organization almost as old as the Nippon Club is the Japan Society. In 1907 two Japanese warships visited the United States and a banquet was given by seven hundred Americans for the officers and other Japanese commissioners, including Ambassador Viscount S. Aoki, General Baron T. Kuroki and Admiral G. Ijuin. Shortly after the event the American group banded together and called themselves the Japan Society. Dr. John H. Finley, Head of the College of the City of New York, became the first President of the Japan Society, and Dr. Jōkichi Takamine became Vice-President. The Society has continued to hold social events for prominent visiting dignitaries from Japan, such as the banquet in the Grand Ball Room of the Waldorf-Astoria for H. I. H. Crown Prince Akihito on September 17, 1953, which was attended by 1,600 persons. The Japan Society also awards graduate fellowships annually to about twenty-five Japanese students attending American universities, supports eleven summer schools where American teachers may learn of Japan, publishes books and other printings on Japan, and circulates films and exhibitions to all sections of the United States.

At the United Nations' headquarters in New York City there are two symbols of Japan's desire for friendly relations with the world. The first is a silk brocade tapestry on which is represented, in 170 tones of color, an image of the Buddha seated on a lotus preaching his first sermon on boundless mercy. He is surrounded by the flames of anger and swords of destruction. The tapestry, which required three years to make, was given on January 29, 1951, on behalf of 70,000,000 Japanese Buddhists, in gratitude for the "sincere endeavors which have been exerted by the United Nations organization since its inception for the preservation of peace and prevention of war." The silk image was hung in the office of the Under-Secretary for Public Information. The second gift is the Peace Bell. It is suspended in a small square pavilion with a flaring roof, set on a marble podium on the west side of the Secretariat Building (§216). On the bell are five characters in relief, that may be translated: "Long Live Absolute World Peace." A longer inscription states that the bell was completed at the Tada Foundry on United Nations Day, October 24, 1952. Chiyoji Nakagawa was the prime supporter of the casting project. The Peace Bell was presented by the United Nations Association of Japan on the part of the Japanese people and dedicated in New York on June 8, 1954. Its clapper is accessible to anyone wishing to sound the instrument.

The Japanese influence has seeped down into many aspects of American life below the spiritual and cultural levels. A prosaic manifestation is in the increased use made of paper for purposes formerly utilizing other substances. In 1879 an article published in an American periodical observed:

"Many varieties of paper are made in Japan, and all are from the bark of trees. The best, and that most generally in use, is produced from a shrub called Kozou (*Broussonetia papyrifera*) . . . the Japanese can employ their paper in many ways unknown in Europe. For instance, they use it instead of glass for their windows, bandages for wounds, pocket-handkerchiefs,

cords, thread, etc....for covering umbrellas, packing goods, making cloaks for travellers, etc. In these cases the paper is oiled and thus made impermeable to moisture.''[2]

The traditional paper of the West is rag paper, which was acquired from China by way of the Middle and Near East many centuries ago. Nowadays much of our paper comes from trees—albeit from wood pulp instead of from the bark alone—in which the Japanese practice undoubtedly had a hand. Paper has not supplanted glass for windowpanes, except in a minority of cases, but has become the favorite light filter in lamp shades and other fixtures not exposed to the elements. It has practically replaced the pocket handkerchief, and at least one brand name for facial-tissues has become rooted in the American vocabulary. In packaging, paper and cardboard boxes have proved far superior to wood or other materials for conserving space in their pre-use state, ease of assembling, lightness and durability.

Bamboo is a second versatile material, used in innumerable ways in Japan, that has acquired almost as widespread acclaim in the United States as in its homeland. Its length, strength and light weight assured its immediate adoption for fishing rods and rug poles. It became useful in the garden for fences, trellises, lattices, and in the construction of casual summerhouses and conservatories—and has served in a split form as roll-blinds since the end of the nineteenth century. A modern variation of the last is the so-called match-stick blind that opens and closes on a track, like a drapery. Bamboo is used for picture frames, basket-like containers, racks of various sorts, place mats, trivets, chopsticks and hair ornaments.

Chopsticks, by the way, have served for packing Heinz pickles in deep jars since before the First World War.

Rattan, reeds and grasses also have acquired a respectable position in the American home scene because of previous recognition in Japan. Mats, *tatami* coverings and grasscloth have become part of the decorator's standard repertory, though they may be applied in ways different from those generally known in Japan. The point is that the Japanese are aware of the value of commonplace materials in creating a pleasant environment. A British writer noted this about 1890, when he wrote:

"This art, which is the embodiment of all that is graceful in the national character, derives not a little of its charm from its power to weave into its purposes everything in nature which has a line of beauty. The simple natural wood decoration, which is so common in the Japanese house, is at the same time one of its most charming and attractive features. It is one of the things one longs to transport, and, not find, but make, a fitting place for in the wilderness of a modern British house....The principle which pervades it all is assuredly not an uncivilized one, namely, to let the eye wherever it may wander rest on something beautiful; not to ignore the smallest of nature's works, and to seek to obtain from everything something to add to the sum of a day's delights.''[3]

A few years later an American commented on this same source of appreciation for unpainted woods in an essay entitled "The Value and Use of Simple Materials in House Building":

"The Japanese have taught us, among some other things, the beauty of the grain of even the commonest woods. Most of the exquisitely toned work is in soft spruce-like woods. The use of perfectly plain casings with a little care in selection and treatment, would give our houses a distinction not otherwise obtainable in work of moderate cost.''[4]

Any of numerous other statements saying virtually the same things could be repeated with equal suitability, because many Occidental writers were struck by the phenomenon.

With the few materials named above, adding perhaps plaster, an entire Japanese house could be constructed and fitted up ready for occupancy. The success of the Nipponese home depended upon these everyday substances, left natural and not confused by adding clutter.

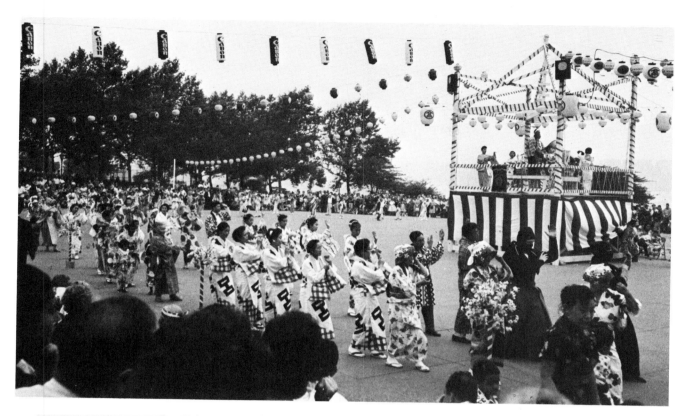

§215. Bon Odori, Riverside Drive Park dance mall, New York City, 1958. (Edward Kurokawa.)

§216. The Japanese Peace Bell at the United Nations Headquarters in New York City.

The last two articles quoted both go on to say that restraint heightens the effect of whatever accents are selected for a room. The American phrases the thought in this manner:

"The Japanese not only know the beauty of simple backgrounds for their priceless treasures, but they also know that the value of this beauty is enormously enhanced by the fact that the treasures they show have no competitors. They are locked away in cupboards for the joy of another day. When they adorn with flowers, it is with no mere overpowering mass, but exquisite arrangements of line and color of which vase or bowl, leaf, branch, blossom and grey or dull gold silk or paper background, form one simple and harmonious whole. How we 'civilized' people envy them . . . !"

The matter of under-decorating brings up the important point that to the Japanese an applied design itself is art, and art is not something applied to the design. By the same token, the well-proportioned, carefully-constructed building itself is architecture, and architecture is not something applied to the building, as according to the orthodox viewpoint in the West. The difference between the Eastern and Western outlook is that in one the art resides in the essence, or in the inner being, of the work, and in the other it applies to the outer aspect only. The Japanese, therefore, consider the quality of anything made to be intrinsic and not merely extrinsic.

In building this operates through the agency of craftsmanship. The Japanese have taken great pride in their craftsmanship in construction. This factor was recognized in the first building erected by Japanese in America, in the declaration that the Japanese Dwelling at Philadelphia was the "best-built structure on the Centennial grounds . . . as nicely put together as a piece of cabinet-work" (*Chapter Five*). Marguerite Glover concurred in an article published in 1906, on the "Simple Life in Japan—Achieved by Contentment of Spirit and a True Knowledge of Art," in which she says: "The simplicity of their daily existence has been cultivated until it is an art. . . . There is no striving for higher place . . . no greed for wealth . . . the artisan, the mechanic have been able to take time to work in the most perfect and durable manner."[5] The other side of the coin is that in the West there is a considerable deficiency in artisanship. Edward Morse, in the Introduction to *Japanese Homes*, implied that this was due to the workman's being more interested in his wages than in performing a good job. If this were true in 1886, it is even more true today. One has only to compare the shoddy brickwork of any contemporary house or apartment building with the brickwork of any residential building dating from before 1910 for tangible evidence of the decline. Exceptions are claimed in the restoration work at Williamsburg and its sphere of influence, where an attempt was made to duplicate eighteenth-century methods, and in work done for a perfectionist like Philip Johnson. America already may have learned many lessons from the Japanese, but there is one more yet to be learned which would be to her advantage: the greater reward for one's work is the satisfaction come from its having been done well rather than the remuneration received. The job thus becomes a living, expanding, creative process in place of a once-done, immediately-forgotten source of revenue. The American artists who have dipped into Zen have come up with a realization of the importance of throwing one's whole being into one's work. Zen is indeed an excellent dispenser of the higher values, but there are other sources, and they need not have come from Japan.

The question may be asked what has been the result of the Japanese influence in the United States. Has it been only a fad, or has it made real and lasting contributions to American life? Has it supplemented or changed the course of American culture? Has it aided or sidetracked the normal trend of American evolution? The question is complex and therefore requires some analysis.

First of all, the Japanese mode in America has been considerably more than a fad. This is borne out by its duration—if nothing else—lasting, as it has, from the third quarter of the nineteenth century through the greater part of the twentieth. Throughout this long period the influence has been fairly constant, with the exception, of course, of the war years. It reached a fad tempo only in association with the Chinese vogue in home furnishings that began in the late 1940's, and here the Japanese played a decidedly secondary role because of the fewer Japanese furniture types. The Chinese trend of that brief interval operated only on a superficial decorative plane. On the other hand, the Japanese was a determining factor in the architecture of the house as a whole, and was being felt in landscaping and certain branches of the fine arts as well. The Japanese influence has made its deepest impression upon the small American house, beginning about 1880 in the vacation house, and later, with the reduction in the size of the average family home, in the year-round residence as well. The cozy bungalow, a successor to the plain or romantic cottage based upon European styles, was greatly beholden to the Japanese dwelling in form and interior use of space, especially as regards the newly developed main living room, which was a permanent replacement of the old formal parlor. The living room was a place in which every member of the family could feel comfortable and relaxed, quite unlike the parlor that was used only for stiff, state occasions. The living room was inevitable, in consonance with the forthright American way of life, and the Japanese precedent merely confirmed it and hastened its fulfillment.

Even a type of architecture as far removed from the Japanese as the International style of Europe was modified by it in America. This was because its two outstanding exponents in the eastern and western halves of the continent, Wright and Neutra, were steeped in the Japanese tradition, prompting them to merge harsh rectangular concrete forms with multifarious nature. The solution they devised to the admittedly difficult problem was molding architecture into an abstraction of its setting. At Falling Water upright piers respond to vertical cliffs, and cantilevered balconies to horizontal ledges, and in Neutra's California houses the predominantly flat roof planes hover over the flat desert floor, with clear glass connecting the two and making a livable domestic volume.

The espousal of the natural park, as opposed to the geometric garden, by A. J. Downing, America's first authority on horticulture and gardening, was overture to the future adoption and adaptation of the Japanese landscape in the United States. In his day (Downing was drowned the year before Perry sailed into Yedo Bay) Japanese gardens were practically unknown in the Western Hemisphere, but the principles they embrace were inherent in the Chinese garden, and in the interpretation of it in England known as the *jardin anglo-chinois*. The Chinese park or garden came to America by the roundabout way of Europe and hence was understood very imperfectly here. The Japanese garden came directly across the Pacific, and from the beginning was laid out and tended by native gardeners, a situation probably no Oriental garden in America of the era of Chinese influence could match. The Japanese garden, whether of the hill-and-water, tea, or flat variety, was less compromising than domestic architecture, but they serve different functions. A garden is for recreation and diversion, whereas a house has to be utilitarian. Besides, houses were designed by American architects having in mind specific local needs. The relation of the Japanese residence to its garden brought about a closer integration of architecture and environment in the United States. In most cases the setting reverted to a handling of nature mostly oblivious to its original stimulus; but oversight can make a fact no less real. As in Japan, Japanese gardening played up the indigenous characteristics of the land, so in America the application of its principles divorced from extraneous mannerisms brought out the native qualities of our topography.

The first important artist in the Occident to recognize the value of Japanese painting and printmaking was the American Whistler. His work was a forerunner to Impressionism, which at the end of the nineteenth and beginning of the twentieth century dominated Western art—American as well as European. Whistler was a writer in addition to being a painter and etcher, and the Japanese influence upon Impressionism operated in the literary as well as in the pictorial field, especially among Yankee poets. Americans were instrumental in bringing Japanese fine arts to the West, both as collectors and interpreters, and these two functions first met in the person of Ernest Fenollosa. What Fenollosa—or Mrs. Fenollosa—was unable to complete in the second capacity was passed on to his literary executor Ezra Pound to finish. The Islands of Japan attracted a group of searching artists from the United States during the 1890's, and a generation later, the modernists Mark Tobey and Morris Graves studied calligraphy and Zen philosophy in the Far East to further their artistic and spiritual unfoldment. Abstract expressionism, which was the new international manner that succeeded Impressionism and its ramifications, was not an American innovation, but it is less strictly European than its predecessors. Japanese handicrafts also have touched American industrial art, giving a warmth to machine-made products, and the ideal of artistic diversity expressed by the Japanese word *shibui* may yet save America from the deadly standardization and monotony of "sets" of furnishings mass-produced in the West.

Japan was the hotbed of highly-evolved species of popular art. By the relatively simple means of the woodblock technique the artists of *ukiyoe* achieved designs of such beauty that they shook—and shook loose from their former moorings—the traditional easel and poster arts of the West. The counterpart of the woodblock print was the Japanese dwelling, being equally simple of materials and execution, and modest in size and cost. Short *haiku* poems also reflected the economy of means of prints and houses, and gave rise to Imagistic poetry in the Occident. These forms from Japan were the first sophisticated crystallizations of democratic art, and democratic America was to have them for the mere asking. That they were ready-made for adoption or adaptation in the United States, being a further development of what we were aiming toward, can be summarized in the terse statement made by Frank Lloyd Wright upon his discovery of the art of Hokusai and Hiroshige : "It was my own stuff!" he exclaimed. Wright was a well-rounded artist, though predominantly an architect, and it was primarily in the field of architecture that the Japanese was reflected most strongly, and with the most lasting results, in the United States.

Notes

CHAPTER TWO

1 I. V. Pouzyna, *La Chine, l'Italie et les Débuts de la Renaissance*, Paris, 1935, pp. 78-96.
2 Symbolic gestures were already present in twelfth-century European art and may be compared to the *mudrā* in earlier Buddhist art. See : Alfred Salmony, *Europa – Ostasien Religiöse Skulpturen*, Potsdam, 1922, plates 12-15.
3 Eleanor Von Erdberg, *Chinese Influence on European Garden Structures*, Cambridge, 1936. Appendix : Annotated List of Buildings Mentioned in the Text, pp. [145]-189.
4 Unpublished manuscript by Rudolf M. Riefstahl.

CHAPTER THREE

1 Charles H. P. Copeland, "Japanese Export Furniture," *Antiques*, July, 1954, pp. 50-51.
2 Helen Comstock, ed., *Portfolio*, The Old Print Shop, New York, January, 1949, pp. [99]-102.

CHAPTER FOUR

1 S. Bing, "L'Art Nouveau," translated from the French by Irene Sargent, *The Craftsman*, October, 1903, p. 3.
2 Although practically unknown at the time of the formation of Art Nouveau, ancient Celtic art of the British Isles and western Europe afforded dynamic delineations, probably derived from the Scyths in Asia, and of course prehistoric. See : Stuart Piggott and Glyn E. Daniel, *A Picture Book of Ancient British Art*, Cambridge, 1951, plates 38-49.
3 Dudley Harbron, *The Conscious Stone: The Life of Edward William Godwin*, London, 1949, p. 78.
4 Bing used only the initial "S." for given name in signing his writings. Lenning calls him Samuel and Madsen considers Sigfried correct. See : Stephan Tschudi Madsen, *Sources of Art Nouveau*, New York, 1955, note 35, p. 360.
5 S. Bing, "L'Art Nouveau," *The Architectural Record*, August, 1902, pp. 281, 283.
6 Bing, *The Craftsman*, pp. 3-4. Gustave Soulier had stated a similar principle in 1897, "the form of an object must be adapted to the use of the object and not altered by ornamentation...." (Henry F. Lenning, *The Art Nouveau*, The Hague, 1951, p. 54).
7 Extensively illustrated in the catalogue : *Collection S. Bing, Objets d'Art et Peintures du Japon et de la Chine*, Paris, 1906.
8 Clay Lancaster, "Oriental Contributions to Art Nouveau," *The Art Bulletin*, December, 1952 pp. [297]-310.
9 *Revue des Arts Décoratifs*, 1891-92, p. 14.
10 Kenyon Cox, "The Art of Whistler," *The Architectural Record*, May, 1904, p. 474.
11 Illustrated : Harbron, *The Conscious Stone*, p. [127].
12 See Glossary.
13 See illustrations in Georges Duthuit, *Chinese Mysticism and Modern Painting*, Paris, 1936.
14 A. D. F. Hamlin, "L'Art Nouveau, Its Origin and Development," *The Craftsman*, December, 1902, pp. 133-134.

CHAPTER FIVE

1 *South Carolina Gazette*, April 1, 1757.
2 Illustrated in Thomas Tileston Waterman, *The Mansions of Virginia 1706-1776*, Chapel Hill, 1946, pp. [227], [371], [377].
3 R. T. H. Halsey and Elizabeth Tower, *The Homes of Our Ancestors*, Garden City, 1937, p. 122.
4 H. D. Eberlein and C. Van D. Hubbard, *Portrait of a Colonial City*, New York, 1939, p. 477.

5 *Ibid.*, p. 478.

6 Henning Cohen, ed., "An Unpublished Diary by Robert Mills, 1803," *The South Carolina Historical and Genealogical Magazine*, October, 1950, p. 194.

7 Elevation and plan: H. F. Cunningham, J. A. Younger and Y. W. Smith, *Measured Drawings of Georgian Architecture in the District of Columbia, 1750-1820*, Washington, 1914, sheet [59].

8 Joseph Jackson, *Encyclopedia of Philadelphia*, Harrisburg, 1931-33, Vol. III, p. 915.

9 *A Hand-Book for the Stranger in Philadelphia*, Philadelphia, 1849, p. 82.

10 Ascribed to "J. Haviland Arch." on the Evans lithograph.

11 Harnett T. Kane, *Plantation Parade*, New York, 1945, p. 33.

12 Thompson Westcott, *Centennial Portfolio: A Souvenir of the International Exhibition at Philadelphia*, Philadelphia, 1876, p. 22.

13 James D. McCabe, *The Illustrated History of the Centennial Exhibition*, Philadelphia, [1876], p. 615.

CHAPTER SIX

1 See Edward S. Morse, *Japanese Homes and Their Surroundings*, Boston, 1886, "Tea-Room in Imado, Tokio," figure 134, p. 156.

2 Both rooms are illustrated in *Artistic Houses*, New York, 1883-84, Vol. I, Part I, facing p. 48, facing p. 2.

3 Russell Sturgis, "The Famous Japanese Room in the Marquand House," *The Architectural Record*, September, 1905, pp. 192-201.

4 Illustrated: *Artistic Houses*, Vol. I, Part II, following p. 122.

5 Illustrated: Antoinette F. Downing and Vincent J. Scully, Jr., *The Architectural Heritage of Newport Rhode Island*, Cambridge, 1952, plates 160, 200.

6 Communication from Mrs. Emily Post, December 14, 1955.

7 Alwyn T. Covell, "Variety in Architectural Practice: Some Works of Walker and Gilette," *The Architectural Record*, April, 1914, pp. 298, 308 (illustration).

CHAPTER SEVEN

1 *The American Architect and Building News*, December 12, 1885, p. 2; *ibid.*, January 2, 1886, pp. 3-4.

2 *Building*, March 20, 1886, pp. 142-143.

3 R. A. C., "An Architectural Experiment," *The Architectural Record*, July-September, 1898, pp. 88, 91.

4 *Brickbuilder*, February, 1900, p. 35.

CHAPTER EIGHT

1 Theodore M. Brown, *Old Louisville*, Louisville, 1961, p. 11.

2 Herbert S. Fairall, *The World's Industrial and Cotton Centennial Exposition, New Orleans, 1884-1885*, Iowa City, 1885, pp. 393-95.

3 Montgomery Schuyler, "Last Words About the World's Fair," *The Architectural Record*, 1894, p. 292.

4 Hugh Morrison, *Louis Sullivan*, New York, 1935, p. 184.

5 Descriptions of the interiors have been condensed from Okakura Kakudzo, *The Hō-ō-den...an Illustrated Description of the Buildings Erected by the Japanese Government at the World's Columbian Exposition, Jackson Park, Chicago*, Tokyo, 1893, pp. 14-39.

CHAPTER NINE

1 Letter from Daniel H. Burnham, September 30, 1954.

2 Illustrated in *The Architectural Record*, July, 1915, p. [7].

3 Illustrated in *The Inland Architect*, November, 1890, 5 plates.

4 Frank Lloyd Wright, "In the Cause of Architecture," second paper, *The Architectural Record*, May, 1914, p. 406.

5 Frank Lloyd Wright, *An Autobiography*, New York, 1942, p. 194.

6 Henry-Russell Hitchcock, *In the Nature of Materials*, New York, 1942, plate 29.

7 Wright, *An Autobiography*, pp. 196-197.

8 Wright, "In the Cause of Architecture," first paper, *The Architectural Record*, March, 1908, p. 156.

9 Illustrated: *House and Garden*, September, 1912, p. 159; *The Western Architect*, August, 1913, facing p. 78.

10 *The Western Architect*, October, 1913, following p. 90.

11 *The Architectural Record*, October, 1916, pp. 299-300, 305-306.

12 *The House Beautiful*, December, 1915, p. 23.

13 *The Architectural Record*, October, 1900, pp. 332-333.

14 *The Architectural Record*, April, 1904, p. 369; *House and Garden*, October, 1910, p. 232.

15 *The Architectural Record*, December, 1915, p. [602].

16 *Country Life in America*, January, 1914, pp. 63-64.

CHAPTER TEN

1 Albert Q. Maisel, *They All Chose America*, New York, 1955, pp. 128-129.

2 Interview with Lucien A. Marsh, March 29, 1954; interview with Hale I. Marsh, April 2, 1954; subsequent letters including data from Burnham Marsh, February 5, 1962.

3 *Appleton's Annual Cyclopaedia and Register of Important Events of the Year 1894*, Vol. XIX, new series, New York, 1895, p. 91.

4 Perspectives of the Manufacturers and Liberal Arts, and Mechanical Arts buildings were published in *The American Architect and Building News*, November 4, 1893.

CHAPTER ELEVEN

1 "What is a Bungalow?" *Arts and Decoration*, October, 1911, p. 487.

2 Mrs. Sherwood, *The Lady of the Manor*, Bridgeport, 1828, Vol. V, p. 50. The first British edition, in several volumes, was issued at Wellington between 1825-29.

3 "The Origin of the Bungalow," *Country Life in America*, February, 1911, p. 309.

4 M. H. Lazear, "The Evolution of the Bungalow," *The House Beautiful*, June, 1914, p. 2.

5 Mrs. B. W. McKenzie, "A Home in the Desert," *Country Life in America*, June 1, 1911, p. 76.

6 Thanks are due Donald L. Pray of Grossmont, California, for locating the Bandini house (1149 San Pasqual Street, Pasadena) and supplying certain architectural details that have made possible the completion of this restoration drawing.

7 Seymour E. Locke, "Bungalows, What They Really Are: the Frequent Misapplication of the Name," *House and Garden*, August, 1907, p. 50.

8 Clay Lancaster, "My Interviews with Greene and Greene," *AIA Journal*, July, 1957, pp. 202-206.

9 *Country Life in America*, October, 1906, p. 637; *ibid.*, December, 1913, p. 84.

10 Aymar Enbury, II, *One Hundred Country Houses, Modern American Examples*, New York, 1909, pp. 217-[221].

11 A detailed analysis of probable models for various features of the Irwin house is given in Clay Lancaster, "Some Sources of Greene and Greene," *AIA Journal*, August, 1960, pp. 39-44.

12 *The Craftsman*, July, 1907, pp. 446-451; *House Beautiful*, January, 1911, p. 49.

13 Interview with Cecil Gamble, April 5, 1954.

14 Published in *The Craftsman*, October, 1907, p. 76. See also Lancaster, "Some Sources of Greene and Greene," *AIA Journal*, August, 1960, pp. 44-46.

15 A portfolio of photographs of the Blacker house and grounds was presented in *The House Beautiful*, March, 1909, pp. 76-77.

16 Arthur R. Kelly, "California Bungalows," *Country Life in America*, May, 1914, p. 82 (illustration p. 43).

17 *The Architect*, December, 1915, pp. [258-259].

18 Henry H. Saylor, *Bungalows, Their Design, Construction and Furnishing...*, Philadelphia, 1911, pp. 20-25; *Country Life in America*, May, 1916, pp. 38-39.

19 Saylor, *Bungalows...*, pp. 57, 114-[115]; *The Architectural Record*, March, 1916, pp. 290-291.

20 *The House Beautiful*, September, 1910, p. 106.

21 *House and Garden*, June, 1916, p. 11; *The Architectural Record*, October, 1914, pp. [369]-371.

22 Saylor, *Bungalows...*, pp. 58-59, [82], 83; *Country Life in America*, May, 1914, pp. 45, 82.

23 *The Architect*, October, 1915, p. [173].

24 *The American Architect*, August 9, 1911, pp. [49]-53; *The Architectural Record*, August, 1911, p. 131.

25 *The Architectural Record*, January, 1948, pp. [72-79].

26 *The Architectural Record*, October, 1906, pp. 296-305; *Country Life in America*, November, 1915, pp. 27-30.

27 *The Architect*, November, 1915, p. 245.

28 Arthur C. David, "An Architect of Bungalows in California," *The Architectural Record*, October, 1906, p. 309.

CHAPTER TWELVE

1 *The Bungalow Magazine*, August, 1916, pp. 490–491.
2 Letter from Blanche Sloan, December 18, 1954.
3 *The House Beautiful*, May, 1903, p. 421.
4 The May, 1909, edition of *Country Life in America* carried a set of six articles on outdoor sleeping written by a physician, a minister, a naturalist and laymen.
5 Made by Marshall and Stearns Co., San Francisco and Oakland: Adv., *Architect and Engineer*, March, 1914, p. 39.
6 *The House Beautiful*, December, 1911, p. ix; *The Craftsman*, May, 1910, p. 287.
7 J. H. Daverna and Son, 1908.
8 *The House Beautiful*, May, 1912, p. xv; *ibid.*, January, 1913, p. iv.

CHAPTER THIRTEEN

1 A photograph of this gateway in place at the Saint Louis fair is in the collection of the Pictorial History Gallery of the Missouri Historical Society, Saint Louis.

CHAPTER FOURTEEN

1 See Chapter VI, "Built Upon the Rivers," Clay Lancaster, *Architectural Follies in America*, Rutland, 1960, pp. 104–122.
2 *The Thirty-fourth Annual Report of the Fairmount Art Association*, 1906, p. 15.
3 Letter from Fiske Kimball, Director of the Philadelphia Museum of Art, March 22, 1950. Also *The Craftsman*, April, 1906, p. 120, illus. p. [105].
4 Works Progress Administration, *Philadelphia, A Guide to the Nation's Birthplace*, Philadelphia, 1937, p. 571.
5 By F. Maude Smith, August, 1907, p. 63.
6 The author is grateful to Douglas Rowley for calling to his attention the existence of Grey Lodge and for continued assistance in collecting data on the house; also to Mrs. Helen Huies Caskey for correspondence and an inspection of the house on September 9, 1957.
7 See Grace Tabor's article, "Shoo Foo Den," with ten illustrations of photographs in black-and-white and color by F. A. Walter, *Country Life in America*, December, 1914, pp. 59–63.
8 A for-sale advertisement gives statistics regarding the property and is illustrated with four photographs: *Country Life in America*, April, 1916, p. 5.
9 K. K. Kawakami, *Jokichi Takamine, A Record of His American Achievements*, New York, 1928, pp. 63–67.
10 Makino is given credit for painting these scenes in C. Matlock Price, "Japanese Idealism in Interior Decoration," *Arts and Decoration*, April, 1914, p. 219.
11 Illustration for Cabot's Creosote Stains: *The House Beautiful*, September, 1915, p. xviii.
12 Illustrated advertisement: *House and Garden*, April, 1912, p. 84.
13 See Robert Allister's article, "Yama-no-Uchi," illustrated with photographs by Helena D. Van Eaton, *House and Garden*, September, 1911, pp. 158–161.
14 Advertisement: *House and Garden*, February, 1912, p. 7.
15 Interview with Mrs. Gordon Brown (Mrs. Seaman's sister-in-law) September 10, 1954.
16 *Architecture*, February, 1917, p. 34.

CHAPTER FIFTEEN

1 Such as the Palais Stoclet in Brussels, built by Josef Hoffmann, 1905–11; special issue of *Wendingen* (Amsterdam), August–September, 1920, p. 4.
2 Wright, *An Organic Architecture, The Sir George Watson Lectures of the Sulgrave Manor Board for 1939*, London, 1939, pp. 2–4.
3 *Antonin Raymond, His Work in Japan, 1920–1935*, Tokyo, 1935, pp. 48, 96–97, 72.
4 *Ibid.*, p. 18.
5 Tetsurō Yoshida, *Japanische Architektur*, Tübingen, 1952, figures 188–189, pp. 156–157.
6 A fully illustrated account of the Japanese Exhibition House at the Museum of Modern Art is given as a supplement in Arthur Drexler, *The Architecture of Japan*, New York, 1955, pp. 262–286.

CHAPTER SIXTEEN

1 Illustrated: James F. O'Gorman, "The Hoo Hoo House," *Journal of the Society of Architectural Historians*, October, 1960, pp. 123–125.

2 *The Pacific Coast Architect*, December, 1914, pp. 222-224.

3 Interview with H. H. Harris March, 16, 1954.

4 *The Architectural Record*, October, 1938, p. 101.

5 *California Arts and Architecture*, May, 1942, p. [54].

6 *House and Garden*, June, 1950, p. [118].

7 *The Architectural Forum*, July, 1939, pp. [9]-11.

8 *AIA Journal*, July, 1952, pp. 4-5, illus. p. [29].

9 Kenneth M. Nishimoto, "The Architects' Trek to Japan," *AIA Journal*, October, 1956, pp. 172-173.

10 Lithograph after a watercolor by William Alexander: G. H. Wright, *The Chinese Empire Illustrated*, London [1858-59], Vol. II, facing p. 42.

11 *The Architectural Review*, November, 1947, p. 151.

12 Drexler, *The Architecture of Japan*, illustrated pp. 106-107.

CHAPTER SEVENTEEN

1 Pp. 102-103. A slightly different version of the passage was given by Frère Cibot in *Mémoires Concernant l'Histoire, les Sciences, les Arts, Moeurs, Usages des Chinois*, Paris, 1782, Vol. VIII, the Chinese author's name given as Lieoutchou: Osvald Sirén, *Gardens of China*, New York, 1949, p. 136.

2 Thompson Westcott, *Centennial Portfolio*, Philadelphia, 1876, p. 50.

3 Advertisement: *Country Life in America*, March, 1908, p. 545.

4 *House and Garden*, July, 1908, pp. 17-21.

5 *Ibid.*, August, 1906, pp. 63-68; *ibid.*, February, 1909, p. 52.

6 *Ibid.*, January, 1910, pp. 24-25, xii.

7 *Ibid.*, May, 1903, p. [292].

8 *Ibid.*, September, 1909, pp. 90-91, [93].

9 *The House Beautiful*, October, 1925, pp. 366-367, 394-400.

10 *Country Life in America*, March, 1905, p. 493.

11 *Ibid.*, March, 1903, pp. 182-185.

12 Letter from Mrs. Claire Tison Kennard of New York to Douglas Rowley, August 30, 1960.

13 Illustrated: *House and Garden*, September, 1911, p. 161.

14 Illustrated: *The Craftsman, August*, 1913, pp. [482-483].

15 T. Shiota, *The Japanese Landscape*, Newark Museum booklet, *ca.* 1915, biographical sketch, pp. 12-13.

16 Illustrated: *House and Garden*, December, 1916, pp. 14-15.

17 Listed in T. Shiota, *The Japanese Landscape*, p. 13. Illustrations of the Saklatvala and Brown gardens appear in *House and Garden*, June, 1916, pp. 12-13; Skalatvala also in *ibid.*, August, 1918, pp. 10-11.

18 *The American Architect*, January 4, 1911, pp. [1]-8, 10.

19 Saunders Norvell, "A Japanese Garden," *Hardware Age*, November 2, 1939. This article on the Clemson garden has been reprinted as a 10-page booklet.

20 Brochure: *The Ritz-Carlton Hotel of New York*, New York, 1919, with woodblock illustrations by John J. A. Murphy; advertisement with illustration of the garden in *Country Life in America*, June, 1919, p. 109.

21 *Country Life in America*, February, 1915, p. 7.

22 *The House Beautiful*, March, 1913, p. 120.

23 Henry H. Saylor, "The Japanese Garden in America . . . Illustrations from the Japanese Garden of Mr. John S. Bradstreet, at Minneapolis," *Country Life in America*, March, 1909, p. 482.

24 W. P. Kirkwood, "Bradstreet Island," *The Bellman*, January 29, 1912, pp. 73-76.

25 Illustrated: *The Craftsman*, September, 1913, pp. 567-570.

26 Articles by Stephen Child: *The House Beautiful*, April, 1901, pp. 113-116; *Art and Progress*, May 1914, pp. 256-257.

27 Illustrated: *House and Garden*, July, 1906, p. 41.

28 Illustrated: *The New Country Life*, May, 1917, pp. 60-61.

29 Illustrated: *Country Life in America*, March, 1922, p. 50.

30 W. L. B. Jenney, "Parks and Gardens of Southern California," *The Inland Architect*, January, 1907, pp. 4-5.

31 *The House Beautiful*, July, 1914, pp. 44-45.

32 F. M. Todd, *The Story of the Exposition . . . at San Francisco in 1915 to Commemorate the Discovery of the Pacific Ocean & the Construction of the Panama Canal*, New York & London, 1921, Vol. III, p. 210.

CHAPTER EIGHTEEN

1 *American Architect and Building News*, January 6, 1883, pp. 7-8.

2 *Ibid.*, January 16, 1886, pp. 33-34.

3 Daniel Howland Maynard, "A Japanese Collection in America," *The Craftsman*, August, 1904, pp. 465-470.

4 Listed in Clarence Cook, *The House Beautiful*, New York, 1877, p. 109. Vantine's advertisement: *The House Beautiful* (periodical), March, 1911, p. xxxi.

5 *Japan in New York*, New York, 1905, pp. 15, 23.

6 *Artistic Houses*, New York, 1883-84, Vol. I, Part I, facing p. 2.

7 Amy L. Barrington, " 'A Field of Delite' The Country Home of Two Well-Known Artists—Mr. and Mrs. Albert Herter," *The House Beautiful*, April, 1919, pp. 189-191.

8 Lillian Hart Tryon, *The House Beautiful*, June, 1915, pp. 12-13.

9 "The Simple Beauty of Japan in an American Apartment Achieved through the Magic of an Italian Decorator," *The Craftsman*, July, 1915, pp. 358-365.

10 Illustrated : *Japan in New York*, p. [9].

11 Illustrated : *The Architectural Record*, April, 1914, p. 308.

12 Henry-Russell Hitchcock, *In the Nature of Materials*, New York, 1942, figures 316-317.

13 The author is indebted to an excellent paper on John Scott Bradstreet prepared by Miriam Lucker Lesley for much of the information contained in these paragraphs.

14 *The American Architect and Building News*, July 8, 1893, p. 27.

15 Illustrated : *Revue des Arts Décoratifs*, 1894-95, p. 118.

16 *The House Beautiful*, June, 1920, pp. 63, 499-501, 530.

17 *Ibid.*, February, 1903, p. 180.

18 Illustrated : *Arts and Decoration*, October, 1914, p. 433.

CHAPTER NINETEEN

1 Henry-Russell Hitchock, *In the Nature of Materials*, New York, 1942, Figs. 191-197, 220-231, 235-239, 324-325.

2 Bertha E. Jaques, "An Artist's Home in Japan : How Helen Hyde has Modified an Eastern Environment to Meet Western Needs in Its own Way," *The Craftsman*, November, 1908, pp. 186-191.

3 *The Monthly Illustrator*, July, 1895, p. 6.

4 Nancy Wilson Ross, "What is Zen ?" *Mademoiselle*, January, 1958, p. 116.

5 *Ibid.*, pp. 65, 116.

6 Biographic material from leaflet issued by Comerford Gallery, New York, 1960.

7 Reiko Yamazaki, "An Interview with an American Art Lover," reprint from *Nippon Bijutsu*, August, 1959.

CHAPTER TWENTY

1 The Fenollosa-Pound Nō plays are most readily available in Hugh Kenner, *The Translations of Ezra Pound*, Norfolk, Conn., 1953.

2 *The American Architect and Building News*, October 25, 1879, p. 136.

3 Reprint of F. T. Pigott in *Fortnightly Review: Architecture and Building*, June 4, 1892, p. 289.

4 William L. Prince : *House and Garden*, October, 1905, p. 114.

5 *The Craftsman*, August, 1906, p. 614.

Glossary

amado, Rain door. Sliding wood panels for closing house at night.

biyō-bu, Folding screen composed of hinged panels.

bonkei, Three-dimensional miniature landscape in tray.

bonsai, Potted plant, usually a dwarfed tree.

bonseki, Tray landscape achieving painted effect with white sand and stones on black lacquered background.

cha-niwa, Tea-house garden.

cha-no-yu, Tea ceremony.

cha-seki, Tea ceremony house.

chigai-dana, Shelves on different levels (in an alcove).

chūmon, Main gate.

daimyō, Feudal lord.

den, Villa or lodge.

dō, Hall (of a temple).

funairi-no-ma, Entrance hall.

fusuma, Sliding screens between rooms (usually decorated with paintings).

gyō, Intermediary. The style of flower arrangement between formal and thrown-in.

haiku, Seventeen-syllable poem.

haniwa, Early Japanese terracotta vessels or figures.

hinoki, Cypress.

hira-niwa, Flat garden, composed of raked white gravel, rocks, and perhaps a few plants and ornaments.

hisashi-no-ma, Galleries under the eaves.

hogyō, Pyramidal roof.

hokku, Haiku poem.

ikebana, Flower arrangement.

irimoya, Combination roof form of gable over hip.

jodan-no-ma, Innermost room.

jūshoku, Chief priest (of a Buddhist temple).

kakemono, Vertical or hanging scroll painting.

ken, An architectural unit of measure, as of a bay, about six feet in length.

kiridansu, A chest of kiri wood.

kirizuma, Gabled roof.

kondō, Golden hall.

kon-no-ma, Serving room.

kōzo, Paper mulberry.

kura, Fireproof storehouse or godown.

ma-bashira, Middle post (adjoining *tokonoma*).

makimono, Horizontal scroll painting.

manga, Cartoon or caricature sketch.

nanga, Southern style of Chinese wash painting.

misu, Roll blind.

musume, Daughter or girl.

nageire, Thrown-in or casual style of flower arrangement.

nijiriguchi, Creeping-in door (of a tea-house).

nōtan, Light-and-shade (arrangement in a painting).

ramma, Transom grille.

rikka, Standing. Formal flower arrangement.

rōmon, Tower gate. Gateway with upper story.

samurai, Military class or member of it.

satori, Sudden enlightenment (Zen Buddhism).

shibui, Tasteful in a rustic manner.

shin, Elaborate (applied to types of gardens or flower arrangements).

shinden-zukuri, A type of house in which the interior is divided by sliding screens.

shintō, The primitive religion of Japan.

shitomido, Shutters hinged at the top.

shōin-zukuri, A house type akin to *shinden-zukuri* but having a *shōin* or writing alcove.

shōji, Sliding window-doors, filled with translucent paper.

shosai, Library.

sō, Abbreviated or simple (type of flower arrangement).

sugi, Cryptomeria.

sumi, Ink wash (painting technique).

sumie, Ink wash painting

tansu, Chest of drawers.

tatami, Floor mat (standard size approximately 3 × 6 feet).

ten-chi-jin, Heaven-earth-man. Three levels of massing in a flower arrangement.

to-bukuro, Storage box for rain doors.

toko-bashira, Main post separating *tokonoma* and *chigai-dana* recess.

tokonoma, Alcove for display of art objects.

toko-waki, Tokonoma-side.

torii, Freestanding Shintō gateway.

tsubo, *ken* squared.

ukiyoe, Floating world pictures. Prints or paintings of genre subjects.

yamatoe, Pictures in native Japanese style.

yashiki, Manor or the enclosure of a manor.

zashiki, A dwelling house.

zen, Meditation. A school of Buddhism adopted from China *(ch'an)*.

Index